BARNETT NEWMAN

BARNETT NEWMAN

THOMAS B. HESS

THE MUSEUM OF MODERN ART NEW YORK

Distributed by
New York Graphic Society Ltd.
Greenwich, Connecticut

Copyright © 1971 by The Museum of Modern Art
All rights reserved
Library of Congress Catalog Card Number: 72-150086
ISBN 0-87070-501-6 (cloth binding)
ISBN 0-87070-500-6 (paperbound)

Designed by Carl Laanes
Type set by Finn Typographic Service, Inc., Stamford, Conn.
and Boro Typographers, Inc., New York
Printed by Eastern Press, Inc., New Haven, Conn.
Bound by Sendor Bindery, New York

Grateful acknowledgment is made to the following publishers
for permission to reprint copyrighted material:

On the Kabbalah and Its Symbolism by Gershom G. Scholem,
Copyright © 1965 by Schocken Books Inc.

Major Trends in Jewish Mysticism by Gershom G. Scholem,
Copyright © 1946, 1954 by Schocken Books Inc.

Zohar, The Book of Splendor by Gershom G. Scholem,
Copyright © 1949 by Schocken Books Inc.

9½ Mystics by Herbert Weiner,
Copyright © 1969 by Holt, Rinehart and Winston, Inc.
Reprinted by permission of Holt, Rinehart and Winston, Inc.

Types of Religious Philosophy by Edwin Arthur Burtt,
Copyright © 1939, Harper & Row Publishers, Inc., New York

Thomas Mann's *Dr. Faustus,*
translated from the German by H. T. Lowe-Porter,
Copyright © 1948, Alfred A. Knopf, Inc.

Goethe's *Faust,* translated by Louis MacNeice,
Faber and Faber Limited, London

"Barnett Newman" by Don Judd,
by permission of the author and *Studio International*

Finnegans Wake by James Joyce, The Viking Press, Inc., New York

From "Ecce Puer," *Collected Poems* by James Joyce.
All rights reserved.
Reprinted by permission of The Viking Press, Inc., New York

Frontispiece: Barnett Newman photographed by Ugo Mulas

The Museum of Modern Art
11 West 53 Street, New York, N.Y. 10019

CONTENTS

LIST OF ILLUSTRATIONS

This list includes only works by Barnett Newman. Dimensions are given in feet and inches, height preceding width. For sculpture, depth is also given. For mixed media and ink drawings, sheet size is given; for prints, composition or plate size. A single date indicates that the work was begun and completed in the same year. A hyphenated date indicates that the work was begun one year, worked on without interruption, and completed the second year. Two dates separated by a comma indicate that although the work was begun and completed the first year, the artist changed it the second year. An asterisk following the page number indicates that the work is reproduced in color.

Here II. 1965. Hot-rolled and Cor-ten steel, 9 feet 4 inches high x 79 inches wide x 51 inches deep. The Museum of Modern Art, New York. Promised gift of Philip Johnson. *116, 117*

Here III. 1966. Stainless and Cor-ten steel, 10 feet 5½ inches high x 24 inches wide x 18½ inches deep. Estate of the artist. *119*

Lace Curtain for Mayor Daley. 1968. Cor-ten steel, galvanized barbed wire, and enamel paint, 70 inches high x 48 inches wide x 10 inches deep. Estate of the artist. *123*

Zim Zum I. 1969. Cor-ten steel, 8 feet high x 6 feet 6 inches wide x 15 feet deep. Estate of the artist. *125*

WORKS ON PAPER

The Blessing. 1944. Oil and oil crayon, 25½ x 19 inches. Estate of the artist. *44*

Canto I. 1963. Lithograph, 15¹⁵⁄₁₆ x 12³⁄₁₆ inches. Longview Foundation, New York. *130*

Canto IV. 1963. Lithograph, 14⅝ x 12⅝ inches. Longview Foundation, New York. *130*

Canto VI. 1963. Lithograph, 14¾ x 12¹¹⁄₁₆ inches. Longview Foundation, New York. *131*

Canto VII. 1963. Lithograph, 14¾ x 13 inches. Longview Foundation, New York. *131*

Canto VIII. 1963. Lithograph, 14¹³⁄₁₆ x 13⅛ inches. Longview Foundation, New York. *131*

Canto IX. 1964. Lithograph, 14¹¹⁄₁₆ x 13⅛ inches. Longview Foundation, New York. *132*

Canto XIV. 1964. Lithograph, 14¹¹⁄₁₆ x 12⅝ inches. Longview Foundation, New York. *132*

Gea. 1945. Oil and crayon, 28 x 22 inches. Collection Annalee Newman, New York. *44*

Notes. 1968. Eight plates from an unpublished portfolio of eighteen etchings and aquatints. Collection Annalee Newman, New York. *138–139*

The Slaying of Osiris. 1945. Oil and oil crayon, 19½ x 14½ inches. Estate of the artist. *45*

The Song of Orpheus. 1945. Oil, oil crayon and wax crayon, 19 x 14 inches. Estate of the artist. *44*

Untitled. 1945. Oil, oil crayon and pastel, 19½ x 25⅜ inches. Estate of the artist. *45*

Untitled. 1945. Watercolor, 22 x 15¼ inches. Estate of the artist. *46*

Untitled. 1946. Ink, 24 x 18 inches. Collection Annalee Newman, New York. *46*

Untitled. 1946. Ink, 18 x 24 inches. Estate of the artist. *46*

Untitled. 1946. Ink, 17 x 14 inches. Estate of the artist. *49*

Untitled. 1946. Ink, 24 x 18 inches. Estate of the artist. *49*

Untitled. 1946. Ink, 19 x 13 inches. Estate of the artist. *51*

Untitled. 1946. Ink, 23¾ x 17¾ inches. Estate of the artist. *51*

Untitled. 1960. Ink, 14 x 10 inches. Estate of the artist. *96*
Untitled. 1960. Ink, 14 x 10 inches. Estate of the artist. *96*
Untitled. 1960. Ink, 14 x 10 inches. Estate of the artist. *97*
Untitled. 1960. Ink, 14 x 10 inches. Estate of the artist. *97*
Untitled. 1960. Ink, 12 x 9 inches. Estate of the artist. *96*

Untitled. 1960. Ink, 12 x 9 inches. Estate of the artist. *97*

Untitled. 1961. Lithograph, 24¹¹⁄₁₆ x 9⅝ inches. The Museum of Modern Art, New York. Gift of Mr. and Mrs. Barnett Newman, in honor of René d'Harnoncourt, 1969. *129*

Untitled. 1961. Lithograph, 22⅞ x 16⅝ inches. The Museum of Modern Art, New York. Gift of Mr. and Mrs. Barnett Newman, in honor of René d'Harnoncourt, 1969. *129*

Untitled. 1961. Lithograph, 13¾ x 9⅞ inches. The Museum of Modern Art, New York. Gift of Mr. and Mrs. Barnett Newman, in honor of René d'Harnoncourt, 1969. *129*

Untitled ("Onement I"). 1947. Ink, 10⅞ x 7⅜ inches. Collection Mr. and Mrs. B. H. Friedman, New York. *56*

ARCHITECTURE

Model for a synagogue. 1963. *112, 113, 115*

ACKNOWLEDGMENTS

This book, published in conjunction with a retrospective exhibition held from October 21, 1971, to January 10, 1972, at The Museum of Modern Art, New York, could not have been written without the continuous help of Annalee Newman, whose knowledge and documentation of Barnett Newman's work is the result of an extraordinary labor of love and scholarship. She has been kind enough to let me study her files of her husband's unpublished writings and to permit extensive citation from some of them in these pages. She has also been most generous with her advice and has taken the trouble to read my manuscript and check points of fact. Whatever contribution the text may make in furthering an understanding of Newman's art is largely owed to her patience, understanding and insight. The interpretations of Newman's work—especially in the light of Jewish mysticism—are my own. However, the analysis of Newman's development, which must be grasped before any interpretations can be drawn, could not have been made without Annalee's knowledge and comprehension of the artist's intentions.

When I started to write, I was ignorant of all important Kabbalist thinking. I followed the clues left by Barnett Newman, but would not have known how to proceed without the help of Arthur A. Cohen and Karl Katz. Harold Rosenberg, Meyer Schapiro and Harris Rosenstein were of great help. Dr. Theodore Gaster, whose lectures on Judaism Newman attended from time to time, patiently explained a number of points.

Donald Lippincott and Donald Gratz supplied important information about Newman's sculptures, as did Philip Johnson. Sculptor Robert Murray told me about how the synagogue model was built and also discussed some of Newman's ideas on sculpture and studio procedures. Tom Crawford, Newman's studio assistant in the last year of the artist's life, was interviewed about some of the artist's technical procedures.

Tatyana Grosman supplied information about Newman's *Cantos* and etchings; Leonard Bocour, about the early experiments with Magna paints.

Alexander Liberman was most generous in letting me study his photographs of Newman and of his studios, as well as talking to me about the artist's achievements. Xavier Fourcade, the artist's friend and his dealer since 1969, was both helpful and efficient. I should also like to thank all the New York artists with whom I have talked about Newman's work over the years, especially Willem and Elaine de Kooning, Tony Smith, Philip Pavia, Saul Steinberg, Adolph Gottlieb and Philip Guston, and the late Franz Kline, David Smith and Jackson Pollock.

It was in May 1969 that Newman and I first discussed the possibility of his having a retrospective exhibition which would travel abroad, especially to the Stedelijk Museum, Amsterdam, where the director, E. de Wilde, had long been urging such a show, and to London, where E. J. Power and his son Alan had been among the first enthusiastic collectors of Newman's work, and where he found The Tate Gallery and its director, Sir Norman Reid, especially sympathetic. Meanwhile, The Museum of Modern Art, which for some time had been eager to have a show of Newman's work—the first firm plans were formulated in 1966, to be abruptly halted by the tragic death of Frank O'Hara—was once again planning its own exhibition. Subsequently, The Museum of Modern Art asked me to take responsibility for that exhibition, which was then coordinated with those being planned in Europe. A showing at the Grand Palais, Paris, under the auspices of the Centre National d'Art Contemporain and its director, M. Blaise Gautier, was then added to the itinerary.

At The Museum of Modern Art, our old friend Walter Bareiss, then acting director, made the indispensable arrangements, aided by William S. Lieberman and Wilder Green. Virginia Allen, Associate Curator in the Department of Painting and Sculpture, helped to make the project a reality. She was aided by Cora Rosevear, Curatorial Assistant. Judy Goldman in the Library ably reorganized and updated for this book the bibliography originally compiled by Helmut Ripperger.

Tony Smith brought to bear on the installation of the New York exhibition his extraordinary sense of space and scale and his intimate knowledge of the artist's work and approach.

All of the lenders and every other person who was asked to collaborate with the exhibition and with the preparation of this book accepted, which is a unique tribute to Newman and a sign of the deep affection in which he was held by those who knew him and of the respect his strong personality elicited.

The exhibition and this volume will become a part of our memory of the artist—and a part of the tribute which so many people have paid to him. —T.B.H.

BARNETT NEWMAN

. . . we are making it out of ourselves, out of our own feelings. The image we produce is the self-evident one of revelation, real and concrete, that can be understood by anyone who will look at it without the nostalgic glasses of history. —Barnett Newman, "The Sublime Is Now"

"The history of modern painting, to label it with a phrase, has been the struggle against the catalogue, . . ." wrote Barnett Newman, on a piece of lined notebook paper, around 1944, in a scribbled first draft of a preface to a friend's exhibition catalogue.

Precisely.

The sleek picture book, the footnote-peppered monograph, the eulogistic catalogue are various attempts to pin down the artist, to explain away his art in defining it, to falsify the recent past with omissions, oversimplifications and propaganda, to shove a living, mysterious body of art into the cold slot of an historical category. It is a repellent, barbaric practice seen at its worst when the methodologies of art history are deployed against the art of our own time, dissecting pictures that still move us with the shock of originality and attract us by their enigmatic presence. It is extraordinary how living art is made to seem tired and faded through the same discipline which, in skilled hands, can make old art seem fresh and exciting.

Newman is right as usual. The catalogue is the enemy—and how typical of Barney to establish the fact in the opening phrase of a catalogue foreword.

He is a master of contradictions, antinomies, leaps of the imagination to inspired syntheses that transform his premises even as they establish a new-found conclusion. Contradiction structures his art and his thought. His style—his unique manner of perception, the character of his image, his metaphysical fingerprint, so to speak—is based on contradictions he first formulated around 1948; they are so strong that you would think a man's brain would explode before reconciling such a collision of sensations. Instead they opened his way to produce in twenty-two years of work some of the most influential and magnificent pictures of the century: grand, strong, profoundly moving.

The nature of the contradiction—the development of Newman's art to the crisis in 1948, and its subsequent drama—constitutes one of the main themes in this text. It is a sign Newman made for himself and under which he chose to live, as others choose to live under the sign of a career, a family name or a star.

Two other major themes are also stated in Newman's 1944 draft for a catalogue foreword. After establishing that the history of modern art has been a struggle against the catalogue, he went on to note that: "It is the catalogue's function to focus the mind on a picture's subject. The modern artist has fought to escape its shackles, and it is this struggle against subject matter that is the essence of the contribution the modern artist has made to world thought. . . . Yet the artist cannot paint without subject matter."

As Newman would say, "I raised the issues" of modernity and of subject matter, the necessary shackles.

The modern.

Newman, like other leading artists of the Abstract-Expressionist generation, his friends and colleagues, had the highest ambitions for art in general and for his own paintings in particular. He claimed that there are more things between heaven and earth—between the artist and the easel—than are dreamed of in the philosophy of everyday painting, and he once cut into a discussion about the importance of two minor masters with: "I thought that our argument was with Michelangelo!" World thought, as he wrote in his foreword, is the proper arena for the modern artist; it is at the peak of civilization, the only place for those heroic—and thus tragic—actions which a man of courage should undertake. Art is equally important, it is Newman's whole life; being an artist, he once said, was "the highest role a man could achieve—it was a dream." To enter the realm of "world thought" as an artist—to realize this double-dream—Newman's logic demanded that he must be, as Rimbaud decreed, "absolutely modern." Obviously, Newman reasoned, the artist cannot simply produce handmade decor for the marketplace. Equally obviously, he cannot simply indulge himself in the manufacture of "quality"—of luscious paintings that would please his sensuous nature and certify him as a member of a profession. On the contrary, after taking the past into account, after analyzing the present situation, the artist, like a physicist or a philosopher, must bring his new insight to bear on the most fundamental contemporary problems and move them into the future—he must "open things up."

In his belief in the necessity of being modern, he was close to his friends Adolph Gottlieb, Mark Rothko, Clyf-

Barnett Newman, Jackson Pollock and Tony Smith at the Betty Parsons Gallery, 1951.
Vir Heroicus Sublimis is hanging at left. Photograph by Hans Namuth

ford Still, Tony Smith and Jackson Pollock; in the early 1940s, he articulated some of the views they held in common. Taking this position, he was opposed to such equally close friends as Willem de Kooning and Franz Kline (although their opposition never became overt).

Newman told me once that around 1944, during one of his regular visits to his neighbor de Kooning, "Bill said, 'Art history is a bowl of alphabet soup; the artist reaches in and spoons out what letters he wants; which letters do you want Barney?' and I didn't know what to answer; I mean it wouldn't have been polite to say that I've nothing to do with that bowl of soup."

For Newman, the only way to be an artist was to be modern, just as for de Kooning, the only way to be modern was to be an artist.

Subject matter is the apparent contradiction in modern art, which proclaims a purely visual, or "plastic" expression. The modern artist thinks about what he paints—there is an epistemology somewhere in between the pigment stored in sealed jars and the pigment drying on the finished canvas—and what he thinks, that is, the subject of his creative actions, will dictate the way he begins, how he works, when he decides to stop and the nature of his contribution. Newman spent his first twenty-two years as an artist in a search for his subject matter—sometimes in gleeful quest, sometimes in desperate loneliness. He always insisted on its crucial importance; it was the only way to contribute to "world thought"; it was the single element that distinguished the artist from the decorator or craftsman.

In the draft for a catalogue preface quoted above, Newman of course punned on the phrase "subject matter." In the first part of it, he used the common meaning, referring to what the picture is "about," its plot, what it describes, a farm scene, a battle, a string quartet, or what he once called "old oaken-bucket art." But for Newman it also implicated the deepest content of art, what it *is*. Sometimes he borrowed a distinction from his friend the art historian Meyer Schapiro and contrasted "subject matter" with "object matter" (the latter refers to what Newman considered to be largely secondary technical and formal considerations, the former includes everything else).

Subject matter, for Newman, was by definition metaphysical, a visual (nonverbal) equivalent to a mathematician's formula, a composer's sonata or a poet's verse. When he named an art school, he called it "The Subjects of the Artist"; what else is there for a serious student to learn?

What else is serious about painting? Newman, for all his enormous social gaiety, happy wit, warmth, charm and genius for friendship, took art with the highest seriousness. When he would talk or write about his subject matter, it would be in terms of absolutes, the Sublime, the Tragic (words that demand capital letters which, in conversation, he invoked with his index finger pointing

to the sky, palm turning inward, the characteristic Augustus Caesar gesture). The spectator, like the artist himself, would encounter these metaphysical forces through the medium of the painting in a mysterious, perhaps empathetic, perhaps archetypical contact: a rendezvous on grounds perhaps genetic, perhaps cultural, perhaps both. He appeals to a basic apprehension, to a hidden structure in the brain, like that model hypothesized by linguisticians, which receives sensations and words and produces syntax and concepts. From the artist's and the spectator's comprehension of the experience emerges insights to the Tragic and the Heroic—a meeting with Absolutes, with the spiritual.

One is reminded of Burke and of Longinus (and of Newman's own 1948 essay, "The Sublime Is Now," in which he attacked Burke for being a bit Surrealist,[1] but more especially of Spinoza, whom Newman had studied in college and on whose philosophy he had based his first esthetic manifesto. In E. A. Burtt's paraphrase from Spinoza's *Ethics*[2]:

When knowing truly, the human mind transcends its otherwise hampering finitude; it apprehends its object under the form of eternity. This is so because knowledge of anything is clear intuition of its essence as contained in the eternal nature of God and its existence as necessarily determined by God. Such knowledge is a part of God's own knowledge of himself, which is not subject to change or destruction. And the love of God, since it arises from true knowledge and depends solely upon it, cannot be a transitory emotion, but is likewise eternal. However, this knowledge and love, as gained by an individual mind, are not without qualification identical with God's knowledge and love of himself. They retain an element of individuality of the thinker in whom they were realized. This circumstance arises from the fact that each human mind is intimately united to a bodily organism which occupies a particular spatio-temporal locus in existence and undergoes its own distinctive vicissitudes. Thus, while we may come truly to know God and other things in their eternal dependence on God, that knowledge still reflects the particular perspective in existence which attachment to an individual body has imposed upon it . . . the eternal part of any mind is hence also unique. . . .

Newman was named Baruch ("the Blessed") and Barnett was his parents' transliterated Americanization. In high school, he retranslated Baruch into the Latin "Bene-

dict" and used it as a middle name or an extra initial ("I was getting tired of being called 'Barney' all the time"; soon he was known around De Witt Clinton as "B.B.").

I do not think it a coincidence that the philosopher who seems to have most strongly marked this philosophically minded young man was Baruch Benedictus Spinoza; he would open a gate for Newman to new areas of thought.

It was as Barnett Benedict Newman that he first wrote his demands for an art that would be radically modern, informed by an epic subject matter, and treat with the issue of man in the universe on the level of world thought.

[1] For Newman, the "sublime" was more a matter of the artist's motives than a mode of painting or of how a painting could look. For him it referred to the ambition of Michelangelo, not to panoramas of the Grand Canyon or the gestures of Ajax. It was "sublime" of Michelangelo "to make a cathedral out of man. . . ." He felt that the New York artists of around 1948 were attacking the same elevated "plastic problem."

[2] Edwin Arthur Burtt, *Types of Religious Philosophy* "Spinoza's Philosophy of Religion" (New York: Harper & Brothers, 1939), pp. 180 et seq.

Yet it was almost enough to be growing up in that city.
—John Ashbery, *The New Spirit*

He was born in New York—Manhattan—on January 29, 1905, son of Abraham Newman and Anna Steinberg Newman, both emigrants from the town of Lomza, in Russian Poland. An older brother had died shortly after birth. Barnett was the eldest, but not the firstborn child; after him came a brother, George, and two sisters, Gertrude and Sarah.

Newman was a quintessential American. His passion to move with pragmatic curiosity and idealist self-confidence into the modern experience came, as it has to many American artists, not only from living an experiment of freedom and independence in a new country, but also from an understanding of, and holding on to connections with, a tradition, with Europe—in Newman's case with that Poland which, Martin Buber writes, "had a solid Jewish community, strengthened in itself by the alien, disdainful environment, and here for the first time since the Spanish flowering there unfolded a life of activity [with] values of its own, an indigent and frail, yet independent culture."[1]

Abraham Newman, a strong, self-reliant man with a military bearing, and his wife Anna, who came from a family of well-to-do bankers and who enjoyed music, literature and the arts, found Poland, with its orthodox, inbred Jewish culture, far too constricting. They emigrated from Lomza a year after their wedding, and, of course, they took Poland with them.

They did well in America. Abraham began as a salesman of sewing machines to workers in the garment district. By 1911, when the family moved to the Tremont section of the "rural Bronx," he owned a prosperous, growing company that manufactured men's clothes.

Newman's stories of his childhood evoked a comforting family and a boy's happily adventurous life—a kind of urban Huck Finn's. There were torchlight parades, excursions to neighboring farms, skating in the winter, street fights ("juvenile pogroms," Newman called them once, but implied that, in these religious wars, the Jews won as often as the Irish), football, baseball, swimming (Abraham taught his boys by holding them under an arm

and dunking them under water). For the rest of his life, Newman was a sports fan. A boxing match was the high point of his first visit to London. He invented an only semicomic mythological analysis of baseball which gives it an equal footing with the mystique of the bullring ("you'll see that the player in the batter's circle kneels in ceremonial prayer before achieving the right to hit"). If he happened to be in a town when the horses were running, a visit to the track was obligatory. Like all fans, he enjoyed the nuances of games and their jargons. He hated crowds. All artists, I think, detest them, subconsciously recognizing an enemy that wants to tear them limb from limb. When he went to Brazil, however, he braved torrents of howling partisans in order to see a championship soccer match.

If sports could represent the American side of growing up, learning was the Jewish contribution. In addition to regular classes, the Newman children attended the National Hebrew School in the Bronx, of which Abraham was a founding trustee and where Hebrew was taught "as a living language" with the method since made famous by Berlitz. The synagogue was not important in the household and only attended as a community duty—a social rather than a religious obligation. Abraham was a freethinker, but an ardent Zionist. Like many of his generation, he strongly felt that the establishment of a Jewish state was the only possible solution to the human misery that existed in Eastern Europe, and so Hebrew was part of a modern education to prepare for the possibility of a future political reality—not a mystical or nostalgic attachment to some distant past. Because of Abraham's prominence as a Zionist leader, the Newmans' home was always "lousy with tutors." Young intellectuals on their way to Palestine from Europe, or on their way back from the Middle East to work for the cause, would be tossed up in New York, in need of money and a job; they would apply to Abraham, and "Of course," Barney said, "he wouldn't take them into the business; so he'd say, 'O.K., go home and teach the kids.'" Under Anna's supervision, there were music lessons. Barney studied piano, and he attended concerts and operas almost as avidly as the home games of the Bronx Orioles—the local semipro club.

The Newmans' Jewishness, then, took the form of a tremendous respect for education and for learning, plus a belief in progress, in the betterment of man and nation.

[1] Martin Buber, *The Tales of Rabbi Nachman* (Bloomington: Indiana University Press, 1962; original printing New York: Horizon Press, 1956), p. 11.

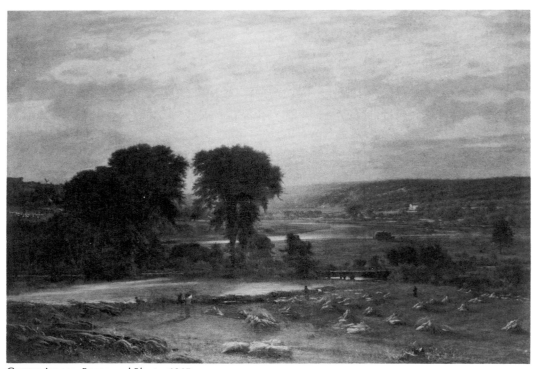

George Inness. *Peace and Plenty.* 1865.
The Metropolitan Museum of Art, New York. Gift of George A. Hearn, 1894.
A favorite work of Newman on his visits to the Metropolitan

In other words, it was American. But with a difference—it was American with a past, a culture. If they brought their past with them it was as memory, not as something to be relied on or relived. For the children, it was an object of affectionate curiosity and pride. They did not study it systematically, but treasured bits and pieces of Jewish lore and custom. They read its Book. They respected its achievements. They loved its aura. And they burned with a sense of rage at the injustices to Jewry which run through European history like a thread of blood. This is perhaps what most distinguishes the feelings of an American family such as the Newmans for the Jews from those of an American family such as the Mellons for the Scots. A hatred of injustice also underlies, I believe, part of Newman's attraction to radical, anarchist politics and his combative role as a polemicist for the emerging American abstract paintings of the early 1940s.

It is a hatred of injustice, it should be noted, that is based on a love for, and knowledge of, a great and greatly traduced culture. It is a positive force, intent on preserving. When Newman would fight for his own art, which he often did, or for that of his friends, which he did even more frequently, it was in order to clarify intentions or set the record straight. Although he dearly relished a good brawl, he never attacked people or institutions because he felt they were wrong or evil. He dismissed that. He battled to defend the Right.

His education as an artist began early. His mother used to say that as soon as he learned to hold a pencil, he began to make drawings. Newman vividly remembered a kindergarten teacher's demonstration of how to tell time: she drew a circle on the blackboard—numbered like a dial—and then, with the addition of a curve, made a clock in perspective. At first the diagram was flat, Newman recalled, then it suddenly became "real—my first art experience!" He also remembered modeling little animals out of warm tar scraped from the pavement, working his hands in the sticky substance. These two recollections stayed with him probably because both found strong echoes in his later work: in the circle theme that was one of his major preoccupations from 1945 to 1947 and in the roughly modeled surfaces of his first sculpture. When he was twelve, he made chalk sidewalk drawings of patriotic subjects, such as George Washington, the American eagle and the defeated Kaiser, at Liberty Bond rallies. Years later, in a symposium, he was asked if he was really the father of "stripe painting." "If I *am* the father," he replied politely, "I never had the honor of knowing the mother"; but he regretted the joke, thinking that it might be construed by a paranoid New York art world as an attack on Kenneth Noland or Frank Stella. So when the question inevitably was asked at another artists' round-table discussion, he replied that, no, he was really the unknown father of Pop Art and had been the first New York artist to specialize in flags, in 1917,

on the streets of New York. Drawing with crayons and chalks was also one of his favorite techniques from 1944 to 1948.

Art opened to him, claimed him, at The Metropolitan Museum of Art. He cut classes (often missing two days a week from De Witt Clinton High School) to visit the galleries all morning, eat a sandwich in one of the rustic gazebos that decorated Central Park, pay his respects to the obelisk, and then return to the museum for the rest of the afternoon. It was a powerful adolescent experience, common to many New York artists and poets of his generation. The Metropolitan was a hushed, sacred place, but you felt at home there, too, as comfortable as a French child in a cathedral; it was otherworldly, but a part of daily life. As a citizen of New York, Newman felt he owned the museum; his being there was a right. He "owned" his first loves, the high-keyed Romanticism of the Hudson River landscapes, the lush panorama of Inness' *Peace and Plenty* (1865) and the melodrama of Jonas Lie's *The Conquerors* (1913), which celebrated man's triumphant will in forcing the Culebra Cut of the Panama Canal. Later he studied Homer and Ryder. He started, in other words, with what evidence he could find that it is possible for an American to be an artist. This might seem curious to Europeans, who see their national art outside their nursery windows, and to young American artists today, who work freely in a tradition largely formulated by Newman and his friends. For Newman's generation, however, American culture with its harsh emphasis on the middle-class values of progress, success, pragmatism and conformity (that is, fear of the unusual and of the unknown) accepted and respected art only as a decoration which symbolizes power and riches. It was something for "others," for aliens to make; artists were strangers.

In the American painters at the Metropolitan, he found older brothers, friendly examples and precedents. And he found art in the streets of New York, too, in railroad stations, post offices, firehouses, courthouses, skyscrapers, warehouses; in down-to-earth buildings with fantastic cast-iron façades, in the adventurous dispositions of huge volumes and acres of fenestration, in red-stone masonry ingeniously cut and fitted to shelter twentieth-century steel machines. A walk down Wall Street was for Newman a walk through ancient Rome and Athens and Thebes. He studied his monuments as carefully as a fifteenth-century Humanist studied the Forum.

He was never a chauvinist. Rather, he gloried in what he had, as in Rabbi Nachman's famous tale of the Simple Man who declared that his glass of water was a clearer wine and a finer beverage than the king's.

In the evenings, Abraham Newman would describe The Hermitage, which he had visited when he had been stationed in St. Petersburg as a conscript in the Czarist armies, and how its walls were carpeted in paintings. And, ducking out of school, Barney would return to the

Snapshot of Barnett Newman, age twelve

Metropolitan to study the Rembrandts in the Altman Collection, the Hall of Armor where he admired "a magnificent Portuguese breastplate," the Egyptian wing, the Italian artists (one of his favorites was Piero di Cosimo, a master haunted by images of the beginnings of mankind).

At some point in 1919–1921, he decided to become an artist, or rather to try and become one, to achieve this highest role. In 1922, he convinced his mother to let him study at the Art Students League while he finished his senior year at De Witt Clinton, and he entered a beginners drawing class, working from casts under Duncan Smith. According to Newman, he did not have the precocious flair for drawing that marks many artists' first efforts. His copybooks were not studded with those salient cartoons and sketches which foretell the emergent genius in the chronicles of Vasari and Bellori. Piecing together Newman's own accounts, one is reminded of Cézanne's early, all-thumbs drawings or Pollock's clumsy student efforts. "I kept plugging away," said Newman, at a rendition of the Belvedere torso, and the strength and purity of the effort must have come across (as it does with Cézanne and Pollock), because Duncan Smith picked Newman for inclusion in the League's annual exhibition of the best students' work.

The next spring he decided not to go to college but to attend art school full time. His parents, especially his father, did all they could to dissuade him. Abraham wanted him to go to an Ivy League school; Barney did not want to leave New York. After considerable drama, his father talked Barney into accepting college (it was for Abraham a necessity, an essential part of the American life); he could still attend the Art Students League, and later, if he remained determined to be a painter, that option was open; but if he skipped higher education, Abraham pointed out, and later wanted to become a banker or a lawyer, it would no longer be possible.

It was a drama that would be repeated several times during Newman's early life. Becoming a serious artist meant an open conflict with his family, with all he had come to love and to rely on for security; worse, it was a kind of betrayal, a breach of trust, a broken covenant.

Newman, who had enjoyed studying French with a marvelous teacher at De Witt Clinton, once told me to my surprise that he preferred Corneille to Racine, admiring the stark rhetoric of the older poet to the more subtle (and to most people, more profound) lyricism of *Phèdre* or *Bérénice*. Later I understood that the typical Corneillian hero is usually locked in a dilemma very similar to Newman's as a young man. Should the hero be loyal to himself, to his own love, or to a larger social force embodied by his family, his country or his religion? He declaims in anguish as he realizes that to honor one, he will have to betray the other. Each is equally demanding and equally necessary to his existence. "Pierced to the bottom of my heart . . ." cries Don Rodrigue in *Le Cid*:

My love has taken sides against my honor:
I must avenge a father, and lose my beloved;
One enflames my heart, the other checks my arm.
Infinite sorrow! I must either
Betray my passion or live in infamy.
O God. . . .[2]

Newman loved to recite Corneille in the sonorous voice and with the wide gestures of the classic actors. I think he had memorized this famous passage from *Le Cid* but could never be sure, for if his rendition of the music in the words was perfect, his pronunciation was, let us say, highly stylized. He would perform the speech with a delighted grin, enjoying the ham quality in theatrical indignation, although he was a man of tremendous delicacy. Irony and comic distance secured his privacy. He turned Corneille's laments into jokes, but I think he chose them because he felt them himself.

He finally agreed to the compromise of going to college in New York; at his father's urging, he applied to New York University, which rejected him, evidently because its quota for Jewish students—in those days it was notoriously small—had been filled, and then to the City College of New York (CCNY), where he matriculated in the fall of 1923. He kept going to classes at the League, studying life drawing with von Schlegel and later painting with John Sloan and Harry Wickey. He visited museums and galleries with friends, and they educated each other in the possibilities for an American modern artist.

At CCNY, which always has been famous for the aggressive brilliance of its undergraduates, most of his education took place in conversations in parks when the weather was warm and in cafeterias when it was cold. He became interested in poetry, radical politics and in that humane combination of both which is known as anarchism. The one class that, forty years later, still came to mind was a philosophy course conducted by Scott Buchanan in which the curriculum progressed backward from Bertrand Russell to Vico. Newman had run across many references to, and become interested in, the paintings at The Barnes Foundation, in Merion, Pennsylvania, and when he read in the newspapers that Russell was teaching there, Newman organized the whole class to travel down to visit it. He was astounded to find that he and the class were refused permission to see the famous Renoirs, Cézannes, Picassos and Matisses. A rich man claimed them as private property and denied access to them. Newman walked around the city "in shock." Late that night, in a Greek restaurant, on a batch of paper bags, he wrote his first manifesto. He attacked "objective attitudes" toward art and esthetic analyses; he attacked Russell and Barnes's other philosopher-in-residence, John Dewey; and he held up in their stead Spinoza's principle of intellectual intuition as the key to the meaning of art. It was, he said, "a moment of self-discovery—

[2] Pierre Corneille, *Le Cid*, act I, scene 6.

of what a painting is . . . that it's something more than an object."

For Spinoza, there are "three classes of knowledge"[3]:

Lowest is data, school-book rules, customs, things learned "without order to the intellect." (So much for John Dewey, whose famous precept was "learn by doing.")

Second-class knowledge consists in things learned by deduction and logical inference, as in geometry and in the new mathematics which was so promising in Spinoza's day that it seemed to prove an order in the universe. (So much for Russell and the emerging logical positivists.)

Highest is immediate knowledge, based on the functions of reason, but obtained through intuition to "the essence of things." For Newman, a work of art should be an instrument for and paradigm of such intuitions. Rational, not mystical. Real and disciplined, not self-indulgent, romantic (one of his early pet hates was Richard Wagner). Moving from man, and from man's knowledge, outward, where through a leap of insight it joins "world thought."

His search for subject matter had begun.

Through friends at the Art Students League, Newman met Adolph Gottlieb, who was two years his senior. Gottlieb was a "romantic figure . . . already a dedicated artist"; he had dropped out of school and worked his way through Europe on a five-dollar-a-week allowance wangled from his family. He was sophisticated to art and, in Newman's eyes, a virtuoso technician, a man who could do anything he wanted to with a paintbrush. They remained close friends for over twenty years, visited the Metropolitan Museum together on weekends (Sunday was, and to a certain extent remains, a day when the Metropolitan turns into an artists' club, where young painters comb the galleries and their elders give informal lectures on out-of-the-way favorites—a bit of Roman painting, a Cypriote relief, a passage in Pissarro), and they went to the few art galleries which offered modern pictures and important old masters. There was Matisse at Valentine Dudensing (where Gottlieb would have his first one-man show in 1930), Chardin at Wildenstein, Niles Spencer and Charles Demuth at Stieglitz's An American Place. They went to sketching classes at the Educational Alliance, and later Gottlieb organized one in his studio.

Most of all, there were hours of conversation, but the relationship never became one of those mutually creative symbioses which curiously mark the history of modern painting—as Gottlieb would have with Rothko in the early 1940s and de Kooning with Gorky, Duchamp with Picabia, Picasso with Braque, Matisse with Derain, Bonnard with Vuillard. In such often brief alliances, the artists, in a sense, pooled their strengths to overcome their weakness. When problems became conceptual, they

[3] Karl Jaspers, *The Great Philosophers,* trans. Ralph Manheim (New York: Harcourt, Brace & World, 1966), pp. 295–298.

solved them, one feels, by concentrating on technical applications. When the difficulty became technical, they would bypass it with shared ideas. One sees this clearly in the rapid development of Cubism, for example, where Braque's introduction of lettering and wallpaper collage elements suddenly gave image to an idea Picasso had been wrestling with since the still life in the *Demoiselles d'Avignon.* With Gottlieb and Newman, however, the conversation never got beyond the verbal level and to the point where paint is applied on canvas. Gottlieb remembers Newman as "the all-American intellectual." Newman remembers Gottlieb as a fluent painter of images which he, Newman, admired but found irrelevant to his own needs. They helped each other as friends, of course. Gottlieb, after all, represented for Newman not only an American who had become an artist (like the leaders of the Hudson River School), but also a painter out of Newman's own generation and social milieu who had made the breakthrough. Furthermore, of all the New York artists, Gottlieb was always, and remains, in the best sense of the word, the most professional: unswerving in his commitment, dedicated to work as well as to his inner vision, secure in a stable identity. He was a valuable sea anchor to his younger friend whose high ambitions as often filled him with hopelessness as with elation. Newman's motto might have been "to the stars!" Gottlieb's advice was "persevere."

In 1927, Newman graduated from CCNY, with a sigh of relief. At last he could concentrate on becoming a full-time artist. But Abraham Newman, who evidently did not want his son to take such a risky step, brought up a new plan. As his business was prospering in the postwar boom, Barney and George should work there a few years as full partners. Then, by 1929 or 1930, Barney could leave, if he still wanted to be an artist, and he would have about a hundred thousand dollars in the bank to tide him over at the beginning; he would be able to study, travel, think at leisure. All Newman's friends, the intellectuals, poets, anarchists, urged him to take the offer, including the persuasive Gottlieb. So he became a manufacturer of men's clothes—an expert in materials, cutting, fitting, marketing—and just when his stint was over, when he was scheduled for transformation into a painter with an independent income, the 1929 crash wiped everything out. It became the Corneillian dilemma with a vengeance.

Newman urged his father to go through bankruptcy, but that was not acceptable to Abraham's chivalric code. A Zionist who voted Republican, an enemy of tyrants who nevertheless accepted middle-class standards as a body of unalterable law, he decided to fight for his business according to the same Horatio Alger precepts on which he had founded it. Ten years of struggle followed in which Barney took the leadership of the enterprise; Abraham became more and more withdrawn; George, at Barney's urging, started a new career as an architectural

Newman at his graduation from college in 1927.

draftsman; it was up to the artist to keep things going in complicated loans, speculations and various other types of fancy paperwork. If nothing else, it was a thorough education in the economic underworld of the market-place and of capitalism. In 1937, Abraham had a heart attack and retired from the company, which Barney was then free to liquidate.

In those ten years, Newman changed from being the brilliant but difficult son into the head of the family; he sheltered Abraham as if he were his own child; he took charge of his brothers and sisters. He became the extraordinary self-confident, independent figure—father figure you could say—who would leave so deep an impression on a generation of young artists in the 1960s.

Patching up a sick business was, of course, hardly enough to occupy a man of Newman's energy. He became interested in municipal politics and started a magazine that fought for a clean civil service and against Tammany Hall pork-barrel bureaucracy. Not that he was against corruption in *high* office; he claimed only half-jokingly that crooks make better mayors because they are sensitive to the needs of people and are not distracted by idealist programs. He taught himself Yiddish in order to be able to read the only local anarchist newspaper. In 1933, sitting around at Bickford's over a late coffee, he attacked all three mayoral candidates (Joseph V. McKee, John P. O'Brien and Fiorello La Guardia), and announced, "I'll vote for myself!"

On November 4, 1933, A. J. Liebling, later to become famous as the best critic of our "Wayward Press," then a staff reporter, published a story in the *New York World-Telegram* under the headline:

TWO AESTHETES OFFER SELVES AS CANDIDATES
TO PROVIDE OWN TICKET FOR INTELLECTUALS
The subheads announced:

B. Barnett Newman Seeks Mayoralty—
Alexander Borodulin Runs for Comptroller.
Manifesto to Artists, Teachers and Musicians
Asks Cultural Write-in Vote.
Liebling's report went right to the point:

Time before the election was fleeting, but art is eternal, and B. Barnett Newman, of 984 Sheridan Ave., The Bronx, and his friend, Alexander Borodulin, of 2107 E. Third Street, Brooklyn, felt that the forces of self-expression should express themselves by the ballot.

So Mr. Newman, who is 27 and a teacher of art in a senior high-school in Queens, decided to run for Mayor. Mr. Borodulin, also 27, a writer on aesthetics, decided to run for Comptroller.
SEND OUT MANIFESTO

Just like Karl Marx, whom they cordially detest, they got out a manifesto:—"On the Need for Political Action by Men of Culture." They have sent several thousand copies through the mails, to school and college faculties, newspaper staffs, art schools and the personnel of symphony orchestras, asking for a cultural write-in vote.

"I don't particularly expect to be elected," admitted young Mr. Newman, as he folded manifestoes in his father's merchant tailoring establishment at 154 Nassau St. yesterday. "We offer our names as focal points for a demonstration of the strength of the intellectuals in New York."

"It is humanity's tragedy that today its leaders are either sullen materialists or maniacs who express the psychopathology of the mob minded," he quoted from the manifesto.

NOTHING FOR ART

"The present political campaign in New York has now run long enough to reveal that once again the artist, the musician, the writer, the actor, the teacher, the scientist, the thinker, and the man of culture generally, have nothing to hope for from any of the candidates."

"The artist is free," Mr. Newman went on. "He doesn't belong in a government of expediency. Expediency always proves inexpedient in the long run. Vote for Communism as a protest, and you help saddle yourself with a regime incompatible with art."

Free music and art schools in every district, a municipal opera house and orchestra, a civic art gallery with selling facilities (no jury), closed right-of-way on certain streets for the use of street-cafés and a municipal bank and insurance system are included in the Newman-Borodulin platform.

"Of O'Brien there need be no discussion with those to whom we appeal," the manifesto states. "McKee has sufficiently revealed himself, in his long association with Tammany and its policies, and by his present opportunistic campaign, to be out of the question for us."

"La Guardia, of the three major candidates, needs consideration," the manifesto concedes, but goes on to say that he is no better than the rest.

"But don't you think a party limited to men of culture would inevitably remain a minority party?" the candidate was asked.

"No," he said. "We must spread culture through society. Only a society entirely composed of artists would be really worth living in. That is our aim, which is not dictated by expediency."

APOLOGETIC REJECTION SLIPS

He does not have as much time as he would like for his own painting, Mr. Newman said. He admires John Sloan, Picasso, Kuniyoshi and the less-known Adolph Gottlieb and Tom Nagai above other artists. Mr. Borodulin's father is science editor of a Jewish newspaper and pays Mr. Borodulin for writing on aesthetics in such a high-class way that nobody will publish his product.

"But the letters he gets from publishers are apologetic," says his running-mate.

"In writing yourself in for an artist and a writer," he concluded, "you declare yourself not for personalities but for a principle of government which is too easily lost sight of in these desperate demonic days."

Newman, as he announced, did not expect to be elected, but he thought he might rally "a body of votes" that would be "powerful and united" enough to demand "direct consideration and action." "Then," he continued, "we would not have the supreme sneer of a cheap hypocrite and politician who refused to allow artists to exhibit their created works in Washington Square because in his fat head peddling is peddling, whether it be fish or paintings, that is to say, whether it be sole or soul!"

As for the program enunciated in the manifesto, it does not seem as droll today as it must have to Liebling almost forty years ago. Free art schools and a municipal opera were instituted by La Guardia, one of whose aides contacted Newman early in 1934 to get his recommendations. Streets have been closed for New York's pedestrians by Mayor John Lindsay, and he has also encouraged sidewalk cafés. Newman's "Program for Cultural Life" turns out to have been prophetic of every American politician's program for 1972. In his manifesto, he demanded:

A CLEAN AIR DEPARTMENT, like the Dep't of Sanitation, to rid the air of its present pollution, by ordinance and compulsion.

A DEPARTMENT OF LOCAL WATERS to clean up the bays, beaches and rivers.

ESTABLISHMENT OF extensive waterfront parks.

ALL PARKS closed to automobiles.

LOW PRICE PARK CASINOS.

PUBLIC WORKS connected with City Planning, to clear slums and beautify city.

A LOCAL PLAYGROUND AND PARKS SYSTEM.

A LARGE INDOOR AND OUTDOOR PUBLIC FORUM FREE OF POLICE LICENSING.

All this, plus an extensive education program, financed by the city engaging "in all income producing activities."

It is a lovely, jaunty vision of the city, where the "maniacs of dogma" of the Socialist and Communist parties could sit down with the fat-headed bosses for a low-priced beer picnic in the clean air of a riverfront park and discuss Mozart and the new painting. And, as time has gone by, there have been few better offers.

To make money, Newman worked off and on from 1931 to 1939 as a substitute art teacher in high schools for $7.50 a day, and the day was from 8:40 A.M. to 3:00 P.M. (He never could pass the regular art teacher's exam; Adolph Gottlieb flunked it, too; and in 1938, Newman arranged for Thomas Hart Benton, America's "most famous artist," to state that he, also, could not meet those bureaucratic standards. Newman organized a protest exhibition at the ACA Gallery titled "Can We Draw?" to denounce the Board of Examiners, and ended up with the privilege of taking the test again—only to fail it again.)

Despite a natural gift for teaching, he never enjoyed classroom work with children. Since he was one of the few strong men teaching in the school, the women would send pupils they wanted punished to his class; he

Barnett and Annalee Newman at Ogunquit, Maine, 1936.
Photograph by Aaron Siskind

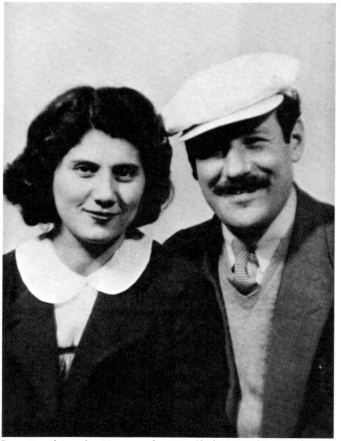

Barnett and Annalee Newman, from a self-photographing machine
in Times Square, New York, ca. 1940

was expected to make them stay silent at their desks, and he found that the need to keep discipline drained him emotionally; after all, he believed in total freedom. There was a compensation, however; in 1934, at a teachers' meeting, Newman got into a heated argument with a beautiful girl who insisted on defending Wagner's operas. As Newman was demolishing her case (he often used to prove a point by singing an entire scene from Mozart, taking all the voices), she ran out of the room and slammed the door. Newman was very impressed. He found out her name, Annalee Greenhouse, and he courted her with concerts, dancing and poems. They were married June 30, 1936, and went on a trip to Concord, where they spent a week visiting Walden Pond, the Bridge, Emerson's and Hawthorne's houses, and Bronson Alcott's academy—the shrines of American culture and revolutionary thought. Their love became the center of their lives; they were always together.

Husband, politician, publisher, writer, anxious businessman, litigant (he spent some five years in a legal battle on behalf of his father-in-law in an attempt to reclaim some basic patents for the manufacture of carbonated drinks), he also became a student of botany, geology and ornithology. He wanted to "study nature with science," he said, and break out of the artist-in-a-studio environment. Instead of admiring landscapes, he wanted to investigate the beginnings of life, how it emerged, how its orders developed.[4] In 1941, he went to Cornell University for a summer session; he was fascinated by birds, "their wilderness—the idea of freedom." He enjoyed studying their skins ("the only way you can get to know them") and their songs, evolving an "Esthetic Taxonomy" that classifies birds on the evolutionary scale according to the complexity and variety of their calls. A few years later, confronting philosopher Suzanne Langer in a panel discussion at Woodstock (August 1952), he attacked her observations on the symbolic nature of art with an ornithological simile that later was polished into the now-famous epigram: "Esthetics is for artists as ornithology is for the birds."

When the army called him for an interview and physical under the Selective Service Act, he claimed exemption as a conscientious objector on the grounds that he would be deprived of his "right to kill," as guaranteed by the Constitution. He was perfectly happy to shoot Nazis, he pointed out, but he was not going to kill just anybody

[4] "The same tendencies that provide for visible order in the world, for the existence of chemical elements and their properties, for the formation of crystals, for the creation of life and everything else, may also have been at work in the creation of man's mind. It is these tendencies which cause ideas to correspond to things and which ensure the articulation of concepts" (Werner Heisenberg, *Physics and Beyond* [New York: Harper & Row, 1971], p. 6).
Newman probably had a similar thought in mind in his "postgraduate studies," for they focused on the processes of genesis and on the creative acts of nature: in short, on what would become his main subject matter.

on the say-so of some lieutenant. It is not known what the officials made of this, but they deferred him on physical grounds and, when he insisted on his moral rights, for reasons of conscience also.

He kept painting. In fact everything he was doing, no matter how disparate it may seem in the retelling, was tied to art. He tried to become mayor to transform New York into a city of artists. He studied the natural sciences to verify his approach to nature. He taught art. In the early 1930s, he met Milton Avery through Adolph Gottlieb, and they organized a sketch class. Later he recalled that he found Avery "meaningful" as an artist, but the older painter's thinly washed areas of crisp colors did not have the refreshing effect for him that they had for Gottlieb and later Rothko. Newman's own work at the time was what he called "a form of American Expressionism." "It was flat painting," he said, "and because I was fed up with brushes, I used a felt-tip with a holder, the kind that you load with pastel powder to make large areas of flat color. Some of my work was serious—it looked a bit like David Hockney's (in 1967)—but everything around bored me stiff. I was interested in serious questions. What *is* painting? Is it really *circles*? Is it really *nature*? What are we going to paint? Surrealism? Cubism? I was drifting away and casting about, involved in a search for myself and for my subject . . . in a hunger about myself."

He tried applied art, teaching two-hour classes two days a week at the Washington Irving Adult Center and giving instruction in silk-screening, fabric dyeing and printing, batik, even inventing some ingenious techniques. New York, he felt, should also become the center of world fashion. But commercial art repelled him with its useful objects, superficial designs and ideology of the commonplace. He grew to detest dyeing and dyes for their "tutti-frutti" color, their ephemeral substance and for the pseudofolk culture they so often represented. In the 1960s, when heard to utter a rare word of negative criticism for some of the then-new color painting, it was a grumbled "Batiks!"

He told Gottlieb that "painting is finished; we should give it up." But Gottlieb encouraged him to persist, keep working, seeking; they would find something, he was sure. Newman described this period in the late 1930s and early 1940s as a "limbo." But had he not given up painting all along? Was he not a super Marcel Duchamp, abandoning art in disgust? But, in Newman's case, had he not abandoned it before he had seriously begun?

The contrary is true, of course; Duchamp felt he had risen above art, gone beyond the old-fashioned mucking around with paints and the shuffling of the old playing-card ideas of composition, symbolism, self-expression and the like. He evolved a strategy for climbing out of it. Newman, on the other hand, was trying to get himself in. He would have agreed with Duchamp's clinical analysis of the situation. It was intolerable. But Newman's resolve

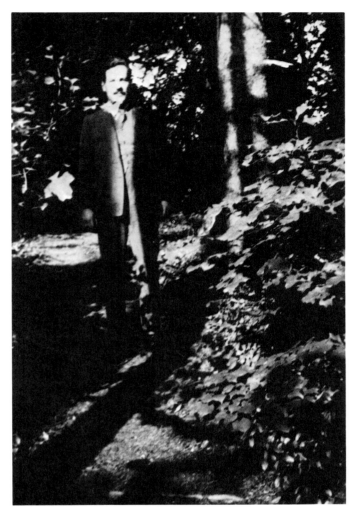

Newman in Hawthorne's Wood near Concord, Massachusetts, during his honeymoon in July 1936.
Photograph by Annalee Newman

Newman during a 1937 visit to Martha's Vineyard, Massachusetts.
Photograph by Aaron Siskind

was to change it, make it new—a new life, a new art, a new world.

The question remained, how? In Paris, Cubism was played out in the hands of the masters who originated it. Instead of finding daring projections from their original hypotheses, they seemed to be content with stroking the harlequin patterns of their shapes with ever more pleasing colors. The Surrealists had reverted to reactionary, illusionistic techniques. They were admired by the young American artists for the high poetry of their manifestos; for their proclamations that every man should be a free spirit and that art was in the service of a revolution (an anti-Stalinist revolution, of course); and for their insistence on the importance of a new subject matter founded on images from the subconscious and from dreams (Freud and Jung). But as the American Regionalists and Social Realists made clear every day, you could not express a new subject matter with a methodology that had been discarded since Impressionism. There remained the options of Mondrian, Miró and Kandinsky (all of whom were far more familiar to the New York artists by the late 1930s than they were to their colleagues on the Continent). But Mondrian's image, extrapolated from nature, was too dogmatic to attract an unfettered spirit such as Newman's; Miró's was too involved with some code from a Catalonian childhood and folk experience; and Kandinsky's, although his early Improvisations were clues to a new lyricism, had hardened in both image and spirit and seemed to be dedicated to fatuous exercises in theosophic mysticism and dubious color-music parallels. These were the predominant names, the examples for young artists of the late 1930s. None of them seemed to offer any openings to the future. In Germany, the Bauhaus and the Expressionists also appeared to be closed books, promising in early years but closed by the 1930s.

Newman's was a common situation; almost all the artists who were to emerge in the 1940s with radical new styles found themselves stuck in the 1930s with nothing to paint. Many of them kept working out of a trust in work itself. Many of them thought that the historical crisis would solve itself—something would come along, as it always had in the past. Newman, with his extraordinary sensitivity to the times and acute analysis of the dilemma they presented, found himself unable to look at any of his pictures without disgust. He destroyed most of them as soon as they were finished. Later, he ripped up the few he had given to his family as souvenirs. The only surviving works are a half dozen drawings made from a model in a sketch class in Ogunquit, where he and Annalee had gone in the summer of 1936 after their pilgrimage to transcendental Massachusetts, and these are preserved only because Annalee managed to tuck them away. Direct, fast, competent studies, they reveal some clumsiness in the "difficult" anatomical passages—hands, feet—but, as might be expected, a great flair in placing the drawing on the white sheet of paper.

He decided that the only way to become a painter was to stop painting and to rethink the whole problem from scratch—from the Cartesian tabula rasa that for him was the most stimulating hypothesis of all, a challenge which often led to insights.

Many other American painters came to the same conclusion a little later in the game. They simply stopped work. It was a time of anxiety, crisis and a kind of oppressive, boring hopelessness. The 1930s were coming to an end. Paris was sealed off by the Nazi Occupation. Each artist was on his own, and the most they could share was a camaraderie of laughter at the futility of their case. Each man undertook an elaborate interior quest. Newman is unique in that he made his errantry public, in writings, published wherever and however they could be, in epic conversations and in private essays.

At this point in time, the American painters made a decisive break with history—it was so daring a move that it startled everybody, even themselves. Looking back at the period from a perspective of three decades, we can put history together again, make a seamless web of process out of what had been a shambles of false moves, happy accidents and precious insights gained through heartbreaking labors. Once something is accomplished, it always fits into place; in fact, it fits so neatly that some art historians hold that forms have lives of their own and develop as a tulip grows from its bulb, naturally; the intervention of the creative artist is only as important as that of a conscientious gardener. Other historians string artists together like Christmas-tree lights on a wire, each shining its own bright color, and each taking the current from the light down the line. This is understandable because a break in history is inconceivable to the historian. Furthermore, it is partly true. Art does grow from art, and artists from artists and from the period they belong to and possess.

The American artists—Newman and Pollock, de Kooning and Gorky, Hofmann, Still, Rothko, Gottlieb, Kline, David Smith and their friends—broke with the 1930s of Paris and New York, but some of the revolutionary poetry that would inform their new images in the following years comes from that much-maligned decade that opened with the greatest Depression and closed during the greatest World War.

Five attitudes from this immediate past haunted Newman and his friends; these were, so to speak, hidden hypotheses behind their resolution to make completely fresh starts.

1. Art should not be a middle-class, luxury object. The Dadaists had said as much, but one kept seeing the most shocking Dada objects handsomely framed in luxury flats where they sang as happily among the chintz as any Meissen bird. The Surrealists were for the Revolution, but their barricades looked like props for an elegant vaudeville, and their manifestos were apt to scan as purely as Bossuet. The American Social Realists and the Mexicans, however, were made of tougher stuff. Even though Newman and many of his colleagues disliked their art, they agreed that painting should be taken away from the connoisseur (but not necessarily be given, *en revanche*, to the commissar). In the 1930s, the cultivated niceties of art came under devastating attack. A picture should not be ingratiating. It should *be*, in the most economical, stripped-down, lean, direct way possible. It would communicate to a wide public—perhaps the Universal Public—not through Social Realist caricatures dedicated to the enlightenment of the proletariat, but through a strategy adapted from Freud and Jung, by direct connection to the subconscious and (here Pollock is a case in point) archetypal imagery. If the positive part of this program was vague, the negative side was emphatic: no more cuisine, no more matière, no more refinements for their own sakes; delicate glazes and scumbling, nicely tilted impastos, delicious passages, art as an emphatic caress, were out.

2. Even as he put his art on the line, in the streets so to speak, the artist was by no means joining the people. On the contrary, he stood among them only as the unfairly unacknowledged legislator of the world. The role of the artist, transcending artisanship, disdaining the purveyance of luxury products to a "happy few," was exalted to the highest level of the intelligentsia; and what other aristocrats are there? In the past—from the beginnings of American painting by imported Europeans and by native limners through the 1920s, when American artists were seen as country-cousin versions of their European betters or as unique embodiments of some idiosyncratic flair—the American artist was felt to be something of a boob (this attitude was general even in the most enlightened circles). Most people thought him a more or less dangerous nut: useless, unclassifiable, pretentious. American writers—poets and novelists who had been making their reputations in Paris and London for over a century—were always slightly ashamed of their local painters. In their fictions, the typical American artist is a passionate hero who fails in his ambitions because of the curse of provinciality, with the inevitable implication that he was also cursed with a low IQ. All this changed, from the artists' point of view, sometime in the late 1930s and early 1940s. (The writers, I might add, on the whole never changed; most of them still consider artists to be a special breed of God's Fools, only now they are a little bitter about it, as they see artists' incomes matching their own royalties, and artists' statements getting published as if they really had something to say.) The tradition of the artist as a culture-hero, of course, goes back to nineteenth-century France and beyond into the Renaissance. Until the 1930s, however, it seldom attracted the Americans; institutional and cultural pressures, probably, made it unthinkable. Thomas Eakins never pretended to be Walt Whitman. John Marin wrote: "and if I like to go

Newman at Martha's Vineyard, summer of 1937.
Photograph by Aaron Siskind

fishing, what then—Does one have to set a pace? Does one have to be great? Does one have to try and jump farther or higher than someone else?" For Newman, Pollock, de Kooning and their friends, for the first time, the opposite would be the case. They would set up a new culture; they would create a new kind of understanding; they would, in de Kooning's phrase, "shoot the works." In his talk at Woodstock in 1952, Newman was only half joking when, in words aimed at the philosophers on the podium, he made a distinction between Nature and Reality. Reality, he said, is what is there, like a river, but Nature is what the artists create—we see it as they reveal it to us. All women's lips, he pointed out as an example, had been painted by Picasso two years before. The artist is *the* Creator.

This exalted view was reinforced by the example of European artists in exile in America during the war years. Such men as Mondrian, Duchamp, Léger, Miró, Arp, Ernst, Masson, Moholy-Nagy, Tchelitchew, Tanguy, Hélion, architect Mies van der Rohe, musician Edgar Varèse, poet and Surrealist chairman André Breton, for years had been star names in well-thumbed magazines; now they appeared on the local sidewalks and salons, cosmopolitan actors in an international drama whose theme was the crucial importance—indeed the necessity—of art.

3. It followed almost inevitably that if the artist is a hero who acts on a world stage, his works will be epic in scale—vast, ambitious pictures that would be commensurate with the scope of his thoughts. Underlying this development was the experience of many painters in various government-sponsored arts programs (especially the WPA) in the Depression years. Murals for post offices, schools, hospitals, housing developments and public buildings became common projects, and such artists as Pollock, de Kooning, Gorky, Guston, Brooks and Noguchi were attracted to big, public enterprises. The concept of a new, sparse art which would bypass the estheticism of middle-class taste and appeal directly to a wide audience was not only the program of the Social Realists and their Mexican mentors, but also of the younger artists who were seeking a new form of modernism. Even though the big paintings which would mark so much of the art of the 1950s (and become a trademark of the 1960s) did not appear with full impact until the late 1940s, their scale was very much a part of the heritage of the previous decade. Probably one of the reasons for the slowness of their emergence is the fact that most of the young Abstract Expressionists had not traveled abroad. Caught by the Depression and the war, they had skipped the years in Paris and trips to Italy that had been part of the standard education of American artists of previous generations. Thus they did not know how massively the huge Delacroixs, J. L. Davids and Ingreses dominate the Grande Galerie in the Louvre. When, in 1968, Newman first visited the Louvre, he was astonished at the size of Géricault's *Raft of the Medusa* and of Cour-

bet's *Studio*. His reference points for the masters always had been the Metropolitan, where the pictures are comparatively small and have the appearance of objects that have been frequently and easily moved about. Another, and probably more important inhibition to working on a large scale was the simple, stark financial one. Practically all the American artists were broke; they worked in small studios (often a room set apart in an apartment); they were forced to skimp on purchasing supplies; and there was also a certain lack of confidence. It is one thing to claim the right to an heroic role—and that claim in itself marked a revolutionary step in American art—but to execute it takes time and practice. Pollock's pictures in his first exhibition (at Peggy Guggenheim's Art of This Century Gallery, 1943) seemed big at the time, double and triple the size of the Hartleys one could see at Paul Rosenberg's or of the Stuart Davises at the Downtown Gallery. It took Newman several years more—until 1949—to break into wall-size paintings.

4. The fourth legacy of the 1930s to the extraordinary flowering of painting in New York in the 1940s was the creation by the government arts programs of a community of painters, sculptors, writers, poets, musicians, free-wheeling intellectuals, in short of a little world of the spirit within the otherwise gray, bleak environment of provincial America. The artists on the projects shared a chance to paint full time, for many of them a decisive experience. They also shared rent-parties, complicated social interactions and gallons of cheap wine. Years later, David Smith told me that these were the happiest days of his life—the most romantic and carefree—and although his recollection was heavily tinged by the nostalgia that comes at 2:00 A.M.; it was, I think, a typical one. Newman worked and lived apart from this community of artists. He refused to go on the project, he explained, for two reasons: he made a little more money teaching, and he did not want to compromise himself by taking handouts from the government, which after all was *the* enemy of the people. A third reason suggests itself: artists on the project had to prove that they were artists by producing a certain number of paintings per week. This would have been practically impossible for Newman, who was so dissatisfied with his work that he destroyed his pictures as soon as he finished them.

Newman's absence from the project would have a telling effect on his later reputation. The WPA experience became, by the early 1950s, a kind of visa to the New York artists' milieu, a necessary credential. Lacking it, Newman was dismissed by many as a stranger, a Johnny-come-lately, even an amateur. Or worse, a teacher, an intellectual, a man of theories. He always worked outside of conventions. In this case, he found himself outside the conventions of his most anticonventional friends.

5. Finally, a general change of attitude occurred in New York in the 1930s about the quality of New York itself. If you asked a young artist in 1929 where the new art was bound to develop, he would instantly reply, "Paris." He would fight his way there to connect with it. If you put the same question to a young artist in New York in 1939, he might have answered with the title of one of Newman's paintings: *Not There—Here*. There was a mysterious shift in the awareness of possibilities. It had something to do with the war, of course, and with the emergence of America as the world power, with New York as its intellectual and cultural center. It had something to do with a vision of what the modern city is and of where the modern experience can be received at its most intense. It was a general feeling, usually unspoken, because to give it utterance might sound chauvinist, like old-fashioned American jingoism, a booster's rhetoric characteristic of a provincial way of thinking which was being discarded. Perhaps it was more of a dim hope than a real feeling. For Newman, it was a conviction.

Not There—Here is one of his titles; another is *Right Here*; his first three sculptures are *Here I, Here II* and *Here III*.

Site or location meant many things to Newman, and the idea would develop into some of his most poetic and mysterious images. On this side of mystery, "Here" is where the form is, in the painting, in the metal sculptures; the title immediately refers the viewer to the object, urges him to stick with the object and not bring in his own associations, irrelevancies, historical contexts. The art stands as an absolute, but "Here" is also where Newman is, the artist strolling through Wall Street on a Sunday, visiting the waterfront and the fish market, the obelisk in Central Park, a friend's studio, an artists' bar, a post office in Brooklyn, an off-Broadway theater, a Times Square movie house. He could not have been anyplace else.

There is at bottom only one problem in the world, and this is its name: how does one break through? How does one get into the open? How does one burst the cocoon and become a butterfly? The whole situation is dominated by the question. . . . We spoke of it as a problem, a paradoxical possibility: the recovery, I would not say the reconstitution—and yet for the sake of exactness I will say it—of expressivism, of the highest and profoundest claim of feeling to a stage of intellectuality and formal strictness, which must be arrived at in order that we may experience a reversal of this calculated coldness and its conversion into a voice expressive of the soul and a warmth and sincerity of creature confidence. Is that not the 'break-through'? —Thomas Mann, *Dr. Faustus* (translated by H. T. Lowe-Porter)

Newman stopped making pictures around 1939–1940, and everything he did afterward was aimed at the purpose of starting to paint again. It took him about five years. Most of the other Abstract Expressionists went through a similar experience, and the cleavage between the present and their past, as Elaine de Kooning noted in her article on Kline and Rothko, was comparable to the conversion of Saul on the road to Damascus.[1] There is a moment of blinding light. There is a moment that seems like death, a paralysis. Then a new man, Paul, emerges from the experience. Rothko, the most famous example, changed his name, his wife and his style in a few months of profound self-questioning. Kline, in less than a year, moved from a compressed, repressed realism to an extraordinary, vivid, radical, abstract imagery. Gottlieb's move to the pictograph and Gorky's to thin-paint lyrical distillations of visceral abstraction were also dramatic and sudden. With Pollock, de Kooning, Hofmann and perhaps Still (although his evolution remains problematical and, by his own orders, veiled), the artists moved steadily if fitfully from comparatively conservative beginnings to the extreme positions they established from 1948 to 1952. Newman would seem to be the odd man in this division, but in fact his revelation took place earlier, and the resulting paralysis lasted longer than Gottlieb's, Rothko's and Kline's.

He kept teaching art classes, which might have been a way of keeping his hand in, but they only left him ex-

hausted with visual work. He remained an avid participant in the art world; he saw every exhibition, visited friends' studios to encourage them in their latest work, kept track of the comings and goings among critics and curators. This, after all, was his community, even if he did not have a stack of landscapes or portraits to prove it. He studied botany, geology and ornithology, especially the last, out of a true passion for the subjects, and he also felt that a scientific, down-to-earth grasp of theories and facts would be a sound antidote to romantic, artistic, conceptions of nature. Like a good political radical, he began to analyze the situation, objectively, in writing.

Many of his texts were torn up in early drafts. From 1947 to 1949, five of them appeared in a little magazine, *Tiger's Eye*, published by poet Ruth Stephan and her husband, painter John Stephan (Newman helped them find artist contributors and was briefly listed as an adviser on their masthead, although he later emphasized that his role was unofficial and that his advice usually was ignored). Two of these essays have been widely quoted and reprinted: "The First Man Was an Artist" (October 1947) and "The Sublime Is Now" (December 1948). Their polemical, epigrammatic and, in places, hermetic nature gives a somewhat distorted impression of Newman's deadly serious campaign in the 1940s to understand the situation in modern art, to make sense of it for himself and for others, and, most of all, to open a way to the future.

One of his heroes was Alexander Herzen, socialist, prince, Russian, cosmopolite, brilliant feuilletonist and intellectual man of action. Newman, I believe, based his prose style on him and on his other hero, another Russian prince, the anarchist Peter Kropotkin. From Herzen, he adopted the mode of a swift, topical language, which punches the enemy on the nose in a brief, revelatory exposition of the scandalous historical situation, and then praises friends and allies and demonstrates how they are taking positive steps toward a progressive solution. From Herzen, Newman also learned the beauty of effervescent action; he followed the example of a man always ready to take to the barricades, who loved the excitement of a fight and whose creative imagination kept him free from the hundreds of petty causes which might have hindered him from concentrating on grand aims and noble decisions. Readings in Kropotkin and in Brandes, Kropotkin's interpreter to the West, reaffirmed Newman's passionate

[1] Elaine de Kooning, "Kline and Rothko," *Art News Annual* (New York), vol. 27 (1957–58), p. 89.

regard for the transcending importance of the individual, for a deep, radical humanism. Newman's motto in the 1940s could have been the title of Kropotkin's famous treatise, *Mutual Aid*.

In order to start painting again, he reasoned, he must first analyze the past—reinterpret art history—to discover what had happened; what events really had taken place and for what causes; how they had been interpreted—and probably misinterpreted—by exegetes who, as much as anybody else, were responsible for the crisis in modern art. Given a true understanding of the past, it would then be possible to reexamine the present, to discover whether it was indeed as hopeless as it seemed to the artists who were forced to confront its issues. In this overview of past and present, it would also be essential to define certain basic premises—certain common denominators of great art. In other words, what is the subject matter proper to art—what has it said in the past and what should it say in the future? Indeed a comparison of past greatness and present misery should, by a process of subtraction, isolate those elements lacking in the present. Finally, Newman wanted to find ways out of the situation, and here he operated on a mixture of Kierkegaardian faith and old-fashioned New York friendship. In all his writings, he would end on a note of hope: new possibilities were emerging, new artists were at work. Like Herzen, Newman took the role of the optimist in his writing; he always had a cause to champion, even if he himself, face to face with a canvas, felt nothing but chaos, absurdity and despair.

In 1942, in one of the earliest of his preserved typescripts, he confronted the issue of American Regionalist art, which, under the leadership of Benton, Curry and Wood, and championed by the writer Thomas Craven, was the most famous style of the time. Newman asked:

What about Isolationist Art?

"Historical painting has sunk . . . in the North into the patient devotion of besotted lives to delineations of bricks and fogs, fat cattle and ditch water." —Ruskin

Is Isolationism dead? Wilkie, Wallace among others have recited its obituaries. The isolationists themselves have begun to join the panegyric chorus. Congressman Harry Coffee, isolationist from Nebraska, admits, "I am reconciled to the fact that public sentiment will force us to intervene in any major conflict in the future on either continent." And when isolationists are reconciled to be interventionists in wars, it will not be as difficult as it has been to get them to intervene in peace time. No man can tell what Pearl Harbor will bring us but we can feel certain that no matter what, isolationism as a factor in the political life of America has seen its best days. But does that mean that it is dead?

The answer lies in the proper comprehension of its nature and scope. It is a serious shortsightedness, now widespread, to consider isolationism a regional political bloc. To do so means not only that we shall fail to understand its force but it will give us that false sense of security that must make us more vulnerable to isolationist tactics should they ever have the opportunity to resurrect their bogeymen. To get rid of these enemies of world progress we must drive them from every field they have penetrated. . . .

Isolationism is no narrow political bloc. Isolationism is a powerful intellectual movement that has been and even today continues to dominate the cultural life of America with an iron hand. It may have met defeat on the political front. But from all the evidence Pearl Harbor has had little effect on its other strongholds. To examine its success in two fields of American culture will prove enlightening to those who think that all we need to do is win the war and we shall automatically be headed for a Renaissance of living and thinking.

Isolationism's most blatant penetration in the intellectual life of America has been in the peace movement. Here the peace leaders [were] duped, . . . and playing with the time-worn fallacy that one can unite with anybody for the sake of political expedience found themselves bedfellows with those who did not want peace in the world—only Hitler's peace for themselves. [Young readers might want to be reminded that during the so-called Berlin-Moscow pact, American communists and their friends were as violently against U.S. participation in the war as were the right-wing America firsters.] Consider the noisy history of the peace leadership, since the last war, the overwhelming disillusionment that swept the country all those years, the intensity with which the writers of the period used the "peace" motif, the Disarmament Conference, the first event of its kind, the Briand-Kellogg Pact, the Embargo Act, and all the other phenomenal "peace" victories—how remarkable indeed [was] the ease with which Pearl Harbor annihilated this movement. It does not do to say it was expected that Pearl Harbor should so unite the country, that war means the end of peace. In the last war we find that without the advantage of two decades of peace propaganda, without the bitter taste of war still sharp, there was strong anti-war protest. By comparison the First World War seems to have acted as a catalyst of a peace movement. Then, Eugene Debs went to jail because he was against the war, Roger Baldwin went to jail, Holmes and Emma Goldman held anti-war meetings and both went to jail. Then there was a peace movement that meant it. This time, the peace leadership vanished overnight. And it could not be otherwise. A peace movement is the finest expression of a people's ethics and represents the summation of its cultural striving. The standards of leadership in such a movement must be of the highest. That is why Gandhi despite the distortions by the British of his motives can maintain his position and the loyalty of his party. The people know he is incorruptible. Corruption would become patent even to the politically inexperienced Indi-

ans. Where you have a politically experienced people like the Americans, it erased its peace leaders with one sweep.

The Flynns, the Norman Thomas's, the Libbys, even some of the Quakers, who [were] yelling no compromise with war, showed by their alliance with the Lindberghs, the Wheelers, the Nyes, the Coughlins, the Fishes that they were willing to accept Hitler's peace. . . . The shock of Pearl Harbor put an end to the tolerance of these corrupt peace leaders who could not tell the difference between peace and surrender.

What a contrast do we find when we examine another field of American culture where isolationism is rampant. Here in the field of the arts the grip of the isolationists is absolutely unbroken. Art in America is an isolationist monopoly. Publishers and critics, art dealers and museum directors, willingly or unwillingly are completely dominated by an isolationist esthetic that permits no deviation. There is today not a single art or literary critic of prominence, not a single publisher or dealer, not a museum director, who hasn't been corrupted by this philistinism. The whole art and literary world is, to use Hitler's phrase, theirs. . . .

Isolationist painting, which they named the American Renaissance, is founded on politics and on an even worse esthetic. Using the traditional chauvinistic, isolationist brand of patriotism, and playing on the natural desire of American artists to have their own art, they succeeded in pushing across a false esthetic that is inhibiting the production of any true art in this country. First, the isolationists preached their cardinal political principle of nationalistic dogma, that to have your own life you must repudiate the world. It followed that if you are to have your own art you must repudiate the art and artists of the world. To achieve their goal isolationists did not try delicate methods. Isolationism, we have learned by now, is Hitlerism. Both are expressions of the same intense, vicious nationalism. . . . [Both use] the "great lie," the intensified nationalism, false patriotism, the appeal to race, the re-emphasis of the home and homey sentiment. The art of the world, ranted [the isolationists], as focused in the Ecole de Paris, is degenerate art, fine for Frenchmen, but not for us Americans. This French art is like themselves, a foreign, degenerate, Ellis Island, international art appealing to international minded perverts. It is definitely un-American. How could French art be any good anyway? The French people themselves are no good, a bunch of filthy, pennypinching, tourist-gouging, drunken lot of foreigners. And who are their American fellow-travelers, a bunch of New York Ellis Islanders who aren't even 50 percent American, most of them communist and international minded, etc. What we need is a good 100 percent American art based on the good old things we know and recognize, that our good old straight-standing, clean American folks back home can understand . . . the beauty of our land, the traditions of our folk-lore, the cows coming home, the cotton-picker, the farmer struggling against the weather—the good old oaken bucket. . . .

The isolationist esthetic . . . is based on two fallacies so flagrant one wonders how they could have succeeded with any artist group that wasn't intellectually corrupt. First they claimed the need of an American art. . . . How? By painting Americana. Instead of stimulating the emergence of great minds by creating conditions that might help to stimulate their appearance, they created a label based on bad logic around which mediocre minds equipped with some manual skill could rally to create a movement. It is easy to create a label. It pays men unusual power if they can enforce it. It is surrender to submit to it. Yet the artists did. . . . Art in America today stands at a point where anything that cannot fit into the American Scene label is doomed to be completely ignored.

What was this America that artists were to paint? Was it a certain national character one was to express, a point of view, a taste, a cultural nuance? Not at all. Even if these qualities could have been evoked they were not wanted. To the isolationist artists, America was the geographic life around them. The crassest philistinism. A complete reversion to the exaltation of subject matter. Here they ran into a bit of trouble.

They solved it easily by some more sleight-of-hand logic. They knew that despite their noisy attack they were up against the solid wall of modernism. Despite all their disparagement of the Ecole de Paris, so complete was the victory of modernism over the Victorian subject-matter picture that it would have been suicide for them to have attempted to announce a straight reversion to subject matter. The isolationist master-minds here executed a cunning piece of propaganda only a Hitler can properly appreciate. For they agreed immediately with the point of view that modern esthetics did not permit a re-emphasis of subject matter. And if subject matter isn't important, so what is? It's how the subject is painted. If it is a good picture it makes no difference what is painted. Well, then any subject is valid. If so, why not America, with its rich source material, its varied landscape, its inexhaustible treasury of picture motifs?

Strangely enough, the American artist fell for this subtle fallacy, paint, brush and sketch-box. So seductive was the isolationist bloc, it didn't mind a bit if the artist stole European painting styles and techniques, so long as they were confined to the American Scene. . . . The result has been the emergence of an ever-expanding school of genre painters who, using borrowed painting techniques, have dedicated themselves to telling the story of America's life of humdrum. Their commercial success has been tremendous, amidst the widest art-buying public in history. Many have been fooled into believing that this has meant a rising art audience, a veritable Renaissance. Alas, it is the same sentiment-buying public that has supported every academy. The only difference has

been that the American Scenists modernized the sentiment. Instead of the old oaken bucket, it based its appeal on the hurricane cellar; instead of the man behind the plow, now it was the poor, starved sharecropper; instead of Bess coming down the road, it was an old Okie jalopy. Instead of that whole school of sentiment based on sex, with its hundreds of lacy ladies against a looming sky or lost among the shadowy willows, it was the new sentiment of rural America, of sweet old pa and ma leaning on their pitchforks. It worked well. The pull was there. Subject matter was back—it had come in through the back door.

Its complete success was marred for a moment by a leftist "revolt" which thought it had a new esthetic—social painting. But it turned out to be nothing but a variation of the same theme. Their "revolt" was an insistence on a redefinition of what makes up the American Scene. They wanted prior rights for the industrial worker, the introduction of class struggle. But it was still American Scene. Essentially it was a struggle of leftist artists—who had been ostracized as Ellis Island artists by the original regionalist tinge of the American Scene movement—to join the philistines. They agreed to the fundamental isolationist premise of American painting. All they wanted was to be able to include the worker, the Pittsburgh smelter, alongside the Kansas farmer. . . . Art in America was purposefully made regional. The South painted its Negroes, the West its cowboys, the Middle West its corn and hogs, its fat cattle and its ditch water, and the East its factories and foundries. And all told the same story of a picture-postcard art done in modern painting surfaces, with modern distortions, in modern color and design. The whole mess a cheap, successful, new commercial art.

Every nation has its commercial artists. But no nations, not even the Fascist nations, claim that they have made art history with them. All except America. Here our commercial official art is called an American Renaissance by our critics, dealers and museum directors. They fill the American wings of our museums, they dominate our art schools, our art galleries. They have their own Museum. They have penetrated the Museum of Modern Art!

It might be of interest to tell how this happened, how once they had succeeded with the artists it was necessary to achieve and maintain social position for complete success. How they got Gertrude Whitney, sculptress, millionairess, and old family, to put money behind them, society behind them, a museum around them so that it would be ready bait for all the museum director graduates of the Yale and Harvard art schools, who, full of discovery of a great American art movement, gave them the domineering position they sought. But it would achieve little to fight against the Museums, the dealers, the publishers and prize committees. They do not make an art. Neither do they unmake it. It is the artists who make and unmake art. And in America it is the artists who stand guilty of corruption.

It is easy to repeat that Isolationist art found its easy place in America because America as a nation is immature in matters of taste and culture, that suffering from an inferiority complex on that account, it fell easy prey to a Nazi philosophy that promised to bolster up an injured pride and a warped national ego, very much as the German people fell prey to a similar movement in the political field. But is this the case? Is it the real reason or is it not an easy excuse?

Such an explanation would be valid if its implications were true; if it were true that it was the people, i.e., the art public made up of the inexperienced cultural mass that fell victim to isolationist art propaganda against the struggle of an alert, mature minority of artists and art connoisseurs who had tried to prevent it. We cannot say this. It was not the inexperienced art public that became American Scenists. It was the artists themselves, a highly sophisticated group, thoroughly familiar with the art work and the art traditions of the world, who had flocked to Paris to participate in the great cultural center, who were very conscious of the Impressionist and Post-Impressionist revolutions, who fell for this propaganda. It is upon them that responsibility falls. Their support of this reactionary philistinism is an inexcusable betrayal.

The so-called American Renaissance was a deliberate exploitation of a deep-seated desire by our artists to make a native contribution to the art of the world by a regional group of commercially minded artists who, hungry for personal success, misled a generation of artists, art students and the art public. Those artists who joined believing in it did so because they needed the movement to cover over their mediocrity. Those artists of ability, however, who joined the movement or who tolerate its presence . . . are traitors to art. For they are willing to overlook the ruthless reaction, inhibiting philistinism, in order to be able to join the bandwagon for the slight ballyhoo that will fall to them. They know that otherwise they shall have to compete with European artists on equal terms. That might prove difficult. . . .

In order to keep out the more talented foreign artists small men calling themselves artists have succeeded in imprisoning the American cultural world. . . . For can we believe that the American artists are telling us the truth? Has there been an art Renaissance in America? . . . Anybody with a critical eye and an honest respect for art and America can only contemplate the mass of cheap genre painting with sadness. It is not an art but an expanded Currier & Ives revival.

On the political front Isolationism has been wiped clean. There is hope of a new political outlook. Are we going to create a new philosophy of American politics and world society only to lose our art and culture to isolationist philistines? How long are artists to remain silent?

It is time for the artists to wake up and re-examine their esthetic foundations; to rid themselves of the millstone that has made art in America an expensive picture-

postcard factory. It is time they understood the political foundation of their art, cleaned house and went back to the study of art, where they belong. It is time artists refused isolationist money, repudiated the art dealers, the favor of the museum directors. It is time artists forgot about success. . . .

It is clear from the typescript that "What about Isolationist Art?" is not a final draft. There are rough corrections and some rough spots that Newman would have ironed out, but it is interesting for a number of reasons. It is a fairly objective picture of the situation; Newman had no reason to believe that he was attacking a movement that would disappear almost as quickly as political isolationism after Pearl Harbor. Regionalism still seemed the dominant mode in 1942. Characteristically, he links art to the major political issues of the moment. The battle with Benton is as important to him as the Battle of Britain, not because Newman was a cold man who valued art above human lives nor a solipsist who put his own interests above the world's. On the contrary, Newman was deeply involved in a basic humanism and was interested in everything that went on in society around him. The point is that for him art was the highest manifestation of human culture—the visible tip of the iceberg of civilization—and when art was sick, it meant that all society was in peril. American Scene painting and its widespread success indicated to him that vulgar chauvinist ideas were still rooted in the American psyche, and he fixed the responsibility for action directly on the artists—the best artists—as they were the men with real power in their hands.

The text is characteristic of Newman in its rough, happily polemic tone—he relished a good fight and often carried on his battles in letters to the press. He could find great issues in what seemed small causes to many of his friends; like a doctor, he would spot a symptom of lethal corruption in what looked like superficial irritation. Also typical of Newman's writings is the lofty moral tone of his attack on the isolationists. In conversation, he was given to a happy irony; his discourse was leavened with gestures, laughter and snappy asides. In his public statements, he usually was all seriousness. The philistines, he reckoned, would not understand his jokes anyhow, and as for the unsophisticated mass public, one of his tasks was to educate them in the seriousness of the artist's calling.

Once, after going through a book of photographs by his friend the artist Alexander Liberman on French artists in their studios, Newman said that he felt artists should not permit themselves to be photographed smiling, nor in their work clothes—and this from a man who would burst into the most radiant smile whenever he met a friend. The photograph is for the public—it is an educational document—and through it the artist must make the point of his dignity and of the value of his role. He is a man involved with transcendental matters. It was

from this old Roman stance that Newman approached his notes and essays.

Newman also reexamined the past in his writings, ranging from primitive and prehistoric art to Surrealism and Neo-Plasticism, with frequent stops in between. He was especially interested in Impressionism, which he felt was the first true Post-Renaissance revolution—the first modern movement—and in Post-Impressionism, whose giants he admired but whose tendency was, according to his analysis, retrogressive. Many of these insights were developed piecemeal in separate brief essays and communications—he called them "monologues"—from the artist to himself; some are stated in a strange eleven-part essay, written from around 1943 through 1945, titled "The Plasmic Image," which takes the form of a fugue on the themes that preoccupied him. Other unpublished monologues deal with "The Problem of Subject Matter," "The New Sense of Fate," interpretations of Impressionism and the importance of Pissarro and Monet.

The Plasmic Image, Part I

The subject matter of creation is chaos. The present feeling seems to be that the artist is concerned with form, color and spatial arrangement. This objective approach to art reduces it to a kind of ornament. The whole attitude of abstract painting, for example, has been such that it has reduced painting to an ornamental art whereby the picture surface is broken up in geometrical fashion into a new kind of design-image. It is a decorative art built on a slogan of purism where the attempt is made for an unworldly statement. The failure of abstract painting is due to [a confusion similar to the confusion] that exists concerning the understanding of primitive art. . . .

It is now a widespread notion that primitive art is abstract, that the strength in the primitive statement arises from this tendency for abstraction. An examination of primitive cultures, however, shows that many traditions were realistic . . . [and] there always existed . . . a strict division between the geometric abstraction used in the decorative arts and the art of that culture. . . . The practicing artist always employed a symbolic, even a realistic, form of expression. One of the serious mistakes made by artists and art critics has been the confusion over the nature of distortion, the easy assumption that any distortion from the realistic form is an abstraction of that form. . . . In primitive tribes distortion was used as a device whereby the artist could create symbols. It is also very important to try to draw a sharp line between art and the decorative arts. . . . In primitive tribes this separation was well-defined.

All artists whether primitive or sophisticated have been involved in the handling of chaos. The painter of the new movement clearly understands the separation between abstraction and the art of the abstract. He is therefore not concerned with geometric forms per se but in creating forms which by their abstract nature carry

some abstract intellectual content. [The "new movement," of course, refers to Gottlieb, Rothko, Pollock, et al., and Newman himself, even though his own paintings had not yet germinated.]

There is an attempt being made to assign a Surrealist explanation to the use these painters make of abstract forms.... [But] Surrealism is interested in a dream world that will penetrate the human psyche. To that extent it is a mundane expression.... The present painter is concerned not with his own feelings or with the mystery of his own personality but with the penetration into the world mystery. His imagination is therefore attempting to dig into metaphysical secrets. To that extent his art is concerned with the sublime. It is a religious art which through symbols will catch the basic truth of life which is its sense of tragedy.

The present painter can be said to work with chaos not only in the sense that he is handling the chaos of the blank picture plane but also in that he is handling the chaos of form. In trying to go beyond the visible and the known world he is working with forms that are unknown even to him. He is therefore engaged in a true act of discovery in the creation of new forms and symbols that will have the living quality of creation. No matter what the psychologists say these forms arise from, that they are the inevitable expression of the unconscious, the present painter is not concerned with the process. Herein lies the difference between them and the Surrealists. At the same time in his desire, in his will to set down the ordered truth, that is the expression of his attitude towards the mystery of life and death, it can be said that the artist like a true creator is delving into chaos. It is precisely this that makes him an artist for the Creator in creating the world began with the same material, for the artist tries to wrest truth from the void.

In Part II of "The Plasmic Image," Newman reiterates the distinction between "a purist art and an art used purely," that is, between the decorative, tasteful or merely beautiful and the new art which offers the "emotional excitement that accompanies insight or revelation." He goes on to confront purism's most important protagonist, Mondrian (who had recently been the subject of a retrospective exhibition [March 21–May 13, 1945], at The Museum of Modern Art):

There has been a great to-do lately over Mondrian's genius. In his fanatic purism, his point of view is the matrix of the abstract esthetic. His concept, like that of his colleagues, is however founded on bad philosophy and on a faulty logic. Mondrian claims that should we reduce the world to its basic shape, we would see that it is made up of horizontal and vertical lines, the horizon table-line of the earth, the vertical lines of things that stand and grow on it. Were this over-simplification true, what logical process is it that asserts that since the world is made up of vertical and horizontal lines, therefore a picture made up of such lines is the world or a true picture of it?

The insistence of the abstract artists that subject matter must be eliminated, that art be made pure, has served to create a similar result to that of Mohammedan art which insisted on eliminating anthropomorphic shapes. Both fanaticisms which strive towards an abstract purity force the art to become a mere arabesque. Modern abstract painting is only a new form of the decorative arabesque.

On the other hand, the point of view maintained by the new painter which asserts that an art form must be used purely has the virtue of creating a category, of making it a tool for the refined expression of concepts that cannot be handled by lesser methods to the end paradoxically that it is able to express the most abstract thoughts. Just as mathematics, which is abstract, has a limited beauty in its nature when used to express an important concept so that we see its convolutions, just as mathematics is a language that gives shape to thought, just so the new painter feels that abstract art is not something to love for itself, but is a language to be used to project important visual ideas.... I therefore wish to call the new painting "plasmic" because the plastic elements of the art have been converted into mental plasma. The effects of these new pictures is that the shapes and colors act as symbols to [elicit] sympathetic participation on the part of the beholder with the artist's thought.... The new painter owes the abstract artist a debt for giving him his language, but the new painting is concerned with a new type of abstract thought.

Part III of "The Plasmic Image" attacks the idea of "quality" as "an objective attribute."

Most artists and critics in order to avoid the problem [of quality] have decided to take it for granted. It has become sort of understood, like a missing verb in a sentence.... The result has been an objective approach to a subjective truth. It is this mistake in psychology or logic that is at the root of abstract painting. The feeling of objectivity towards these subjective factors has been transferred to the painting itself so that it has become a gadget, a fancy object, with the result that beauty has become a similar objective fact to the end that painting has been reduced to a kind of manufacture. The result, of course, in line with its objective base has been to create an object that has beauty. But the beauty here is nothing more than a manifest of taste, for the manipulation of good color, pure shapes, good composition can only affect the sensuous nature of man. It is a type of virtuoso painting, and the logical outcome of such an esthetic must be a virtuoso art where men of skill and taste, like skillful violinists play with color, line and shape.... They have reduced painting to an interpretative art.

In contrast, the "new painter" does not take the subjective nature of "quality" for granted; it is his issue. "Color, line shape, space are the tools whereby his thought is made articulate. They are not pleasure ele-

ments that the artist should dote over. . . . It is the subjective element in them, that will in turn stir a subjective reaction in the reader of the language, that is important."

This distinction between the older, hedonist abstract artists and the symbol-making new artists is applied to primitive arts in Part IV of "The Plasmic Image," which points to the crude, tough quality of materials in the best Pre-Columbian, African and American Indian sculpture. In Part V, a comparison is made between the new artist and the primitive—both of them concerned with the mystery of life, with terror and majesty. The modern, however, works with the accumulated technical knowledge of the Impressionists, Post-Impressionists, Cubists, Abstractionists and Surrealists: "New painting has arrived at a point where the technical problems of the language have been pretty well solved. The new painter is taking his language for granted. He accepts and has absorbed the plastic devices of art and has developed what perhaps is the most acute level of sensitivity to the grammar of art ever held by any painter in history." He must move on to "an expressive art, yet not of the painter's personal feelings so well explored by the Expressionists. The truth is not a matter of personal indulgence, a display of emotional experience. The truth is a search for the hidden meaning of life."

Part VI of the text announces that "an unequivocal stand is being taken and the break with Western European traditions is complete." Modern artists since the Impressionists have temporized with the decorative qualities of conventional painting, even going so far as to be inspired by primitive art, and at the same time misreading it as merely another kind of objet d'art. The new painter "desires to transcend the plastic elements in art. He is declaring that the art of Western Europe is a voluptuous art first, an intellectual art by accident. He is reversing the situation by declaring that art is an expression of the mind first and whatever sensuous elements are involved are incidental to that expression. The new painter is therefore the true revolutionary, the real leader who is placing the artist's function on its rightful plane of the philosopher and the pure scientist who is exploring the world of ideas, not the world of the senses. Just as we get a vision of the cosmos through the symbols of a mathematical equation, just as we get a vision of truth in terms of abstract metaphysical concepts, so the artist is today giving us a vision of the world of truth in terms of visual symbols."

The remaining sections of "The Plasmic Image" concern academic and academically modernist attacks on the new painters; Newman insists that their new ideas must involve them with a new plasticity and that it is ridiculous to judge them by The Museum of Modern Art's or Roger Fry's standards—much less those of the New York Times. Finally Newman turns to current events:

Mr. H. Putzel in his recent exhibition [May 14, 1945] at his 67 Gallery called "A Problem for Critics" has shown the need of explaining and perhaps naming the new movement in painting that is taking place in America. That such a movement exists—although [it is] not organized in the way the Surrealist and Cubist movements were organized—is certain.

There follows a passage mentioning Rothko, Gottlieb, Gorky, Pollock and Baziotes as members of the "movement in the direction of 'subjective abstraction.'"

Before we investigate what these painters are doing to entitle them to the classification of an art movement, it is important to understand that only a few of these men who as some believe are combining Surrealism and abstract painting stem from either movement. That is the danger of crystallized movements. Their limitations are binding, except in the very strong. . . .

Essentially these painters were dissatisfied with realism yet they could not enter into the reactions against realism typified by the abstract and Surrealist artists. In the one case they felt it was no solution for the painter dissatisfied with cheap subject matter to deny it entirely. . . . The problem was what kind of subject matter?

At the same time they could not accept the dream world of the Surrealists. . . . The forces in Surrealism of fancy acted on by the pressure of realism produces a resultant fatigue. In New York it is now admitted that Surrealism is dead. [But] while the dying are being kicked, it is well to remember that Surrealism has made a contribution to the esthetic of our time by emphasizing the importance of subject matter for the painter.

Abstract art in America has to a large extent been the preoccupation of the dull, who by ignoring subject matter, remove themselves from life to engage in a pastime of decorative art. . . . Even the stimulus of Mondrian has done little to change the character of the work, even though his example as artist and man has created respect for the steadfastness to principle these artists have maintained. . . .

[Expressionism was] a risky esthetic because the emphasis on feeling had a tendency to shut out intellectual content. If it were possible to define the essence of this new [American] movement, one might say that it was an attempt to achieve feeling through intellectual content. The new pictures are therefore philosophic. In handling philosophic concepts which per se are of an abstract nature, it was inevitable that the painters' form should be abstract. . . .

Abstract art, too, has its history and its imperatives. Newman examined the problem in an essay, ca. 1944.

The Problem of Subject Matter

If we could describe the art of this, the first half of the twentieth century, in a sentence, it would read as the search for something to paint; just as, were we to do the same for modern art as a whole, it must read as the critical preoccupation of artists with solving the technical problems of the painting medium.

Here is the dividing line in the history of art! Whereas every serious artist throughout history has had to solve the problems of his medium, it has always been personal, a problem of talent. It was not until the Impressionists that a group of artists set themselves a communal task—the exploration of a technical problem together. With them, talent became axiomatic. What to do with it? That has become the earmark of modern art movements. This critical re-evaluation of the artist's role, this refusal to continue blindly the ritual of what art professors like to call tradition, has become a dividing line in art that is sharp indeed. For, were all knowledge, written and oral, of the dates of production of those great works that make up the art treasury of Western Europe to be lost (let us hope the work is not) all of them, from Veronese to Delacroix would become a dateless jumble. No man could trace its chronological progress with accuracy, so unified is its general appearance. Were this jumble, however, to include the work of anybody after Courbet, beginning with the Impressionists, it would segregate itself at once. For good or bad, Impressionism has given art an unmistakably different look.

This heretical insistence on a dividing line may provoke those critics from Bell to Read who have made careers for themselves as "friends of modern art" by broadcasting the sophism that the values of modern art were a continuation of the great tradition of European painting begun in the Renaissance. Impelled perhaps by the Englishman's innate aversion to revolution, these critics devoted themselves to talking everybody out of its revolutionary character. This shrewd popularization of the big lie, that modern art isn't modern, succeeded in establishing the position of respectability modern art now enjoys with museum directors and professional art-lovers, but it wrought havoc with the creative forces struggling for a footing wherever this false thesis took root. It goes a long way to explain the intellectual barrenness and sterility that dominates the art of the English-reading world. For it is the critic that sets the tone of the audiences of art.

It can now be seen that the art critics who maligned Cézanne during his lifetime had a better understanding of the revolutionary implications of his art than his English and American defenders who hailed him as the father of modern art on the grounds that he was the great proponent of the art of Poussin. It was the good fortune of the Ecole de Paris that it did not have the protection of such friends. It also may explain its fertility because there the man of talent was able to approach the revolution in art uncorrupted. For it was in its revolutionary differences, in its radicalism, in its "modernism" that this art was able to lay down the basis for a continued creativeness; not in the elaborate and erudite "affinities" with "tradition" that have been read into it by its apologists.

Modern painting begins with the Impressionists precisely because for the first time in history a group of artists arose, who, repudiating the role of the great personal message with its attendant doctrine of the immaculate conception, decided to devote themselves exclusively to solving a technical problem in painting—color. Painting throughout Europe, despite its rugged individualism, had become blanketed by the velvet standards of the School of Venice. Only when the cutting of this velvet surface, begun by Constable and Courbet, culminated in a transfusion of the scientific discoveries of the time concerning the nature of the spectrum into the bloodstream of the painting art; only when Pissarro, Monet, Seurat, et al. created a new color esthetic, was this Venetian velvet finally repudiated to open up a richer world of possibilities. No matter what we may think today of the Impressionists as artists, they solved the problem of color for all those painting since. They set the artist's palette free of its prison.

The discovery of a new idea is intoxicating. Reveling in its exhilaration it was natural that the Impressionists should minimize, even disregard all other art elements. It could not occur to them that drawing and subject matter were problems. The color of light was the problem. The result was inevitably a school of landscape painting. For light, despite our lamps, still means the great outdoors. In that great theater of color, form and shape lose outline. Since the problem of lines does not exist in nature, drawing becomes [irrelevant]. There also the problem of subject matter finds automatic solution. What to paint? Paint what you see! Anything. This automatic subject matter was to produce a laissez-faire eclecticism. . . . Eclecticism is chaos. . . .

The Post-Impressionists, although not formally nor consciously organized, were, nevertheless, a group in the unity of their opposition to the monist esthetic of the Impressionists. Cézanne, van Gogh, Renoir, like isolated scientists who discover the same truth, formed a community when they reasserted that color, no matter how important its liberation, was still only one of the artist's problems. They realized the necessity to devote themselves to the exploration of these other elements. Continuing the new role of the artist begun by the Impressionists, they reaffirmed, each in his way, that only by understanding the purpose of painting rather than its mechanics, no matter how advanced scientifically, can we arrive at its true nature. Where the Impressionists shouted that vision is light, these men made the point that light makes us see—shapes. The result was a re-examination of the mechanics of drawing and form.

Cézanne was the first artist to comprehend that in nature there are no lines. Herein lies the significance of his remark that nature is a collection of cubes, cones and spheres. He saw the world as it is, mass instead of contours. . . . Line could not count, not one exists in nature. It was what was between the lines that mattered. The artist's function is to use, not to draw what is between the lines. The secret lay in the discovery and use of distortion

as a principle. *Fundamentally this is his great discovery, for where the Impressionists used science to discover the hidden resources of the palette, the Post-Impressionists found that they had to deny scientific perspective.*

They were well aware that the Impressionists in freeing the palette had only succeeded in enslaving the artist to nature. The real problem these men felt was to free art from nature. They solved it by discovery and use of distortion. The fact is that this principle is better science, for it was their skeptical approach to the nature of shapes (which they asserted were lines . . .) which resembles the skepticism of the Impressionist who questioned the make-up of pigment—that you cannot believe what you see whether it is a shadow or a shortening of space—that is the basis of their critique which made possible the emancipation of the artist from nature.

It was inevitable that in concentrating on mass that the problem of subject matter should become automatic. For it was in the simplest of shapes that we find the secret of all shapes. Post-Impressionism therefore, was to be a school of still-life painters for men with a Nature Morte critique towards all things.

In a later paper, Newman revised his interpretation of Cézanne, and pointed out that he brought back into painting a "retrogressive" dependence on perspective and single-focus images, while the Impressionists—especially Pissarro and Monet—were more advanced in their allover compositions. And he also attacked The Museum of Modern Art for ignoring Impressionism and beginning its "history" with Cézanne.[2]

The main issue, the problem he skirted and attacked over and over again, was, what is the proper subject matter for the modern artist? How can he find his way to the profound, tragic, universal expression that had been lost among technical and anecdotal trivia? One of the most eloquent of his papers on the theme (from 1945) follows.

The New Sense of Fate

The artist today has more feeling and consequently more understanding for a Marquesas Island fetish than for the Greek figure. This is a curious paradox when we consider that we, as the products of Western European culture, have been brought up within the framework of Greek esthetic standards—the tradition of the Greek style, and have had no intimate contact with the primitive way of life. All we concretely know of the primitive life are its art objects. Its culture patterns are not normally experienced, certainly not easily. Yet these art objects excite us and we feel a bond of understanding with the primitive artist's intentions, problems and sensibility, whereas the Grecian form is so foreign to our present esthetic interests that it virtually has no inspirational use. One might say that it has lost its culture factor. . . .

Even the French, persistent cultivators of the Greek tradition . . . have been unable to equal the brilliant successes they have achieved manipulating the Greek style in their literature. All they have done in the visual arts is to illustrate the Greek dream. From Poussin through David and Ingres they could only present it but they could not continue or re-use Greek plastic thought. Picasso seems, on the surface, as new blood in French art, to have given new life to the Greek style, yet aware that his French predecessors had only sentimentalized it, he failed too, for all he could do was to play with it, in virtuoso fashion. . . . Picasso's Greek period was an expression of his conceit, his will to dominate all art history and cannot be considered a continuation of that style.

The Surrealists have been the only ones who have made a serious and vigorous attempt to revive Greek plasticity and sensibility, within a context of tragic subject matter. Inevitably they had to go outside the Greek sphere to achieve their tragic content; to give up the Greek hope. De Chirico could only use the Grecian form to express his yearning for his lost Greece. He degenerated into inanities as soon as he tried to say more than his despair. The Surrealists who followed were able to continue where de Chirico ended but only by moving away from the Greek into the fantastic world of the Oceanic magic-makers. They were able to maintain the highly polished surface of the Greek form but they found that this form was barren of the tragic subject they sought, and they had to assume the subject matter of the primitive world to express their Freudian terror, in order to reach what they thought this terror represented—the higher reality of tragedy. In other words, to express the tragic concept they sought they had to go beyond the forgotten to the unfamiliar. De Chirico himself, to express even his nostalgia, had to destroy the very thing he wanted, and was compelled to transform the sterile Grecian form—the ancient notion of the perfect man which had lost all meaning—into solitary and empty mannikins. He had to come back to the heroes of our modern world.

Why has this happened? Why is the Greek plastic achievement for us so sterile? We have repudiated both the Greek invention and the love for it that had become the postulate of the science of art.

It was the Greeks who invented the idea of beauty. Before their time a work of art was concerned with the problem of meaning and was a visible symbol of hieratic thought. Art was an attempt to evoke the metaphysical experience. The Greeks had the romantic will to create such an art which they hoped would function on this level, but they demanded in addition that their art be object too. Their gods had to be not only the serious forces but also ideal sensations. Whenever they strove to

[2] In 1953, when Abstract Expressionism was beginning to be popular, The Museum of Modern Art included a recently acquired Monet in its summer exhibition; Newman wrote a blistering public letter to its president demanding that the Museum openly recant and repent of its past mistreatment of the Impressionists and of history, and not try to sneak in a new interpretation; the *New York Mirror* picked the story up under the headline: "Why Hush Monet, Artist Asks Modern Museum?"

achieve the majesty of the Egyptian form, they insisted that their gods be objects of beauty too, and they succeeded in secularizing their divinities, making them things to admire rather than worship. The pyramid, for example, excited and dominated their plastic thinking but instead of seeing it as a symbol, they were enraptured by its physical purity in an excess of ecstasy over its perfect geometry. This Greek inability to accept the meaning of the Egyptian symbol was due to their pride over their sense of civilization, so that their will to achieve the monumentality of the barbarian's symbols was always frustrated by the awareness of their own effeteness. Pride of civilization prevented them from understanding the barbarian's totemic fanaticism. Unable to penetrate the numinal base of barbarian objects they misunderstood the Egyptian symbols of purity, so that Greek plasticity developed as an art of refinement, of the pure shape. Purity as a poetic metaphor became for the Greeks the geometrical equivalent of material perfection. The Egyptian gods had been the result of a need to symbolize abstract mysteries involved, for example, in their attempt to comprehend death, whereas the Greek gods were the material projections of the unknown factors of their material world—their civilization, the fact that a man could kill or be killed. That is why Greek art is always concrete rather than symbolic, and that is why Greek fanaticism, as all fanaticisms that are built on the concrete, became a fanaticism of refinement. And that is why we have rejected it, for an art of refinement must in the end lead to an art of self-conscious sensibility, to the love of ideal sensations, to an economy of beauty. We now know because of our wider knowledge of comparative art forms that the notion of beauty is a fiction. But what is more serious, beauty, that is, the love of ideal sensations, creates in us today sheer physical embarrassment.

In addition, the Greek idea of beauty instead of being understood as a specific art form, so captured the imagination of men that it has become for many, particularly for the professional esthetes, the art historian, the esthetician, those practicing the science of art, a categorical imperative. So intense became the love for the Greek notion of beauty that it developed a mystique that is known by the name of Classicism. And there still lingers in many, even those who are skeptical toward the label, the belief that if nowhere else, perhaps in Greek art there was a period that we can safely understand to have been classic. The word "classic" involves categories of value. With our wider range of knowledge, we today repudiate the notion that any hierarchy of value can be established. The fact is that the Greeks were romantics and that their art no less than anyone else's was a romance. All agree that the Minoan period was such a romance in its desire to achieve the plastic success of the Egyptian artist but it is generally accepted that as the art moved from Crete into Greece that it miraculously moved away from this Egyptian dream to become an absolute style of classic

value. A re-examination of Greek art must dispel this attitude. For despite their distortion of it and despite their inability properly to understand it, the entire Greek tradition was deeply involved and overwhelmingly dominated by the romantic quest to achieve the sublime content of the Egyptian symbol. The pyramid and the Sphinx, the temples and the Pharaoh figures stood as absolute symbols of inevitability, and all Greek sensibility had the equal achievement of it as its aim. The Egyptian figure dominated the Greek image. The rigid figure in death, the absolute repose, the silence of the Egyptian, all find their attempted counterparts in the Caryatids, the Apollos. The Parthenon, standing in all its simplicity on the natural mountain, strove to duplicate the grandeur of the Egyptian temple on its artificial mountain terraces.

The Greek artist was a romantic, and the art he made was an expression of his dreams. There has never been a classic style in history, and Greek art as all other art, must fortify our conviction that the possibility of a classicism is not only in itself an expression of the highest mysticism (Kant's theory of sensation is its expression at its highest pitch), but the notion of its possibility is a dangerous and misleading hope. Those who believe that classicism is possible are the same who feel that art is the flower of society rather than its root.

Whereas the Greek artists can be said to have failed because of their inability to transcend their love of the Egyptian form to arrive at its tragic subject matter, the Greek writers were more successful. I believe that it can be partly explained on the ground of language difficulty, that the writers did not have the forms to fall in love with, and they could concern themselves with raw problems without the handicap of anyone else's formal presentation. . . . The writers had to grapple with the subject matter. That is why we as artists can paradoxically reject the Grecian form—we do not believe any longer in its beauty—while we can accept Greek literature, which by its unequivocal preoccupation with tragedy is still the fountainhead of art.

This is not to imply that the tragic concepts of Greece were a duplication of the Egyptian. . . . The Egyptian notion of tragedy was an expression of inevitability, a personal statement of being. The Greek notion of tragedy was not ontological, but a social notion, a statement concerning the chaos of individual action. Contrary to the prevailing psychological interpretations that it was concerned with individual frustration, with the problem of human failure and success, Greek tragedy constantly revolves around the sense of hopelessness that no matter how heroically one may act, no matter how innocent or moral that action may seem, it inevitably leads to tragic failure because of our inability to understand or control the social result; that the individual act is a gesture in chaos so that we are consequently the helpless victims of an insoluble fate. This is quite different from the Egyptian notion that each man is his own tragic entity and

that the nature of his being is in inevitable death; a death-in-life and a life-in-death.

This is also different from the psychological notion of tragedy that the Surrealists tried to achieve for modern man. The Surrealists hoped to produce with Greek force the despair they felt. But it was a despair not of the individual act, but a despair felt at the world and at life. They reduced Greek tragedy . . . into an abstract formulation. To them tragedy was identified with an outside force that prevented man from acting. They thereby identified tragedy with terror. That is why they had to go to the ideas of the primitive world with all its overtones of terror. Surrealist art under its realistic and ideal surfaces contains all the weird subject matter of the primitive world of terror.

But that time is over. The war, as the Surrealists predicted, has robbed us of our hidden terror, as terror can only exist if the forces of tragedy are unknown. We now know the terror to expect. Hiroshima showed it to us. We are no longer then in the face of a mystery. After all, wasn't it an American boy who did it? The terror has indeed become as real as life. What we now have is a tragic rather than a terror situation.

After more than two thousand years we have finally arrived at the tragic position of the Greek and we have achieved this Greek state of tragedy because we have at last ourselves invented a new sense of all-pervading fate, a fate that is for the first time for modern man as real and as intimate as the Greeks' fate was to them. And it is not without significance that, like the Greek fate, which was the projection of a social image—the only valid symbol for a people proud of their sense of civilization—our fate is likewise the product of civilization. Our tragedy is again a tragedy of action in the chaos that is society (it is interesting that this Greek idea is also a Hebraic concept), and no matter how heroic or innocent or moral our individual lives may be, this new fate hangs over us. We are living then through a Greek drama and each of us now stands like Oedipus and can by his acts or lack of action, in innocence, kill his father and desecrate his mother.

In this new tragedy that is playing itself out on a Greek-like stage under a new sense of fate that we have ourselves created, shall we artists make the same error as the Greek sculptors and play with an art of over-refinement, an art of quality, of sensibility, of beauty? Let us rather, like the Greek writers, tear the tragedy to shreds.

It is evident from these texts that Newman's position is very different from that taken by his friends Gottlieb and Rothko, which they made public in a much-reprinted letter to the *New York Times* (published June 13, 1943). He had helped them formulate its text, but more as an editor than a collaborator. They appealed to the spirit of primitive and archaic myths, but for him, primitive art was not a source of themes or images, much less techniques. Rather, he was attracted to its matrix, to the culture that underlay it. All primitive art, he believed, was based on terror. African art, he recognized quickly, was informed with terror of the jungle, of deadly beasts hidden in impenetrable vegetation. Pre-Columbian American art, he deduced, expressed the terror of man for man, for the cults of sacrifices, flayed bodies, pierced flesh. Oceanic art puzzled him, for there on the islands men were gentle and tigers did not lurk behind the palms. After long study, he decided that here was a terror of the invisible, of the wind which comes sweeping across the Pacific and wipes out a whole village.

The modern artist can use terror, too: in Paul Klee, fear seems to shake the fine ink lines, and in the disappearing figures of Giacometti, flesh is gnawed by light. For Newman, however, terror, frankly, was incompatible. He was the civilized, city man. His drama had to be open to analysis, a tragedy that could be apprehended, as Spinoza could apprehend the nature of God.

Newman did not write easily. He rewrote his "monologues" over and over again, editing the language, refining the concepts. That is one reason why, I believe, these texts are phrased in a public voice, even though they were not meant for publication. The sound of his spoken words is seldom heard in his essays. If he was writing to himself—like Delacroix in his *Journals*—he never brought himself into the discussion. Furthermore, he enjoyed the rumble of a grand polemical line. This, too, accounts for his rhetoric. More importantly, he was essentially a modest man, oppressed by the idea of pushing himself forward as a personality.

He believed in correct behavior, manners, punctilio, a certain classic reserve. His "confessions" are couched in the language of an oration or of an edifying lecture. His modesty became a kind of mask behind which he could keep his private thoughts to himself. No texts could be less expressionist. He reserved the energy of his subconscious associations and secret images for his paintings. Perhaps talking about them would weaken their charge.

While he was writing his monologues, Newman was also active in the art world. He organized some exhibitions of primitive art, he wrote some catalogue forewords for his friends. Then he started to write fiction, influenced by Joyce's *Ulysses*, automatic writing, getting it down as fast as he could. He began a long, mildly erotic story—something about nuns in a subway on their way to a funeral—but he became bored with it. It was the summer of 1945, in Provincetown. A girl he had hired to take dictation kept disappearing to the beach. Casting about for ideas, he went back to a series of drawings he had begun the year before, pinned them up on the walls of a beach-shack studio, and raced through a series of new ones, as fast as they would come, in chalks, oil crayons, ink, watercolor—any medium that lent itself to rapid execution. "How it went," he said later, describing these works, "that's how it was . . . my idea was that with an automatic move, you could create a world."

The Blessing. 1944.
Oil and oil crayon on paper, 25½ x 19 inches.
Estate of the artist

Gea. 1945.
Oil and oil crayon on paper, 28 x 22 inches.
Collection Annalee Newman, New York

The Song of Orpheus. 1945.
Oil, oil crayon and wax crayon on paper, 19 x 14 inches.
Estate of the artist

Newman never showed his friends what he was doing, and almost all of these works have been destroyed. However, he kept a few of them, perhaps to remind himself where he had been, and there are enough to suggest the development of his thinking.

The 1944 drawings still reveal the artist "sweating out" his image, working hard and sticking to it, as he had at art school. In one, a bird form appears, another is an abstract landscape notation, but the rest of the pictures are concerned with plant-and-seed growth. The backgrounds are textured with rubbed chalk. The shapes tend to move across the edges of the paper, as if the image were a detail of a larger whole—one plant in a field of plants, perhaps. There are small circular shapes on stems, like seedpods. Around them unfold leaves or tendrils. It suggests a life process, germination, fructification: the seed has come out of the flower, it opens its sails and is about to be blown away. The old growth is dying and the new life has begun. One of the 1944 drawings is titled *The Blessing*. The germinated seed shape seems to bless its parent plant shape; the artist blesses the possibility of starting to work again, of beginning a new life.

In the summer of 1945, Newman worked with an energy and enthusiasm that would increase over the next ten years. He concentrated on two themes—the new seed with its leaf-wings and the abstract landscape over which it flies. The seed metaphor is sometimes developed to an image where the seed becomes the ovum and its trailing leaf, the sperm. There is an element of Joycean punning, of meanings within meanings in these shapes which celebrate fertility. The landscapes curl with new growths. There are hints of Gorky's visceral-vegetable-sexual pastures in these drawings and perhaps of Gorky's sources in Kandinsky's early Improvisations (which had long been available to New York artists in the Guggenheim Museum of Non-Objective Painting). The most striking elements in the 1945 drawings are the speed and vitality of their execution. The backgrounds still posed a problem for the artist, and the busyness with which they assert the flat plane of the paper reminds us of Newman's admiration for Pissarro and the allover Impressionist effect. The lines move across the paper in large, sure gestures and in lyrical, almost laughing squiggles and knots. Small forms dance around the edges of large ones, a mass of detail is contrasted with empty areas—and all reinforce the basic image of generation, an oval or egg shape.

Only three of the pictures are titled: *Gea, The Slaying of Osiris* and *The Song of Orpheus*. Such mythological references are public statements of Newman's solidarity with the positions of his friends Gottlieb and Rothko, and they also underline his public interest in primitive arts and ancient civilizations. But, like almost all of Newman's titles, they also have private meanings, like autobiographical signposts that indicate his preoccupations and the issues he felt were important.

Untitled. 1945.
Oil, oil crayon and pastel on paper, 19½ x 25⅜ inches.
Estate of the artist

The Slaying of Osiris. 1945.
Oil and oil crayon on paper, 19½ x 14½ inches.
Estate of the artist

Untitled. 1945. Watercolor on paper, 22 x 15¼ inches.
Estate of the artist

Untitled. 1946. Ink on paper, 24 x 18 inches.
Collection Annalee Newman, New York

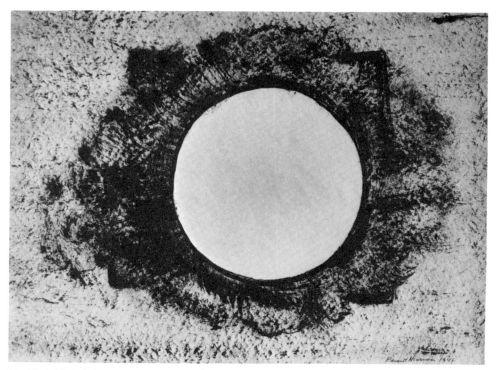

Untitled. 1946. Ink on paper, 18 x 24 inches.
Estate of the artist

The goddess Gea (or Gaea, or Ge) is a personification of the earth, the first being that sprang from Chaos; she gave birth to Uranus (Heaven) and Pontus (the Sea); by Uranus she became the mother of the Titans. For both the Greeks and Romans, she reigned in the underworld. Osiris, the great civilizing king of Egypt, was murdered by his brother, cut into pieces and scattered over the country. His queen Isis discovered and united his remains, defeated his brother and, resurrected, Osiris ruled in the Field of Reeds, the Egyptians' joyous afterworld. Orpheus's song, of course, is what permitted him, archetype of artists, to penetrate Hades and bring his love back to life.

Linking all three titles is the world of life after death and the emergence of life from death, just as the new seed takes wings from the center of the dried flower. It seems evident that the artist was commemorating, in these titles, his return to the act of picture-making after a long period of writing, studying, talking and searching for a way out of the crisis of modern art.

In one watercolor of 1945, the horizon line of the abstract landscape was emphasized, and I believe that it is likely that the artist later turned the picture on its side; what had been pods and stems springing from the ground, with a leaf and cluster of seeds (or sperm) floating down, become images moving in a more abstract space divided into two vertical sections; about half of the picture, at the left, is dark, the remainder is light in color. The vertical stress in the left side is reinforced by a heavy, textured, branchlike shape. Thus the strong horizon line is turned into a vertical band or stripe. This probably is the first statement of the central vertical motif in Newman's art. That autumn, when Newman returned to New York, the vertical element—at first probably a tree trunk or flower-stem shape—joined the egg shape (which, in turn, developed into a moon and/or sun form) in Newman's repertory. Both motifs were developed independently, and were combined, in paintings and drawings of 1946–1947.

The circle—perhaps it reminded him of the clock his kindergarten teacher had drawn on the blackboard one day in class—was presented as an enigmatic abstract shape in a pair of black-ink drawings (both untitled), the white of the paper forming the disk, which is defined at its circumference by heavy brushing, like a negative photograph of a solar eclipse. It suggested to Newman an image of the the Void, the pregenetic moment, but it has a physical glow or aura, which takes an ectoplasmic shape in such early paintings as *Pagan Void,* 1946, and becomes a white halo in *Genetic Moment,* 1947. In the latter, as well as in *Genesis—The Break,* 1946, and *Death of Euclid,* 1947, the circle is associated with the vertical element which retains a tree, branch, root or flower-stalk connotation. Newman, however, tended to reduce this naturalistic implication by hardening its edges and making it more of a space-defining member (like a bit of fan-

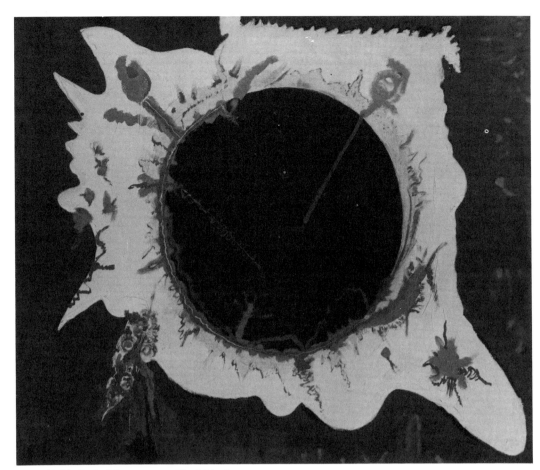

Pagan Void. 1946. Oil on canvas, 33 x 38 inches. Collection Annalee Newman, New York

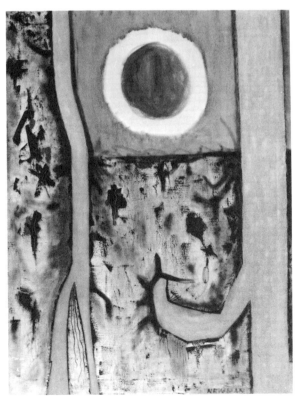

Genetic Moment. 1947. Oil on canvas, 38 x 28 inches. Collection Annalee Newman, New York

Death of Euclid. 1947. Oil on canvas, 16 x 20 inches. Collection Mrs. Betty Parsons, New York

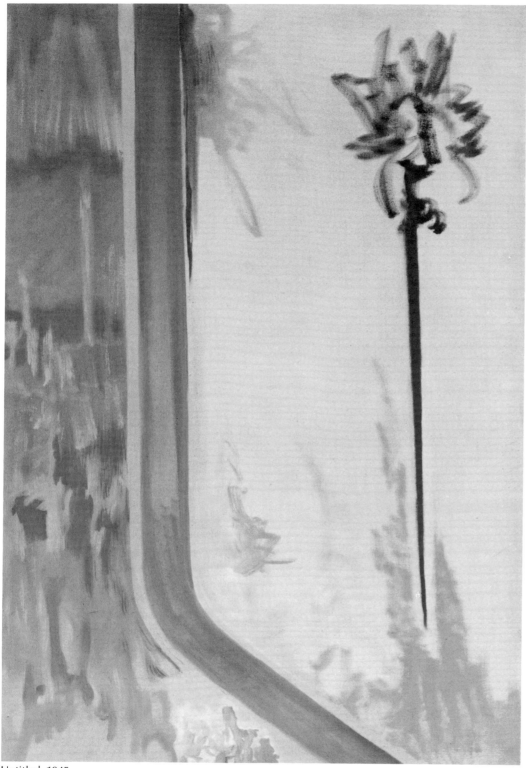

Untitled. 1945.
Oil on canvas, 36 x 24¼ inches.
Estate of the artist

tastic architecture—a growing pilaster). It is both more ambiguous and more abstract than the egg-sun-circle with its overt sexual and mythological allusions.

The vertical element occupied more of Newman's efforts in a larger group of 1945–1947 pictures, and in retrospect it is easy to see how he worked out the form that was to make his imprint on modern painting and sculpture. At the time, however, the artist obviously was reluctant to abandon any possibilities that might be opening to him. He worked with bends and circles as well as bands. He was always leery of dogmatic solutions and fought fanaticism—especially esthetic fanaticism—with cheerful vigor all his life. The vertical makes its first appearance in a three by two foot painting in the late fall of 1945,[3] his first comparatively large oil in over five years. The vertical marks the left-hand division of the canvas, as in the earlier watercolor, and it is echoed by a thinner vertical band which, toward the bottom of the canvas, veers to the right. Between the band—which looks a bit like a highway traversing the picture, first running northwest and then due north—and the left division is an area of negative space which both cuts and unites the section. To the right, balancing the tree-trunk mass on the left, is a flowerlike shape held aloft by a stalk in the shape of a ray of light, or the blade of a sword with a spinning, petaled handle.

Newman used the bend or turned stripe a number of times in the following year (it makes a surprising late appearance in *Adam,* added to the finished work in 1952), in *Euclidian Abyss,* 1946–1947, and *Death of Euclid.* The idea of the ray, the tapered band, also attracted him. He was still involved in concepts of genesis and creation, and the shape might have reminded him of certain images in Jewish mysticism, which will be discussed later. A number of paintings present rays of color, "streaks of light," as if from the great beacon moving in the night sky: *The Beginning,* 1946, *The Word I,* 1946, and *Two Edges,* 1948, as well as an extraordinary series of drawings. It is possible to read in these pictures an after-image from Jonas Lie's *The Conquerors,* in which columns of smoke divide the painting with similar, angled shafts.

The straight vertical line appears by itself as early as 1946 in *The Command* and *Moment,* and it was also used in conjunction with circles and rays. Evidently, it worked better in the drawings, where the white paper of the stripe zipped under and across the brushed and scumbled black ink with the velocity Newman was seeking.

[3] The untitled 1945 painting is in fact 36 by 24¼ inches. Newman ordered his canvases stretched to an even dimension; he used to refer to a painting as his "twenty footer" or describe it as "ten feet wide." However, after the painting was finished, restretched when necessary, framed, moved around, exhibited, the dimensions naturally changed a bit. Thus, such a painting as *The Third,* 1962, is a "ten-foot painting," despite the fact that accurate remeasuring shows it to be 120⅜ inches wide. Whenever possible I have tried in the text to use the dimensions specified by the artist in his plans. Only in this way can some of the underlying structures in his art be understood.

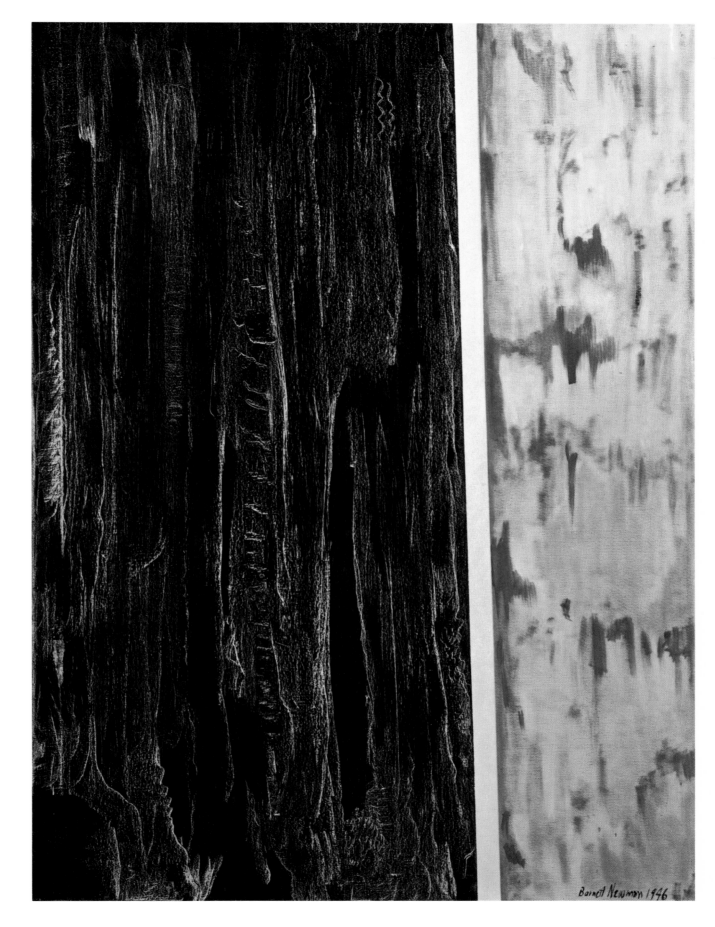

The Command. 1946.
Oil on canvas, 48 x 36 inches.
Collection Annalee Newman, New York

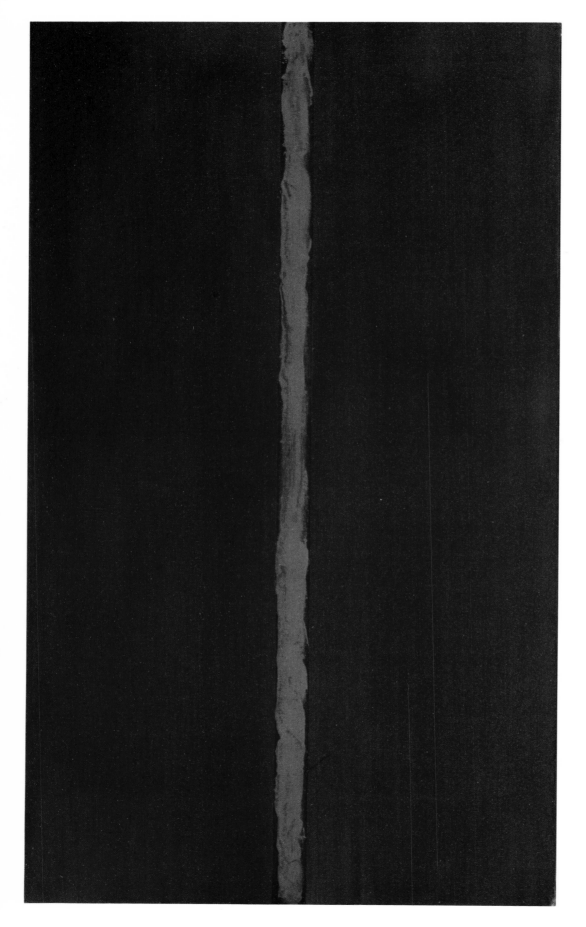

Onement I. 1948.
Oil on canvas, 27 x 16 inches.
Collection Annalee Newman, New York.
See pages 53 ff.

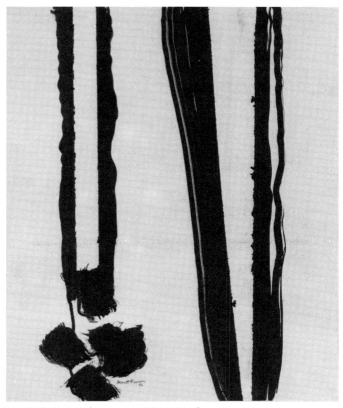

Untitled. 1946. Ink on paper, 17 x 14 inches.
Estate of the artist

Untitled. 1946. Ink on paper, 24 x 18 inches.
Estate of the artist

The Beginning. 1946. Oil on canvas, 40 x 29¾ inches.
Estate of the artist

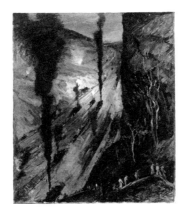

Jonas Lie. The Conquerors: Culebra Cut,
Panama Canal. 1913. The Metropolitan
Museum of Art, New York. Arthur H. Hearn
Fund. One of the paintings Newman
remembered seeing as a boy in his many
visits to the Metropolitan Museum. The
painting's vertical accents are echoed,
perhaps unconsciously, in Newman's
The Beginning.

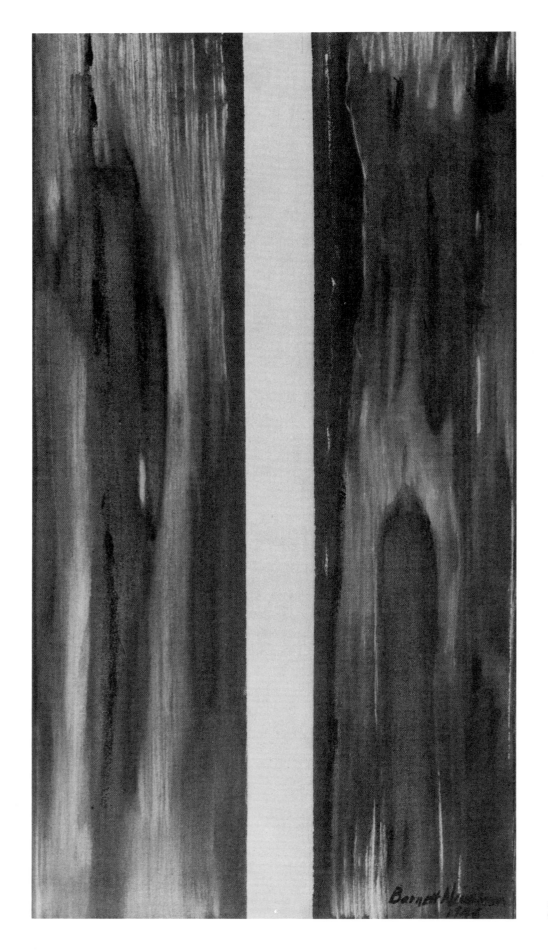

Moment. 1946. Oil on canvas, 30 x 16 inches.
Collection Annalee Newman, New York

The tapered ray also moved quickly, and the circle was always satisfactorily "there." But in the paintings, the stripe would bog down in textured backgrounds. "It was always going through an atmosphere," he said, "I kept trying to make a world around it."

He kept his motifs separate from the backgrounds by masking them with tape. On his birthday, January 29, 1948, he prepared a small canvas with a surface of cadmium red dark (a deep mineral color that looks like an earth pigment—like Indian red or a sienna), and fixed a piece of tape down the center. Then he quickly smeared a coat of cadmium red light over the tape, to test the color. He looked at the picture for a long time. Indeed he studied it for some eight months. He had finished questing.

Newman's work before this breakthrough has a particular importance both intrinsically and as a part of that extraordinary group effort that brought about the flowering of modern painting in New York in the 1940s.

He began, as we have seen, from the assumption that there was nothing left for an artist to do but start at the beginning, all over again, as if Europe never existed. One way out, as many artists found, was through some form of automatism—to let the hand and eye run loose, to free that part of the brain which lives in the wrist and in the optic centers from the hypercivilized mind that has read all about Cézanne and talked endlessly about Picasso. It was a technique in which all techniques were permitted. The Surrealists in France, especially Miró of the 1920s, Masson and, in a way, Stanley Hayter, could provide examples for such men as Newman, Pollock and Rothko. Indeed Gorky made good use of some shortcuts indicated to him by Miró and Matta. For most New York artists, however, just having an example was enough to reject it. Shortcuts were exactly what they were trying to avoid, having observed the deadly lessons in virtuosity that had wiped out a whole generation of late Cubists and Surrealists.

They had learned to trust nothing but themselves and their own emotions, whose resonance they anxiously sought in each attempt at a picture. Newman, like Rothko and Gottlieb, called his early works "Surrealist" because he was working with automatic gestures and, more importantly, was attempting to penetrate deep levels of thought. In other words, they were Surrealist like Lautréamont's poetry—independently. They had nothing to do with the official school of Surrealist painting, conducted by Breton, nor with its various ostracized subgroups. They worked directly—brush, color and canvas, or brush, ink and paper. They avoided the Surrealists' complicated methods of exciting (or exasperating) the vision—such as frottage, or tearing papers according to "the laws of chance," or shooting bullets at the picture, or procedures of blotting, pasting, printing, framing, smashing, collaborative working, using found objects, and the like. The Americans simply painted their pictures

Untitled. 1946. Ink on paper, 19 x 13 inches.
Estate of the artist

Untitled. 1946. Ink on paper, 23¾ x 17¾ inches.
Estate of the artist

Euclidian Abyss. 1946–1947.
Oil and gouache on canvas board, 28 x 22 inches.
Collection Mr. and Mrs. Burton Tremaine, Meriden, Connecticut

Two Edges. 1948.
Oil on canvas, 48 x 36 inches.
Collection Annalee Newman, New York

with a pragmatic faith that the spirit of modern art would somehow renew itself through the same medium with which it had been established in the hands of Pissarro, Monet and Cézanne.

The ethical pressure informing Newman's early works gives them a strange grandeur. Small in scale, modest, open, sometimes direct to the point of being tongue-tied, they are filled with hints of forms about to develop and with nascent ideas. They are also filled with negative qualities: you see paint trying to get rid of the cosmetic nature of traditional cuisine, symbols attempting to shed any allegorical impurity, paintings in the process of breaking with the high style of bourgeois art. They mark, as it were, a moment in what Trotsky called "parallel development"—a leap out of provincialism into the revolutionary future. From a consciousness heightened in pictures like the early Newmans, Pollocks and de Koonings, American art was able to achieve its radical élan.

Newman's early paintings, such as the untitled 1945 canvas with its vertical demarcation facing a flowerlike or sword shape, are executed with an authority and technical imagination that are surprising not only in an artist returning to the medium after a long absence, but also in the context of American painting of the period. The pigment is applied directly and confidently, without the flash and filigree touches that mar so much abstract art of the time. There is no false, neo-Neo-Plastic austerity either. He uses a wide range of methods—scumbling, scraping, drawing with the brush and with the edges of shapes. The pared-down laconic quality of his pictures of 1945 to 1947 makes them seem sparse and elegant, well-made, dignified. When Newman found his image, and moved it radically to the limits of painting, he kept to a technique that expresses pride in an economy of means—poetry with a minimum of tropes.

The titles of Newman's pictures from 1946 to 1948 also give clues to his developing positions. Some are frankly combative. *Pagan Void* refers to contentless Mohammedan abstract art, to all abstract art without subject matter. The elaborators of merely decorative geometric patterns will be lost in *The Euclidian Abyss,* and the collapse of their style is signaled in *The Death of Euclid.* The other titles indicate Newman's continued interest in the great theme of creation, but around 1946, he left the classic myths and turned to the Old Testament, the Talmud and to certain insights and phrases from Jewish mysticism. He draws our attention to *Genesis,* which is the same as *The Break*—the division between heaven and earth: in *The Beginning* was *The Word* and *The Command* of God: "Let there be light."

The idea of a tapering, vertical, beamlike shape could have come from his readings in Jewish mysticism. A passage from a hymn to "Zoharariel, Adonai, God of Israel" in the Greater Hekhaloth runs:

With a gleam of His ray he encompasses the sky and His splendor radiates from the heights.

The symbol in which the life of the Creator and that of Creation become one is—to use Creuzer's words—"a beam of light which, from the dark and abysmal depths of existence and cognition, falls into our eyes and penetrates our whole being."[4]

The dark-red painting with an orange stripe painted down its middle, which was to provide a starting point for almost all Newman's later work, was titled *Onement*, a word which suggests wholeness, harmony, but also, as Newman himself pointed out, refers to At-onement, Atonement, the events of Yom Kippur which is a day of remembrance of the dead, but for the Kabbalists, also was the ideal moment for meditation on the Messianic secret, on rebirth, new life—in a word, Creation.

Newman was not an overtly pious man, much less a member of any organized religion. He had, in Thomas Mann's words, "a feeling and taste for the infinite," and with Mann held that the "fact" of this feeling should be dedicated "to the fine arts, free contemplation, yes, even to exact research, which as cosmology, astronomy, theoretical physics, can serve this feeling with entirely religious devotion to the mystery of creation."[5] Being Jewish was a part of his past and of his present; he was heir to a culture and took delight in studying it—more delight than he did in studying other religions. One could say that all civilizations and sciences were like an enormous museum through which he loved to wander, and among his favorite galleries were those devoted to Jewish myths and customs, philosophers and artists, and especially to that remarkable fusion of mysticism and logic that is known as the Kabbalah,[6] and to the men who, for over two thousand years, contributed to its insights.

Mallarmé, whose crisis in poetry was similar to that of Newman in art (although the Frenchman's was of a much shorter duration), used a similar approach, one might even say a similar substructure, for his art. He wrote his friend Cazalis:

Yes, I know, we are only empty forms of matter, but most sublime because we have invented God and our Soul. So sublime, my friend! that I want to present myself with this spectacle of matter, conscious of being, and yet rushing frantically into dreams, which it knows do not exist, celebrating the Soul and all such divine impressions which have accumulated in us since the first ages and proclaims, in the face of the nothingness that is truth, these glorious falsehoods![7]

Jewish mysticism perhaps became Newman's "glorious falsehood," perhaps something more. It suggested many ideas he already held; it reinforced and gave a new poetic language to many of his insights.

The step from Spinoza's theory of intuition to the insights of Jewish mysticism, especially as they were given form by the great Kabbalists, seems an easy, logical one. Both believe that intuition can be stimulated and deepened by an application of rigorous intellectual, logical thought.[8]

The Kabbalist's mystical knowledge is his private, even secret affair, but the more perfect it is, the nearer it is to the original stock of common knowledge. He believes in "the creation out of nothing . . . a nothing that is infinitely more real than all other reality." The Kabbalah has many symbols, but not a single instance of an allegory. It seeks a Hidden God, One who is hidden from His own Self, and, depressed by the world of history, its mystics turn to the prehistoric period of Creation from whose vision they seek consolation.

"Praise be to the Sublime," Rabbi Akiba said to Rabbi Ishmael, "Praise be to the Sublime in the chambers of grandeur."

[7] *Mallarmé*, ed. and trans. Anthony Hartley (Middlesex, England: Penguin Books, 1965), p. xix.

[8] The step in the opposite direction, however, is almost impossible. The Kabbalists disliked Spinoza, above all, because as H. A. Wolfson has pointed out, Spinoza believed that the Torah was a book written for every man. In this inspired stroke of enlightenment, he undercut all the beautiful Scholastic architectures of the Kabbalists. But there are deeper feelings, too. The distinguished Kabbalist S. Setzer told Rabbi Herbert Weiner: "I never could forgive [Spinoza] his bowing and scraping before Christianity, his constant attacks on Judaism and his apologies for Christianity. I could never forgive him his lack of feeling for the martyrdom of the Jews, which he himself witnessed. And I had no respect for him because he borrowed much of his philosophy from the atmosphere and thought of the *Zohar*—and never acknowledged or mentioned it by a single word."

[4] Quotations throughout this text from the Kabbalah and from various Jewish mystics and savants are taken from the books of the brilliant scholar Gershom G. Scholem, in particular his *Major Trends in Jewish Mysticism* (New York: Schocken Books, 1946, 1954), *On the Kabbalah and Its Symbolism*, trans. Ralph Manheim (New York: Schocken Books, 1965) and his edition of the *Zohar, The Book of Splendor* (New York: Schocken Books, 1949). Rabbi Herbert Weiner's *9½ Mystics* (New York: Holt, Rinehart and Winston, Inc., 1969), a more popular study, also has been very useful to the writer.

[5] Thomas Mann, *Doctor Faustus*, trans. H. T. Lowe-Porter (New York: Alfred A. Knopf, 1948), p. 43.

[6] The Kabbalah is not a book or a set of books or a secret society or even a sect, as common parlance usually suggests. "The Kabbalah, literally 'tradition,' that is, the tradition of things divine, is the sum of Jewish mysticism. It has had a long history and for centuries has exerted a profound influence on those among the Jewish people who were eager to gain a deeper understanding of the traditional forms and conceptions of Judaism."—G. G. Scholem

(Faust opens a Bible)
It is written: In the beginning was the Word.
Here I am stuck at once. Who will help me on?
I am unable to grant the Word such merit,
I must translate it differently
If I am truly illumined by the spirit.
It is written: In the beginning was the Mind.
But why should my pen scour
So quickly ahead? Consider that first line well.
Is it the Mind that effects and creates all things?
It should read: In the beginning was the Power.
Yet, even as I am changing what I have writ,
Something warns me not to abide by it.
The spirit prompts me, I see in a flash what I need,
And write: In the beginning was the Deed.
—Goethe, *Faust* (translated by Louis MacNeice)

Inspiration may surprise an artist, but not with the "new." Studying *Onement I* through the winter, spring and summer of 1948, Newman recognized the format of drawings he had done before, elements of paintings he had already made, techniques he had fully mastered; but it was a breakthrough; he saw a way to a new kind of painting. (Color illustration facing page 49.)

The background, instead of being a textured environment whose details express the physical materiality of paint, and thus put it in focus on the plane of the canvas surface, is an even, "blank," abstract material. It is solid color, a section of red-brown, as if "stamped out" of a larger sheet to the artist's specifications. The color adheres to the surface with a mural tenacity, and the orange stripe stands anchored in it. Instead of expressing a relatively slow or fast motion across the surface, it is an instant divider, a "zip" as Newman would call his vertical elements. Motion is suggested, but in electric action, instantaneous, like lightning. There is an evident relationship to Mondrian, who also used tapes, and whose stripes divide and articulate abstract space on a plane that is both material (in paint) and metaphysical (in the symbolizing constructs of equivalences, that is, of balancing but unequal colors and masses). By using symmetry, by placing the zip dead center in the painting, the constricting apparatus of composition was wiped away at a sweep. By achieving what composition aims for—balance, harmony, scale, order—symmetry makes the whole elaborate, academic ritual obsolete. For the lethal artificiality of its dicta, symmetry substitutes two related dangers: boredom (or banality) and oversimplicity. Symmetry traditionally had been avoided for these reasons. It was supposed to stiffen a composition, to kill its sense of spontaneity, naturalness, variety. Newman discovered in *Onement I* that whatever the perils of monotony might be, symmetry more than compensated for them by destroying the whole art-look, art-object convention. The risk of boredom has been one which modern artists long have been willing to take—the longueurs of Mann and Proust, the noises of Varèse, the silences of Cage, or the repeated haystacks of Monet. Boredom is defined only by the viewer's span of interest, which in turn is defined mainly by his conventional expectations; it is a frivolous consideration. Furthermore, the banal can be a sign of the common, of the primitive, archaic and elemental, whence it might be just a step to the universal, to that intellectually winged simplicity which is the object and the craving of art. Newman's ambitions, as has been indicated, were to achieve masterpieces; he wanted to break into the highest levels of discourse. The open availability and freedom of the symmetrical format suggested a way.

By reducing composition to the equivalent of zero, Newman also raised color to its highest power. When, much later, Newman was recognized by critics and collectors, color was the element they praised: they noted how he had liberated it, how it moved freely across the surface of his pictures, raised to new intensities by the lack of digression in textural and graphic details. Yet Newman always insisted that his true originality, his basic contribution, was in creating a new kind of drawing. The color sensations, he felt, were more or less a by-product. But surely, when he was studying *Onement I* during the months of 1948, he must have noted and been delighted by how this relatively simple concordance of red-orange and red-brown—the high and the low notes on the cadmium scale—vibrated with light.

Finally, *Onement I* represented an elegant solution to his problem of subject matter. He was to be the celebrant of the act of Creation, of life and renewal—the poet of Genesis; but he was a poet whose words are visual forms, just as the words of the Torah have their own life as visual forms, as letters which were not joined into words until Adam's sin, when, according to Rabbi Eliyahu, "God arranged the letters before Him into words

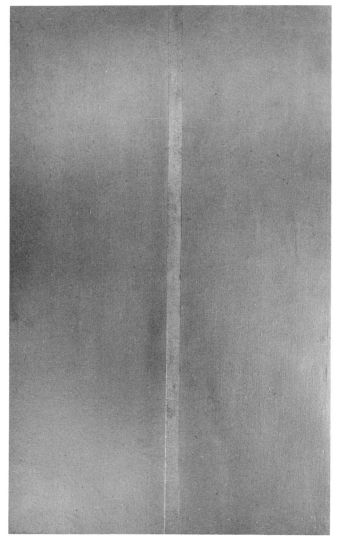

Onement II. 1948. Oil on canvas, 60 x 36 inches.
Wadsworth Atheneum, Hartford. Anonymous gift

Untitled ("Onement I"). 1947.
Ink on paper, 10⅞ x 7⅜ inches.
Collection Mr. and Mrs. B. H. Friedman, New York

describing death and other earthly things." *Onement I* is a complex symbol, in the purest sense, of Genesis itself. It is an act of division, a gesture of separation, as God separated light from darkness, with a line drawn in the void. The artist, Newman pointed out, must start, like God, with chaos, the void: with blank color, no forms, textures or details. Newman's first move is an act of division, straight down, creating an image. The image not only re-enacts God's primal gesture, it also presents the gesture itself, the zip, as an independent shape—man— the only animal who walks upright, Adam, virile, erect. The red-orange stripe on its red-brown field could have suggested another metaphor from the Kabbalists' interpretation of Genesis; red-brown is the color of earth; Adam is the man created by God; the Hebrew word for earth is *adamah;* and "Adam was made from the matter of earth, literally from the clay." However, as Philo wrote: "It is conceivable that God wishes to create his man-like form with the greatest care and that for this reason he did not take dust from the first piece of earth that came to hand, but that from the whole earth he separated the best, from pure primal matter the purest and finest parts, best suited to his making."[1] Thus the fine cadmium red light of the stripe relates to the cadmium red dark of the field as the body of man relates to the body of the earth. The orange form is fleshy, bodied, with sensuous edges.

Such a reading of "Onement" as the creation of man and of Adam, newly created, on the earth, finds further elaboration in the *Zohar,* where it is written:

It is only when he is complete that a man is called "one," but not if he is lacking, and so God when He is made complete with the patriarchs and the Community of Israel, then He is called "One." . . .

When is "one" said of a man? When he is male together with female and is highly sanctified and zealous for sanctification; then and only then he is designated one without mar of any kind. Hence a man and his wife should have a single inclination at the hour of their union, and the man should be glad with his wife, attaching her to himself with affection. So conjoined, they make one soul and one body; a single soul through their affection; a single body, for only when male and female are conjoined do they form a single body; whereas, and this we have learned, if a man is not wedded, he is, we may say, divided in two. But when male and female are joined, God abides upon "one" and endows it with a holy spirit; and, as we said, these are called the children of the Holy One, be blessed.

"Onement" thus is another way of saying "Genetic Moment" or "Adam and Eve" and the title celebrates a heroic vision of man and of man's creative powers.

It is possible that I am pushing the Kabbalist interpretation too far. Certainly Newman never spoke about such

[1] Philo, *De opificio mundi,* as quoted in Gershom G. Scholem, *On the Kabbalah and Its Symbolism, op. cit.,* p. 160.

a basis for his art—and he loved to talk about his paintings and sculptures. Furthermore, he was violently opposed to "mystic*ism*"—by which he meant attempts to organize such ineffable states into rules and systems of art or religion—but he stood up for the individual "mystic," a poet such as Blake, "a man with a unique vision." Newman left many clues in his titles, and in at least two statements, that he was well aware of the great poets and philosophical mystics of the Kabbalah. There were several books on the Talmud and on Kabbalism in his library, particularly the brilliant texts of Gershom G. Scholem. Finally, the Kabbalah itself has a long tradition of silence and strict privacy; its visionaries sought the *Deus Absconditus,* the God who is hidden in His own self.

In October 1948, Newman began to paint again, and by December 1949, he had completed twenty paintings in an extraordinary spurt of energy, unique in his career. There is no record of the precise order in which the pictures were done, although it is possible to reconstruct a general outline of how he developed and expanded his ideas. The first picture he took up, and completed by December 1948, was *Onement II,* which, at five by three feet, is a little more than double the size of *Onement I,* but also red on red.

Onement I, it must be remembered, is in a sense an unfinished painting—or let us say a painting "finished" by an insight which interrupted the artist in a stage of his work. Newman was about to texture the background; then he would have removed the tape and painted in the stripe inside the masked edges. *Onement II* presents the complete image in its new form. The stripe and its field are very close in value—almost the same red. The field is meticulously, evenly painted with several coats to arrive at a consistent surface and a full color. The zip retains the imprint of raised edges where the masking tape protected the field. It is also evenly painted, but a certain variation of stroke gives it scale.

The vertical in *Onement* I has a rough hand-brushed character. It is reminiscent of the early Giacometti plaster figures which were first shown in New York in February 1948. Newman has said that the Frenchman's elongated, tenuous women, compressed into straight lines, "looked as if they were made out of spit—new things, with no form, no texture, but somehow filled"; he added, "I took my hat off to him." I like to think that these sculptures reinforced Newman's decision to stick with *Onement I,* even though Giacometti's trembling, angst-filled personages, as well as their introduction to New York in a text by Jean-Paul Sartre, who made much of the Existentialist despair and concentration-camp nightmare he found in them, were far removed from Newman's ambitions for an epic statement. How far removed can be seen in *Onement II:* calm, radiant, self-possessed, completely anti-Expressionist, antibravura, present as a concrete object, complete.

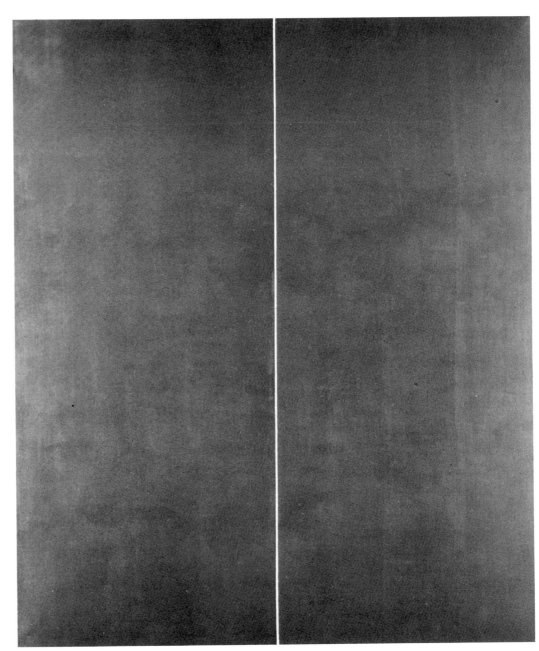

Be I. 1949.
Oil on canvas, 94 x 76 inches.
Estate of the artist

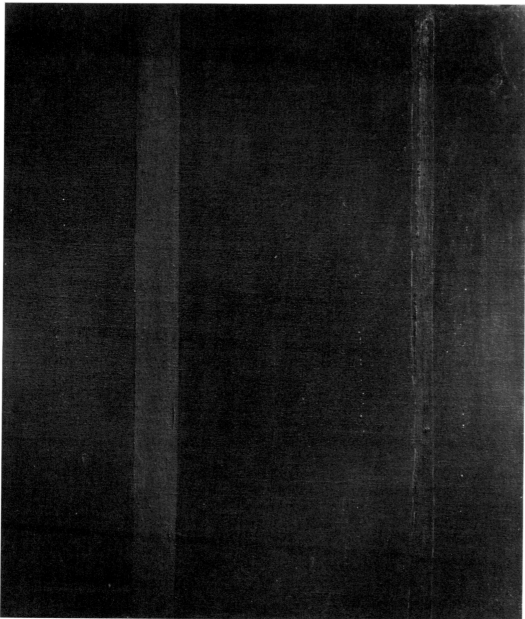

Galaxy. 1949.
Oil on canvas, 24 x 20 inches.
Collection Mrs. Anthony Smith, Orange, New Jersey

The red line divides the red field in an iconogenesiac statement; the separation of the picture into two equal parts is made as if by fiat: "Let there be. . . ."

Let there be a firmament in the midst of the waters and let it separate the waters from the waters. . . .

Can you like Him spread out the skies, hard as a molten mirror? . . .

In *Onement II,* the symmetrical format is stated radically and explicitly. By elongating the vertical axis, the split in the center—dead center—becomes a direct challenge to the old art conventions. It is doing the undoable. The field of the canvas opens up to a greater freedom than any of the brilliant allover, evenly spotted, Impressionist anticompositions of Newman's heroes, Pissarro and Monet. The whir of Mondrian's geometry on its Swiss-watch bearings is replaced by a serene, affirming silence. "Let there be, . . ." says the artist. "Light," replies the painting.

Newman then reverted to a smaller, more modest format in *Galaxy,* and, still using a gamut of reds (where he could get a maximum chromatic contrast with the smallest shifts in value), introduced two zips, roughly dividing the picture into about three-fifths in the center and one-fifth to either side. The larger vertical on the left marks a full fifth and the thinner one to the right, a scant fifth. Evidently, Newman was dissatisfied with this kind of "felt" placement, but he was pleased with the concept of doubling the vertical stripes. He returned to it in his next painting, the more ambitious *Concord.* Here the two stripes are tracked close together down the seven-and-one-half-foot canvas (in 1949, this was considered an unusually ambitious scale), dividing it symmetrically. The yellow paper of the tapes was left on the canvas, which is loosely brushed in turning, almost atmospheric strokes. The blue-green washes of oil paint stained the tapes in places and elsewhere the yellow paper comes through. There is a romantic hint of water lilies in this painting, a pleasure in the happy accident, which Newman evidently felt was too good to spoil. He interrupted the picture, as he had halted *Onement I,* in midprocess, and left it with the tapes and washes exposed.

In the summer of 1949, he painted the largest picture that would be exhibited in his first one-man show at the Betty Parsons Gallery; in fact it was the largest picture that could be handled in his little studio on East Nineteenth Street. To maneuver it, he and Annalee had to walk out into the street with it, turn it around, and then walk back into the room. Titled *Be I,* again in the man-earth color of cadmium red, it is divided by a thin white zip in the center—as thin and as metaphysical a presence as white paint can be in the context of red paint. The whiteness glares against the darker ground. At the press opening of his first exhibition, Newman tacked a statement to the wall urging the audience, critics and friends to stand close to the pictures. He hoped they would make the same intimate contact with the large color

fields that he had felt while painting—that they would feel as drenched as he had in the chaos of red, and then feel touched by the organizing power of the vertical division—the fine line that says "Be," as God had commanded Adam: "Be fruitful and multiply, and fill the earth and subdue it. . . ."

Two other themes preoccupied Newman in this hectic year. The first, and most important, is a visual metaphor which I shall call "secret symmetry." Like the Kabbalah, it is a matter which Newman never discussed; he never hinted at it (whereas he did offer clues to his involvement with Jewish mysticism), and, strangely, it has passed unnoticed in most of the lengthy analyses of his work.

Secret symmetry makes its initial appearance in one of Newman's masterpieces of 1949, *Abraham*. It is a black on black painting, nearly seven feet high and three feet wide. A shiny black stripe seems to divide a comparatively mat black field off-center to the left. It suggests a "felt" situation—an intuition by the artist that such a placement would be "right" in his general format. And this is how *Abraham* has generally been "read."

The real action in *Abraham*, however, is an accurate bisection of the image accomplished by the right-hand edge of the stripe which cuts straight down the center of the painting.[2] It is as symmetrical a division as the overt split in *Be I*. Furthermore, there is a kind of thematic substructure: the width of the stripe is one-third of the width of the right section of the field and half the width of the left-hand part; in other words it is a sixth. (Reading from left to right, the relationships could be expressed as: 2a–a–3a.)

A move in a similar direction was defined in *By Two's*, also 1949, where parallel zips disguise the fact that the left-hand element bisects the long, vertical format. The energy of instant division—the gesture of "Let there be . . ."—is heightened, and Newman further emphasizes this quality in *Abraham* by increasing the scale to a more-than-human proportion. By widening the zip until it almost becomes a section of the ground, both its edges become independently important—thus further disguising the secret symmetrical action of the right edge.

Why black? There are, as there always have been, historical precedents. Rodchenko's *Black on Black* was sometimes shown in the rehanging of the collection of The Museum of Modern Art, but it (as well as Malevich's rumored black-on-black partner to his famous *White on White*) was ignored. Indeed, Newman was surprised

[2] Annalee Newman remembers that he made most of his measurements on the canvas by eye, using a ruler or tape measure only to make sure that a tape was fixed plumb. His sense of size and scale was extraordinarily acute, so much so that when once he "spotted a chair out of line, we measured and found that one side was a thirty-second of an inch higher." Some working notes found after his death indicate that Newman calculated the placement of his zips and divisions of the field down to an eighth of an inch. Of course, in verifying with a ruler the location of his masking tape, and knowing the dimensions of his stretched canvas, he would also know where the zip was in relation to the center of the painting.

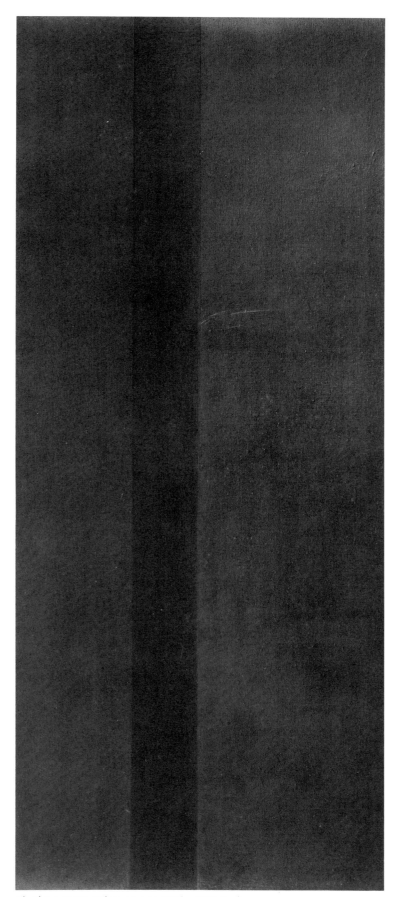

Abraham. 1949. Oil on canvas, 82¾ x 34½ inches.
The Museum of Modern Art, New York. Philip Johnson Fund, 1959

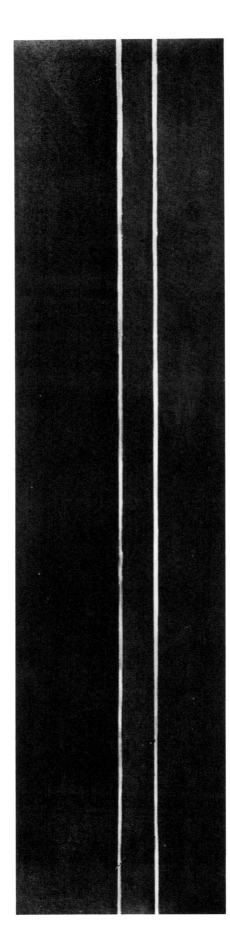

By Two's. 1949.
Oil on canvas, 66 x 16 inches.
Collection E. J. Power, London

when a friend, in the middle of the 1960s, told him about the existence of the Rodchenko; he had never even heard about it. (When, finally, he did take a look at it, he decided that it was really "brown.") The New York artists were disillusioned with ideologies and especially with those which would insert revolutionary politics into painting through some public dialectic, as practiced by the Russian avant-garde. The left-oriented art of the 1930s was regarded as a naïve escapade, and socialist and communist governments were proving to be just as oppressive, inhuman and contemptuous of artists' values as the capitalist establishment. The New York artists interiorized their radical politics; if they had a movement, it was an underground.

Another precedent for black painting was Picasso's *Guernica,* but like the work of the Russian Constructivists, it too was generally disliked and virtually ignored. However, it had a stronger impact—Picasso, after all, had been a god to artists in the 1930s. The painting might be dismissed, disliked for its caricatural drawing and promiscuous esthetic ("Picasso had love-affairs with all art history," said one painter, "and he's the lover who'll kiss and tell."); nevertheless, the image of those big, torn black shapes must have lived in every artist's subconscious.

By 1947–1948, however, black as a color—the idea of black as a new basis for painting—was very much in the air. De Kooning had been working on his black and white—but gradually almost all black—abstractions since 1946; he exhibited them in 1948, and in 1949, took them a step further, where the whites are only razor-thin curves and knots above and below the shiny black Ripolin enamel. In 1949, Franz Kline was beginning to formulate his widely influential black and white presences. In February 1948, the first postwar exhibition of Matisse was held (at the Pierre Matisse Gallery, New York), and it included a number of his extraordinary black ink drawings which seemed to be done with a brush as wide as a fist and to progress in slow motions which somehow induced black to suggest the brilliant colors of his neighboring paintings.

Given these precedents, *Abraham* still represents an extraordinary invention. Black on black—shiny black of oil and mat black of earth, the mirroring surface and the absorbent surface—raised almost to seven feet in height, it was a powerful and fresh experience that would have a deep influence on later American painting. Art seemed to have been reduced to an absolute statement in this image—and, as so often happens when a reduction which appears to be total is established, a new sense of freedom and a new range of options opened out. Paintings as different as Reinhardt's silent squares and Still's grandiose, gestural walls relate directly to the sensation of *Abraham.* More importantly, the black painting opened new areas for Newman himself, not only in his possession of the idea of black, but also in the freedom

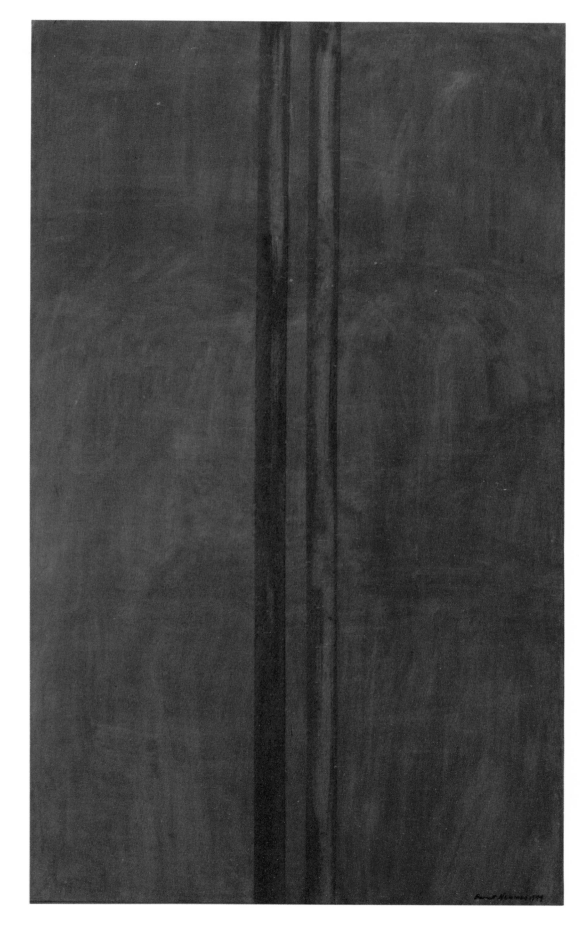

Concord. 1949.
Oil on canvas, 89¾ x 53⅝ inches.
The Metropolitan Museum of Art, New York.
George A. Hearn Fund, 1968

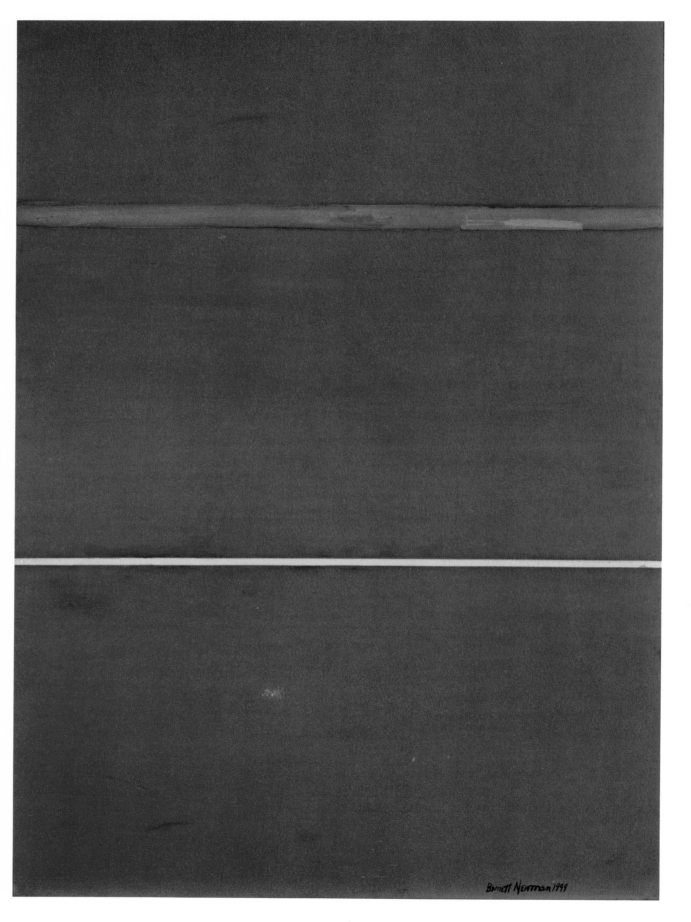

Dionysius. 1949.
Oil on canvas, 69 x 48 inches.
Collection Annalee Newman, New York

made available through a symmetry that is both overt and invisible.[3]

The period of the late 1940s and early 1950s was one of intense experimentation and of breakthroughs to new forms. When an artist wants to change, when he wants to invent, Newman once said (discussing the 1948 and 1950 pictures of de Kooning and Kline), he goes to black; it is a way of clearing the table—of getting to new ideas. When, for example, Pollock wanted to bring heads and figures back into his image in the summer of 1951, he did it in paintings reduced to black enamel on white, that is, on raw canvas. For Newman, too, establishing the daring image of *Abraham* was facilitated by restricting his palette. In this sense, black can be compared to a technique, a tool—rather like a surgeon's scalpel. It is an objective instrument. But, paradoxically, no color is more subjective. Black carries with it a whole store of associations and implications—the severe, the grandly formal, the tragic. There is no escaping this. De Kooning's black paintings were instantly related by critics to a mood of Existentialist despair—nor did the artist ever contradict this interpretation. Newman's title for his first all-black painting also reveals his acceptance of—indeed emphasis on—the elegiac poetry subsumed in our concept of blackness. *Abraham* refers directly, of course, to his own father, who had died on June 30, 1947, and also to his idea of the "sadness of the father"—the man who sacrifices himself for the son, the parent whose love of his child is shadowed by the knowledge of the distance which separates them. The father sees his death in the life he has brought forth. The painting suggests the mood of Joyce:

> *A child is sleeping;*
> *An old man gone.*
> *O, father forsaken,*
> *Forgive your son!*

The concept of secret symmetry, or of a power hidden within a power, announced in *Abraham*, suggests a further interpretation, clues for which are found in the Kabbalah. The symmetrical zip, as has been suggested, announces Newman's grand subject: Genesis, Creation, the creative act. Scholem writes of the *Book of Yetsirah*:

Insight into the creative power of the linguistic elements is attributed to Abraham as the first prophet of monotheism:

"When our Father Abraham came, he contemplated, meditated and beheld, investigated and understood and outlined and dug and combined and formed [that is, created], and he succeeded. Then the Lord of the World revealed Himself to him and took him to his bosom and kissed him on the head and called him His friend [an-other variant adds: and made him His son] and made an eternal covenant with him and his seed."

It seems to me that the author of this sentence had in mind a method which enabled Abraham, on the strength of his insight into the system of things and the potencies of letters, to imitate and in a certain sense to repeat God's act of creation.

"The First Man Was an Artist," wrote Newman (in *Tiger's Eye* in 1947), and according to the great tradition of Jewish mysticism, Abraham was the first man to create; he was the godlike artist.

If a Kabbalist interpretation of Newman's subject matter in general, and of *Abraham* in particular, is correct and I believe that the number of examples which will be adduced later in this text amply demonstrates it to be so, the tragic nature of his subject matter also becomes apparent—and the tragic was the mode to which he always aspired. His image is Genesis. Reinforcement for his ideas and sensations which lead him to the image comes from two thousand years of Jewish mystical thought. It is a part of his heritage, but he had cut himself off from its orthodoxies and taboos. Newman himself, passionate anarchist, fought for a culture without cult. Thus, the tragic dimension is added to actions and forms which traditionally were based on a secure, common faith, anchored in belief in the existence of Eternal Glory, the coming of the Messiah, and the ultimates of justice and bliss. Ritual is absent from Newman's celebrations of creativity. He is the artist as modern man, alone, surrounded by chaos, by social events over which he has no control, a transient material being—absurd. The arena of the tragic hero opens to him as he realizes and accepts this, but still continues to work, like Mallarmé, as if he could believe in man's supreme creation. He chose to live with this contradiction and found images in its tensions.

As a young man, Newman had sensed the nature of the esthetic experience in Spinoza's apprehension of the nature of God; as a mature artist, he found stimulation, resonance and (if the old-fashioned word still has a meaning) inspiration in the writings of the Jewish mystics. Perhaps he was following Pascal's advice to atheists. If you do not believe, said Pascal, you should continue making the gestures and acts of belief—prayer, mass, sacraments. There is something in the actions themselves, Pascal felt, that can bring the actor to a state of grace. Whether or not this happened to Newman, I am not sure; there is not a scintilla of evidence that it did, or that it did not. He would go to a neighborhood synagogue twice a year on the anniversaries of the deaths of his parents; he would say the Kaddish and give to the temple the symbolic $18. In Hebrew, numbers are also letters; 18 is *heth yud,* and the letters *heth yud* spell *Hai,* which means "life." In Israel they sell watch charms with the numeral 18 on them; it is a good-luck charm, a beloved custom. Thus Newman's donation of $18 was a proper gesture. Appropriate.

[3] A further metaphorical reading of Newman's preoccupation with symmetry should be indicated; symmetry is the hypothesis upon which the brilliant school of modern physicists around Bohr based their descriptions of the universe, and from his essays we know that Newman was interested in these post-Newtonian investigations.

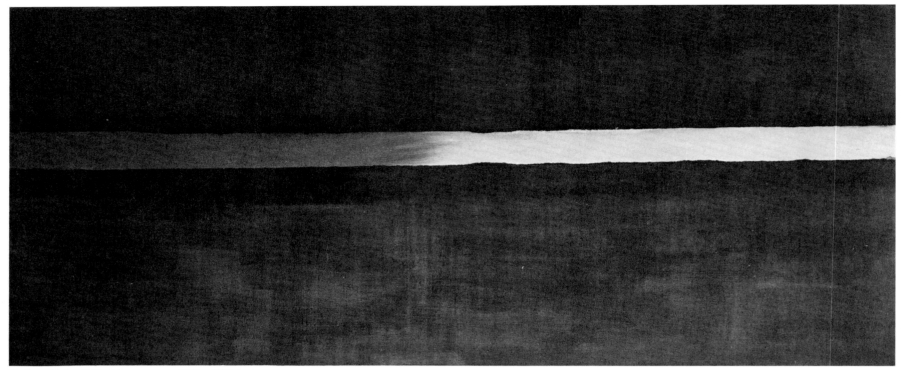

Horizon Light. 1949. Oil on canvas, 30½ x 72½ inches.
Collection Mr. and Mrs. Thomas Sills, New York

Argos. 1949. Oil on canvas, 33 x 72 inches.
Estate of the artist

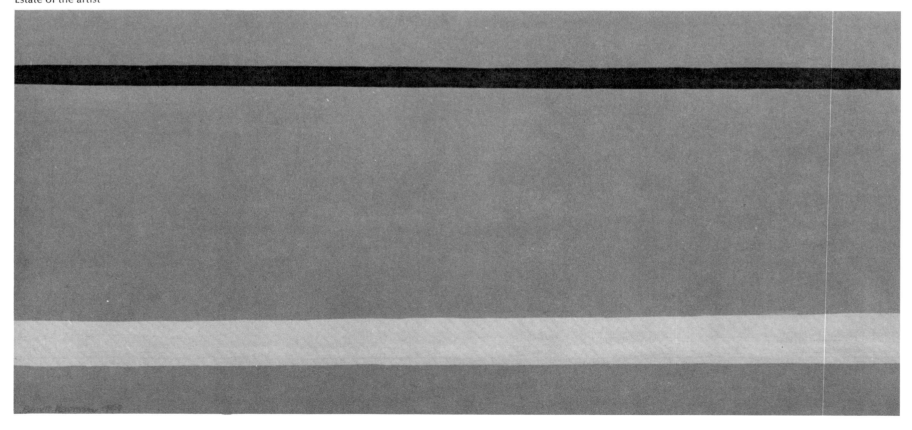

"Secret symmetry" was one of the moves Newman made away from the direct, open statement of *Onement I;* another was to investigate the horizontal format. It is difficult to retrace with any precision the chronology of all the seventeen 1949 paintings, however, it is reasonable to assume that the artist developed his images in a way more or less similar to the moves from *Onement I* to *Be.* That is, the first statements are apt to be smaller, more tentative, exploratory, and then they are quickly stated in large scale and given a full definition. Thus, in *Dionysius, Argos* and *Horizon Light,* we see zips used as horizontal elements to cut the format. In *Dionysius,* a vertical canvas, the bottom and the middle divisions of the field are the same height; the top section is one-half as high. If you assign the dimension of *x* to the top section, the picture would read from the top down: $x–2x–2x$. The top stripe is brushed in a soft, lyrical, handmade way. The bottom one is hard, defined by masked edges. In *Argos,* sharp horizontal zips traverse the horizontal canvas, placed in a balancing relationship with the wider, lighter line at the bottom and the thinner, darker one at the top. In these horizontal pictures, Newman evidently avoided "drawing" in the center of the picture, which would have cut a horizon line and introduced a strong landscape sensation to the image. This would in turn have brought back all the compositional and academic conventions he wanted to jettison. He approached the problem most daringly in *Horizon Light,* where the format is pulled even more to the horizontal; the zip is reduced to a single band, but painted in two colors that blend from left to right, from dark to light, and its modulation is echoed in the paint handling above and below. The sensation is not that of a landscape, but of forces pulling an image wide apart, of stretching a color horizontally across an area. Newman would not revert to this again until 1967, but it was immediately important to him in opening up the possibilities of an extended, horizontal format in which events take place in the narrative way traditionally associated with it, as in the frieze, and with the instantaneous effect he had discovered in *Onement I.* In *Horizon Light,* the image registers at a glance, even though the spectator feels impelled to follow its development as if scanning a sequence. But a problem evidently arose; horizontal divisions in a horizontal format leave little room for maneuvering. The field quickly becomes transformed into a cross-section of slices or layers (as Kenneth Noland would discover and brilliantly exploit in the late 1960s) and the image changes structure completely. So the artist turned to a series of horizontal pictures divided by vertical elements—a series which probably was started at the same time as *Dionysius* and *Argos.*

In the first two of these, *Onement IV* and *Covenant,* images are divided symmetrically, although in *Covenant,* the left zip defines the central area with its outside edge while the right zip makes the decisive dead-center cut

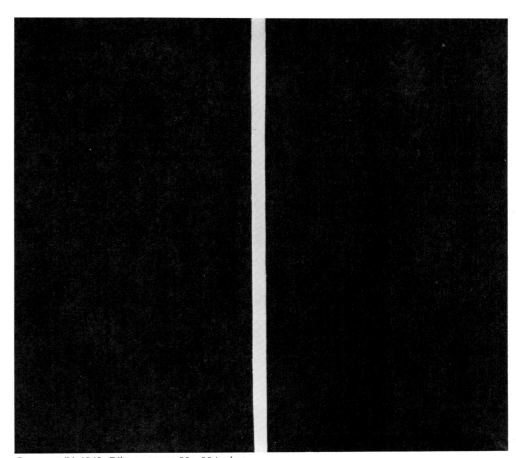

Onement IV. 1949. Oil on canvas, 33 x 38 inches.
Allen Memorial Art Museum, Oberlin College, Oberlin, Ohio

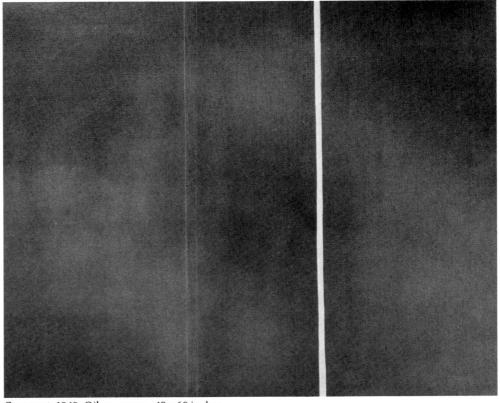

Covenant. 1949. Oil on canvas, 48 x 60 inches.
Joseph H. Hirshhorn Collection

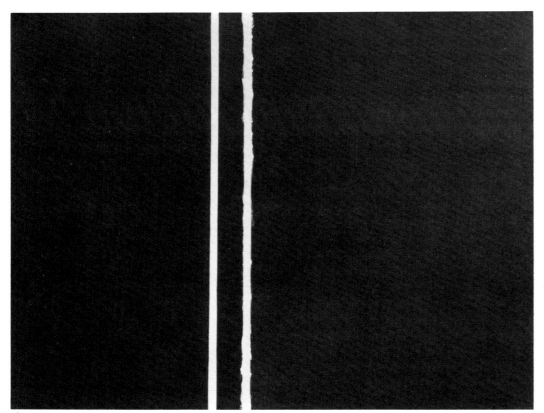

The Promise. 1949.
Oil on canvas, 52 x 70 inches.
Collection Carter Burden, New York

on its inside edge. From here, Newman probably went to *The Name I,* in which four vertical zips of different widths disguise the action of the second one from the left, which cleanly bisects the format. From these came *The Promise,* which (like *Dionysius* and *Covenant*) is divided by a hard-edged zip and a more lyrical, gestural, hand-brushed element; *The Promise* was the last painting to be finished in time for Newman's first one-man show (January 23–February 11, 1950).

The exhibition was, in a sense, an interruption. The works he had just finished were opening up an increasing number of possibilities, especially the last-named pictures which would be the groundwork of his first eighteen-foot painting, *Vir Heroicus Sublimis.* All the useless busywork that goes into making an exhibition probably came as something of a relief. He had completed twenty-one paintings since 1948—many of them ambitiously large. Each picture he made seemed to suggest a multitude of new images and procedures.

In *The Promise* (a black painting), for example, he pushed secret symmetry a step further. The field is divided by two white zips; a sharp one is to the left, and to the right of it is a soft, brushy one; between them they define an interval of black; if you repeat this interval one step to the right, that is, if you let it move in your mind's eye as it tends to go, from the narrow part of the painting to the wider part, you hit the exact point of bisection. The symmetry is perfectly revealed and explicitly hidden. Here blackness surely represents the experimental tabula rasa and not anguish or dread.

Late January and February 1950 was a good time for Newman to take some time off and to reconsider. And this exposition, too, needs to pause, and the arbitrary point of January 1950—chosen by Newman so his birthday would fall within the duration of the show—makes a certain rough sense. The danger in discussing an artist's work along the lines of a probable chronology is that the artist's will, his own hard-won volition, disappears in a smooth chain of "inevitable" events.

It is important to look again at *Onement I,* that remarkable, and remarkably modest painting. It is, as I have indicated, an interrupted work. Newman started it with a certain image, probably based on a 1947 drawing, more or less clearly in mind. He began the process: painted in the background, put a tape down the center, tested a smearing stroke over the tape. The next move would have been to add texture to the background—to start turning the object into a painting, but Newman stopped. It must have been almost impossible for him to stop. An act is a unit as the distinguished psychiatrist David M. Levy has demonstrated.[4] Once an action has begun, the whole organism urges it to completion. One of Levy's examples is Lorenz's description of the surrender signal among fighting wolves. The two animals are in

[4] David M. Levy, M.D., "The Act as Unit," *Location,* vol. 1, no. 1 (Spring 1963), pp. 24–26.

a struggle to death. The issue is decided, and then the loser, now fighting for survival, rolls over on his back and exposes his jugular. It is the signal that the fight is over. The winner stops his attack. The action is interrupted, but the situation still is filled with tensions, with the latent energy of the uncompleted act. The winner trots off; the other wolf begins to get up; suddenly the winner spins at him; the loser must fall back on the ground and offer his neck again. The drama goes on and on, until finally the energy of the drama is dissipated, and the winner leaves the arena.

For Newman to leave *Onement I* in its naked, raw state necessitated a tremendous act of will. He had to fight off all his instincts for how his painting should "look." He had to keep himself from pursuing a whole interconnected series of events which his eye and his hand demanded he complete. He had to break loose from circumstances; to invent a gesture of freedom. It must have been an experience as painful as it was exhilarating. Working within the tensions of the unfinished, he completely turned his art around. The next painting he did would be from new hypotheses. It was a conversion: Saul on the road to Damascus. For Newman, it was probably a more difficult experience than were the "conversions" of Rothko and Kline. They had mastered established styles. Their conversions were simply (relatively simply) responses to the pressure to *change*. Newman, on the other hand, had just begun to paint fluently again after some five years of enforced, unhappy silence. His vision demanded the sacrifice of a very recently won prize. *They* were established artists. If their changes turned out to be mere stumbles, they could catch their balance and continue again. He was asking himself to abandon, after the briefest respite, his self-knowledge and identity as an artist, his reason for being. ("If I can't be an artist," he once said quietly, "I can't live.")

Everything he must have seen in the "unfinished" *Onement I* would have mocked as much as encouraged him. The oversimplification of its symmetry, the apparent emptiness of its formal structure, the sadly few elements that remained to him to work with, the "aggressive" quality of its reduction—were as evident to the artist as they since have been to innumerable critics whose hostility to Newman's work has increased along with its acceptance among his fellow artists. But the vision must have been as compelling as it was dismaying. Obviously, he did not see many paintings in this one little oil; he saw only a way out of the bind. As he developed his ideas, he had to resort to other modest starts and tentative probes. Ideas did open up, however, each from each, and Newman must have been absolutely convinced that he had been right when, after eight months of study, he moved from *Onement I* to the large scale of *Onement II*. Probably this confidence is what gave him such self-assurance and conviction in the following years. He had been through the worst.

In 1952, Harold Rosenberg wrote an essay which attempted to define the new American art as "Action Painting," and although it was based in part on the insights of several major artists, and although the artists themselves were pleased to work with Rosenberg's interpretation and with his creative historical vision of their role, there was a certain unease about the whole matter.[5] It was a brilliant formulation. But did it apply? Looking back on the situation twenty years later, it seems to me that the only real "act," in terms of Action Painting, was Newman's decision to interrupt *Onement I*. This was a true metaphysical choice, with true consequences, not simply a matter of moving pigment about on a canvas, no matter how violently. The artist affirmed *himself*; he freed himself from process.

Newman was seldom classified among the Action Painters (they were usually considered to be Pollock, de Kooning, Hofmann, Kline, et al.), although he and Rosenberg always were close friends and happy debaters; each considered the other an ally. So perhaps there is a double irony in the fact that Newman may have been the only real Action Painter, and that Rosenberg predicted it four years after the fact. Not predicted: prophesied; for now that history is always on our backs, the prophet of the past is even more miraculous than the one who simply takes note of the calamities history has scheduled for us.

There are at least two types of interrupted paintings, of course. There is *Onement I*, which results in a totally new vision, and there is *Concord*, where the artist simply stops because to make more additions would spoil a certain effect he has achieved. There are many paintings by Matisse, for example, where whole figures are left blank, or backgrounds neglected; these pictures had captured a sensation that could be ruined in elaboration, so the artist declared them finished. Such interruptions are a matter of refinement. Only in Cézanne, it seems to me, are there parallels with *Onement I*; there is a painting of a cardplayer and there are fragments of still life which Cézanne stopped with what appears to have been an immense effort of will. In the relationships between the blank canvas and the "unfinished" faceted strokes, he saw a way to change, to synthesize his illusion of volume with a new radiance of color.

After *Onement I,* there are many adventures in Newman's art, but no cataclysms. *Concord*, where the masking tapes are exposed, as they are in *Onement*, is one of the artist's most relaxed, pastoral pictures. He interrupted it because it came to a finish sooner than he had planned. The title hints at Adam and Eve before the Fall, and at the Kabbalist vision of a "primal space full of formless, hylic forces." *Concord* also refers to the American Revolutionary battle site and the village with its beautiful trees in the June light which Barney and Anna-

5 Harold Rosenberg, "The American Action Painters," *Art News* (New York), vol. 51 (December 1952), pp. 22–23.

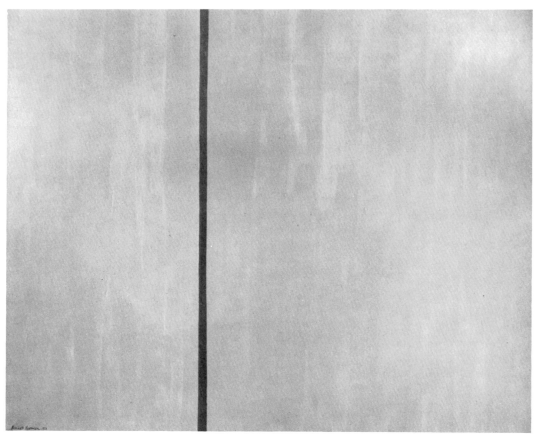

Tundra. 1950. Oil on canvas, 72 x 89 inches.
Collection Mr. and Mrs. Robert A. Rowan, Pasadena, California

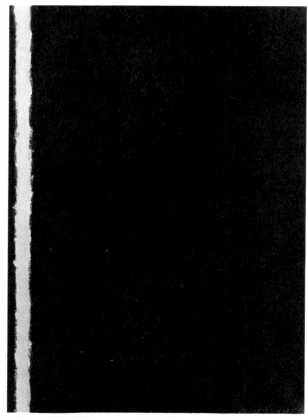

Joshua. 1950. Oil on canvas, 36 x 25 inches.
Collection Mrs. Harriet Weiner, New York

lee had visited on their honeymoon. Newman's titles are apt to give autobiographical hints as well as clues to subject matter. *End of Silence,* for example, is a small picture which repeats, but in a masterful fashion, the theme of *Onement I;* the title could refer to the very beginning of Genesis; the first act of God, and the centered stripe, painted in fast bravura motion, could be the capital "I" of "In the beginning...." More likely, I believe, is its allusion to Newman's own return to active painting, his new confidence in speaking through his art, after years of silent search and frustration. The titles of *Ulysses* (1952) and *L'Errance* (1953) also refer to his long, difficult quest for art in the 1930s and 1940s.

In the winter and spring of 1950, Newman went back to his little studio on Nineteenth Street and worked on a small painting, *Joshua,* with a single loosely brushed stripe at the far left side of the field; and on *Tundra,* a six-by-seven-and-a-half-foot canvas, as large as his studio space could contain; he divided *Tundra* with a single hard zip. This double theme of the hard zip, its edges cleanly demarcated by the removal of masking tape, and the softer, more painterly one, is implicit in the move from *Onement I* to *Onement II,* and it reappears in such relatively sketchy works as *The Name I.* Both motifs are united in *The Promise,* and Newman would keep both options available until his last paintings and sculptures. The hard versus the soft line, the flat versus the lumpy surface, anonymous versus personal, linear versus painterly, epic versus lyric—there is an evident dualism here which appealed to the artist. Annalee Newman once suggested to him that they represent something like the male and the female energies, "the he and the she of it." Barney, she says, shot her a quick stare and grumbled inaudibly. Perhaps this was pinning down the duality too sharply; I feel it is a good insight. Certainly the consistent use of the two contrasting methods indicates that Newman was keeping his art open for both possibilities—the hard, clean surface and the soft, roiled passage.

I would suggest, again taking *Onement I* and *II* as clues, that the painterly stripe—like that in *Onement I,* which perhaps stands for the newly created man, Adam, could also be his metaphor for the physical sphere, that which is touched, felt, informed by the manipulation of the artist. Its sensuous nature is palpable. On the other hand, the taped, clean-edged, smooth zip could refer to the more intellectual, metaphysical sphere, as in *Onement II,* where it assumes the presence of an abstract force of division—as God separated the waters and the firmament in Genesis.

Surely in *Joshua,* the artist makes evident his pleasure in the dragging, pushing, spreading action of the paint that energizes and gives scale to the edges of the vertical. In the monumental *Tundra,* however, it is the orange field that carries the marks of the artist's work, while the vertical division cuts silently, gliding as silently "as a flight of wild geese in my home country," as a Swedish

girl once described the picture to Newman, to his delight.

In *Tundra,* and in Newman's next two paintings, he seems to have been working toward the idea of presenting a square within a rectangle, but in such a way that the square would be invisible—a further variation and complication of his secret symmetry. He was able to pursue this concept on an efficiently big scale when, in the summer of 1950, he moved into a larger studio on Wall Street.

One of the first paintings he undertook after the move was *The Voice* (eight by nine feet); then he stretched another canvas the same size but prepared to work on it as a vertical format.[6]

This fugal element—a theme, then its reverse, then inside out, outside in, upside down and so on—is strong in Newman's art and in his thinking. You could say that he would examine each proposition as if it were a completely new thing to be tested in every way. He enjoyed irony and standing accepted precepts on their heads. It also suited his sense of structure to plan pictures that would chime with each other, vary in their elements, contradict each other, while retaining certain stable functions.

The Voice is white on white, as if an ''answer'' to the black on black of *Abraham;* its field is divided to the right as *Abraham's* was divided to the left; it uses a thin zip where the vertical element in *Abraham* was weighty; it has a horizontal format which tends to the square (12 : 13), while *Abraham's* is pulled to a long vertical; in *The Voice,* the zip divides the width of the painting into areas of one-sixth and five-sixths; in *Abraham,* the proportions relate to halves, sixths and thirds. They could be, in a sense, opposites, but both relate fundamentally in the maximum use of the smallest nuance—of black within black and of white moving in white.

To get his contrast, Newman used egg tempera for the white and applied it over the field with the extraordinary care and sensitivity characteristic of his technique. The paint is brushed flatly, allover, but there is no attempt to eliminate the signs of facture in the small strokes the medium necessitates. The tempera is contrasted with oil paint white in the zip, and the two meet at a trembling edge which, if at first barely visible, becomes startingly abrupt and decisive on examination, like the verge of a frozen lake: snow on ice by snow on sand.

As in *Tundra,* there seems to be a square hidden in the format. In both pictures, if you move from that edge farthest from the zip to a distance equal to the height of the painting, you find yourself approximately at the center point between the zip and the other edge of the paint-

ing. It is as if a square were lying inside the rectangle; its visible side is one side of the canvas, its invisible one, defined by an imaginary bisection between the zip and the other edge.

In Newman's mural-size *Vir Heroicus Sublimis,* this hidden structure is fully articulated. Before he embarked on it, however, he probably completed the second white-on-white painting, *The Name II.* The paint manufacturer Leonard Bocour had shipped Newman some samples of his new Magna colors, one of the first lines of acrylic resin paints on the market in New York, and Newman used it instead of tempera for his contrasting white. He was always drawn to experimenting with materials and to perfecting his use of traditional ones. He used egg tempera up to the last year of his life. And he tried all the new media.[7]

The Name II is divided into thirds by two vertical zips that give the effect of a square to its slightly vertical format—the motion of the vertical sections across the surface gives a horizontal pressure to the image which lightly swings it into an appearance of having equal sides.

These secret squares may be conjectural, but not the one in *Vir Heroicus Sublimis,* Newman's first attempt at a very large painting. The idea of the large picture, like the idea of blackness, was very much in the air in the late 1940s in New York, for a number of reasons.

As we have seen, painting big was a heritage of the Social Realist ambitions of the 1930s. By the 1940s, the application of the 1930s esthetic to large public walls with didactic or other social motives seemed comical. Still, the idea of an important scale remained, and with it, the notion that such a picture would be beyond middle-class, middle-brow values; it could appeal directly to the widest possible audience.

Size makes a difference; quantity changes quality. Artists wanted to make images with direct, powerful impact. They wanted to get rid of artifice and style. And in the large picture, which envelops the viewer, an intimate relationship is established. The edges of the painting extend beyond the perimeters of his vision. He is sucked into the action on the canvas. A red six yards wide is a totally different color from the same red six feet wide, and has a different effect.

[7] In order to achieve the desired density and intensity of color, Newman almost always put many coats of paint on his pictures, sometimes using undercoats of different colors to arrive at a particularly deep or luminous hue. The use of oils necessitated long periods of waiting for each coat to dry, and he arranged to keep working on several pictures, so that while one was drying, he would work on another. Often he alternated mediums for what he called ''separating coats'' of paint—for example, egg tempera on oil on egg tempera on oil. In this way, he could increase the opacity and weight of his colors—especially those which usually are transparent. He continued this practice throughout his life, even when, in the 1960s, he made a more extensive use of fast-drying plastic paints.

He also often used shifts in medium within a single picture to contrast a shiny oil surface with a mat, egg-tempera, or acrylic coat—a subtle parallel to the soft-stroke versus hard-edge dualism already mentioned in his painting.

[6] Newman frequently used one set of dimensions several times, often for very different pictures. It was basic to his approach, to the interlocking nature of his art. The two 1946 drawings of circles, both on sheets of paper the same size, are the earliest examples of this vision which simultaneously pairs and opposes.

The Voice. 1950.
Egg tempera and enamel on canvas, 96⅛ x 105½ inches.
The Museum of Modern Art, New York.
The Sidney and Harriet Janis Collection, 1968

For New Yorkers, the big painting also put them directly in competition with the great Paris masters. Even if *Guernica* was sneered at, it stuck in the back of the mind. Nor was this sense of competition a kind of trivial showmanship, like that which had marked 1930s Regionalist painting in its rivalries with Paris. The New Yorkers were ambitious to produce masterpieces on the same level as the heroes they had adored in art school.

Furthermore, the big painting was a kind of declaration of independence from the art market. Although practically no pictures by the new American artists were selling, these vast canvases seemed by definition totally unsalable. No collectors had room for them. No museum would give up that much space. Heroic in scale, the paintings also had the heroic temperament of gratuity.

Such were some of the more or less superficial motives behind the new big paintings. More important, however, was the inner force which made the images expand to what were then astonishing dimensions. Pollock, throwing paint on the canvas placed on the floor, putting his whole body into the gesture, needed the space—the shoulder-room, so to speak. His linear, looping image also had a centripetal dynamism. Pollock's first sixteen-foot painting, *Number 1, 1949,* exhibited that year at the Betty Parsons Gallery, impressed Newman, whose own image also had a built-in pressure to expand. He was preoccupied with a horizontal format divided by verticals (among other themes), and only if he could get the painting wide enough could the zips act both as self-contained presences and as cuts (that is, drawing) in color.

Newman always worked from stretched canvases made to specifically designated sizes.[8] He once said he never knew how he was going to paint his next picture (a remark that caused a certain amount of ill-natured hilarity in the early 1950s), and this was because his method forced him to begin with a complete blank, with nothing, chaos. Pollock, on the other hand, would unroll his canvas on the floor, make some marks on it and begin to work with or against his first strokes. De Kooning would tack a canvas to his painting wall and paint in some letters, or a profile of his thumb—anything to get into the creative act. Later both men would crop or enlarge the surface, adjust it to the image. Newman, however, had only a pencil and a piece of paper on which he scribbled columns of figures. Sometimes these numbers would mystify his friends who knew that he was not involved with accounts, nor was he very fast at addition. What he was working on, it seems, was finding the proportions

[8] When Newman moved in 1968 into his last and largest studio, he devised a painting wall on which to affix unstretched canvases. The wall itself, however, was divided by a checkerboard pattern into nine-inch squares. He executed his two nine-by-twenty-foot paintings on it: *Anna's Light,* 1968, and *Who's Afraid of Red, Yellow and Blue IV,* finished in 1970. In both cases, he calculated beforehand precisely what the dimensions of his image, and of its subdivisions, would be. With these two exceptions, he worked on stretched canvases; he liked to paint on a surface that gives a little.

and dimensions of his canvases. Until he arrived at them, he was nowhere. They were, as we shall see, intricate constructs despite their simple appearance.

The pictures in his 1950 exhibition were radically large for the time; indeed, they stunned most spectators, who were still accustomed to easel-size canvases from American artists. They were as large as his old studio permitted. But once he was settled on Wall Street, he began to plan his first mural-size painting. He studied Pollock's *Number 1, 1949,* which was eight by sixteen feet, and although he accepted the height as logical—above human, but not superhuman—he felt that its one-by-two proportions were static, too architectural, too classic. Pollock was, in effect, putting two eight-foot squares together. Newman decided to stretch the format, and after a long process of interior reasoning, arrived at two eight-foot squares, plus two feet, that is, a canvas eight feet high and eighteen feet across.

Annalee Newman remembers how pleased he was to find these dimensions, for the pictorial solution also implicated *his* number, 18, *heth yud, Hai,* life.

There is more to 18 than a bit of folklore and a happy custom. For "eighteen" is *Shemoneh Esreh,* which is also the name of the prayer that is most important, because of its antiquity, in the three daily services of the temple.

Philip Birnbaum writes:

Originally, the Shemoneh Esreh, *denoting eighteen, consisted of eighteen benedictions; in its present form, however, there are nineteen. The addition of a paragraph concerning the slanderers and enemies of the people was made toward the end of the first century [A.D.] at the direction of Rabban Gamaliel II, head of the Sanhedrin at Yavneh.*

The Talmud offers a variety of reasons for the number eighteen. It corresponds to the eighteen times God is mentioned in Psalm 29 as well as in the Shema. The three patriarchs of the Jewish people, Abraham, Isaac and Jacob, are mentioned together eighteen times in the Hebrew Bible. The number eighteen is also said to correspond to the essential eighteen vertebrae of the spinal column (Berakhoth 8b). . . .[9]

In examining Newman's œuvre, it is surprising how many times eighteen or a number evenly divisible by eighteen occurs. Granted that if the artist was thinking in feet, eighteen inches, as one and one-half feet, would be a common divisor. Even weighing this fact (and it is evident that Newman almost always used feet as his unit), it should be noted that well over a third of the artist's paintings contain the eighteen-inch unit. One has the feeling that he did not start with eighteens; he was neither superstitious nor engaged in mystical exercises, but he was delighted when he found it, and he probably facilitated the possibility of such meetings.

With the eight-by-eighteen-foot canvas stretched and

[9] Philip Birnbaum, *A Book of Jewish Concepts* (New York: Hebrew Publishing Company, 1964), p. 618.

The Name II. 1950.
Oil and Magna on canvas, 108 x 96 inches.
Collection Annalee Newman, New York

affixed to the wall, Newman began to apply his tapes, two to the left and two to the right, in what looks like a "felt" series of placements around a generally symmetrical scheme. What he had done, however, was to define a square, exactly eight by eight feet, in the center of the painting.[10]

The whole horizontal vista is keyed to a cadmium red someplace on the scale between medium and dark—it is a red that has an earth-color tinge to it (like the background of *Onement I*), but with more resonance and advancing body. The zips are the same color, a bit darker and heavier, except for the second from the left, which is white. In March or April 1951, just a few weeks before the opening of his second one-man show, Newman added the last zip at the extreme right, and it also is markedly lighter—reading yellow-brown against the red expanse.

With only five elements in a large field, there are bound to be several arithmetical relationships, but most of them in *Vir Heroicus Sublimis* are farfetched: for example, if you letter the areas from left to right a, b, c, d, e and f, you can make the equation $b=a+e+f$, which is evidently mere coincidence. Thus it can be concluded, I believe, that the zips are placed intuitively to mask the central nature of the perfect square, c $(a+b=d+e+f)$. Giving the square a white, quickly visible edge to the left and a slightly darker red edge to the right also makes it difficult to read; its shape tends to blend into interrelationships with the other shapes. Finally, adding the pale stripe at the far left reduces the apparent length of the red field and acts to make the square seem off-center.

The effect of the painting is at the farthest remove from any idea of a diagram or a coldly articulated structure. The color envelops the spectator; the verticals stand as presences in it, like the angel sentinels who guard the Throne of the Lord. One thinks of Valéry, who said the lyric poem is an elaboration on the exclamation of an "Ah-h!" And of the poet Seferis who added, "For me the 'Ah-h' is quite enough." Here, color in modern painting breaks through its last constraints, and is proclaimed the essence of visual art; in its liberated surge, the zips do not act as reins, but as spurs, heightening the pressure of the sensation.

Such has been the common interpretation of *Vir Heroicus Sublimis;* it has been analyzed by formalist critics into systems and methodologies that sanction the "Ah-h" by tying it to the picture plane, or to the expres-

Left: Untitled (number 1). 1950. Oil on canvas, 36 x 6 inches.
Right: Untitled (number 2). 1950. Oil on canvas, 48 x 5¼ inches.
Both, estate of the artist

[10] Measuring the unmeasurable is characteristic of Jewish mystical experience. One of the earliest tracts of the Kabbalah is known as *Shiur Komah* (that is, the body of God); in it cosmic dimensions are given for each part of His body, even the soles of His feet (thirty million parasangs high). In *Chronicles,* Solomon's temple is defined in precise cubits, from the nave to the lampstand. Newman's "measuring" partakes of this experience. He did not move a tape back and forth on the canvas, millimeter by millimeter, until it looked and felt right—as Mondrian did. This calculation, rather, was an imaginative, metaphysical decision for him. The endless work that followed was a search for a way to paint it—to make it physical.

sion of the framing edges, or to an "advanced" elimination of graphic gesture and surface episode. Nor did Newman ever contradict such interpretations, although he always insisted that he was interested in subject matter and that "formalism is a dirty word." Nor indeed are such readings of the picture wrong; the sense of a strong emotion (or esthetic reaction) emanating from the color and from the calm, clean surfaces of *Vir Heroicus Sublimis* is a fairly accurate metaphor for what happens in the painting. What it misses, however, is the richness and ambiguity of Newman's own metaphor. He had taken his image of Genesis, of the creative act, of the artist as God, and expanded it into an ardent, pulsing glow of color. The secret symmetry that informs his structure, that was his starting point on the blank canvas and that had opened up a space for him to paint in, was as invisible as the God to whose actions it alludes and to whose presence the Kabbalists testified in ways as private and as hermetic as Newman's.

The method which the Kabbalist mystics used, according to Scholem, was "to extract, I may even say distill, the perpetual life of God out of life as it is. This extracting must be an act of abstraction. It is not the fleeting here and now that is to be enjoyed, but the everlasting unity and presence of Transcendence."

For Newman, it could be said that God *was* art. The long hours of concentration and exercises with the infinite possibilities of shapes, proportions and colors comprised for him, indeed, a distillation, an act of abstraction, in search of a unity and a transcendental presence for his image.

Nor was Newman turning the Kabbalah upside down in order to find the image-maker in himself; he was not committing an act of heresy or even impiety. The Kabbalists themselves often used such dramatic intuitions and daring reasoning.

After finishing *Vir Heroicus Sublimis,* Newman said that he "felt intoxicated with scale," and in reaction, and to test further the range of his vision, he began a series of six very narrow pictures.

Newman's friend Tony Smith has another version of how he began these thin paintings, but it also connects them to *Vir Heroicus Sublimis.* A museum curator saw the big painting, according to Smith, and announced that he had finally understood it; it was just a relationship of shapes—Bauhaus! Newman growled that the only things in the picture that "count" are the stripes, and to prove it he made paintings just of them.

Smith's story rings true, but it is also probably true that Newman had been preparing for some time to make this move—even while the earlier picture was in progress.

It is possible to reconstruct an approximate chronology for these narrow pictures of 1950, although probably Newman, as usual, worked from several directions. In the first, a modest thirty-six by six inches, Newman spread color roughly on the left, rather as he had in *Joshua,* but

Left: Untitled (number 3). 1950. Oil on canvas, 56 x 3 inches.
Center: Untitled (number 4). 1950. Oil on canvas, 74 x 6 inches.
Right: Untitled (number 5). 1950. Oil on canvas, 77 x 3½ inches.
All, estate of the artist

The Wild. 1950.
Oil on canvas, 95¾ x 1⅝ inches.
The Museum of Modern Art, New York.
Gift of the Kulicke Family, 1969

now pushing across toward the other edge of the canvas. He thus again established a narrow format within a wider one; then he dropped a zip on the right side, trisecting the image. The next painting is four feet high and five and one-quarter inches wide, with a "secret" trisection, the dark vertical on the right being one-third of the width, the lighter color to the left filling the remaining two-thirds. In the third picture, he moved up to fifty-six inches high and three inches wide. Two loosely painted stripes meet roughly in the center, connecting in wavy vertical strokes, the left side pushing in toward the lighter right. In the fourth state, seventy-four by six inches, he again trisects the field, but the center stripe is double the width of the side ones, thus simultaneously trisecting and bisecting the area into ¼-¼-½ sections. In this painting, he predicted *The Way I,* executed almost a year later, which Newman felt was his first work in which there are no zips, stripes or divisions but equal elements, and which profoundly affected his later work. Even as he had "predicted" *Onement I* in a drawing of 1947, he ignored the premonition to follow the beast in view. Indeed, he moved in the opposite direction and isolated a very painterly (or one might term it an Action Painting) stripe on a canvas seventy-seven by three and one-half inches.

Newman's creative thinking is beautifully exemplified in these five works, none of which ever was named (although one of them has appeared on an inventory with the title *Little Eve*). The artist feels where he wants to go—to the final state, the nearly eight-foot high, one-and-five-eighths-inch-wide picture *The Wild*—the dimensions of a zip out of *Vir Heroicus Sublimis,* and echoing its cadmium red medium color, but now with some blue underpaint exposed. It is a radical picture, an extreme. Newman arrived at it through a series of intuitions, a testing of scale, and with scale, emotion—for he often insisted that size was a product of feeling. He moved in a way that with hindsight may appear hesitant, although how an artist working at the leading edge of modern art can be considered hesitant is difficult to understand. The point is, I believe, he did not want to discard any part of his art just because that would be an easy way to develop it. He wanted to keep everything with him, like a mountain climber who, on a dash to the summit, may have to lighten his pack by throwing away supplies; he does so reluctantly, as a last resort, and like the mountain climber, Newman marked his discards carefully so that he could get back to them if possible. Thus moving toward *The Wild,* he tries to give his paint the hard, flat, even surface of *Vir Heroicus Sublimis* but finds that in a narrow format the image becomes reduced to the look of a facet. He tries his divisions, but they impede attainment of the very thin and the very tall. He uses the sensuous impastos of *Onement I* and *Joshua,* pushing them up, flattening them. Then, finally, he combines the dimensions of the zip from the *Vir Heroicus*

Vir Heroicus Sublimis. 1950, 1951.
Oil on canvas, 95⅜ inches x 17 feet 9¼ inches.
The Museum of Modern Art, New York.
Gift of Mr. and Mrs. Ben Heller, 1969

Cathedra. 1951.
Oil and Magna on canvas, 96 inches x 17 feet 9 inches.
Collection Annalee Newman, New York.
See page 78.

Sublimis with the physical, textured paint of *Onement I*.

For all six of these narrow pictures, Newman carpentered his usual meticulous stretchers, with quarter-rounds (curves inside) nailed on the outside edge of each stretcher to hold the canvas away from the wood frame. For *The Wild*, he needed all his ingenuity as a cabinetmaker. It was one of Newman's ways of telling the world that this picture was no stepchild but had received the same thoughtful, disciplined effort as all his other pictures. It was also Newman's way to tell the world secretly—because without cutting off the canvas, who but another expert carpenter would ever know?

There was more than mere attention to the protocol of craft in this decision because adding the quarter-rounds doubled the thickness of the picture, and it assumed an object quality—the critic Lawrence Alloway later would call *The Wild* the first shaped canvas. Newman had been talking about making a sculpture, and *The Wild* is a shaft as much as a plane. It has a strong three-dimensional quality, and as Barbara Reise has pointed out in her perceptive, enthusiastic essay on Newman in *Studio International*, "It is not a surprising jump to an urge to work in freestanding sculpture; and *Here I*, made in wood and plaster . . . seems an inevitable concretion of Newman's concern with the physicality of the vertical."[11]

Newman, however, seldom jumped. The sculpture had been in his mind for more than a year, probably since a visit to Akron in August 1949. He had gone to meet Annalee's family and to explore Ohio, where he discovered the Indian-mound country. He wrote some notes about it in an unpublished monologue titled "Prologue for a New Esthetic": "Standing before the Miamisburg mound, or walking amidst the Fort Ancient and Newark earthworks—surrounded by these simple walls made of mud—I was confounded by the absoluteness of the sensation, their self-evident simplicity. . . ."

Later, in a conversation, he described the experience as that of "a sense of place, a holy place. Looking at the site you feel, Here I am, *here* . . . and out beyond there [beyond the limits of the site] there is chaos, nature, rivers, landscapes . . . but here you get a sense of your own presence. . . . I became involved with the idea of making the viewer present: the idea that 'Man Is Present.'"

Newman evidently was alluding to the Jewish concept of *Makom*, of "place" or "location" or "site" (he refers directly to this in a 1963 statement about his model for a synagogue, in which the temple itself is designated as *Makom*, and he calls the "place" where members of the congregation stand to read from the Torah a "mound").

Early Jewish mysticism, Scholem points out, is a kind of "throne worship"; through processes of insight, meditation and logical speculation, the devout man rises from sphere to sphere until he stands before the Throne of God where he "hears a voice speaking from the celestial

[11] Barbara Reise, "The Stance of Barnett Newman," *Studio International* (London), vol. 179 (February 1970), p. 53.

fire like a voice of many waters, like the sound of the sea in its uproar," and where he sees how:

With a gleam of His ray he encompasses the sky and His splendor radiates from the heights. Abysses flame from His mouth and firmaments sparkle from his body.

Unlike mystical experiences in Christian and Eastern religions, the Jew stands in front of the Throne as a man; he experiences the reality of being there; it is an objective condition and not a sense of grace or of the ineffable.

Newman seems to have related his epiphany among the Indian mounds in Ohio to the Kabbalist's before the Throne.

Makom is place. *Hamakom* is, literally, "the place." It is also one of the secret names of God and one of the many poetic locutions which the Torah uses to avoid pronouncing His name or spelling out its letters. Thus Moses would not say: "The Lord spoke to me . . ." but "The Place spoke to me. . . ."

For the early Kabbalists, as for Aristotle, "place" and "space" were identical. There was no such thing as an abstract, metaphysical "space." Everything was "place," even heaven, and for the Jews "the place" is imbued with the transcendental presence of God.

In Newman's fragmentary "Prologue for a New Esthetic," after invoking his experience among the mounds, that is, his sensation of *Makom*, he went on to attack the idea of "space" as a cliché in modern criticism and art jargon. Newman's connections to Kabbalist thought often reinforced his thinking about painting and sculpture. They are, in a sense, harmonic images from a sphere in the past, and their role is to sustain and enrich the artist's radically modern esthetic formulations. Newman wrote:

Everybody says that painting is a space art. The story of modern painting is always told as a struggle for and against space—deep space, shallow space, flat space, positive and negative space, cube space, the space of "infinity," etc. What is all the clamor over space? It is all too esoteric for me as if the crucial essence in music was the fact that composers, that Mozart wrote in 3/4, 2/4 or in no specific rhythm; or that poetry really depends on whether it is written in Alexandrian, blank verse or free verse. Is painting crawling over a canvas in a great paroxysm of intoxicated improvisation like a collection of hot jazz players?

Everybody says that the important thing in painting is the image—the real image, the imagined poetic image, the whole image, the nostalgic image, the automatic image of chance, the broken Surrealist image, the pure, universal image of the material itself, the coup-d'œil image.

My paintings are concerned neither with the manipulation of space nor with the image, but with the sensation of time. Not the sense of time, which has been the underlying subject matter of painting, which involves feelings of nostalgia or high drama; it is always associative and historical. . . .

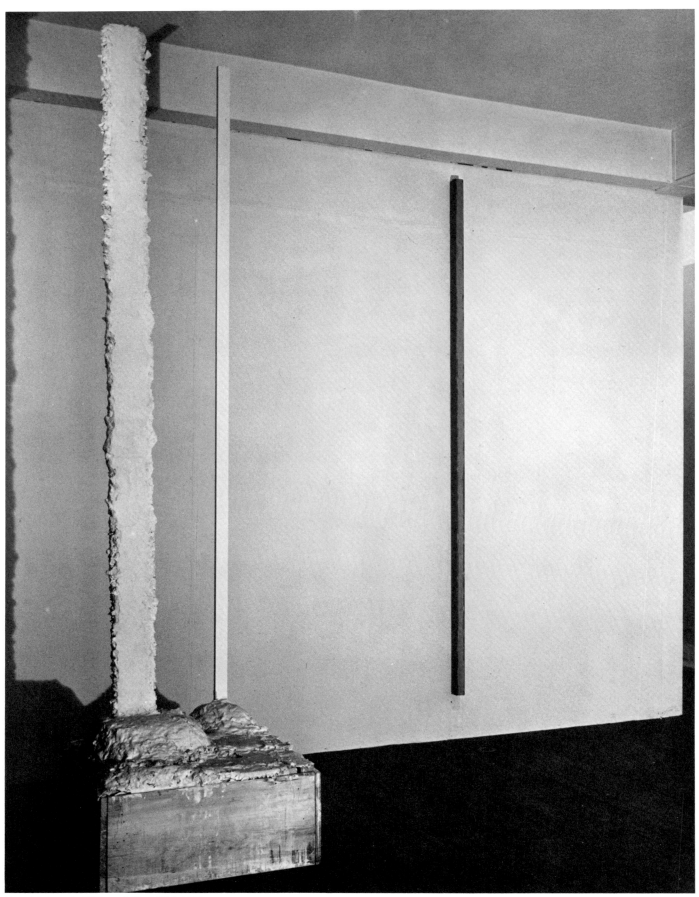

Here I (plaster), 1950, and *The Wild,* 1950,
as installed at the Betty Parsons Gallery, New York,
during Newman's second one-man show, April 23–May 12, 1951.
Photograph by Hans Namuth

And here his "Prologue" ends.

He probably would have gone on to raise the issue of "timelessness"—one of his high ambitions for art, but I believe that Newman, whose many interests included modern physics, also would have defined time in Einsteinian terms as the essential, defining measure of "space," thus returning space from the sentimental lingo of modernist esthetics to the old Judeo-Greek concept of "place"—*Makom*: something that is *there,* where a man stands. No matter how spiritual a man's experience may be, his vision will be saturated by the human scale.

This, I believe, is what his first sculpture is about, and it is no coincidence that it is titled *Here*—of this time, in this place.[12]

It is about eight feet high—the same height as the zips in *Vir Heroicus Sublimis.* One of the elements is straight, thin and hard—a machine-tooled one-by-three-inch board, simply painted white. The other element is wider and thicker, made on an armature of wood and chicken wire with white plaster roughly piled and fingered into it (making it may have reminded Newman of his childhood modeling with hot tar). Both verticals are stuck into mounds stepped up from a flat plaster base, which in turn is lifted off the floor on a wooden milk-bottle crate, which fits flush beneath the sculpture.

The rough, squeezed element corresponds to Newman's sensuous, smeared verticals in *Onement I, Joshua, The Wild* and the untitled vertical work that had preceded *The Wild.* The thinner, smooth white vertical is like the knife-edged zips in *Onement II* and in many of the other works that followed it. The pairing of both was first established in *The Promise* and elaborated in the first of the untitled vertical paintings that led up to *The Wild.*

His technical problem, he once explained, was to make his sculpture lift off the floor, that is, to establish its independent presence apart from an extraneous architectural context (just as in painting he always wanted to have the work "move away from the wall"). In *Here I,* this was accomplished by mounding up the base to receive the verticals, by organizing a man-made landscape as their context. The manscape, in turn, was raised off the floor by the crate, roughly painted white in smears and drips, which differentiated it from the gallery floor. (The base complex was cut down when, in 1962, *Here I* was first cast in bronze; it has now been replaced.)[13]

[12] A well-known contemporary Existentialist presentation of this experience is Heidegger's *Dasein* ("being there")—man's awareness of being placed, located in the world. Newman, who always mistrusted the Existentialists' tendency to sentimentalize and to feel sorry for themselves, obviously found *Makom* a more heroic and visually satisfying concept.

[13] In the late 1950s and early 1960s, many of Newman's artist friends urged him to cast the piece in bronze; sculptor Philip Pavia took Newman out to visit foundries; sculptor William Turnbull argued that plaster "wasn't a *material*" and that *Here I* must be cast; and a California collector, Marcia Weisman, also urged Newman to do it, telephoning at all hours from the West Coast to get him started on

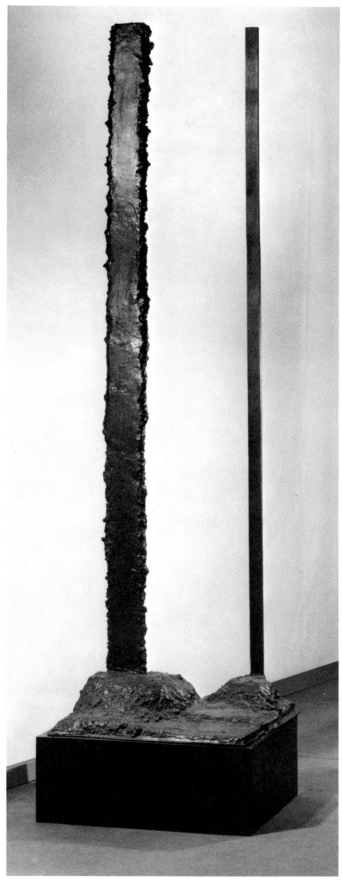

Here I (To Marcia). 1950 (sculpture cast 1962, base 1971).
Bronze, 107⅛ inches high x 28¼ inches wide
x 27¼ inches deep, including base.
Collection Annalee Newman, New York

Queen of the Night I. 1951.
Oil on canvas, 96 x 19 inches.
Collection Ben Heller, New York

The motive, then, was to lift the verticals out of the painting, to solidify them, place them on the earth, relate them only to themselves and to the spectator. They assume independent presence, larger than man, but in a size comprehensible by man. We see them, but they are above us. They mark their place, fill it. We see them, but they are witnesses—solid, objective witnesses—to something else, a vision beyond the "here and now," as if to prove that from *Here,* the hero can contemplate the radiance of man's ultimate vision: the Throne.

Here I was executed, Annalee remembers, in ten hectic days "when we didn't eat or sleep." The artist felt compelled to do it, to see his zips materialized, as it were. He was not at all sure he wanted to exhibit it in his second one-man show that was scheduled at the Betty Parsons Gallery in the early spring of 1951, and finally he did so only at the urging of Jackson Pollock. (More than any other of his artist friends, I believe Pollock shared Newman's sense of the transcendental nature of an American site or location, of the American artist as its witness and of American art as its testimony. Furthermore, Annalee adds, half joking, "Jackson liked the drip down the sides of the crate.") When Newman turned back to his paintings, it is logical to assume that his next undertaking was another tall, vertical work, *Queen of the Night I,* again using eight feet as his height, but establishing the width at one and one-half feet (or, put in inches, the mystical eighteen wide, and twelve times as high; after stretching and carpentry, the width expanded to nineteen inches). The zip, related to the profile of the white machine-edged member in *Here I,* is pushed almost to the left margin, but the deep, lyrical blue of the field, which saturates the image, reappears at the left edge, and with its sapphire ocean and sky associations acts as a background to present the vertical as a strong material presence. Newman "contradicts" this illusion by giving the blue a heavy opaque materiality—as if it were die-cut out of a larger expanse of color, as he once explained. He also saw in the luminous blue a magic quality, and the color began to preoccupy him. *Queen of the Night I,* in this sense, became a move toward *Day before One,* probably his next painting, in which the blue is stretched to eleven feet high, supported at the bottom edge by a luminous, more intense blue stripe and topped by a paler, more opaque one. Here the stripes, instead of acting as zips which create gestures of division or standing like sentinels across the field, move to the edges as if to disguise the size of the painting; the narrow 1:2½ proportions are impacted and contained. *Day One* is the same size as *Day before One,* and the two could be considered as a pair—an interpretation

the project. He finally agreed and with the help of sculptor Robert Murray made a kind of mummy's cradle for the plaster and maneuvered it down three flights of stairs to a truck. Newman made two casts of the piece and amended its title to *Here I (To Marcia).* In the late 1960s, he decided to replace the milk-bottle crate with a bronze box of the same size.

which Newman encouraged in his titles—but *Day One* is paired in the sense of an opposite. It is orange, the primary contrast to blue. Its stripes are on the side edges, which increase the contrast between the major vertical and the minor horizontal axes, whereas the bands in *Day before One,* at the top and bottom, tend to stabilize this tension.[14]

This idea of working in contrasting pairs of pictures and with contradicting elements within them became one of Newman's favorite modes of procedure. We have noted *The Voice* and *The Name II*—two white pictures, one a horizontal rectangle, the other a vertical in the same dimensions. In *Day before One* and *Day One,* he also used two identical formats. While he was occupied with them, he had another canvas stretched, of the same dimensions as *Vir Heroicus Sublimis,* and only bad luck in setting it up on the studio wall prevented him from starting on it as soon as he had finished his first eighteen-footer.

He did not consider such paired works to be in any way pendants. The procedure was evolved to allow him a greater flexibility of ideas and to provide him with visual stimulation. An idea suggested by or discarded from one painting could be expanded in its pair. The concept of a dogmatic art disgusted Newman as did any method of rejection or choice based on ideology. With paired canvases, he could work more openly, welcome fresh associations and structures, keep the levels of creative energy high. Sometimes he turned ideas inside out, as in *Day before One* and *Day One;* at other times, the connections are more difficult to grasp, as that of *Vir Heroicus Sublimis* with its "pair," which would be titled *Cathedra.* So it could be said that such works, and others done over the years that followed, are separate but connected, contrasts but not polarities, parallels but not variations.

Day One and *Day before One,* it should be noted, are typical of many of the big paintings of the first Abstract Expressionist period in that they were not only unsalable, but unexhibitable. Their eleven-foot height could not be accommodated at the Betty Parsons Gallery. There was no chance at all that they could be sold or even seen by anybody but the artist and the friends he invited to his studio. This was not a reaction against the New York gallery system (it did not exist yet), nor against American materialism. Simply by being artists, Newman and his friends were the undeclared enemies and subverters of an established society which treated them with hostile neglect, and whose values they disdained. Rather, it was an urgent matter of following the lead of the painting, giving the image its head and accepting whatever impractical or "impossible" directions it took. It was an

[14] The band at the side of a painting became one of Newman's most important motifs; it is first stated in *Euclidian Abyss,* 1946–1947, which the artist once described as "my first painting where I got to the edge and didn't fall off." He used it again frequently, in *Eve, Adam,* the Stations of the Cross, *Who's Afraid of Red, Yellow and Blue I* and *III,* among others.

Day before One. 1951. Oil on canvas, 11 feet x 50 inches.
Oeffentliche Kunstsammlung, Basel

Day One. 1951–1952. Oil on canvas, 11 feet x 50¼ inches.
Whitney Museum of American Art, New York. Gift of the
Friends of the Whitney Museum of American Art (and purchase)

Eve. 1950.
Oil on canvas, 96 x 68 inches.
Collection E. J. Power, London

Color illustration of *Cathedra* facing page 73.

Color illustration of *The Way I* facing page 144.

exercise in courage, and there was a sense of exaltation among the artists in the late 1940s and early 1950s—the shuddering heightening of spirit that comes from realizing that a risk has been taken, that one has come through, and that another danger lies just ahead. It created a camaraderie among artists. They might be competitive, as Pollock and de Kooning were, but it was competition with a strong mutual esprit de corps: like that of a top baseball club that has two star hitters, both after the home-run record, but each pulling for the team first.

The last two paintings Newman finished before his second one-man show (April 23–May 12, 1951) were *Eve* and *Adam,* both moving back to the red and dark red themes of *Vir Heroicus Sublimis; Adam* being a "paired" canvas with *Achilles,* 1952, and in all probability exhibited before Newman was quite satisfied with it. Both have stripes at the edges—*Eve* at the right, a thin hard band; and *Adam* at the left, a wider, softer, feathered area. The stripe in *Adam* is echoed symmetrically at the right by a zip. Both pictures thus move beyond the format of *Day One.*

After finishing *Vir Heroicus Sublimis,* Newman returned to it and added the pale zip to the extreme right of the painting, further complicating the "unrelated" look of the vertical elements across its surface, and further disguising the central eight-foot square. It seems probable that he undertook his next "eighteen-foot" painting, *Cathedra,* at this time, now saturating the painting with blue to such an intensity that the divisions marked by two pale zips pass almost unnoticed. What you see is a vessel brimming with blue, brimming with a celestial radiance. It is almost impossible for the eye to measure the fact that you are also presented with two eight-foot squares, one at the left, the second next to it, with the "remainder" of the space at the right.

He also undertook to redo *Adam,* adding a heavy cadmium red medium stripe down the left center of the image, bent slightly to the left at the bottom, recalling the trunklike vertical in *Genetic Moment.* Evidently, he felt constrained by the straight vertical division, and it seems probable that he moved on from *Adam* to a canvas of the same size, *Achilles,* in which the central area is broken at the bottom in an irregular, nervous edge. Instead of an image of zones and barriers, there is a central, vivid orange shape cut by black as a continent is cut by the ocean shore. This activity at the bottom of the painting is then taken to an extreme in *Prometheus Bound* where a heavy, highly worked black piles on top of a thin white coast.

It is also possible that a small picture, *The Way I,* intervened between *Cathedra* and *Achilles.* This, according to Newman, was the first time he expanded his central zip into a form of equal importance to the other forms in the field. The picture is roughly divided so that one half is in the center—a bright, deep red—and the other half, cut into quarters, black, on each side. Like all Newman's

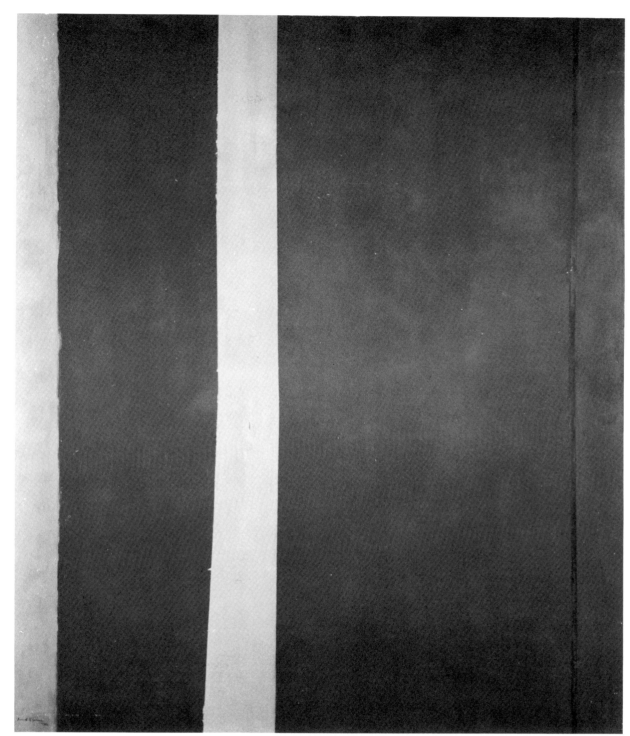

Adam. 1951, 1952.
Oil on canvas, 95⅝ x 79⅝ inches.
The Trustees of The Tate Gallery, London

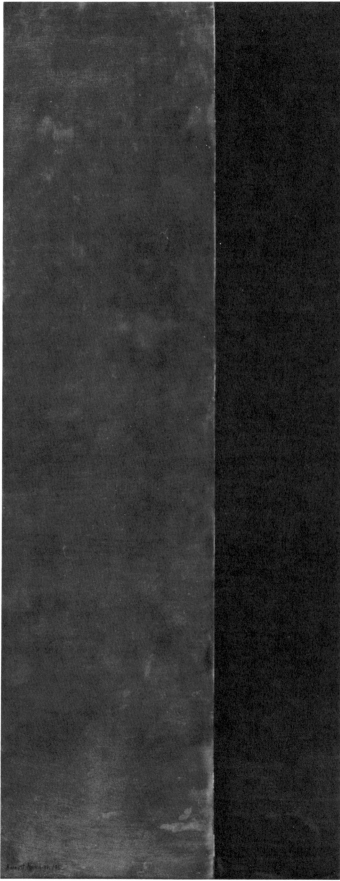

Ulysses. 1952.
Oil on canvas, 11 feet x 50 inches.
Collection Jaime C. del Amo, Los Angeles

first steps, it is modest in size, forty by thirty inches. And like almost all of Newman's first steps, he had done it before (but not recognized it), in the untitled vertical painting finished just before *The Wild.* From *The Way I,* he could move to the wide central shape of *Achilles* or to *Ulysses,* in which the painting is trisected, with two-thirds in one area on the left, and one-third a darker section to the right, their meeting a slightly open, breathing, flaring contiguity. Or to the towering, single shape of *Prometheus Bound.*

These five works, done after the 1951 exhibition, and during 1951–1953, are Newman at his most painterly. He experimented further with his magnificent blues in *Onement V* and *Onement VI,* contrasting them with white in the latter, a dark blue against a more luminous one in the former. He worked (for the first time since *Concord*) with transparent colors contrasting with opaque ones in *Achilles* and *L'Errance* (1953). In a few years, in other words, he had become the master of an enormous range of means and of images; he could project a wide variety of emotions in every mode, from the small intimate statement of *The Way I* to the epic sweep of *Cathedra,* from the blazonlike, tight-lipped dignity of *Day One* to the voluptuous energy of *Achilles.*

He should have been radiating confidence and working with the extraordinary energy that had marked the years from 1949 to 1952. However, the continuous hostility which greeted his work began to wear him down. In the spring of 1952, he felt conspicuously left out of one of The Museum of Modern Art's surveys, "Fifteen Americans" (which included Pollock, Still, Rothko, Tomlin, Baziotes . . .), and shortly afterwards, he removed his paintings from the Betty Parsons Gallery. He began to enter a second period of interior exile.

Before examining the various causes and manifestations of the general response to Newman's work in the 1950s, it is necessary to go back and take another look at the paintings themselves. We have suggested their pictorial chronology, but there is also the issue of their subject matter and how it developed.

As has been noted, Newman's titles are sometimes autobiographical, sometimes they confront other styles of art; usually, however, they concern his subject matter. He himself said that he named his pictures after—sometimes long after—they were finished, "to make the title a metaphor that describes my feelings when I did the painting." Annalee Newman, borrowing Wordsworth's phrase, describes the process as "emotion recollected in tranquility." They also frequently hint at the mystical religious experiences and logical structures of Kabbalist thought, and underline the artist's own preoccupation with the painter's act as an equivalent (or metaphor) of Genesis.

Tundra is an autobiographical title; it recalls a movie, called *The Valley of the Eagles,* that Newman and Pollock had dropped in on one evening off Times Square, ex-

pecting to see a funny thriller; instead, to their astonishment, they watched a spy story set in Lapland, in which men, dressed in armor made of furs, carrying lances, rode reindeer across a dream landscape of snow dunes and glaciers. They hunted like falconers, but with huge eagles perched on their wrists. They could not use their rifles, as a shot would start an avalanche. The painting reminded Newman of that stark landscape, and its burnished pale copper color, of the midnight sun. The movie, by the way, was in black and white, and Newman's understanding of the color of the Arctic winter sun was an imaginative leap. The heraldic quality of *Tundra* might also have reminded him of *The Valley of the Eagles*. *The Wild*, with its spear shape and orange-and-wet-moss brushstrokes, also refers, I believe, to this experience.

Queen of the Night I, the first of Newman's great blue pictures, is in the color's most intense, dark hue, made even darker by a white zip. The reference is to *The Magic Flute*, of course, and specifically to the Queen's last aria. It was one of Newman's favorites because it is filled with what he called stern, angry cadenzas, furious trills—Mozart's extraordinary fusion of gravity with lightheartedness. As certain Hasidim might put it, "pain is the chastisement of His love," and there is joy in sorrow because "there is no place empty of Him."

Vir Heroicus Sublimis is unique among Newman's titles. It grandly announces his theme of the elevated, heroic nature of man, and characteristically disguises it a bit with Latin. When the title was misprinted in a caption in *Art News* (as *Sublimus*), Newman was attacked by the famous art historian Erwin Panofsky as being a typical modern artist, that is, overweening and illiterate. The artist's surprising reply was to prove that modern artists have the philological erudition to show that even a typographical error can be correct, and, citing esoteric verses to obscure chapters, Newman demonstrated that it was Panofsky whose Latin had faltered. Finally, it is the only Newman title which was given on a date that can be precisely ascertained. Newman was studying his pictures in the Wall Street studio prior to sending them up to the gallery, and thinking up titles. He had the radio turned on. Suddenly the news came over the air that Truman had fired General MacArthur from the Korean command and had recalled him to America. The spirit of scrappy, democratic America had triumphed over the medaled pomp and aristocratic fatuity of a would-be Coriolanus, and Newman transferred the imperial Roman language to the man from Missouri. It was April 11, 1951.

In 1952, Newman reverted for the last time to Greek titles, but they had nothing to do with the Aeschelian and Freudian allusions which were common post-Surrealist references. The fate of Oedipus or of the House of Atreus did not interest him.

Ulysses picks up the deep blue of *Queen of the Night I* and refers to the sea journeying, to the hero's "endless

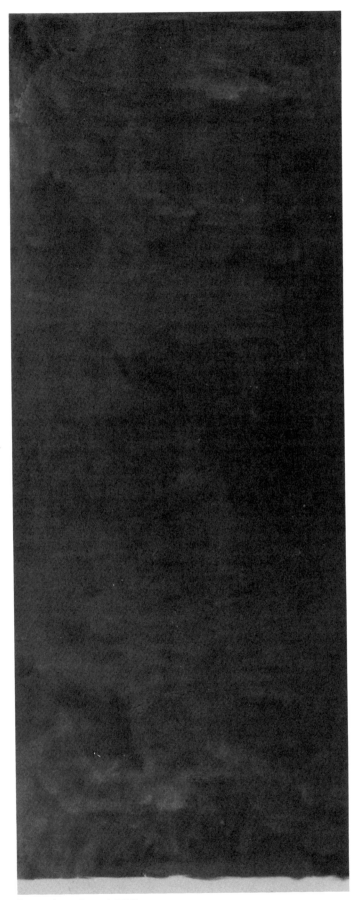

Prometheus Bound. 1952.
Oil on canvas, 11 feet x 50 inches.
Private collection, New York

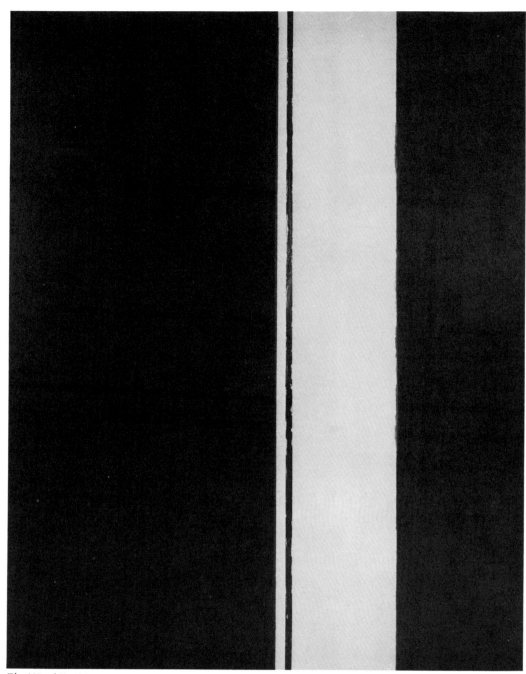

The Word II. 1954.
Oil on canvas, 90 x 70 inches.
Collection S. I. Newhouse, Jr., New York

search"—and to Newman's own long quest for his image and identity in art—as well as to Homer's "wine-dark" epithet. *L'Errance* repeats the theme—the questing, the search of the knight errant. Newman surely checked the word in dictionaries (his curiosity went hand in hand with a passion for accuracy—an unusual combination); he was probably pleased to find two particular meanings of the word—"odyssey" and "wandering," as in "the Wandering Jew."

Ulysses' title probably is also Newman tipping his hat to James Joyce, one of his first heroes. *Prometheus Bound* has the same dimensions as *Ulysses* (eleven feet by fifty inches) and refers, of course, to Prometheus's superhuman intervention which brought light to man. (*Uriel*, a later painting, is Hebrew for "flame of God"; Uriel is the angel of light who performs Prometheus's feat in the world of the Torah.)

The third 1952 picture with a Greek title is *Achilles.* Newman referred to its red and fiery central shape as a "shield"—thus reiterating his great theme, the act of creation and the artist as a god, through Homer's famous description of that masterpiece of Hellenic realism, the hero's armor wrought by Hephaestus.

Dionysius, the only title from Greek mythology among the seventeen pictures in 1949, is, of course, the fertility god, the creator, and of special interest to Newman as the god of tragic art as well as the representative of the productive and intoxicating powers of nature.

Joshua, conquering general of the Israelites, had a particular interest for Newman. The covenant Newman cited as applying to his 1949 picture is Joshua's covenant at Shechem (especially 24:19):

Then Joshua said to the people, "You are witnesses against yourselves that you have chosen the Lord to serve him."

And they said, "We are witnesses."

He said, "Then put away the foreign gods which are among you, and incline your heart to the Lord, the God of Israel." And the people said to Joshua, "The Lord our God we will serve, and we will obey."

So Joshua made a covenant with the people that day, and made statutes and ordinances for them at Shechem.

In 1969, Newman returned to the theme, and titled his first triangular painting *Jericho.*

White Fire and *Black Fire,* two of Newman's later titles, refer overtly to Jewish mysticism and to a passage in the Jerusalem Talmud (fourth-sixth century A.D.) which discusses one of the central issues of Kabbalist thought, the genesis of the Bible itself: "The Torah given by God was made of an integument of white fire, the engraved letters were in black fire, and it was itself of fire and mixed with fire, hewn out of fire and given from the midst of fire."

"Cathedra" means chair or throne, and Newman said of the picture: "I felt it was a very full painting . . . all that blue," and the title invokes, according to the artist, Isaiah's vision (6:1): "I saw also the Lord sitting on a

throne, high and lifted up, and the train of His mantle filled the Temple" (or, in Newman's own translation, included in his statement for the synagogue project, 1963, "His trailing robes filled the Temple"). The two pale verticals standing like sentries on the edges of unseen (secret) squares in *Cathedra* guard the "place," *Makom;* "the place," *Hamakom*—God—where the Lord is and where man stands in ecstatic contemplation of the Throne, the Throne of Glory, surrounded by angels singing His praise. The intellectual energy and passion of the mystic are devoted to his ascent through the spheres which divide the earth from heaven; he must find *The Way* and *The Gate* that are appropriate to him—to the Throne, *Cathedra.*

One distinction between Christian and Jewish mysticism, as has been mentioned, is that "in Judaism," as Buber points out, "there is no *unio deo*" ("union with God"). Scholem adds, the Jewish "mystic who in his ecstasy has passed through all the gates, braved all the dangers, now stands before the throne; he sees and hears—but that is all." In *Cathedra*, the zips are not divisions between shapes, but rather exist in their own right, *with* the expansive blue field, nor are they apart from it, as a background is behind the foreground. They are, in pictorial terms, together, on the same plane. Here Newman was working along the same lines as his friends de Kooning, Kline and Hofmann, who also integrated background and foreground into dynamic locking tensions. But there is no doubt, after examining the many hints Newman gave us in his titles and in certain statements, that he was also looking beyond the picture plane—above it, so to speak, to a place where ideas transcend methods and deal with the highest experiences and insights.

Three other titles, *Primordial Light, Day One* and *Day before One,* bring the subject of Genesis to an even more mystical image. From Newman's later statements and from evidence in the pictures themselves, it seems probable that the artist refers in these paintings to the extraordinary writings of the sixteenth-century Rabbi Isaac Luria of Safed, named by his followers the Holy Ari (*ari* means "lion"). He seems to recall Luria's doctrine of *Tsimtsum,* which Scholem calls "one of the most amazing and far-reaching conceptions ever put forward in the whole history of Kabbalism," and which, as Jacob Emden said, "is the only serious attempt ever made to give substance to the idea of Creation out of Nothing."

Herbert Weiner's paraphrase of Scholem's exegesis of Luria deprives the account of some of its more subtle images (especially one that probably appealed to Newman and which fixes the genetic moment at the appearance of a ray of divine light), but for our purposes it is easier to comprehend. Weiner writes:

The protagonists of this drama are God, the cosmos and man. The language used in relating this myth is not that of the usual storyteller; indeed, if one were to at-

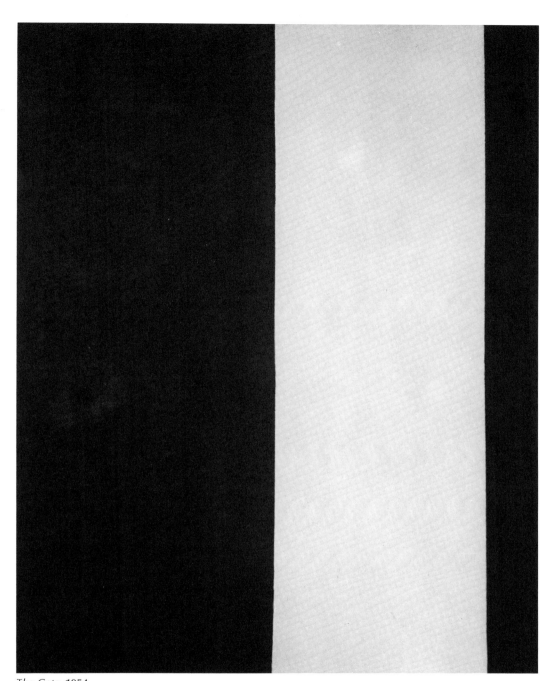

The Gate. 1954.
Oil on canvas, 93 x 75¾ inches.
Stedelijk Museum, Amsterdam

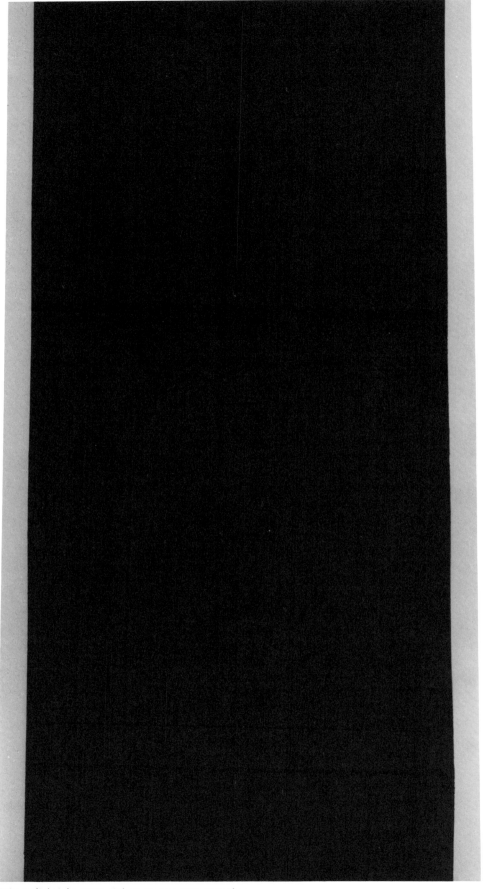

Primordial Light. 1954. Oil on canvas, 96 x 50 inches.
Collection Mr. and Mrs. Eugene M. Schwartz, New York

tempt a visual abstraction of what takes place, one might begin with a blank canvas. But it is not really blank; it is a symbol of a universe coextensive with God. There is only God—nothing else . . .

Scholem notes that "the Divine Being, before *Tsimtsum* took place, contained not only the qualities of love and mercy, but also that of Divine Sternness. . . ."

Then there is a movement. A space opens up, as if within God himself; it is as if God "contracts" himself. The result is an area empty of God. That is the first act of the drama, an act which is called Tsimtsum, that is [literally] concentration or withdrawal.

Scholem notes:

It came to pass within a realm of existence which, to use a Gnostic term, might well be called the sphere of Pleroma, or the "fullness" of divine light. The decisive point is that, according to this doctrine, the first being which emanated from the light was Adam Kadmon, the "primordial man." Adam Kadmon is nothing but a first configuration of the divine light which flows from the essence of the En-Sof (the Hidden God) into the primeval space of the Tsimtsum—not indeed from all sides but, like a beam, in one direction only. He therefore is the first and highest form in which the divinity begins to manifest itself after the Tsimtsum.

I hope it is not necessary to underline the evident relationship of such texts to Newman's images and titles—the beam of light, zips, *Vir Heroicus Sublimis,* fullness, sternness, and so on. To continue with Herbert Weiner's explication:

The next act [after Tsimtsum] involves the re-entry of God into the empty spaces. Obviously, it will not be that kind of re-entry which restores completely the condition that existed before, otherwise the drama will cease. It is only a partial re-entry. A line or charge from the divine is extended into the empty space. This is the second step of the action, called Hitpashut, and it is the opposite of the first act, the breathing out which succeeds the breathing in. Now, something begins to happen in the space which was made by the withdrawal of God.

What actually occurs is a subject for endless speculation on the part of Kabbalists, but its result is a terrible catastrophe. The something which had just begun to be formed is shattered. The outer husks or shell of what has been formed is shattered. The outer husks or shell of what has been formed is broken and the inner light, the creative life-charge of these emerging forms, is scattered in two directions. Some of this light, called holy sparks, returns to its source, that is upwards to the divine root of light, to God. But other sparks are entangled in the shattered husks, which are called klipot, and fall with them. The divine harmony has been broken: "things are not in their place." This is the end of the third action which sets the stage for the entrance of man.

The tension of the action has now been established. The sparks yearn to return to their source and the husks

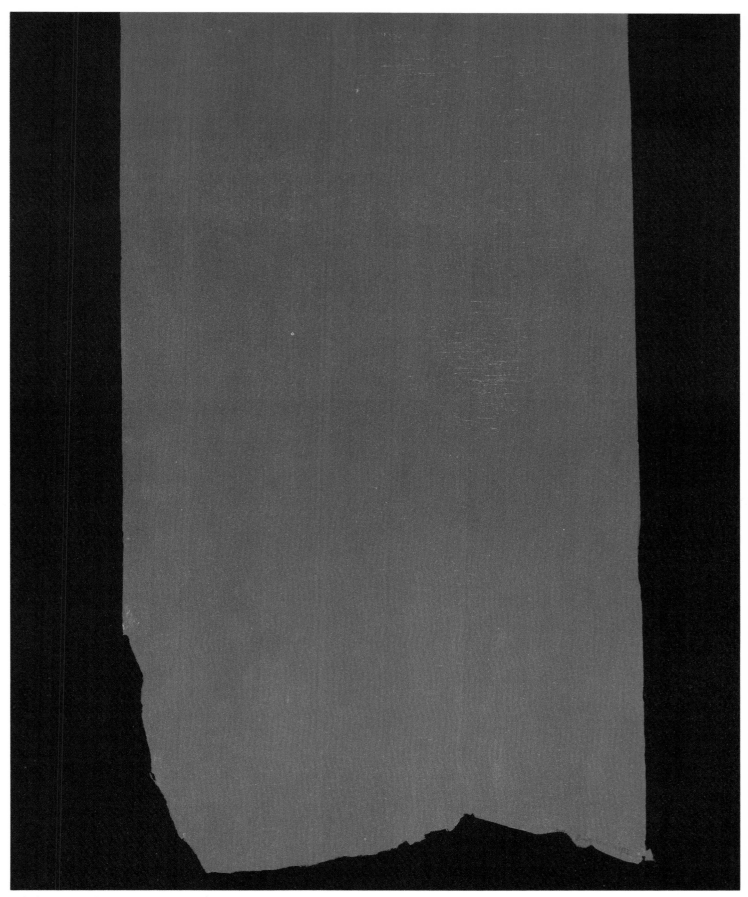

Achilles. 1952. Oil on canvas, 96 x 79 inches.
Collection Annalee Newman, New York

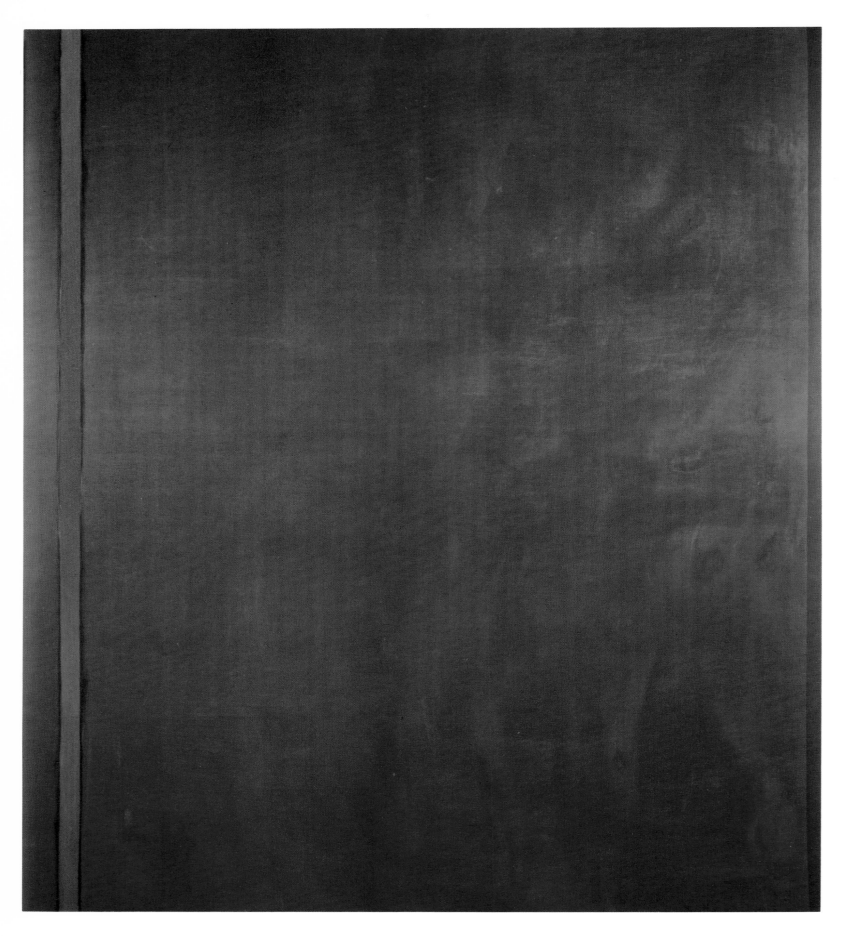

L'Errance. 1953. Oil on canvas, 86 x 77½ inches.
Collection Mr. and Mrs. Robert C. Scull, New York

to their place, both want to be lifted to the roots so that the primordial unity may be re-established. The process of "lifting the sparks" to their roots and effecting a tikkun or "repair" is the task of man, a task in which all the generations can play a role. . . . Through his life and deeds, he can also enable the sparks in the body and soul of man to ascend to its root, which in the mystical cosmology is identified with the image of a primordial man—Adam Kadmon. . . . The holiest of the sparks [by their very power] are farthest away from their originating source, and the man who seeks to redeem them must descend into those depths where the power of darkness rivals the power of light. . . . Terrible and difficult is the struggle which must take place in these depths so far from the divine effulgence . . . and [man] himself may be caught in the abyss.

In the light of Luria's vision, we must look closely at Day before One and Day One, both started by the winter or early spring of 1951. The former is in the full, expansive blue and pale blue of Cathedra, Newman's celestial color; the latter, in deep red with fiery red-orange, Newman's color for earth, Adam—mankind. In Day before One, stripes limit the vertical format and apply a stabilizing pressure from the top and bottom. This probably reminded Newman of the stabilized force of the original "nothing"—of the universe coexistent with God. In Day One, that is the day of Tsimtsum, the mystical pressures contract inward on themselves. In the painting, the bands push in from the sides. The universe, like the painting, is bathed in the fullness of the light of man. When Newman returned to the image again, in 1954, he widened and straightened the stripes on the lateral edges, increasing the mass and thus the weight of the contracting dynamic, and he chose Primordial Light—the radiance of Tsimtsum—as his title.

It is also probable that when Newman revised Adam in 1952 after his second one-man exhibition, he had similar ideas in mind. The wide orange-red stripe added to the left-center is slightly curved, turning to the bottom left as if responding to pressures of contraction and reacting again them. The side bands of color act as contracting forces, metaphors of Tsimtsum.

Nor is it a coincidence, I believe, that Day before One and Day One, the two eleven-foot paintings, were the ones that Newman knew could not be exhibited in his gallery or shown to the public. They were done out of the necessities of his pictorial experiences—the strong Kunstwollen, "will to art," that marked his life. But that they would be kept private corresponds to the privacy which historically protects Luriac and other Kabbalist mysteries, like the high walls around a secret arbor.

The Kabbalah preserves the memories of the prophet Elijah who saw what was "there—when I stood before the Lord." It records visions of the "upper whiteness," which Weiner defines as "that primal openness which contracts as soon as script or sound is imposed upon it,"

and its initiates meditate on how, when Moses descended from Sinai, "all the people saw the voice."[15] Thus it is possible to consider paintings such as The Voice and The Name II, in the white surfaces of which we are urged to watch an image emerge from nothing, as Tikkun—"man's highest tasks"—which attempt to restore the universe to harmony and unity, a labor at which each man must work with what the Kabbalah calls "oneness of soul"—with his unique abilities. The Blessed Luria's image of sparks can add to our understanding of Prometheus Bound, named after the Titan who stole sparks from Zeus, brought them to earth and taught mankind the useful arts. For in this picture, the level of radiance lies deep below a heavy, wall-like mass of black, just as the holiest sparks of God's light must be sought in the deepest levels where Satan dominates.

To make a Tikkun for such fires, man must undergo suffering, mental and physical pain. This was a path that largely was chosen for Newman, but which he also chose—with gaiety and courage.

[15] "To hear with eyes belongs to love's fine wit," wrote Shakespeare.

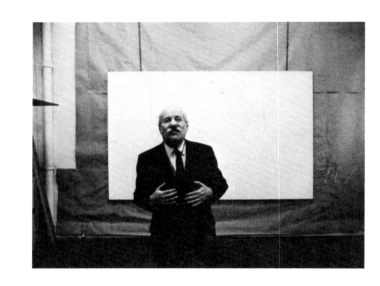

THE STATIONS OF THE CROSS

A hundred cares, a tithe of troubles and is there one who understands me? One in a thousand of years of the nights? All me life I have been lived among them but now they are becoming lothed to me. And I am lothing their little warm tricks. And lothing their mean cosy turns. And all the greedy gushes out through their small souls. And all the lazy leaks down over their brash bodies. How small it's all! And me letting on to meself always. And lilting all the time....
— James Joyce, *Finnegans Wake*

The whole New York underground art world, just about, came to Newman's opening at the Betty Parsons Gallery, January 23, 1950. That evening there was a party for him at the Artists' Club on Eighth Street; the main decoration consisted of about a dozen card-table tops put against the walls with stripes made out of old feathers tied down their centers. It was a lighthearted, mischievous reconstruction of the show. When Newman saw the effect his pictures had made on his friends, tears came to his eyes. Did he realize they were poking fun at him? Or was he flattered, as he told the artists that evening, to see that his particular insignia had been recognized?

Years later, Newman implied that both interpretations are true. An artist who was then considered one of the spokesmen for the New York School came up to him at the opening and said: "I thought you were one of us, but I see you're a threat to us all." He overheard two artists' wives chatting. "What will Barney do next year?" said one. "Easy," was the answer, "he'll just hang the pictures sideways."

Aline Louchheim (now Saarinen), who had recently left *Art News* to write criticism for the *New York Times,* was stunned at the preview by the colors and scale of the pictures; she interviewed Newman and, she says, "I went back to the typewriter and wrote it as I think he told it." It was the only favorable review he would receive for years.

The whole of the New York art world, just about, stayed away from the opening of Newman's second one-man exhibition at the Betty Parsons Gallery, April 23, 1951.

It is easy to account for the official, public hostility to Newman's work. The late 1940s and early 1950s were a period of ugly reaction in the arts, made even more vicious than usual by a mask of *bien-pensant* liberalism.

Part of it came as a backwash from the hyperpatriotism of the war. Such spokesmen as the poet Archibald Mac-Leish, the publisher Henry Luce, the director of the Metropolitan Museum Francis Henry Taylor, and many others attacked modern art in all its forms as irrelevant to Great Human Needs and International Causes. Such men were not illiterate philistines, but rather smug intellectuals who had looked at Picasso, Matisse, de Chirico and even Mondrian, and who had "seen through" them to their "arid" inner meanings, and now they called for a renewal of realism, humanism and even allegorical and religious painting. They attacked the new American artists as pranksters trying to fool the public, as a self-promoting clique, as delinquents, and they phrased their attacks with all the well-used epithets that savage misunderstanding and fearfulness can evoke. It was a deplorable official cultural milieu. Poets and essayists— such as William Carlos Williams, Robert Lowell and Randall Jarrell, to name only the best—either looked to Europe for signs of a new modernism, or they ignored art completely, or they viewed it with a backwoodsman's suspicion. Not since the early days of the Impressionists, I believe, had artists been faced with such meanness and vicious disdain. The curtain of official hostility surrounding the art world seems to have had an effect similar to that on the Impressionists. It drew the artists closer together, created a community where art was considered all-important, where it could be talked about endlessly, seen in studios and hunted down in the corners of galleries and museums. Even a café life was created by the artists, and they supported their own friends in other mediums—dancers, composers, poets, philosophers, many of whom later became famous: Merce Cunningham, John Cage, Paul Goodman, Buckminster Fuller.

You had the feeling that there was an "inside" and an "outside." Outside, Truman would attack all modern art in the person of Kuniyoshi (of all mild bêtes noires); Eisenhower would equate art with painting by the numbers; a congressman would spend hours in the Well of the House reciting lists of artists and critics who had worked for "subversive" organizations; the Institute of Modern Art in Boston changed its name to the Institute of Contemporary Art because, its director said in a manifesto, the adjective "modern" represented a degenerate tendency; *Life* magazine published screeching editorials denouncing Dubuffet. It was rather as if, in losing the

war, cultural hegemony had been won by Mussolini—if not Hitler. That was the noise outside. Inside, as Harold Rosenberg wrote later, it was like living in a stockade. Everyone was united against a common enemy. Each individual's triumph helped a common cause.

Newman's favorable review in the *New York Times* was a freak thing—a bit of welcome sympathy from an unexpected quarter. But his hostile reception among the artists—inside the stockade—was even more unexpected. It hurt him deeply. He was, after all, very much a part of the artists' community in which the mutual aid of encouragement and congratulations was an unspoken rule.

It is instructive to examine some of the reasons for this reaction. First of all, there is the paradox of Newman as the integrated, self-confident citizen in an alien's milieu. He was, par excellence, the native New Yorker, connoisseur of cast-iron façades and of out-of-the-way restaurants, bars and little theaters; he was the cosmopolitan American who felt at home in any part of his country; he had warm deep affection for his family, a perfect marriage; he was as proud of his Jewish background as the du Ponts are of the French or the Kennedys of the Irish. The New York artists' world, however, in the late 1940s and early 1950s, had a peculiar coloration of exile and losses. The day of the American-American artists—pioneer types such as Edward Hopper, Stuart Davis, John Marin, Thomas Hart Benton; aristocrats such as George L. K. Morris and A. E. Gallatin—was passing. Most of the new leaders were "displaced persons"—de Kooning from Holland, Gorky from Armenian Russia, Pollock, Still, Rothko and Guston from the West, and Franz Kline and Baziotes from the Pennsylvania coal country. The city was strange to them and they were strangers in it—Pollock often talked about how lost and lonely he felt when he hit town, and how he wanted to catch the first freight and travel back to the plains. These artists loved the city with the passion of strangers. There was a hint of romance about them and of deep alienation from their roots. They were like princes in disguise, scarred by combats in distant lands, or like Indians who swoop in from the desert to pillage the water hole. Among these men, Newman's frank, open nature, the ease with which he moved through his surroundings and the pleasure he took from them, his very evenness, made him seem odd. There must be something wrong with him—he could not be an artist.

Furthermore, as Newman said, "I paid a severe price for not being on the [government arts] project with the other guys; in their eyes I wasn't a painter; I didn't have the label."

Indeed, much of the substructure of the New York art community was based on friendships made while the artists worked together on the various mural and easel projects of the 1930s. Because Newman had been conspicuously absent from the scene, and because it was known that he had made his living as a teacher, it was

assumed that he was some sort of an intellectual, a theoretician and, as far as painting was concerned, an upstart.

Newman himself, in his effort to encourage the development of an art world in New York, gave a certain credence to this image. In various writings and statements, he appeared as a spokesman, polemicist and philosopher for certain kinds of abstract painting, and from the middle 1940s, he had supported the work of Gottlieb, Rothko, Still, Pollock and a few others. From this it was deduced that he was an ideologue or a propagandist—brilliant, surely, but noncreative.

This at least was the general impression held among many of the "downtown" artists, the ones who might be called "bohemians," as against the uptown "intellectuals" (I suggest these labels for convenience's sake only—some of the "bohemians" were ultraintellectual and some of the "intellectuals" thoroughly happy as "bohemians"). Among the former were artists such as Gorky, de Kooning, Pollock, Kline, David Smith. They had gone through the disciplines of art schools and academies, not to universities. Their social life was centered around Greenwich Village. They wore workmen's clothes (the traditional European artist's uniform), talked about art and life in colorfully Delphic terms; they enjoyed the feeling of independence that comes from supporting yourself with odd jobs plus a little private teaching, from informal domestic arrangements and living in studio-lofts which they remodeled with the patience and tact of shipwrights. Among the "intellectuals" were Newman, Rothko, Still, Motherwell, Reinhardt and, by temperament if not with a college diploma, Gottlieb. Their social life gravitated uptown. They lived in apartments. When talking and writing about art, their language was clearer, more analytical. Many of them, and their wives, had taught in established schools.

The "bohemians" tended to show at the Egan Gallery; the "intellectuals" with Betty Parsons; Sam Kootz's gallery was in between. It was a vague, indistinct separation, but nonetheless a real one.

Although the "bohemians" knew Newman and liked him as a friend, enjoying his warm personality, his wit, and his enthusiasm for art, they did not understand him as well as the "intellectuals" and had no particular grasp of his intentions. Newman had exhibited in group shows at the Betty Parsons Gallery in 1946, 1947, 1948 and 1949, but the works were relatively modest and, to a casual observer, fitted in more or less neatly with the mythographic abstract style of the period. When he suddenly burst forth with his 1950 exhibition, followed by the even larger and more astounding 1951 pictures, the "bohemians" decided that he was merely employing shock tactics—still acting as the spokesman. After all, it was well known that he had helped to build up the Betty Parsons Gallery (organizing shows of primitive art there, urging Mrs. Parsons to take on such artists as Hofmann and Pol-

lock) and had introduced such artists as de Kooning to the pages of *Tiger's Eye* magazine. His paintings seemed to be visual diagrams, didactic attacks on establishment esthetics, proddings to his fellow artists to be more daring and more avant garde—as Picabia and Duchamp had prodded the Dadas in the World War I generation. For the emerging Abstract Expressionists, however, art had a high intellectual seriousness. It was no longer an anti-middle-class game, as it had been for the antiart masters. Art was the grail, and the artist, a tortured hero attempting the impossible task of reaching it. Newman used tapes to execute his zips (as Mondrian had done); this seemed an overt connection with the masking devices of commercial art. Newman left tapes exposed (in *One-ment I* and *Concord*) as if to mock the serious nature of modern techniques. Such, in brief and oversimplified form, was the initial reaction to Newman's exhibitions by his artist-friends who knew him least. Later, as they became more familiar with his work, they recognized him as an artist, but some still misinterpreted his work by attributing an ideological point of view to it. They felt that Newman was a doctrinaire abstractionist, a man who elevated the picture plane and the straight line into fanatical dogma (as the Neo-Plastic artists had done a generation before). Thus while such men as de Kooning and Kline were trying to open up new possibilities—to enlarge the expressivity and content of modern art—Newman, on the contrary, seemed to be trying to reinstate old formalist taboos. This opinion was reinforced by inferences from his writings and statements in which he seemed to be attempting to bring back to life the old concept of avant-garde art. Many of the first-generation Abstract Expressionists held as a fundamental tenet of their revolution against the Paris esthetic of the 1920s and 1930s that the whole idea of a vanguard in painting, and its corollaries of "progressive" movements and "isms," had to be discarded as irrelevant. They felt that no styles were "dead," that no approaches were invalid, that nothing should be excluded from art except the very idea of exclusivity. Pollock, de Kooning and Hofmann, for example, moved freely between abstract and figural shapes and resented any doctrinaire criticism that might tend to hamper this liberty. Newman, it seemed, had taken such a stance. But it was a snap judgment, proving mainly that they had neither read him nor looked at his pictures carefully. Of course Newman's work was not easy to see, and it should be emphasized that his hostile reception among the downtown artists and their friends (including this writer) ultimately was based on an impersonal esthetic argument. That Newman's friends among the "intellectuals" were equally hostile to his pictures is more difficult to understand.

In the early 1950s, he was attacked from most—then, from all—quarters, and there was no defending thunder from Motherwell or Still, no open letters circulated by Reinhardt or Rothko. In those days, when an artist was misunderstood, his friends usually gathered around to applaud and support him and explain him to other artists. (Philip Pavia, sculptor and leading member of the Artists' Club, used to defend Newman, saying in cryptic tones, "Barney found a line to cut color," and Pollock, after 1951, also claimed that Newman was a great and misunderstood artist; but usually both were dismissed on the grounds that they were indulging in their favorite game of teasing de Kooning.) On the whole, silence surrounded Newman's work. And mockery.

In the 1950s, there was an anecdote about Newman that became an anthology piece: Franz Kline and Elaine de Kooning were sitting at the Cedar Bar when a collector Franz knew came up to them in a state of fury. He had just come from Newman's first one-man show. "How simple can an artist be and get away with it?" he sputtered. "There was nothing, absolutely nothing there!"

"Nothing?" asked Franz, beaming. "How many canvases were in the show?"

"Oh, maybe ten or twelve—but all exactly the same—just one stripe down the center, that's all!"

"All the same size?" Franz asked.

"Well, no; there were different sizes; you know, from about three to seven feet."

"Oh, three to seven feet, I see; and all the same color?" Franz went on.

"No, different colors, you know; red and yellow and green . . . but each picture painted one flat color—you know, like a house painter would do it, and then this stripe down the center."

"All the stripes the same color?"

"No."

"Were they the same width?"

The man began to think a little. "Let's see. No. I guess not. Some were maybe an inch wide and some maybe four inches, and some in between."

"And all upright pictures?"

"Oh, no; there were some horizontals."

"With vertical stripes?"

"Uh, no, I think there were some horizontal stripes, maybe."

"And were the stripes darker or lighter than the background?"

"Well, I guess they were darker, but there was one white stripe, or maybe more . . ."

"Was the stripe painted on top of the background color or was the background color painted around the stripe?"

The man began to get a bit uneasy. "I'm not sure," he said, "I think it might have been done either way, or both ways maybe . . ."

"Well, I don't know," said Franz. "It all sounds damned complicated to me."

The story made people laugh at Kline's good nature, but also at the ingeniousness with which he made Something out of Nothing to put in his place an intruder who

had no right to call anything Nothing—even if it was.

History has a sense of humor, too. Only fourteen years later, in 1964, Don Judd, then emerging as an important sculptor in the Minimal style, wrote an article on Newman (published in *Studio International* in 1970) in which he describes among other works *Shining Forth (To George)*:

It's nine and a half feet high and fourteen and a half long. The rectangle is unprimed cotton canvas except for two stripes and the edges of a third. Slightly to the left of the centre there is a vertical black stripe three inches wide. All of the stripes run to the upper and lower edges. Slightly less than a foot in from the left edge there is a black stripe an inch wide. This hasn't been painted directly and evenly like the central stripe, but has been laid in between two stripes of masking tape. The paint has run under the tape some, making the stripe a little rough. A foot in from the right edge there is another stripe an inch wide, but this is one of reserved canvas, made by scraping black paint across a strip of masking tape and then removing it. There isn't much paint on either side of the white stripe; the two edges are sharp just against the stripe and break into sharp palette knife marks just away from it. Some of the marks have been lightly brushed. The three stripes are fairly sharp but none are perfectly even and straight. It's a complex painting.[1]

It is appropriate that both the jibe of 1951 and the praise of 1964 make a point of the complexity underlying Newman's image and the difficulty of finding its source.

It is this real difficulty, I believe, that so dramatically silenced Newman's artist friends. There is no doubt that he expected them to come to his help, to defend by explaining his work. They probably could not.

The impact of symmetry, that tough, uncompromising, head-on image, seemed to baffle all observers. American painters had been working at breaking up composition, but essentially their procedure was to smash the Cubists' armature, flatten it, pull it apart to expose voids, or cover it over with a rain of paint. The act of breaking up composition, and the intellectual and ethical pressures that informed it, remained on the picture as a kind of testimony to a newly gained freedom. There was plenty of evidence of the struggle: spatters of paint became signs of anguish; fragmentary shapes and knots of line were strewn across a picture plane that often looked a bit like a battlefield. Newman, in a gesture, did away with the whole problem. And who was Newman—a Johnny-come-lately, a former teacher, writer, polemicist, painter of gentle mythographies—to sweep the issue away in one lordly (arrogant?) gesture? In his pictures, the "background" presses forward to the surface, and the surface itself is materialized into the actuality of paint—coats of paint, which do not suggest thickness or wall-like stability, but an even, consistent layer of color. Matisse had

made a similar move in such 1910–1911 paintings as *Music* and *The Red Studio*, although Newman never saw the former and viewed the latter only in 1949, when it was acquired by The Museum of Modern Art (the way Matisse pushed the red-brown background walls of the studio in front of the objects in the room might well have bolstered decisions Newman had made in *Onement I* the year before). There is a "touch" to Newman's paint surface, but it does not have the hypersensitivity of Mondrian's patted whites or the latent calligraphy in Matisse's evenly stroked areas of saturated color. Newman's is a uniform handling which gets his effect of a ground of color through careful, steady brushing. It is obviously man-made; autograph Newman. He never went back over his paintings to mask a touch or to pretend an impersonalized or manufactured look. The elegance of the method comes from its radical efficiency. The zip is treated in a similar manner: it is tidy where it is supposed to cut clean down the picture, ragged where Newman decided to give his mark a more emphatic plastic nature. There is no fuss or struggle, no symptoms of Existentialist doubt: it is art without anguish. The whole underlying development of Newman's search is given a shape and a finality that seems self-contained and seamless.

This is how the pictures looked, and why they seemed so shocking to Newman's uptown artist-friends who had followed his struggles and who thought they understood his exalted aims. The second one-man show was even more unnerving, as Newman carried his pictures to the radical extremes of the white-on-white paintings, the eighteen-foot stretch of *Vir Heroicus Sublimis,* and, in the center of the gallery, the gaunt plaster verticals of *Here I,* two poles stuck in plaster mud, the white substance running down the sides of a milk-bottle crate. It was evident he was serious, but was he intent on creating an image or on destroying the assumptions of others? Those who could not understand the work read it as mockery and aggression.

Some of Newman's friends, however, did begin to see what he was getting at. It is no coincidence, I believe, that Rothko's images quickly became larger and contained fewer and fewer forms after his exposure to Newman's paintings. Indeed, Rothko's horizontal rectangular shapes divided by horizontal passages of contrasting color are very close to Newman's vertical format placed on its side. Reinhardt's reduction of shapes to simple monochrome squares also was clued by Newman, and Still's mighty black wall of a painting, which dominated his room at The Museum of Modern Art's "Fifteen Americans" show in 1952, seems a response to the equally majestic assertion of Newman's *Cathedra.* There was, however, still no general acceptance of Newman's paintings inside the stockade, and his omission from the "Fifteen Americans" hurt him deeply; he felt he had been excluded with the consent if not the advice of his friends: he had been betrayed.

[1] Donald Judd, "Barnett Newman," *Studio International* (London) vol. 179 (February 1970), p. 67.

As we have noted, he removed his paintings from the gallery in 1951, although he remained good friends with Betty Parsons. In 1952, he did the three pictures with Greek titles and loosened up his technique to approach the Abstract Expressionist gestures of de Kooning and Pollock, although he kept well within the limits of his own vision. In 1953 and 1954, probably pursuing ideas he had set off in *Cathedra*, he concentrated on blue pictures, the color becoming lighter and lighter as it contrasted with deep red-browns and black, culminating in the eighteen-foot-wide *Uriel* of 1955. He still worked with "secret symmetries," disguising the center division of *The Gate* by setting up divisions in tenths, moving across the canvas (from right to left) as $\frac{1}{10}$-$\frac{4}{10}$-$\frac{5}{10}$ in respectively, black, pale blue and deep red-brown verticals. The halfway point seems to shift optically between the blue and the brown as the dark colors pull at each other across the central blue, making the image seem to read in thirds or sixths. In *The Word II*, the central axis is disguised by a parallel zip and by breaking up one half of the image into four elements which make the single element on the left seem larger than one-half. Here again, quarters and halves tend to read as thirds. *Uriel* also has its symmetry, but an asymmetrical force is in command—with a wide sweeping sleek milky blue meeting an eight-foot-high trisection of black, blue and deep red (like one of the vertical paintings leading up to *The Wild*), and ending in a feather-edged deep red (the blue showing through at the passage). *Uriel* is the only work Newman painted in 1955. In a way it is a résumé of the previous four years' experience.

Newman was more and more disheartened with his rejection by the art world. In 1955, he had his fiftieth birthday. He felt he could no longer let Annalee support him; he would have to make money on his own. Selling pictures was impossible. In a blithe bittersweet mood, he decided to beat the racetrack. He evolved a system for betting on horses, studying the morning forms and plotting numbers on a graph (he even found that a class was offered in this specialty at the Great Northern Hotel). The system worked for a while; but after a few months, it let him down badly, perhaps because he loved horseracing. He tried minor speculation—loans and counterloans. But his situation only grew worse; 1955 and 1956, Newman said, were "the blackest years." When they were first married, he had told Annalee that he had to be an artist or he could not live; now he told her that he was going to get a job as a fitter with a tailor; he had a fantasy of "chalking up" John Hay Whitney—making a drawing on the body of the president of The Museum of Modern Art, an institution that was supposed to help living artists, but which had helped to force him out of the art world. Annalee firmly vetoed the project and canceled his appointment at the shop.

Ten years later, Newman learned that his friend Jasper Johns had bought the building where the pawn shop had

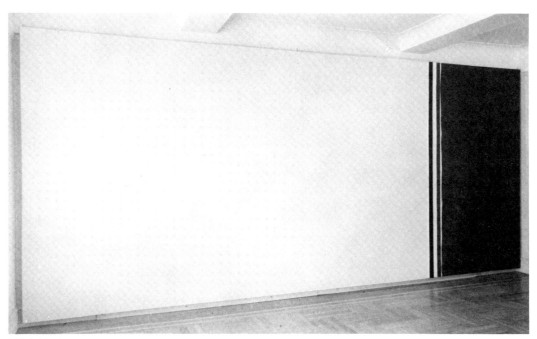

Uriel. 1955.
Oil on canvas, 96 inches x 18 feet.
Collection Alan Power, London

Illustrations of *The Word II,* page 82, and *The Gate,* page 83.

been where he and Annalee used to go with their wrist-watches and binoculars, and that Johns had made it into a studio. Newman said laughing: "I heard it was for sale; I thought I might buy it, take down the sign that said 'PROVIDENT LOANS' and put up one reading 'BARNETT NEWMAN, REDEEMER.'"

If the 1930s and early 1940s were "limbo" for him, 1955 through 1960 was his inferno. The Abstract Expressionists had become well known to a relatively wide public; with color reproductions in mass magazines, their works the subject of serious debate among critics and historians, they were even beginning to sell. Newman felt more than ever that he was locked out—and by the men he had helped advance. Pollock, the artist to whom he felt closest, died in 1956. His other close friend, Tony Smith, was frequently away. The Newmans were evicted from their apartment on Nineteenth Street (it was taken over by a synagogue to Newman's indignation, and he considered suing the temple on the grounds that its rights of eminent domain as a religious institution were void because it was, in fact, mainly devoted to bingo), and they moved across the bridge to Brooklyn Heights, a few minutes from his studio on Front Street (next to Manhattan's Fulton Fish Market). But, as everyone knows, the East River separates you from the center of things as decisively as the Rocky Mountains.

He felt more and more isolated, left out—a dark Dostoevsky cloud from *The Insulted and the Injured* seemed to descend upon him.

This, more or less, is how he later told the story of those years, never directly, but in hints and fragments. To put all the blame for those "blackest years" on forces outside the artist suggests a curious anomaly. Newman was, after all, the totally convinced, independent, highly integrated man; he was a fighter, stood up for his rights, believed in himself as an artist so completely that he did not shrink from drawing the most radical conclusion from his art. Nor did he bother to explain his motives and goals, except in general, elusive, usually negative terms (it's not this, it's not that). He was the man of *semper idem,* of self-assertion against circumstances. Why then should he suddenly have cared so much about what other people thought and how other artists and outside institutions treated him?

Furthermore, things had been looking up a bit. Clement Greenberg included him prominently in an essay surveying "American-Type Painting," which appeared in *Partisan Review* in the spring of 1955. In 1952, Greenberg had noted that the general animosity aroused by Newman's one-man shows probably indicated that the artist was up to something worthwhile; he called him a "major" painter and suggested that Newman's use of color merited serious attention. In 1955, he used Newman to help demonstrate his developing thesis that "modernist" painting—like all modernist forms—was under the irresistible pressure of history to purify its medium, which

for Greenberg meant that it necessarily was heading toward a pure color experience, uncontaminated by drawing, composition, surface textures (the "painterly") or anything else that might distract from the sensation of chroma. This must have been gratifying to Newman in terms of a positive reception, instead of the usual jibes and dismissals, although he objected strongly to Greenberg's formalist interpretation and to his reduction of art to a pawn in the dialectical chess of historical necessities. He also objected to Greenberg's insistence on yoking him to Rothko and Still—"as if we were in bed together"—and to the inference that he, Newman, had been influenced by Still's first exhibition, and finally to Greenberg's description of his paintings as if they were Rothko's, with the paint floated and stained into the canvas so that the colors were an apparent part of the weave itself. He wrote Greenberg a polite letter—overcoming an urge to write a polemical one for publication in the magazine—pointing out, among other things, that: (1) he did not invent the phrase "buckeye painting," which Greenberg had attributed to him, but rather, it was a time-honored epithet for, among other things, restaurant murals, as he had once tried to explain to the critic; (2) he had never applied the phrase "buckeye" to Still's work: that connection was Greenberg's own; (3) he could not have been influenced by Still's paintings, as the organic development of his own pictures from 1946 to 1948 demonstrates; and, finally, (4) that he had never "dyed" color on canvas in his life and never would. Nevertheless, Newman must have welcomed Greenberg's enthusiasm and especially his acceptance of the fact that Newman "belonged" at the forefront of the new American painting.

In 1956, a young New York collector named Ben Heller met Newman (through Pollock); he studied carefully—almost worshipfully—the paintings in the studio, and in 1957, he bought two of them, *Adam* (later sold to The Tate Gallery, London) and *Queen of the Night I.*[2]

These two events may have been slim pickings, compared with the acclaim that was greeting Rothko and de Kooning, Gottlieb and Kline, in the mid-1950s, but compared to Newman's situation in 1954, things seemed to be improving.

Therefore, I believe, it is possible to conclude that the "blackest years" were almost unbearable to Newman not only because of the weight of outside hostility and rejection, but also because he had come to a serious problem in his painting.

Uriel, as has been suggested, is a culminating picture.

[2] Ben Heller was the first serious collector of Newman's paintings, although the artist had sold pictures previously to Mrs. Burton G. Tremaine (in 1947), to Ruth Stephan, then coeditor of *Tiger's Eye* (in 1949), to Frances Cohen (in 1950) and Tony Smith—the last two both close friends of the Newmans. Heller not only bought paintings, but interested others in Newman's work. It was he who took Arnold Rudlinger of the Basel Kunstmuseum and later Alfred H. Barr, Jr., of The Museum of Modern Art to the artist's studio in 1958; both visits eventually resulted in sales.

Its theme is developed in *The Gate, The Word II, Primordial Light, White Fire I, Right Here,* a group of paintings in which blues become paler and paler, but more and more intense as they contrast with black and deep red-browns. The titles, as has been noted, refer to the act of creation (*Primordial Light*—the aspect of the world before Genesis; *White Fire*—the aspect of the Torah before Genesis) and to the mystical ascent of man to a place before the Throne (*The Gate* through which he must pass; *Right Here,* the place where he stands, *Makom*). *Uriel* recapitulates these themes on a grand, monumental scale, and it also, in a sense, recapitulates Newman's two other epic paintings, *Vir Heroicus Sublimis* and *Cathedra.* The former refers to man who, in working to reestablish the unity and harmony of a universe coexistent with God, acts as God in the here and now and aids in the coming of the ultimate reunion. *Cathedra,* the radiant Throne, is man's ultimate vision. In *Uriel,* the two elements are conjoined. The shining pale blue, materialized in layer after layer of paint, stands next to the mud-blood color, which is more thinly painted, allowing the white ground to shine through. The metaphysical presence is opaque; the physical one is translucent. One is eternal, the other transient. One is man's vision—solid, real. The other, his identity—marked by doubts and equivocations. The blue is separated by a black zip from the brown—the last gate? the last guardian? But it pushes through, defining a brown zip (as the light of *Tsimtsum* discovered primordial man), and finally the two colors meet at a soft, lyrical edge. The pale blue dominates, but does not overwhelm, the red-brown (as it would have had Newman kept to the deeper blue of *Cathedra*). This is a vision of the ultimate meeting, the final reconciliation, the first day of the end of the world. Then what happens? What comes next? What is the color of the Day after the Last Day?

For Newman, I believe, his personal dilemma was acutely paralleled by a pictorial one. His next moves, in terms of recombination and variation, must have seemed too easy. His impetus toward a breakthrough had stopped. He had, in de Kooning's phrase, "painted himself out of the picture."

He had loved moving from the studio into the life of the art world and back again, getting recharged from each experience. Now both sides of life had begun to drain his energy.

He painted no pictures in 1956 or in 1957. On November 30, 1957, he went to a party at the house of his friends Jeanne Reynal and Thomas Sills. He left the room and did not come back; Sills noticed his absence, went upstairs and found Newman sitting down, in pain. An ambulance took him to the hospital. He had had a heart attack.

A heart attack, Newman said, "is like instant psychoanalysis." After six weeks in the hospital, he went back to his apartment in Brooklyn Heights. He took care of himself, went for walks along the waterfront. Later, Annalee Newman arranged for the basketball team from the high

Outcry. 1958.
Oil on canvas, 82 x 6 inches.
Collection Annalee Newman, New York

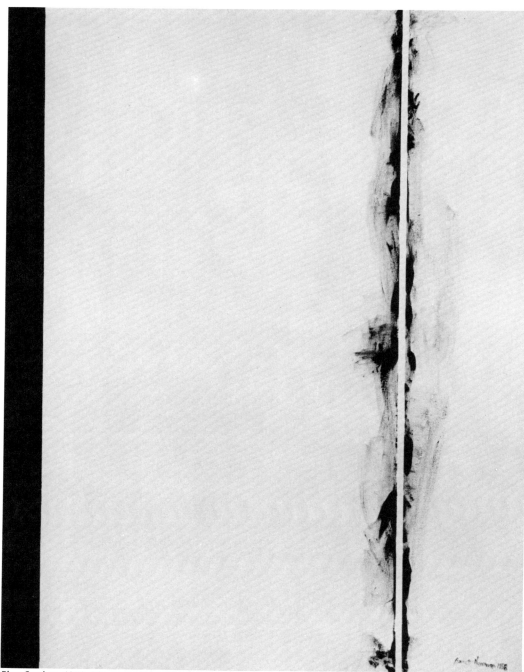

First Station. 1958. Magna on raw, unsized canvas

The Stations of the Cross:
Lema Sabachthani.
All paintings 78 x 60 inches.
Estate of the artist

school where she was teaching to carry Newman up the three flights of stairs to his Front Street studio. It was a dramatic sight, and not without an air of high triumph—the hero's return—as well as of low comedy, which Newman enjoyed enormously.

His first painting was done at the apartment, a narrow, vertical canvas related to the pictures which had led him to *The Wild.* It is a heavily smeared green and dark blue form—the action of the paint is emphatic, although the pigment itself is thin, and the gesture is rigidly contained in the tight, viselike format. He called it *Outcry.* A shout of despair? A call for help? A protest? The title would be explained by his next works.

Around February 1958, he picked out two canvases, stretched to six and one-half by five feet; and without even bothering to prepare the cotton duck with glue, started to work. He chose Magna paint—much easier to use in an apartment because it dries so fast—and restricted himself to black. Black is what an artist uses, he said, when he is trying to break into something new, when he is clearing the decks for experiment, when he wants to find a new way to his image and a way out of the restrictions his old paintings have imposed. *Uriel,* as we have seen, was such an impasse. Using only black, then, he began to divide his canvas into a new set of relationships.

He had generally relied on halves, quarters, eighths and the like, as these are the intervals which can be extrapolated most simply and elegantly from the basic concept of symmetry. He had trisected some pictures, such as *The Way,* but even here the sections were ¼ -½ -¼ . Now, perhaps using a reversal of *The Gate* as a hint to the image, and the trisection of *The Way* as a clue for the system, he began to work with thirds and with the duodecimal procedure which thirds suggest. He had arrived at a very human sort of calculus, not unlike the twelve-tone scale in music, which allows the greatest freedom to the artist but still structures his work in ways that increase the pressure on the imagination while increasing the number of options open to it. The first picture was laid out in divisions that placed two-thirds of the canvas, largely blank, in the left-center area of the image; one-twelfth painted black, to the left; one-fourth to the right, also largely blank white canvas.[3] The two white areas are separated by a negative zip, that is, a three-quarter-inch band of masking tape applied to the surface, over which Newman painted in rough slashes and feathery dry-brushings, and then removed the tape, leaving a white line of reserved canvas. Thus, you have a sharp black band at the left leading to an expanse of white, cut by the presence of a white vertical defined by blacks, which seem to dance from its edges. In the second painting,

[3] The exact measurements of the divisions in the two 1958 paintings are 4⅝ inches (left black area), 40¹⁵⁄₁₆ inches (central blank area), ¾ inch (stripe), 14¾₆ inches (right blank area). Both are 60½ inches wide. The first picture is 70⅛ inches high, the second 70⅜₆ inches. I wish to thank Mr. Orrin Riley, conservator at The Solomon R. Guggenheim Museum, New York, for taking these measurements.

the format is the same; the black band remains, like a sentinel, at the left. But now the white zip is outlined by sharp black lines which in turn rest against sharply edged columns of feathery black (which acts as gray)—a narrow wash of black to the left of the zip, a wider one to the right. The first painting has a lyrical, sensual quality. The white zip seems to gleam within the scumbles and smears that embody it; it seems to be a whiter white than the rest of the canvas, a more tightly focused light. The second painting seems to organize the effect; controls seem to have been established (although in fact the duo-decimal substructure is more clearly articulated in the first image; in the second one, the gray that demarks the white zip shifts in a kind of trompe l'œil emphatically to the right, masking the location of the vertical).[4]

Why did he paint two works, one right after the other, same size, same format, same black and white medium, and in such a hurry that he did not wait to prepare the canvas (untreated duck is as fragile as spun glass; any fingermark embeds dirt so deeply in the weave that it takes a professional conservator to remove it)? He had done pictures using the same dimensions before—*Vir Heroicus Sublimis, Cathedra, Uriel,* for example, and *Adam* and *Achilles* and *Ulysses* and *Prometheus Bound*—but this was usually a sign that the image would drastically shift. In *The Voice* and *The Name II,* identical dimensions are used, but widths and heights are swapped. He also had used similar images, but usually in drastically changed scale, color and dimensions.

I suggest the answer lies in Newman's understanding that, using his new triadic system, the only way to re-establish a secret symmetry and with it the frontal, big-impact, epic quality to which he felt his art must aspire, would be to work in some sort of series. The separate pictures, repeating and varying his shapes, establish a larger unity and a heightened scale. They are secretly symmetrical in the sense that they echo each other in time—the time taken to see one, then the other, then both, then to recognize that one repeats the other. With only two paintings, however, the division of thirds breaks up the larger image by insistently implying a narrative sequence, moving from left to right, even though the right-hand element of the pair (the white on gray zip in the second painting) was given a firm anchoring or braking shape. Newman studied both paintings for months and decided that he would have to make at least two more.

He still had to be careful about working or playing too hard, however; furthermore, the remainder of 1958 was

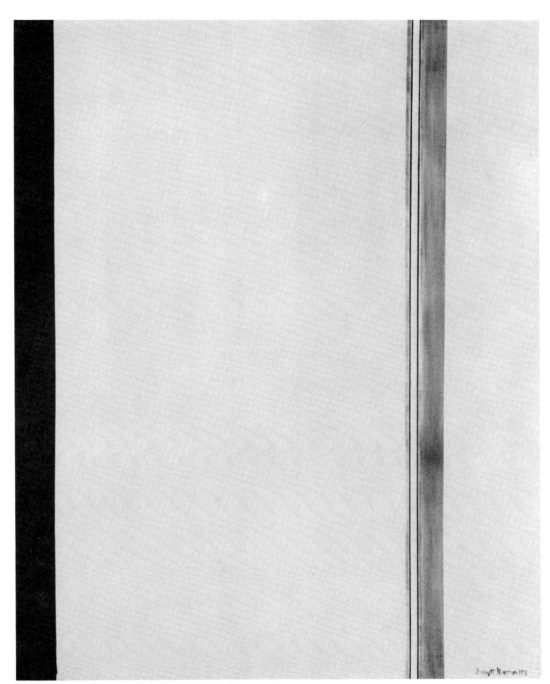

Second Station. 1958. Magna on raw, unsized canvas

[4] The general "feel" of the structure of these two works reminds one of the 1945 untitled painting with a tree trunk at the left and a "flower" or "sword" floated in the space to the right. It was Newman's first return to oils of ambitious scale after the long silence of the early and mid-1940s—at least the first one with which he was satisfied. When he broke silence again, after *Outcry,* in 1958, he perhaps consciously, perhaps unconsciously, remembered the liberating vision of thirteen years before.

Untitled. 1960.
Ink on paper, 14 x 10 inches.
Estate of the artist

Untitled. 1960.
Ink on paper, 14 x 10 inches.
Estate of the artist

Untitled. 1960.
Ink on paper, 12 x 9 inches.
Estate of the artist

filled with distractions—probably very welcome ones, but they kept him from painting. (Or maybe he still had not decided how to break out of the impasse; as I have mentioned, for all his daring and radical ideas, Newman's approach was cautious, modest, slow; and, as Annalee has said, "Barney always acted as if he had all the time in the world, as if life is eternal, and he would live forever.")

In the spring of 1958, four of Newman's pictures were chosen by The Museum of Modern Art for representation in its "New American Painting" exhibition, along with (alphabetically) Baziotes, Brooks, Sam Francis, Gorky, Gottlieb, Guston, Hartigan, Kline, de Kooning, Motherwell, Pollock, Rothko, Stamos, Still, Tomlin and Tworkov. The show toured Europe for two years, to Milan, Madrid and Brussels, and with a Pollock retrospective to Basel, Berlin, Paris, Amsterdam and London. During the same months that the show was being selected, he was invited to have a retrospective at Bennington College. His friends Tony Smith and the painter Paul Feeley were teaching there, and they urged the head of the art program, Eugene Goossen, to give Newman a one-man show in May as part of an annual series that already had included Pollock and Hofmann. Goossen asked for eight to ten pictures, but Newman decided to gamble on a more ambitious affair and sent up eighteen *(Hai)*, including a group of early works, as well as *Onement I, Vir Heroicus Sublimis* and *Day before One,* 1951 (shown for the first time). Greenberg wrote a generous, eloquent foreword, in his customary aggressive tone, and Newman probably was only slightly pained to notice that the critic still insisted on describing his paintings as if they were Rothkos—stained colors, with the weave of the canvas integrated into the plane. One can almost hear him grumbling sotto voce, "Goddamn batik!"

In March 1959, most of the paintings from the Bennington show were exhibited as the opening event of the new French & Co., Inc., galleries, which had been remodeled into airy, elegant space by Tony Smith, and for which Clement Greenberg was acting as artistic adviser. Greenberg asked Newman to inaugurate the Madison Avenue quarters; Newman agreed to show, but only works completed before The Museum of Modern Art's "Fifteen Americans" selection; perhaps he felt that the art world, which had turned him down so brutally in 1952, did not deserve to see his later work; more probably, he felt that he almost had been forgotten and that the public would have to start seeing him as if from scratch.

The exhibition was a revelation to many artists and critics. The general tendency in the late 1950s toward larger, more simple forms and toward a quieter, more objective surface suddenly was confirmed and in a sense defined in ten-year-old paintings. The flat, clean, objective look of the 1960s was established even before the decade opened. The cool, tight-lipped aspects of Pop

Art found a basis in Newman's apparently matter-of-fact presentation of extraordinary inventions. The surgical objectivity of later color-field abstraction also found sanction. The bands in Jasper Johns's flags, in Frank Stella's "pin-stripes" and in Kenneth Noland's layered pictures are based on hypotheses far removed from Newman's introspections on radiance and presence, and that distance is a function of the younger artists' originality. But Newman's work was a firm precedent for them; it opened doors which seemed to have been locked by Mondrian and the Constructivists and painted over by Abstract Expressionism.

After 1959, Newman was increasingly represented in group exhibitions—national and international. His paintings began to sell. The Oeffentliche Kunstsammlung, Basel, bought *Day before One* (in 1958); The Museum of Modern Art bought *Abraham* (in 1959); Betty Parsons took her commission from the sale of *Abraham,* doubled it and bought *Concord* (now in The Metropolitan Museum of Art); Jeanne Reynal bought *Horizon Light.* (It might be noted parenthetically that it took a little time for Newman's prices to catch up with those of his colleagues; $5,000 was the price of *Abraham;* in 1959, comparable paintings by Pollock were selling for about $40,000; by de Kooning for about $20,000; by Kline for about $10,000.)

In 1960, Newman went back to work with an energy he had not been able to tap since 1954. He did a series of twenty-two drawings in ink on ten-by-fourteen- and nine-by-twelve-inch pads; they are meditations on the possibilities of his new-found duodecimal calculus and on the potentials of black as a color. There are areas of black neatly masked and trued; there are cutting strokes like a fencer's lunges; there are heavy deep washes and areas of staccato dapple. Elements are combined and recombined to make a black mass confront a gray quiver, or white contract and expand as its black borders are adjusted. These are not studies for paintings, nor simple warming-up exercises—they are far more finished and expertly controlled. Rather, they seem to be a series within the larger series, undertaken in order to experience a radical shift of scale, being able to cover the span of an image in a stroke and to have it change as rapidly as one could work, as Newman had gone from *Vir Heroicus Sublimis* to *The Wild.*

He returned to his two paintings begun in 1958, adding two more; after studying them, he decided to expand the number to fourteen and title them "The Stations of the Cross." "It was after the fourth that he realized the number and meaning of the work on which he was engaged," wrote Lawrence Alloway, in his important and penetrating essay in the catalogue of the exhibition of the Stations at the Guggenheim Museum in 1966. "In December 1961 what is still the first painting of the Stations was exhibited as a single work under the title of *Station.* The work was subsequently reproduced as *The*

Untitled. 1960.
Ink on paper, 14 x 10 inches.
Estate of the artist

Untitled. 1960.
Ink on paper, 14 x 10 inches.
Estate of the artist

Untitled. 1960.
Ink on paper, 12 x 9 inches.
Estate of the artist

Third Station. 1960. Oil on raw canvas

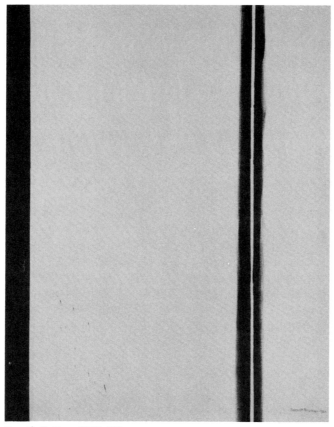

Fourth Station. 1960. Oil on raw canvas

Series, I [and another, independent painting, done in 1963 was titled *Station*], but there can be no doubt that the Stations theme was now a definite project in Newman's mind."[5]

It is possible to interpret the series as an autobiographical metaphor of Newman's "blackest years" of neglect and despair, of his heart attack and confrontation with death. It would also follow logically that this artist, who had made Genesis and the creative act his subject matter, would now turn to resurrection, to life after death—for what else, after all, is the subject of the Stations, which begin with Christ condemned to death and end with the Entombment? Indeed, in 1961, Newman painted a larger picture (eighty by seventy-two inches) which had been labeled "Resurrection." And in his statement accompanying the Guggenheim exhibition, Newman subtitled the series *Lema Sabachthani:*

Lema Sabachthani—why? Why did you forsake me? Why forsake me? To what purpose? Why?

This is the Passion. This outcry of Jesus. Not the terrible walk up the Via Dolorosa, but the question that has no answer.

This overwhelming question that does not complain, makes today's talk of alienation, as if alienation were a modern invention, an embarrassment. This question that has no answer has been with us so long—since Jesus—since Abraham—since Adam—the original question.

Lema? To what purpose—is the unanswerable question of human suffering.

Can the Passion be expressed by a series of anecdotes, by fourteen sentimental illustrations? Do not the Stations tell of one event?

No doubt the critic Barbara Reise is accurate in her response to the *First Station:*

The skinny un-primed zip at the right seems to screech like fingernails up and down a blackboard of dry-brushed edges, as if in terror of the solid vertical band which seems to move with ominous slowness into the painting's space. This painting almost shrieks vital terror in the face of death as an inevitable absolute. . . .[6]

Art is not quite so single-minded, however, nor is Newman ever simple. He never used his painting simply to relay a message to the viewer. Nor did he ever illustrate an idea or paint an allegory. Certainly the Passion and the vision of death is there in the Stations, but what else?

First of all, there is the concept of the series. He saw that the secret symmetry, which had been a key to his earlier paintings, would not apply to his new triadic divisions of the image, neither in one painting, nor in a pair, nor in four pictures. The action kept moving in one direction, at first from left to right, and simply to balance it

[5] "The Stations of the Cross and the Subjects of the Artist," in exhibition catalogue *The Stations of the Cross: Lema Sabachthani* (New York: The Solomon R. Guggenheim Museum, 1966), p. 11.
[6] Barbara Reise, *op. cit.,* p. 58.

with compositional devices would be to apply an academic esthetic solution—the kind of "harmony" he had fought all his life. At this point, I believe, he decided to make a large series, large enough to contain the flow of pictorial actions, to modulate and inflect some so that other individual images could offer violent gestures, but all would be given coherence and definite impact as they became echoed and canceled and reechoed across the sequence.

The Stations is not an open-ended series like Monet's Haystacks, for example, or Warhol's Marilyn Monroes, which apparently the artists kept painting until the drive behind the idea was exhausted. As Alloway pointed out, the number fourteen "embodies an order inseparable from the meaning of the work." This is probably one reason that Newman chose the Stations as his subject.

He wanted to be concerned with the idea of the Passion—of pain and suffering—and with the outcry of despair. In a "Conversation" (May 1, 1966) held with this writer at the Guggenheim Museum at the time of the exhibition, Newman said:

I was trying to call attention to that part of the Passion which I have always felt was ignored and which has always affected me and that was the cry of Lema Sabachthani, which I don't think is a complaint, but which Jesus makes. And I always was struck by the paradox that he says to those who persecuted Him and crucified Him, "Forgive them for they know not what they do." But to God, and Jesus is projected as the Son of God, He says, "What's the idea!"

Later in our "Conversation":

I felt that to the extent that Jesus was crucified and did physically say Lema Sabachthani *in relation to that drama, that it was more appropriate for me to be concerned with the Sabachthani (. . . forsaken me). Also since there is a tradition of Stations, as a painter I felt I could make the point more viable within that framework. . . .*

Hess: *It's like doing a sonnet, a given number of lines, and you fit into that form?*

Newman: *Well, to the extent that a sonnet is an arbitrary poem,[7] and to the extent that the Stations form an arbitrary [number of] paintings, I felt that it was appropriate to do it. . . .*

In other words, Newman purposefully chose a rigid framework on which to present those two slipperiest of modern ideas—the sense of anguished despair (that rock upon which so many Expressionist ships have foundered) and the serial form (which tends to produce *peintures-fleuve* of the most banal variety). He applied severe disciplines to the Expressionist content of the Stations, as we shall see, but it is important to note that in limiting his series and tying its number so inextricably to the subject

[7] In 1934–1935, when Barney was courting Annalee, he wrote her love poems, and Newman, champion of avant-garde art and literature, admirer of Joyce and Lorca, phrased them in severely regulated Shakespearean sonnet forms, iambic pentameter, heroic couplets and all.

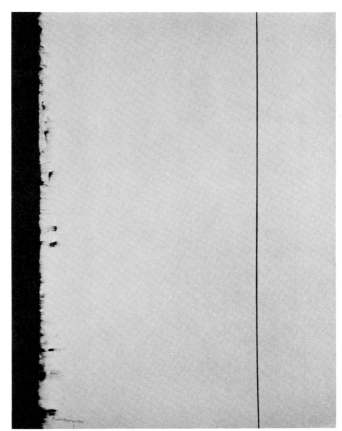

Fifth Station. 1962. Oil on raw canvas

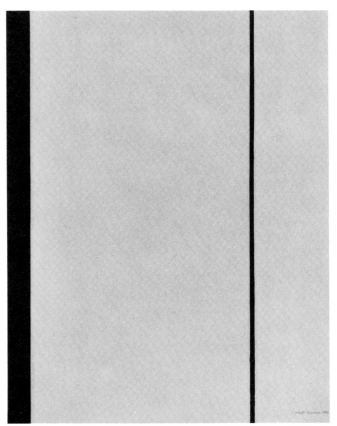

Sixth Station. 1962. Oil on raw canvas

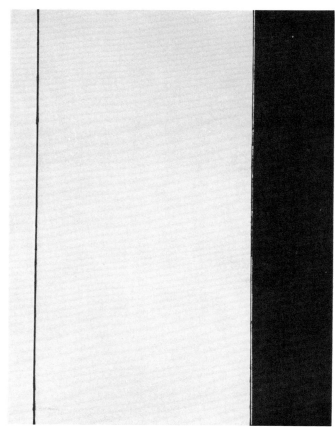

Seventh Station. 1964. Oil on raw canvas

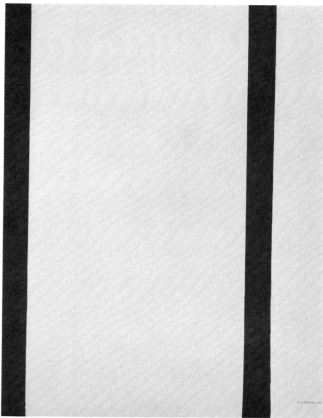

Eighth Station. 1964. Oil on raw canvas

matter, he got rid of the antiart implications of serial mode. A group of more or less identical paintings usually implies that the particular quality of any individual picture in the series is irrelevant. It is the whole effort that counts; each part reinforces and adds new qualities to the others. In an open-ended series, you receive a total impression, a cumulative experience which in turn increases the value of each dependent unit. By limiting his series, Newman forces himself to give each work its independence. He wrote in *Art News* (May 1966): "The Passion is not a protest but a declaration. I had to explore its emotional complexity. That is, each painting is total and complete by itself yet only the fourteen together make clear the single event."

He worked on the Stations for eight years, on and off, using the series as a source for other paintings, and coming back to it as a touchstone. He did the pictures in pairs. Using their conventional titles (whose meanings Newman completely ignored), they date:

First Station (Christ Condemned to Death), *Second Station* (Christ Carrying the Cross), 1958.

Third Station (The First Fall), *Fourth Station* (Christ Meets Mary), 1960.

Fifth Station (Simon Helps Carry the Cross), *Sixth Station* (Veronica Wipes the Face of Christ), 1962.

Seventh Station (The Second Fall), *Eighth Station* (He Comforts the Women of Jerusalem), 1964.

Ninth Station (The Third Fall), *Tenth Station* (He Is Stripped of His Garments), winter 1964–1965 (the Ninth in 1964, the Tenth in 1964–1965).

Eleventh Station (The Crucifixion), *Twelfth Station* (The Death of Christ), 1965.

Thirteenth Station (The Deposition), *Fourteenth Station* (The Entombment), winter 1965–1966.

Newman's is a version of serial art from which practically all the autobiographical, informal, subjective nature of the approach has been eliminated, to be replaced by an intellectual architecture which alone could contain the emotional quality Newman wanted to project, and the impact he had sustained in his early symmetrical paintings.

Just as the number fourteen of the Stations perfectly meshed with Newman's pictorial demand for a long but finite series, so his decision to restrict his palette to raw canvas and black (and, in three Stations, white) paint answered both his pictorial and emotional demands. Black is the stark "color" of tragedy. In our "Conversation," Newman said:

In a large tragic theme of this kind, when Picasso does Guernica, he cannot do it in color. He does it in black and white and gray. I couldn't make a green Passion or a red one. I mean you wouldn't want me to make a purple Jesus or something like that? It had to be black and white—I was compelled to work this way.... Could I get the living quality of color without using color?

But black paint, as we have noted, is the material of

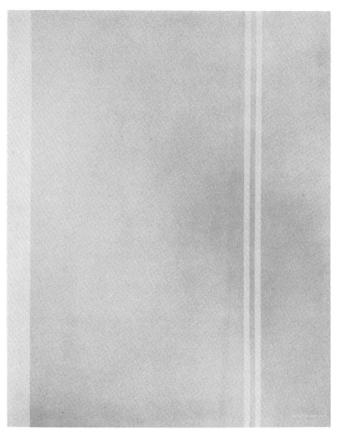

Ninth Station. Winter 1964. Acrylic on raw canvas

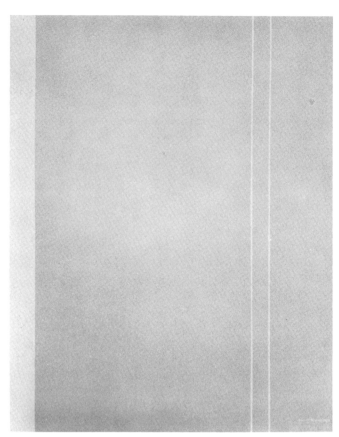

Eleventh Station. 1965. Acrylic on raw canvas

Tenth Station. 1964–1965. Magna on raw canvas

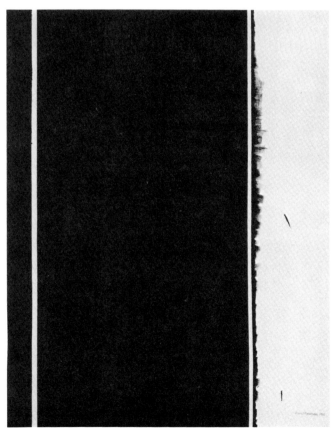

Twelfth Station. 1965. Acrylic on raw canvas

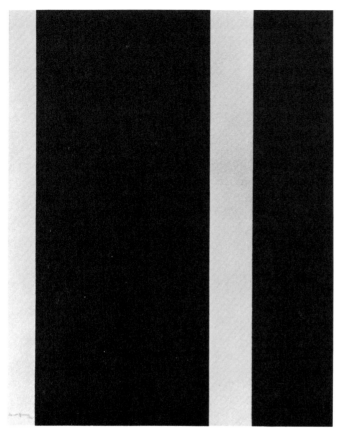

Thirteenth Station. 1965–1966. Acrylic on raw canvas

Fourteenth Station. 1965–1966. Acrylic and Duco on raw canvas

the artist who seeks a maximum freedom for experimentation and range of expression. It is not only the substance of tragedy, but also of release, joyous release. Behind the image in Newman's Stations, you may recognize the cold sweat of agony and the blood of pain in the black paint. Behind it, too, is the artist happily at work, moving ahead, delighted by his relationship with the medium.

The raw canvas also met physical and pictorial as well as emotional needs.

In his eagerness to start the first two Stations, to begin again after a long silence, Newman went directly to the canvas he had stretched in his apartment. The raw duck being there, while he was still too weak to work in his studio, filled a direct physical need.

After the series was finished, he wrote in *Art News:*

Raw canvas is not a recent invention. Pollock used it. Miró used it. Manet used it. I found that I needed to use it here not as a color among colors, not as if it were paper against which I would make a graphic image, or as colored cloth—batik—but that I had to make the material itself into a true color—as white light—yellow light— black light. That was my "problem."

The white flash is the same raw canvas as the rest of the canvas. The yellow light is the same raw canvas as the other canvas.[8]

In other words, the "passionate," or "poor," or "rough" look of the raw duck might be perfectly appropriate to Newman's stark presentation of despair—*Lema Sabachthani*—but it was also a logical function of his decision as a painter to use only black.

Furthermore, raw canvas had a special sensuous attraction for Newman. From his years of work for his father, he had become expert in textiles; he knew all about weaving and mills, how the stuff was made, how it should be treated. He was as intimate with canvas as a whittler is with his stick of wood. He was a connoisseur of duck, just as he was a connoisseur of various kinds of black paint—he used at least three types in the Stations (acrylic resins, oils, acrylic polymers), possibly more.

Finally, in the dynamics of the paintings themselves, in exploring his triadic structure, Newman found an extraordinary number of new opportunities and resonances. ("It is as I work that the work itself begins to have an effect on me," he wrote in *Art News,* "just as I affect the canvas, so does the canvas affect me."[9]) He established a dialectic between the clean-cut, sharp-edged element and the one with fluid, vibrating or plumed definitions—coming back to the hard versus soft theme he had announced in the sculpture *Here I,* and in *Dionysius* and *The Promise,* 1949. The width of the black areas varies, although their placement is relatively fixed, and they all stretch from top to bottom of the canvas. Their chang-

[8] Barnett Newman, "The 14 Stations of the Cross," *Art News* (New York), vol. 65, no. 3 (May 1966), pp. 28, 57.

[9] Barnett Newman, *op. cit.,* p. 26.

ing weights exert changing pulls and pushes across the surface. There is a dancelike quality to this action as it shifts from Station to Station. Sharp black zips emphasize the smudges and spatters that sometimes face them, sometimes replace them, and sometimes define them. In places, the medium from the oil paint bleeds into the canvas, making a "shadow" on the white. Where the black dry-brushing and smears define a narrow white vertical, the canvas gleams blue-white, like an icicle. Where the span of white canvas lies next to heavy black areas, the duck acquires a golden sunny glow. In certain divisions, Newman seems to have made a field for accidents, a place where he invites chance, spontaneous effects, the "quick crazy stroke" as the Zen swordsmen call it, or *sprezzatura* in Castiglione's famous phrase—"the masterful gesture of carelessness." In other divisions, the black moves with a precision that suggests fatality—inevitable, measured.

Culminating the Stations is a fifteenth picture, larger than those in the series, with an impastoed cadmium red light edge to the left of the canvas and a black, hard one to the right, and, in between, white paint replacing the bare canvas. At first it was nicknamed (not titled), at the suggestion of Tony Smith, "Resurrection."[10] Newman began it in 1961 and added some finishing coats of paint in 1964. He also gave it his own title, *Be II*.

There is an important key here, I believe, to an understanding of the Stations. It has been said, and it may be true, that the Stations are Newman's confrontation with death, and that to him the meaning of the Passion is Resurrection: life triumphant over death. I think that even if Newman had such an idea at the beginning (and this is doubtful), he changed his mind later. *Be* is the imperative of God of the Jews. Man should *be*; he should work in the Lord's ways in order to be able to stand before Him—as a man, in a place *(Makom)*, just as the orange stripe—the color which for Newman represented man since *Onement I,* 1948—stands across the white field from its severe counterpart in black.

The large vertical center-left area of the Stations— which generally takes up three-fourths of the image— contracts and expands slightly from picture to picture, as if suggesting Luria's image of the *Tsimtsum* (it contracts most sharply in the *Seventh* and *Ninth Stations*). The *Tenth* and *Twelfth Stations* are flooded with light, as the universe was after *Tsimtsum,* in the moment of creation.

Be II. 1961, 1964.
Oil and acrylic on canvas, 80 x 72 inches.
Estate of the artist

10 The picture is listed and reproduced as "Resurrection" in the catalogue of Newman's two-man exhibition with Willem de Kooning at the Allan Stone Gallery, New York, October 23–November 17, 1962. In fact, it was not exhibited then, nor was *Uriel,* which was also included in the checklist and reproduced. "Resurrection" was a title Allan Stone liked, and as his catalogue was going to press in a rush, he simply gave it to the picture; for some reason he also retitled *The Third* and called it "Orange Colossus"; he listed *Not There—Here* as "untitled" and he called the vertical, untitled 1946 drawing of a circle, "The Void." These were arbitrary acts by the dealer. However, Newman's own plan for the show also is evident in the catalogue— he planned to exhibit *eighteen* pictures *(Hai)*.

One could apply Kabbalist parallels even more closely here, but the crucial element is the command *Be*, which is both Jehovah's "let there *be* . . ." and the Kabbalah's admonition to *Be*.

Thus, Christ for Newman in the Stations is not the Messiah, nor is the Passion a ritual fourteen steps on the road to Resurrection. Rather, Christ is man; prototypical man born to suffering. He has lived from the beginning of the world until now. He suffers the torments of the artist, for "the first man was an artist," and the goal for all men is to be artists. He forgives enemies, but after life's humiliations and pains have become unbearable, he asks God the unanswerable question—*Lema Sabachthani?*

And God replies: *Be!*

Earlier in this text, I quoted the first paragraphs of Newman's Statement for his exhibition of the Stations at the Guggenheim Museum. Here is the rest of it:

The first pilgrims walked the Via Dolorosa to identify themselves with the original moment, not to reduce it to a pious legend; nor even to worship the story of one man and his agony, but to stand witness to the story of each man's agony; the agony that is single, constant, unrelenting, willed—world without end.

> *The ones who are born are to die*
> *Against thy will art thou formed*
> *Against thy will art thou born*
> *Against thy will dost thou live*
> *Against thy will die.*

Jesus surely heard these words from the Pirke Abot, "*The Wisdom of the Fathers.*"

No one gets anybody's permission to be born. No one asks to live. Who can say he has more permission than anybody else?

It seems evident here that Newman distinguishes sharply between the messianic Jesus, Son of God, and the historical Jesus. It is the historical figure who would have studied the *Pirke Abot* (or *Avot*), one of the sixty-three tractates of the *Mishna,* the pre-Talmudic corpus of laws and ethical principles compiled between the fourth century B.C. and the second century A.D. (*Pirke Abot* is usually translated "Ethics of the Fathers"—but Newman was his own scholar and did his own translations from the Hebrew). The messianic Jesus did not study the *Mishna,* but even as a child instructed rabbis; He was Himself the Word.

Furthermore, what "first pilgrims" on the Via Dolorosa would not have identified with Christ, with one Man and His agony, "but stand witness to the story of each man's agony?" They could only be the Jews who had followed Jesus' teachings as a prophet and a king, but not as the Messiah. Christians, on the other hand, would concentrate on the ultimate, informing nature of the Resurrection throughout their passage through the Stations.

Finally, there *is* one man who can say he has "*more* permission to be born" than anybody else: the Messiah. Newman is telling us that He is yet to come.

This, I believe, is the ultimate daring in Newman's Stations. He raises them to a philosophic enquiry on the nature of agony, on the nature of his art and on the life of man-as-an-artist. Fused with the pictorial structure of the black paint and the raw canvas and the serial nature of the image is the symbolic structure of his subject matter, which contains—secretly, although Newman always leaves hints and clues—his own ontological insight, with its parallels to (or metaphors from) the spiritual visions of the great Kabbalists.

In 1960, he finished two paintings outside of his work on the Stations, but both of them relate closely to it. One is a small painting in which dark green paint over two masking tapes divides the raw canvas surface into three equal parts. It is as if he wanted to make an evident materialization of his trisection concept. He titled the picture *Treble*, and in later titles he would refer insistently to this new calculus: *The Third* (1962), *The Three* (1962), *Tertia* (1964), *Triad* (1965). Even the famous Who's Afraid of Red, Yellow and Blue pictures carry in their titles the mark of "three."

The other picture, much more ambitious, is titled *White Fire II,* as if to indicate that, even while committed to the Christian iconography of the Stations of the Cross, he would keep his allusions to the Kabbalah and to its vision of Genesis of the Torah. In Gershom G. Scholem's paraphrase of the *Book Bahir* (one of the earliest books of the Kabbalists), the unknown author interprets

. . . the fiery organism of the Torah, which burned before God in black fire on white fire, as follows: the white fire is the written Torah, in which the form of the letters is not yet explicit, for the form of the consonants and vowel points was first conferred by the power of the black fire, which is the oral Torah. This black fire is like the ink on the parchment. "And so the written Torah can take on corporal form only through the power of the oral Torah, that is to say without the oral Torah it cannot be understood." Essentially only Moses, master of all the Prophets, penetrated in unbroken contemplation to that mystical written Torah, which in reality is still hidden in the invisible form of white light. . . .

The form of the written Torah is that of the colors of white fire, and the form of the oral Torah has colored forms as of black fire. And all these engravings [innermost forms] and the not yet unfolded Torah existed potentially, perceptible neither to a spiritual nor to a sensory eye, until the will [of God] inspired the idea of activating them by means of primordial wisdom and hidden knowledge.

White Fire II can be considered a transplantation of elements from the triadic Stations to the symmetrical calculus of Newman's work in the early 1950s. It is black paint on raw canvas, but the height is increased to eight feet (as in *Vir Heroicus Sublimis*), and the format is narrower than the Stations; its verticality is accentuated by the wide black bands on both edges, and braked by their

Noon-Light. 1961.
Oil on raw canvas, 9 feet 6 inches x 84 inches.
Estate of the artist

Black Fire I. 1961.
Oil on raw canvas, 9 feet 6 inches x 84 inches.
Private collection, New York

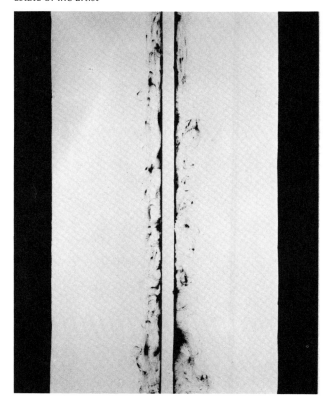

White Fire II. 1960.
Oil on raw canvas, 96 x 80 inches.
Collection Mr. and Mrs. Robert C. Scull, New York

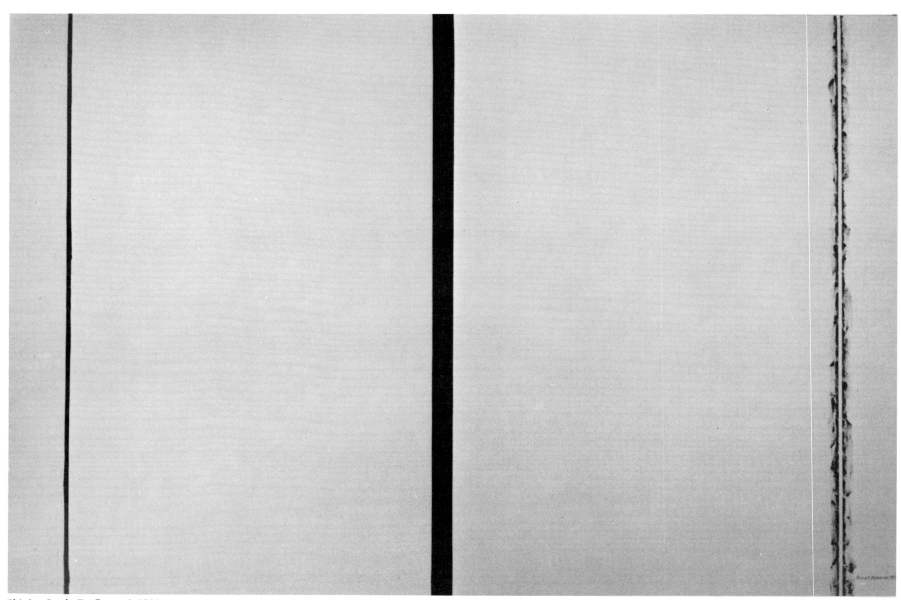

Shining Forth (To George). 1961.
Oil on raw canvas, 9 feet 6 inches x 14 feet 6 inches.
Collection Annalee Newman, New York

slightly curved, blotted "freehand" contours. The central sections of the raw canvas look golden compared with the negative zip formed by black plumes which seem to spray off to the sides, leaving an ice-white, dead-center band.

Noon-Light, 1961, nine and one-half feet high, puts full emphasis on the tawny "color" of white (raw) canvas set off, symmetrically, by a thin black band at the left edge, a thin ruled zip to the right. *Black Fire I,* of the same year, has the same dimensions, but is divided on the duodecimal scale, the center hidden and the raw canvas dominated by a wide, heavy, knife-edged black. These oversize, paired antinomes are closely tied into the experience of the Stations, and also provide a clue to Newman's most ambitious and astonishing work of the year, *Shining Forth (To George).* The ground, again, is raw canvas—it could be the sackcloth of mourning or a glittering cope of sun-flecked snow—or simply cotton duck prepared with a colorless, transparent, plastic medium, depending on how you see it. The format is symmetrical, with a wide black vertical in the center, a black stripe to the far left, a negative stripe defined by foaming, pulsing strokes of dry-brushed black at the right. Its horizontal format (nine and one-half by fourteen and one-half feet), marks one of the very few works by Newman to approach the Golden Section—that magical academic formula for achieving classical repose and grace.[11] Like almost all modern artists, Newman avoided that proportion, in which one axis of the painting is larger than, but does not dominate, the other axis. He preferred either to give his rectangles emphatic articulation, as vertical or horizontal fields, or to relate them to the square. In this picture, however, the format and proportions have the harmonious underpinning of a Greek temple. The stark blackness and whiteness make an even more vivid effect in this lucid context, adding a tragic, vulnerable dimension to the elegiac mood.

The painting is dedicated to Newman's brother George, to whom he had always been very close, and who died in February 1961. George's Hebrew name was Zerach, which derives from the verb "to shine," and which Newman translated as "shining forth."

Alloway, in his Guggenheim catalogue, cites the painting as Newman's testimony of his confrontation with death. But "shining forth" also describes perfectly what the light is doing in the painting; it seems to pour from behind the quivering negative zip and intensify even more brightly at the edges of the severe black cuts.

The picture was executed in unusual circumstances. Newman had had lunch with a friend one day, and in the afternoon, whether because of their conversation, or the food and the vodka, or the psychic climate—who can tell—he went to a second studio he had rented at Carnegie Hall, and in a burst of creative energy he finished the painting in an afternoon. He could not find his glasses, so he did the whole thing with the monocle that always hung from a black ribbon around his neck. (The reason for the monocle was that he often forgot his glasses, and Annalee kept spares for him in the apartment and in the studio, but in this "emergency" none could be found.)

He had thought about the painting for months. It was accomplished in a spurt of creativity that, afterwards, amazed him.

Thus there are three things in *Shining Forth (To George)*—three levels if you will. There is the tragedy of death, and of "being," living in the face of death. There is the conceptual struggle of the artist, the intellectual and emotional decisions which he confronts in the canvas. And there is the joy and exaltation of working and accomplishing, of reaching the vision. *Vir heroicus sublimis!*

It is this passion—it is such a trinity—I believe, that informs the Stations of the Cross.

[11] The Golden Section is a relationship of height to width which can be expressed in the proportion $A : B = B : (A + B)$.

Studio is sanctuary. —Barnett Newman

"Where did you come from?" a friend asked Newman when they met at a party in 1956, the friend remembering suddenly that he hadn't seen Barney in some time.

"I've been invisible," Newman answered.

Five years later, Newman was one of the stars of the New York art world—the community of painters, sculptors, poets, composers, dancers, philosophers, ideologues, curators, critics, collectors, fallen saints, rising sinners, specialized tourists and all-around nuts which he had done so much to help form and from which he took continuing enjoyment, only part of it ironically.

His pictures began to sell regularly and for increasing prices.[1] He was invited to exhibit in Los Angeles, Paris, Milan, Stockholm, Kassel, Tokyo, Basel, Amsterdam, London. While his colleagues withdrew from the active, social interchanges of the art scene and kept largely to their studios and to the company of old friends, Newman delighted in talking with young artists, going to their exhibitions, listening to their views. He always felt that the artist's is the highest calling and admired any man who had the strength to become one and to stick by his guns, no matter how different his attitude might be. The younger artists accepted him, sometimes as a father figure, more often as a friend. If any one of them had a new idea—about art or politics or love or dancing, about anything Newman cared about and he cared about practically everything—he wanted to find out about it. He went to the openings, the artists' bars, the parties. He had a good time, of course, but there was also a certain ritual politeness in his attendance. Nothing could keep him away from the opening of a friend's exhibition. If asked, he would drop all his own work and help install the show, advise about how to present it, be generous with praise and encouragement. This was more than a naturally social man's warm reaction. It was the punctilio of an artist among artists. Of course, the works of the younger artists of the 1960s, especially those who developed some of the premises of Newman's painting, represented a challenge to him and the stimulation of a continuing dialogue, as Elizabeth C. Baker has pointed out.[2]

Some of his contacts with young painters had more material results. One young artist asked Newman to speak to his father, who was worried about his son's choice of a hazardous career, especially as the young man had suddenly broken off professional training as a composer. Newman calmed the father, praised the son's work and potential, and added that if he was really worried about the boy, he would make sure he had enough money to sleep in a properly heated, fireproof studio. Some years later through the father, who ran an importing business, Newman was able to purchase rolls of Belgian canvas twelve feet wide. This permitted him to paint two of his most important late pictures, *Anna's Light* and *Who's Afraid of Red, Yellow and Blue IV*, at a scale he had long envisioned, but had been unable to realize.[3]

As Newman was at the center of the New York art world, it was not surprising in 1963 that the staff of The Jewish Museum had heard the rumor that the artist had certain ideas about designing a synagogue, and that the plan had something to do with a baseball field. Perhaps to add a touch of controversy and gaiety to what promised to be a deathly serious event, Richard Meier invited him to participate in an exhibition he was directing, titled "Recent American Synagogue Architecture." Other exhibitors included Belluschi, Breuer, Philip Johnson, Louis Kahn, Eric Mendelsohn and Frank Lloyd Wright.

The result was one of Newman's most surprising works and one that deeply influenced his own developing style.

[1] Although the French & Co. one-man exhibition in 1959 made no sales, in December of that year the dealer Lawrence Rubin bought three works which had been in the show: *Covenant* (now in the Joseph Hirshhorn Collection), *Onement III* (The Museum of Modern Art), and *By Two's* (Collection E. J. Power, London). He was advised by his brother, art-historian William Rubin, who in the following year bought *Prometheus Bound* for himself; the same year, David Gibbs, then a private dealer, bought *Eve* for E. J. Power. In 1961, Ben Heller bought *Vir Heroicus Sublimis* (which he had reserved in 1960), Marcia and Frederick Weisman bought *Onement VI*, Robert Scull bought *L'Errance*. In 1962, Scull bought *White Fire II*. The Weismans bought the bronze *Here I* in 1963. Alan Power, son of E. J. Power, bought *Uriel* in 1964; Newman's first trip to Europe was triggered by his need to help restretch that large painting which had been rolled up for transport to London.

[2] Elizabeth C. Baker, "Barnett Newman in a New Light," *Art News* (New York), vol. 67, no. 10 (February 1969), pp. 38–41.

[3] A useful study could be made of the importance of certain technical innovations to modern painting and sculpture. Robert Murray tells of watching a Canadian art student attempting to paint brash Franz Kline-type forms using a thin oils brush; but who *was* the first to "discover" how to make full use of the house-painter's brush; who introduced the use of commercial enamels; what was the stylistic effect of the introduction of acrylic paints, very wide bolts of canvas, Cor-ten steel, paint-rollers, Plexiglas, and the like?

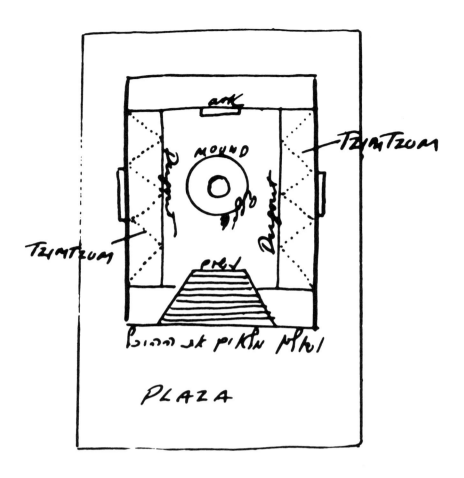

TZIMTZUM

TZIMTZUM

ark

MOUND

Dugout

Dugout

oreh

בומה את פיקת המול

PLAZA

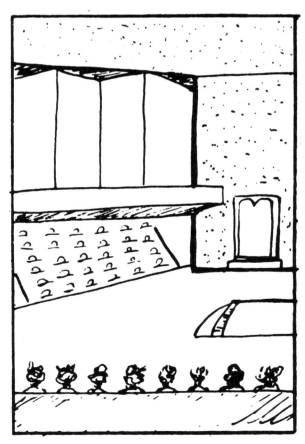

The germ of the idea came from two sources. In the early 1950s, he told Tony Smith that he had figured out a new way to show paintings in architecture. It involved a wall zigzagging at ninety-degree angles, the elements alternately window and masonry. Thus a painting would hang on a solid section of the wall; at right angles to it would be a floor-to-ceiling window. In 1953, the Kootz Gallery had an exhibition titled "Art for a Synagogue," and some months later the artist went out to New Jersey to see some of the modern temples that were being built. Newman was appalled at the insensitivity of the architecture and began to formulate ideas for his own solution to the problem.

When Meier's invitation came, Newman began to grapple with the project with his own unique combination of stubbornness, daemonic energy and deliberate introspection. He asked his friend the young sculptor Robert Murray for help, especially in building the model, and they worked together, Murray remembers, every day for two weeks—Newman, a great insomniac, going from 8:00 in the morning until 4:00 the next morning—finally taking the finished model up to the Museum in a station wagon at 2:00 A.M., on the day of the opening, and convincing a janitor that they were not madmen.

Newman's first ideas were in the form of sketches, about fifty of them, many on Schrafft's napkins, done after late breakfasts. In his final plan, the zigzag walls, now all of glass, are placed at the left and right sides of the building. The men sit below them in "dugouts," like baseball players on the edges of the field. The women are at one end, in the seats like a ballfield's bleachers. At the center is a (pitcher's? Indian burial?) mound—the place from which the Torah is read aloud during services. Opposite the bleachers is the Ark of the Covenant where the Torah is kept.

The basic form of the structure, then, is a rectangular box, with the Ark and the bleachers at opposite ends of the long axis; the accordion-fold windows are on either side; the dugouts are below the windows. The front and back walls are planned as solid, massive stone masonry. The side walls are light, made of glass, steel and plaster.

The problem of getting into the building was solved by adding a narthex behind the bleachers; Newman was not happy with this extrusion, but there had to be someplace for the congregation to hang its coats and prepare to enter the synagogue space.

The model is symmetrically placed on a large board. In building the model, Newman and Murray started from scratch: "We did everything backwards," Murray recalls. Instead of buying some simple architectural textbooks to determine what is the best height for the riser of a step, for instance, or how a window is fitted into a bay, Newman conducted Murray on study tours of his favorite buildings in New York: they measured the great carriage entrance to the Twenty-sixth Street Armory (where the 1913 Armory Show was held), to see how the steps

and ramps joined. Then they would go back to the studio and wrestle with the model.

Newman's statement in the exhibition catalogue indicates some of the concepts that lay behind and shaped his synagogue:

The impression that today's popular architecture creates is that it has no subject. It talks about itself as if it were only an object, a machine or an organic object; or one of new materials, new forms, new volumes, new spaces.

The subject of architecture is always taken for granted, that somehow it will supply itself or what is worse, that the client will supply it, that a building automatically becomes a work of art.

In the synagogue, the architect has the perfect subject because it gives him total freedom for a personal work of art. In the synagogue ceremony nothing happens that is objective. In it there is only the subjective experience in which one feels exalted. "Know before whom you stand," reads the commandment. But the concern seems to be not with the emotion of exaltation and personal identity called for by the command but with the number of seats and clean decor. We have broken out of the Alhambra. Is it only to fall into a new one? The synagogue is more than just a House of Prayer. It is a place, Makom, where each man can be called up to stand before the Torah to read his portion. In the Amsterdam synagogue tradition, man was put on a stage to become an actor and the women were put behind silk curtains. In the Prague synagogue, the women were even put behind walls. In the new synagogue, the women are there, sometimes even sitting with the men, but they are there as members of the Ladies' Auxiliary.

Here in this synagogue, each man sits, private and secluded in the dugouts, waiting to be called, not to ascend a stage, but to go up to the mound where, under the tension of that "Tzim-Tzum"[4] that created light and the world, he can experience a total sense of his own personality before the Torah and His Name.

The women are also there, as persons and not as wives and mothers. Here the women are out in the open, sitting not in any abstract connection with what takes place but as persons, distinct from their men, but in the full clear light, where they can experience their identity as women of valor.

My purpose is to create a place, not an environment; to deny the contemplation of the objects of ritual for the sake of that ultimate courtesy where each person, man or woman, can experience the vision and feel the exaltation of "His trailing robes filling the Temple."

The zigzag windows, then, filling the hall with light and thrusting into the light-filled space, enact the Luriac drama of *Tsimtsum* that took place between *Day before*

[4] Newman used the spelling *Tzim-Tzum* and later *Zim Zum;* I have used Gershom G. Scholem's transliteration, *Tsimtsum;* all three are correct.

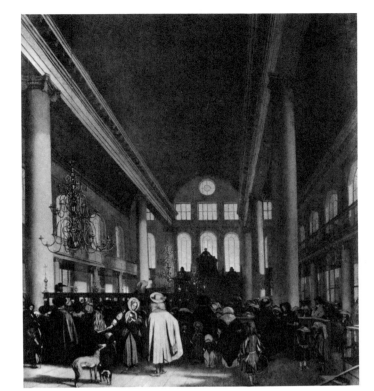

Emanuel de Witte.
Interior of the Portuguese Synagogue in Amsterdam. 1675.
Rijksmuseum, Amsterdam. One of Newman's favorite buildings.

Opposite: Two sketches by Newman for a synagogue, the model for which was constructed in 1963. It combines references to the baseball field with the Kabbalist vision of creation, *Tsimtsum* (or in Newman's transliteration, *Tzimtzum*).

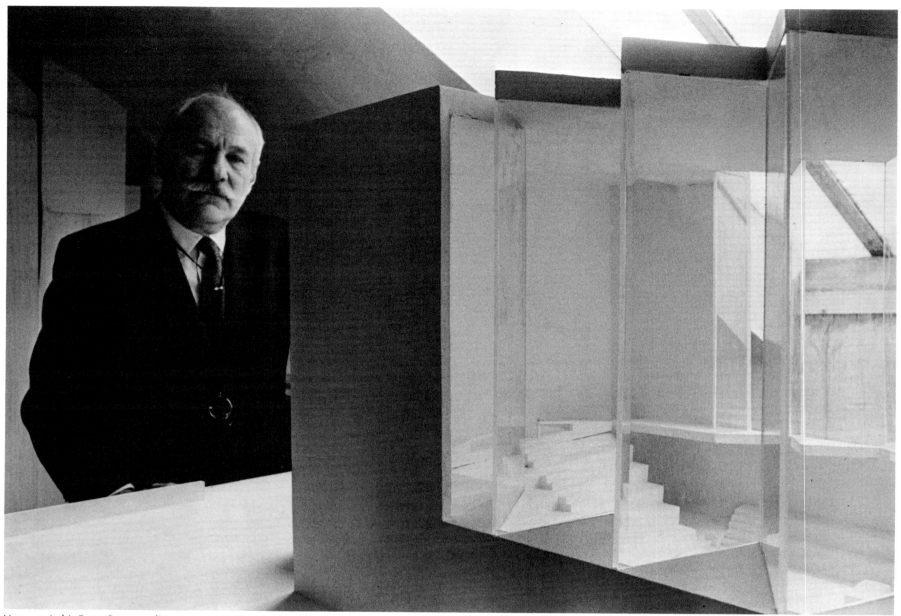

Newman in his Front Street studio
with the model for his synagogue.
Photographed in 1965 by Ugo Mulas

One and *Day One*. They are oriented across the nave so that point faces point, angle rushes away from angle, to heighten the feeling of Divine "contraction," also articulated by the heavy stone walls which act as piers between which the windows are compressed.

Makom is the "place," the locus where man stands, face to face with the Torah, with "The Word," with "White Fire" and "Black Fire"—it is a mound, reminding us of Newman's epiphany at the mound-builders' sanctuary near Akron and also of the mounds into which are thrust the vertical elements in his first sculpture, *Here I.* The total vision invoked by the artist, "the exaltation," is expressed with the same lines of poetry from Isaiah that Newman associated with *Cathedra.*

Newman obviously, and characteristically, carefully researched the synagogue and its history. Of all the models in The Jewish Museum's synagogue exhibition, his was the most imaginative—and the professional architects could claim that his freedom came from the fact that he had no client (Newman always claimed that as far as he was concerned, temperamentally, it would be *impossible* for him ever to accept a commission)—but on the other hand his is also the most respectful of tradition. Only his model, for example, follows the *Zohar's* rule that there should be twelve windows, symbolic of the twelve tribes of Israel. His substitution of the *Makom* for the more recently conventional *Bimah* (or platform, from which the Torah is read) is liturgically sound, as is his orientation of the Ark and the congregation. Although Newman does not specify it, we can deduce that his edifice is designed to face east (toward Jerusalem), because we can assume that his first idea for a zigzag wall-window structure would open to north light.

The separation of men and women also is basic to the historical tradition. Kabbalists explain this division of the congregation in terms of the *Sefiroth* ("the ten spheres of divine manifestation in which God emerges from His hidden abode"—Scholem). Directly beneath the *Sefiroth* or sphere of *Kether Elyon,* the "supreme crown" of God, are the *Sefiroth* of *Hokkmah,* or the male element (to the right), and *Binah,* the female (at the left). The male expresses itself in perceptions of intuition, in flashes of genius; the female in meditation, analysis, synthesis; the male is the *Sefiroth* of "wisdom" or the primordial idea of God; the female is that of understanding or the "intelligence" of God. Without their union, nothing can be accomplished. However, as men and women respond to God and create their prayers in different ways, according to their own temperaments, it is better that they worship Him with the freedom which separation encourages. There is nothing derogatory to women in true Kabbalist thought.

Newman's reference to "women of valor" suggests that he was thinking of the *Sefiroth.* Furthermore, in the Kabbalah, the ten spheres are often diagramed as a tree with interconnected branches moving in and out from a

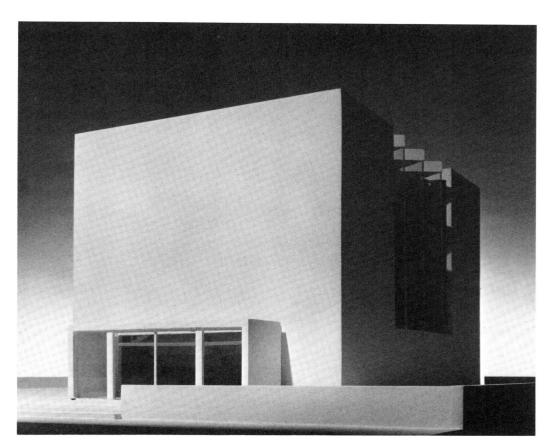

Newman's synagogue model of 1963.
Photographs by Ezra Stoller

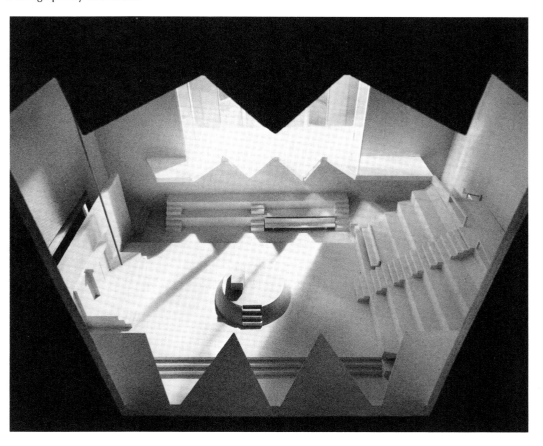

A Kabbalist meditating on the Tree of the *Sefiroth*.
Title page of *Portae Lucis* ("Gates of Light") by Gikatilla,
Augsburg, 1516. Wood engraving by Leonhard Beck

central trunk, at ninety-degree angles from each other;
it is probable, I believe, that the step from a zigzag wall
on which to show pictures to the wall of his synagogue
was facilitated, if not inspired, by this image, which New-
man surely knew from a sixteenth-century woodcut, a
reproduction of which was in his library.[5]

Newman's statement about his synagogue design is
the only one of his texts known to me that makes ex-
tended, overt reference to his studies in Jewish mysti-
cism. Kandinsky, Malevich, van Doesburg, Mondrian and
many other abstract painters wrote about the mystical
bases of their work, usually reverting to a rather soggy
theosophy, with such terms as "music of the spheres"
and "blackness of the soul" adding very little to the
strength of their ideas or to our understanding of their
work. Newman, on the other hand, made use of a solid
cultural tradition to which he was an heir. But aside from
the synagogue statement and from many fragmentary
hints and clues scattered throughout his titles and writ-
ings, he kept this preoccupation private. Not secret—
masked. I think that if anyone had asked him a direct
question about it, he would have given a direct answer.
Nobody did. It seemed the remotest area from his art
and from its evocation of a radical pictorial attack and of
highly generalized, "absolute" emotions. The montage
of the baseball metaphor on top of the Kabbalist one in
his synagogue design might seem also to be a mask, as
if Newman was trying to play simultaneously with the
image of Luriac cosmology and with that of the baseball
player waiting quietly in the dugout for his turn on the
field, while the girls cheer in the bleachers. This would
be a mistake, I believe. Newman's personality accept-
ed—even welcomed—the coexistence of extremes that
seem mutually exclusive. He was a down-to-earth, com-
plete American, as well as a cosmopolitan, sophisticated
intellectual. He enjoyed going to prizefights, hockey
matches and the races as much as to chamber-music re-
citals, lectures by his friend Meyer Schapiro or dances by
Merce Cunningham. He could recite passages from Cor-
neille and, with equal élan, from Yiddish comedies. Im-
peccably dressed with such details as silver watch fobs
and monocle, dark suits, jaunty ties and hats, trimmed
mustache (which reminded the writer Pierre Schneider
of Maréchal Joffre), he evoked such adjectives as fastidi-
ous and elegant—a dandy—but stolid, tough. He always
seemed deeply rooted in the American soil and the New
York asphalt. He took baseball seriously—thought about
it and spun theories around it. As "America's pastime,"
it uniquely expressed an aspect of Americanness, and thus
to study it was also to study himself. He catalogued the
repertory of tragic waves and shrugs of the pitcher who

[5] It represents a Kabbalist meditating on the Tree of the *Sefiroth*, and
was the frontispiece to the *Portae Lucis* by Gikatilla (Augsburg, 1516).
Traditionally, the woodcut is attributed to Hans Burgkmair, but it has
been recently assigned to Leonhard Beck. The Gates of Light are, of
course, the mystic's entrance to the Secret Arbor of the Kabbalah
and to his ascent toward the Throne.

has been pulled out of a game and sent on the long walk to the showers; he saw the bases as an allegory of Everyman's struggle, a kind of *Pilgrim's Progress,* and the home run as a revolutionary act—a direct appeal to the People. These fantasies were only partly whimsical. Baseball was real to Newman, a part of his life, and the pitcher's mound had its place among his *Sefiroth.*

Newman was in no way unique in this duality; many of the other American artists who forged Abstract Expressionism also felt they had to keep in touch with everyday life and popular culture. There is the example of de Kooning who, when stuck one day in front of a painting, went out on Tenth Street "to buy a piece of environment"; he bought a box of Kleenex and put the blue and white rectangle on a shelf near his painting wall. Newman brought his "environment" into his studio in equally simple and radical ways.

Before beginning a painting, after the stretched canvas was attached to his studio wall, he would very carefully surround it with brown wrapping paper, covering the whole wall behind the canvas and all the floor area he needed for working, and, if it was a large picture, part of the ceiling, too. He said it was to protect the studio walls. When pressed for another reason, because it is fairly easy to repaint a wall, he said that he did not want to have the evidence of old paintings and of mistakes in front of him as he worked on a new picture. Also, he said, he would mask whole sections of the picture with the wrapping paper so that if he was at work on, say, a blue and red painting, he could apply the red and protect the blue from splashes and also keep it out of sight. In other words, he would isolate the area on which he worked almost as carefully as a surgeon will isolate that part of the patient's body where he is operating. He could keep the red from contaminating the blue, and also he could concentrate fully on the blue color he was after.

These are all sound, practical reasons, but I think there was also a metaphysic at play, as there usually is with this complicated artist in whose works audacities are often disguised by technical simplicity. The brown wrapping paper is one of the most American materials imaginable. Finding it around the painting is like finding the streets of New York there, too. It must have affected his colors and the light in his pictures, adding to the toughness and decisive materiality he wanted. Robert Murray and, later, Tom Crawford, who was Newman's assistant in the last year of the artist's life, remember fondly a whole "ritual" for the brown paper—laying it out, then carefully smoothing and stapling or taping it into place. It was the beginning of the beginning for each painting—a kind of touching base with the world of here and now before moving into that higher sphere where the artist and his painting await each other.

The architectural and liturgical merits of Newman's synagogue can be left (with not much confidence, it is true) to specialists in those fields; however, the ideas that

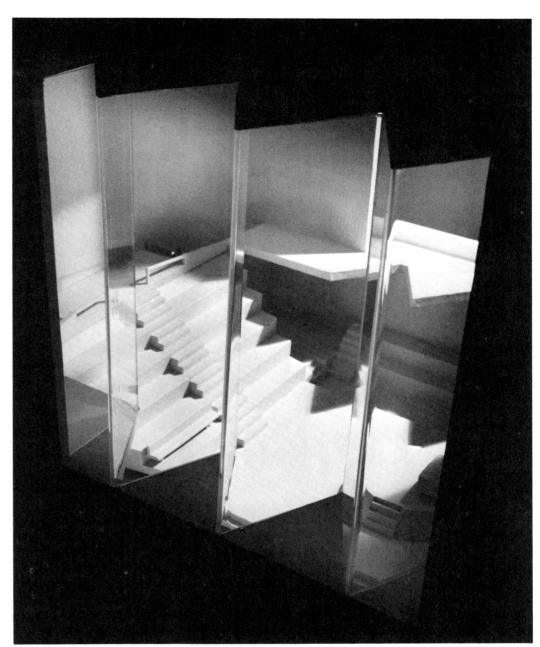

Side view of the synagogue model.
Photograph by Ezra Stoller

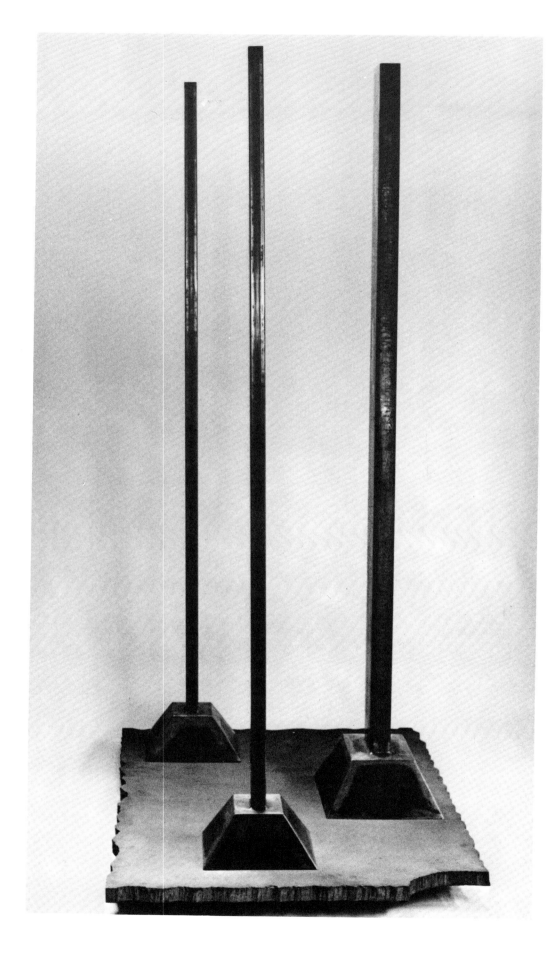

went into the model are so crucial to Newman's later work, and especially to his sculptures, that it is appropriate to consider them at this time, even at the risk of some chronological confusions.

Here I, the plaster sculpture in Newman's 1951 exhibition, was cast in 1962, the year before he designed the synagogue, and the sculpture's moundlike forms at the base as well as its metaphor of place *(Makom)* connect it to that project. The milk-bottle crate with wheels, which formed the base under the plaster *Here I,* was discarded in casting, Newman deciding (with the advice of Robert Murray) that it was more an extension of a dolly than an idea for a base. But later, the artist was not satisfied with the results; the "mounds" seemed to melt into the floor instead of confronting it. And so he decided to have a duplicate of the crate manufactured in bronze. Centering the synagogue model on a board, however, suggested another concept for a base—it was a way of delimiting the area in which a sculpture stands, an indication of its "place."

He adopted this platform-type base in his next sculpture, *Here II,* 1965. Its image relates to *Shining Forth—*three vertical elements, the center one wider and heavier than the others.

Newman's friend, the painter-sculptor Alexander Liberman, introduced him to the Treitel-Gratz Company (a New York firm, which, among other things, manufactures the Mies van der Rohe "Barcelona" chair), and they made a wood mock-up for the artist so he could locate by trial and error the exact positions of each element. The vertical elements all were cut from ten-foot high, hot-rolled steel, welded, rectangular tubes; the side elements are two by four inches, the center one is three by eight inches. They stand on tapered plinths located on a fifty-one-by-seventy-nine-inch steel plate, one-eighth of an inch thick, except at the edges, which are of two-inch Cor-ten steel. The base itself is floated one and a half inches off the ground on removable wheels set well inside the edge so that they cannot be seen.

Newman came to the shop over and over again, Donald Gratz recalls, adjusting the locations of the columns on the base. In the final decision, the central column is set almost at the front edge of the base-plate, in the center of the seventy-nine-inch width. The right column is almost at the back edge. The left column is a few inches back from the center of the fifty-one-inch depth of the base-plate.[6] Thus, seen head-on, the three vertical col-

[6] The elements in *Here II* are visually, not mechanically, centered. The center plinth measures 17 by 22 inches and is set 3 inches back from the front of the base-plate. The other two plinths are 15 by 16 inches. The left-hand unit is 12 inches from the back of the base; the right-hand unit is 4 inches from the back of the base, thus there is an overlap of 7 inches when seen from the side, which, in effect suggests that one plinth springs from the center of (or bisects) the other. The right-hand plinth is set in the northeast corner, 4 inches from the side as well as from the back. The left-hand plinth is 7 inches from its side, putting it in a closer relationship to the central element. (I am grateful to Don Gratz and Philip Johnson for making these measurements.)

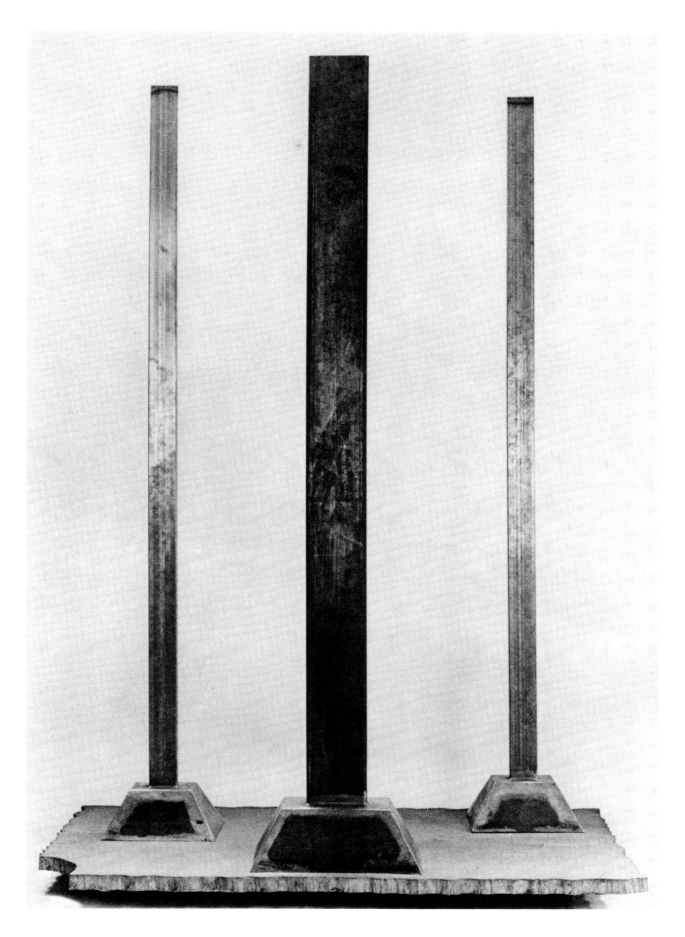

Right and opposite:
two views of *Here II*. 1965.
Hot-rolled and Cor-ten steel,
9 feet 4 inches high x 79 inches wide
x 51 inches deep.
The Museum of Modern Art, New York.
Promised gift of Philip Johnson

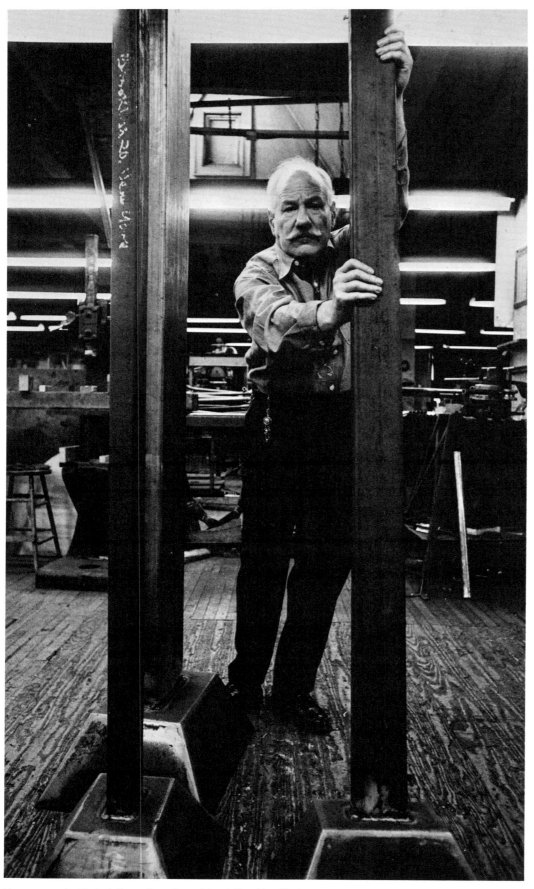

Newman at the Treitel-Gratz shop, Long Island City, New York,
with the vertical steel elements of *Here II*, 1965.
Photograph by Ugo Mulas

umns look symmetrical, but the right-hand column, being further away, is a bit dimmer than the one on the left (as the feathery negative stripe on the right in *Shining Forth* is a bit dimmer than the black zip at the left). Also, the central, nearest element seems taller than the left-hand one, which in turn seems a bit taller than the one on the right. From whatever face the sculpture is seen, three verticals will always be visible.

The vertical elements were all ordered and manufactured so that their edges are machine-perfect. Newman, however, wanted the rim of the base-plate to be ragged, soft-edged, lyric; just as in the Stations and *Shining Forth*, part of the drama comes from a dialogue between the sharply masked elements and the softly brushed and smeared ones, between areas that seem calculated and areas where chance and accident seem to have been invoked. At first, Newman indicated in a drawing how he wanted the base to be cut, along a ragged line; later he drew a line for the cuts with chalk on the steel. He asked the technicians to follow his line with what they call "imperfect burning," that is, with a flame in which there is not enough oxygen and which produces an irregular, melting, jagged, dripping cut.

Thus the "place" of the sculpture is defined physically, in sheet steel, but not sharply. It has been defined by a man; one can see where a hand trembled. In the front-left corner, Newman seems to have emphasized this quality of vulnerability: a whole section has been eaten out of the rectangle.

The jagged rectangle of the base-plate floats an inch and a half off the ground, casting a black shadow and creating a wafer of "void" beneath the piece. On top of it stands the three looming, sentinel presences, perfect, final in their balanced symmetry, which only begins to appear vulnerable itself as the side columns are seen to be not quite equal, adding a quiver of tension to the image. The slight backward and forward energy in the piece urges the spectator to move around it, despite its initial, strong, frontal, two-dimensional, almost hypnotic stare. And in turning around it, you discover a dancing interplay of weights and dimensions which change and interchange, reminding you of the enchanted spires which appeared and reappeared centrifugally to Proust as he drove in the countryside around "Combray."

When Harold Rosenberg first saw *Here II* in New York, it was set on the rough stone floor of the Whitney Museum and he compared it to a marvelous ruined temple in a desert. He saw columns and the classic disposition (adapted from *Shining Forth* and *White Fire II*). It has reminded other viewers, seeing it at Philip Johnson's house in Connecticut, where it is placed outdoors on the lawn, of the crucified Christ between the two thieves. Surely Newman, who in 1965 was finishing the last of the Stations of the Cross, considered the Calvary association, and perhaps this is why he set the uprights out of line on the base-plane, making the piece emphatically three-

dimensional with side views in which each of the "thieves" could in turn dominate the triad. Thus, if the three-by-eight-inch rectangular tube stands for a Christ figure from the front, at the sides it is a Christ seen as Brueghel saw Him—a man lost among men.

In 1965, Newman returned to Gratz with plans for *Here III,* in which a Cor-ten steel plinth and base, again floated off the ground, support a stainless steel column. Newman had fixed his measurements in advance so there was no need for him to worry about the location of elements on a wood model. The height of the piece is ten feet five and one-half inches. The base is eighteen and one-half by twenty-four inches; the plinth is eight inches high, set on a three-inch plate floated two inches above the ground. The nine-foot four-inch column is a three-by-eight-inch rectangular tube located in the exact center of the top of the pyramidal plinth. The base-plate is cut in a straight line, but, as in *Here II,* with an imperfect burn for a ragged, melted surface. Newman's only technical problem was to decide where he wanted the weld between the Cor-ten and the stainless steel—in other words, should the shiny element seem to be sunk into the plinth or to be standing on top of it? In *Here I,* verticals are vividly poked into the claylike mounds: that was also its structure. In *Here III,* Newman reversed this decision (possibly, he also took into consideration an articulation of its different structure) and placed the weld on top of the Cor-ten, that is, in the stainless, so that the column clearly stands poised a fraction of an inch above its base.

The white, shimmering plane of the stainless steel vertical is brought to a satin finish. It accepts the light of its environment, mirroring the sky, the trees, or the room in which it is placed (it is meant to be seen outdoors). It expresses in strong material shape the wide white vertical area which fills the left-center of most of the Stations of the Cross and, like it, also takes on mysterious, reflected colors. It also relates to the high vertical ascent of a 1965 painting, *Now I. Here II* presents the active, present zips of *The Wild* and *Here I; Here III* contains the more passive, contemplative areas into which Newman had organized his fields of color from time to time since *The Way I,* 1951. The dialogue between the hard, finished, organized approach and the soft, accidental, "messy" one is reiterated now in three stages: from the icy, intellectual image of the stainless steel column, through the warmer, more material level of the machine-edged Cor-ten plinth, to the roughly cut lip of the base-plate. It could be said that the weld is where, in Newman's temperament, the jaunty old-fashioned expertise of the baseball pro—the can-do American craftsman—meets the objective intellectual-emotional logic of the avant-garde artist: Babe Ruth, Sultan of Swat, and Ari Luria, Lion of Safed.

Here I and *Here II* were executed in editions of two; *Here III* and Newman's subsequent sculptures are in edi-

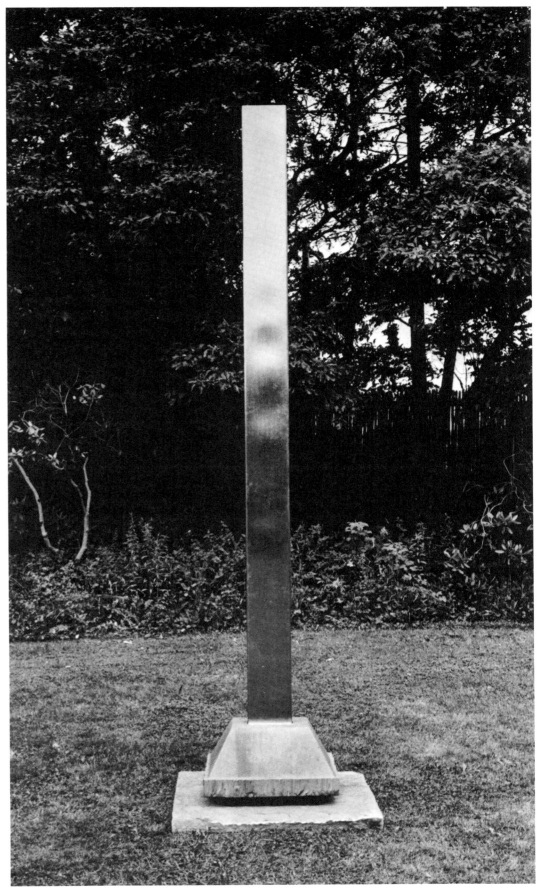

Here III. 1966. Stainless and Cor-ten steel,
10 feet 5½ inches high x 24 inches wide x 18½ inches deep.
Estate of the artist

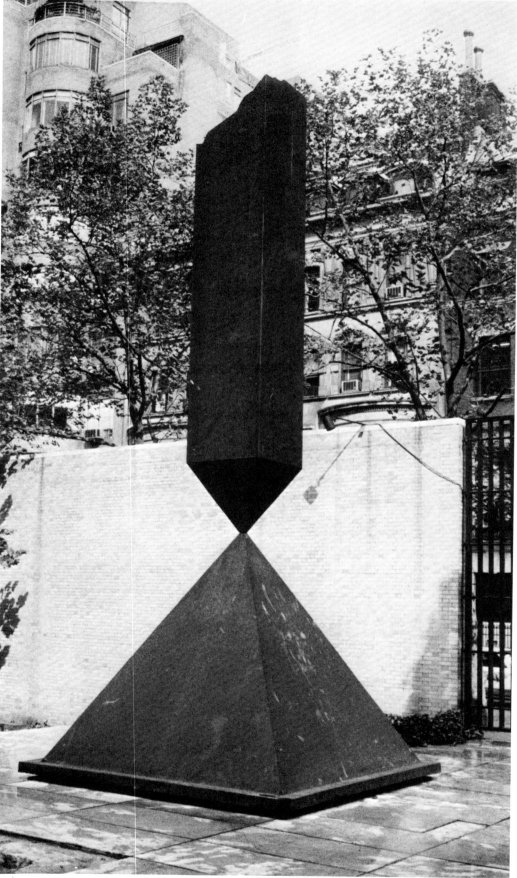

Broken Obelisk. 1963–1967.
Cor-ten steel, 25 feet 5 inches high x 10 feet 6 inches wide x 10 feet 6 inches deep.
The Museum of Modern Art, New York. Given anonymously, 1971

tions of three. There were several reasons for this. The simplest is that Newman wanted to make sure he could keep one example of each for himself. After all, he had once said that an artist paints so that he can have something to look at. He also wanted to own his sculptures. Implicated in this decision was a good-natured running argument with David Smith, who claimed that the whole ethos of modern sculpture depends in part on the uniqueness of each work. Otherwise, said Smith, the artist becomes just another manufacturer of decorative objects—and he used to cite with disapproval the ubiquity of Rodins, Lipchitzes and Moores around the parks and campuses of the Western world. But Smith also made bronzes, and Newman once told how he asked him: "What do you do with your plasters? And he said he saved them. And I said for whom. And he said for his daughters. And I said what's the idea. And he said you're always getting me in trouble. . . ."

Here III's stainless steel signal could also be considered Newman's picking up a challenge from Smith, who was the master of that medium, as was his choice of an edition, even if limited to three. If a method can be used, he reasoned, it should not be ignored; if the technical method was essentially one of producing duplicates, duplicates should emerge. Otherwise, a modern industrial technique was being forced into an older dogma that grew out of hand-carving and the "unique" masterwork of the craftsman—ethical concepts totally alien to the modern artist. The smallness of his editions was Newman's answer to Smith's attack on the commercialism of the contemporary sculpture market.

In duplicating *Here II* and *Here III*, Donald Gratz remembers, Newman ran into some of his worst troubles. The imperfect burns which he specified for the baseplate cuts are hand operations. Each would be slightly different from the other, but Newman insisted on exact replication. That was his point. Consequently, the artist's visits to the workshop increased in number as he found he had to supervise each maneuver in a method which, supposedly, was so perfected and impersonal that it could be carried out with a telephone order from the studio to the plant.

The following year, 1967, he executed *Broken Obelisk*, his largest work and one of the most impressive monumental sculptures of the twentieth century.

Basically, the piece is a pyramid made of four triangles of Cor-ten steel, each with a nine-and-one-half-foot base, nine and one-half feet in altitude and ten-foot-four-inch legs. The triangles are isosceles with sixty-three-and-one-half-degree angles at the feet and an angle of fifty-three degrees at the apex. Meeting the pyramid, apex to apex, is a sixteen-foot-ten-inch obelisk, upside down; the angle at the apex of the obelisk is also fifty-three degrees. Thus the profile of the pyramid should continue in an unbroken line into the summit of the reversed obelisk. However, in order to hold the two elements together,

the tips of both had to be cut off to fit a collar and a steel pipe that threads it and locks the two parts together. The obelisk-pyramid complex rests on a square base-plate ten and one-half feet wide, its edges roughly burnt, which in turn floats on beams about one and one-half inches off the ground.

Newman dates the piece 1963–1967; that is, the idea first came to him around the time that he was designing the synagogue. He could not have it executed until four years later, when Robert Murray introduced him to the Lippincott, Inc. steel works outside of New Haven, Connecticut; until then there was no way he could realize it technically.

The main drama of *Broken Obelisk* lies in the point of contact between the two masses, in the spark-gap of energy where pyramid meets and sends aloft the shaft of the obelisk. It is an impossible conception, daringly carried out, with all its tensions gathered in toward a climactic central junction.

The pyramid and the obelisk are two of the oldest monumental forms known to man; Newman uses their antiquity to add drama to a new form—their meeting.

They meet at a point of maximum contraction and push in toward it with all their energy. That is, between the pyramid and the obelisk is Newman's re-enactment of the drama of *Tsimtsum*, the instant of Creation.

The boldness of the idea is breathtaking, and the interior logic with which Newman carried it through is equally astonishing.

Newman had long been interested in the history of the pyramids and the pyramidal form. For him, it represented an absolute of geometry, informed by the Egyptians' genius for the magical and for the poetry of death. In one of his unpublished monologues, he attacked the ancient Greeks for misunderstanding the pyramid—they fell in love with its grandeur, Newman wrote, but like Romantic artists, they sentimentalized it, tried to make it into something "merely beautiful," and raised it on columns to become the pediment of a temple, a piece of decor. The strength of its geometry, Newman felt, came from its contact with the earth.

In the late 1940s or early 1950s, Newman studied the pyramids more thoroughly; he must have read a number of books about them, and in his library were two copies of a distinguished Pelican publication, *The Pyramids of Egypt* (1947) by I. E. S. Edwards of the British Museum. In this, he found among other things that the angle at apex of the Great Pyramid at Giza is fifty-one degrees fifty-two minutes, and that of the Pyramid of Chephren is fifty-two degrees twenty minutes. His chosen apex angle in *Broken Obelisk* (fifty-three degrees) is almost exactly the same as those of the two most "classic" pyramids. Edwards also points out that the pyramid is not a symbol of death, not a funerary monument or tomb of a dead pharaoh. Rather the "pyramid" is, literally, the "Place of Ascent"—the point from which the dead king rises and sails

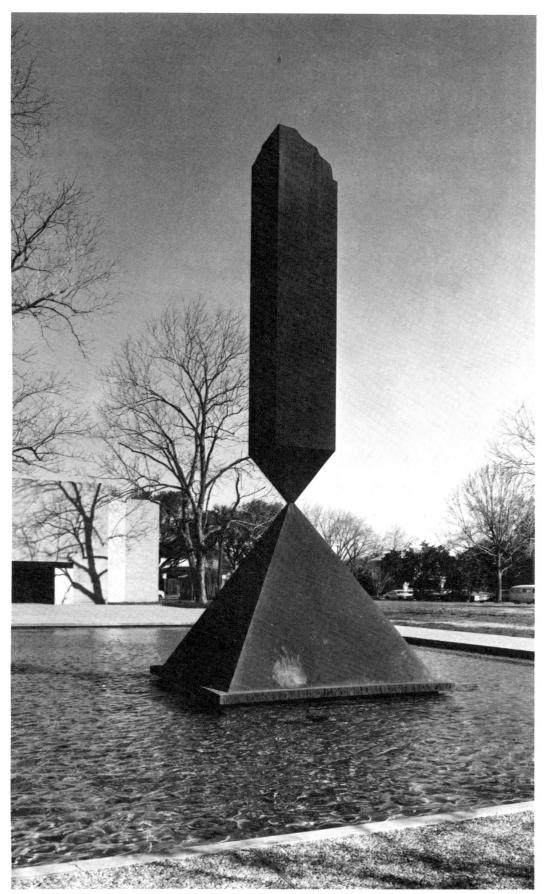

Broken Obelisk, as permanently installed in the garden of the Institute of Religion and Human Development, Houston, Texas

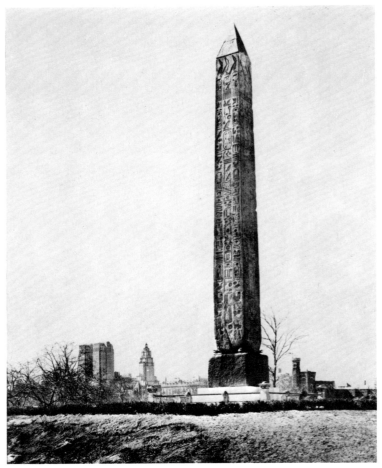

Cleopatra's Needle, Central Park, New York

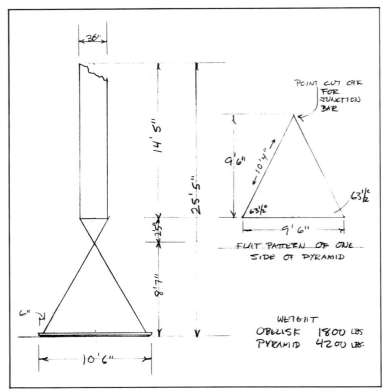

Donald Lippincott's drawing of the dimensions of *Broken Obelisk.*
Note the difference in altitude between the triangle itself and its height
when lowered into position in the pyramid. The proportions for
Newman's triangular paintings were concerned with this differential.

his astral boat up to the sun where he will spend eternity assisting the god Ra in the task of moving the sun across the heavens and beneath the earth. The obelisk also is a symbol of life and renewal; it represented the sun's rays, and it was tipped with polished gold to catch the first light of dawn, before people on the ground could see the sunrise; it announced to them that Ra had once more, miraculously, emerged from the underworld.

In between these two Egyptian symbols—not only of eternal life but also of eternal art, for to Newman they were always the works of inspired artists—Newman placed the *Tsimtsum* of Luria and of Jewish mystical thought, which holds them together in so fine a balance that its shape is almost as invisible as its concept is metaphysical.

The top of the sculpture, that is, the base of the obelisk, is "broken." Newman cut its shape carefully out of paper and worked out each angle for the technicians, just as he made a number of paper models before settling on the final shape of his triangles, arriving "by eye" at the curious proportion where altitude equals base and where the apex angle echoes those of Giza. The obelisk is broken, just as all antiquity is in ruins. The break is schematized—a kind of draftsman's shorthand to indicate that the form continues beyond. The break suggests that the shaft goes on, upward, to the stars, and also has come down from them, in the vertical imperative of Genesis. Finally, the arbitrary break of the obelisk recalls the brusque, vivid, painterly termination of the "shield" in *Achilles*,[7] and of the rough active elements which contrast with the smooth, calculated ones in the Stations.

The point of incandescence in *Broken Obelisk,* the place where the supporting and descending masses collide, or kiss, or separate—for the obelisk rises as much as it falls—relates to the *Tsimtsum* drama of Newman's synagogue plan and relates even more closely than those thirty-foot windows to the diagram of the Tree of the *Sefiroth.*

As a fusion of images and motifs, *Broken Obelisk* can be read partially and imperfectly as follows:

The roughly burnt edges of the base-plate contrast

[7] Two months after these lines were written, Lawrence Alloway published an essay on *Broken Obelisk* ("On Sculpture," *Arts Magazine* [New York], vol. 45 [May 1971], pp. 22–24) in which he also relates the "broken" top of the sculpture to the jagged bottom edge of the central shape in *Achilles.* He makes the valuable point that "Don Lippincott recalls Newman spoke of his desire to 'break the horizon,'" and notes that in its setting in Houston, the sculpture acts like a vertical punch down into the horizontal sky and land masses of suburban Texas. His association of the "break in the plane" in *Achilles* with "a reference to the tragic flaw in the hero; Achilles is remembered for his wrath and for his unprotected heel" is stimulating and poetic. However, Newman himself told me in an interview that the title of *Achilles* comes from the "shield," that is, the creative work of art.

It has been brought to my attention that Lucy Lippard also has noted the resemblance of the "broken" plane to "the symbol in engineering drawing for a greatly expanded but not depicted length." (*Art International,* January 1968, reprinted in her collection of essays, *Changing* [New York: E. P. Dutton & Co., 1971], p. 243).

with the machine-cut profiles of the other forms, reiterating Newman's joining of the intellectual with the sensuous, of the planned image with the chance one.

The pyramid, Place of Ascent, is a symbol of new life.

The juncture of the pyramid and the obelisk repeats the primal action of *Tsimtsum*—the first and ultimate action of creation.

The obelisk, the sun's ray, is life itself. And although both the pyramid and the obelisk are from ancient Egypt, the former, for Newman, was an abstract, historical concept, while the obelisk was a childhood friend from Central Park—Giza meets Manhattan.

The "broken" top is a symbol of infinity and also an allusion to the greatest work of art in Homeric poetry—the shield of Achilles, as envisioned in Newman's own art.

The sculpture, then, is not a confrontation with death, nor with the death-directed religion of Egypt; nor is it by any stretch of the imagination a "memorial." It is a celebration of life, of birth and renewal, in art and in man.

It celebrates the faith of the artist in his art, in his ability to break through dead styles, to find his own forms and subject, his own past and present.

It is an affirmation. If it says anything, it says "Be!" If it is addressed to anybody, it is to each of us: *Vir Heroicus Sublimis*.

Newman's next large sculpture, *Zim Zum I*,[8] 1969, connects directly in its shape as well as in its title to his synagogue project. It was planned originally as a "walk-through" sculpture, twelve feet high, but as Newman wanted to send it to an international sculpture exhibition in Japan in 1969, and as the specifications for shipboard cargo put a limit of eight feet on the piece, he scaled it down to that size—also the height of *Vir Heroicus Sublimis*. (He had worked out the exact proportions by playing with the six-fold announcement of his exhibition at

[8] I have omitted two pieces from this chronological discussion because they are isolated from the rest of Newman's work. After the Democratic Convention in Chicago in 1968, artists, like most intellectuals, were appalled by the events they had seen on television: the brutal handling of young demonstrators by the local police and the equally brutal handling of the antiwar minority by the majority on the convention floor. After the convention, a New York-Chicago dealer, Richard Feigen, organized a protest show in Chicago, with Mayor Richard Daley as its central target. Newman designed two pieces for the exhibition. He had watched Mayor Daley heckle Abraham Ribicoff with anti-Semitic remarks when the Connecticut senator was deploring the actions of the police. Newman said, "Well, if that's the level he wants to fight at, I'll fight dirty too; there're other words besides 'kike.'" His first piece was a steel frame, 5 by 4 feet, strung with barbed wire, like a mattress spring, with blood-red paint staining the center of the wires. Newman titled it *Lace Curtain for Mayor Daley*, and ordered it from Lippincott over the telephone. He finished drawings for a second exhibit, also to be executed in steel, *Mayor Daley's Outhouse* ("He belongs with Chic Sale," said Newman), but there was no time to finish it for Feigen's deadline, so it was never executed. Newman had a healthy respect for "telephoned sculpture," even though *Lace Curtain* was his only try at it. He himself used to haunt the workshops gauging every move, nudging each workman's hand. But he defended the impersonal approach, claiming it was even more difficult. "Why!" he exclaimed, "did you ever telephone an order of sandwiches to a delicatessen and have them get it right?"

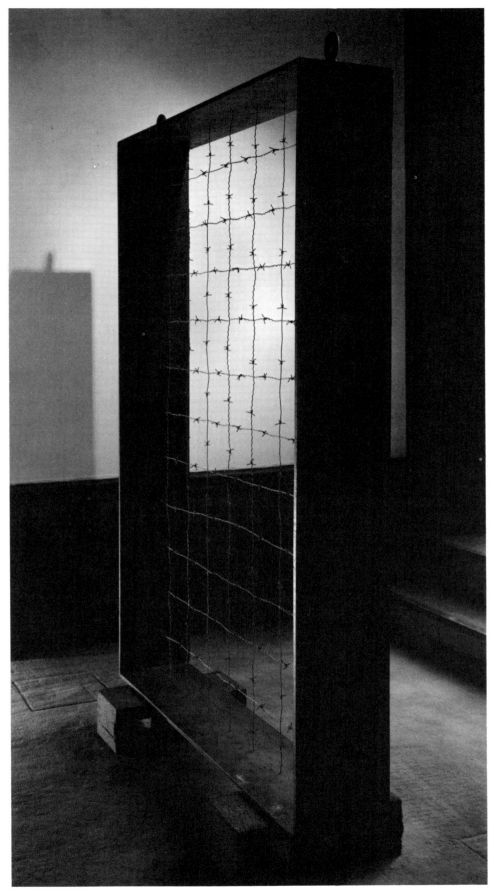

Lace Curtain for Mayor Daley. 1968.
Cor-ten steel, galvanized barbed wire, and enamel paint,
70 inches high x 48 inches wide x 10 inches deep.
Estate of the artist

Announcements of Newman's exhibition at M. Knoedler & Co.,
New York, 1969; used to help visualize the proportions of his
sculpture *Zim Zum I.* Photograph by William D. Hess

Knoedler.) The second, and definitive, version is still to
be executed.

Zim Zum adapts the ninety-degree windows of the
synagogue into sculpture. There are two walls, each
composed of six Cor-ten steel plates, each eight feet
high, set at right angles to each other in a zigzag line. The
zigzags face each other so that the opening plate of one
faces the first right angle of the other. Each plate is thirty-
seven inches wide, and the two zigzags are separated by
a distance of thirty-seven inches, measuring from paral-
lel faces. In other words, the spectator walks through a
corridor of compressions, which, seen from overhead,
would be read as a progression through six perfect
squares. (In the twelve-foot scale, each element would
be fifty percent larger, and the plates, fifty-five and a half
inches wide and as far apart.) The presentation of hidden
squares in a sequential experience reminds one of New-
man's strategy in *Vir Heroicus Sublimis.* The "perfect"
square is there, obviously there, and yet is invisible. The
static quality of geometry has been drained from the
shapes, just as a strict sonnet form in the hands of a mas-
ter will hide the chiming rhymes in enjambments.

In *Zim Zum I,* for the first time in Newman's sculpture,
there is no base. The structure stands directly on the
ground and invites the participation of the viewer. He
may consciously admire the physical proportions, the
rich density of material, the tensions between the two
shifting walls as he walks between them, but he will also
experience a force of contraction and symmetry, and
what Paul Valéry called an "intuition of order," which,
the poet felt, was a sign of the "new society."

Although *Zim Zum I* is rooted in Newman's synagogue
of 1963, its direct, plain, open approach to the viewer is
more characteristic of his later paintings than of those
done while he was still working in and out of the Stations
of the Cross.

He had begun the Stations, it will be remembered, in
1958, working with black paint on raw canvas—black
and white, the instruments of the tabula rasa—and he
stayed with black and white until 1962, when he did two
pictures, *The Moment I* and *Not There—Here,* in which
he used yellow on white paint. The latter painting pre-
sents a yellow band (about a fifth of the canvas's width)
to the right of the picture, a reversal and a contradiction,
in a way, of the *Sixth Station,* also painted that year. *The
Moment I* is a horizontal picture with two yellow zips
advancing from the right, dividing the raw canvas ground
in one-fifth and two-fifths sections.

Yellow seems the logical, perhaps inevitable, move
after a seven-year restraint from color; it is closest to the
golden light that radiates from certain sections of the Sta-
tions. It is, in a way, an extension of raw canvas. The next
picture undertaken in 1962 probably was *The Third,*
which has the same dimensions as *The Moment I,* but
now the yellow has been turned into a fiery orange.
White zips of reserved canvas are stationed symmetri-

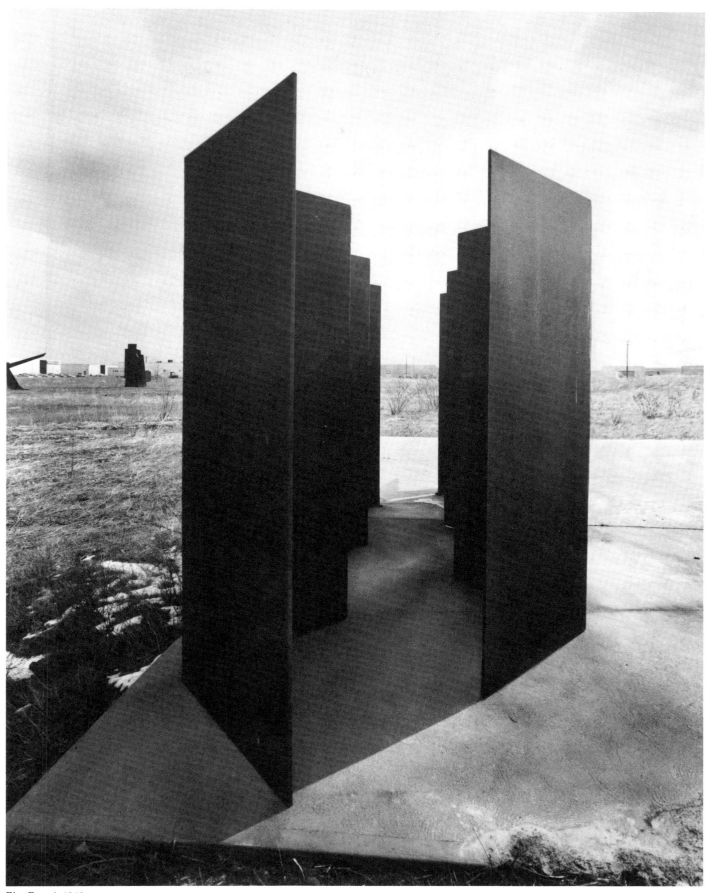

Zim Zum I. 1969.
Cor-ten steel, 8 feet high x 6 feet 6 inches wide x 15 feet deep.
Estate of the artist

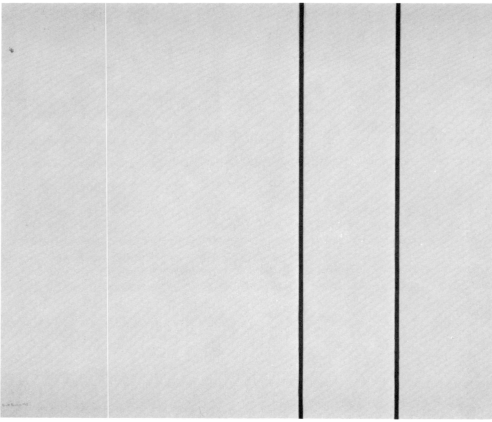

The Moment I. 1962.
Oil on raw canvas, 102 inches x 10 feet.
Private collection, New York

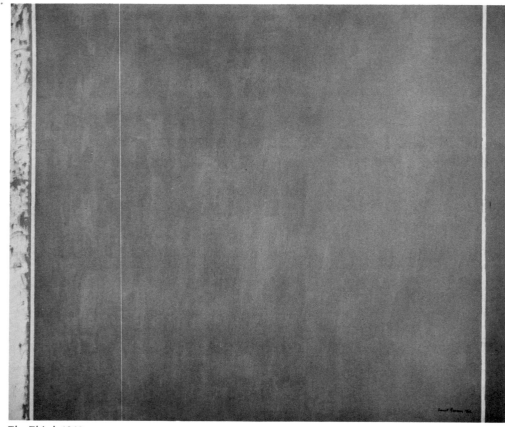

The Third. 1962.
Oil on raw canvas, 101¼ inches x 10 feet ⅜ inch.
Collection Mrs. Dolly Bright, Los Angeles

cally near the edges, and the left edge of the picture is opened to a very free, gestural motion of the dry brush over canvas. There is an impasto effect as the orange is taken from thin scumbles to heavy marks and seems to model the blank canvas, and the oil surface of the central section also preserves the marks of the artist's handwriting. In 1964–1965, Newman executed two more orange paintings: *Tertia* (in the same dimensions as *Not There—Here,* and with a left-hand area reserved for emphatic action strokes, as in *The Moment I*) and *Triad* (again with strong, splashing, pushing strokes at the left). In *Triad,* for the first time since finishing *Uriel* (1955), Newman used a black zip on top of color—it delimits a "secret square" off-center to the left of the format.

Between these colored paintings, Newman had done several in black and white: *The Three, White Fire III* (a white-on-white image recalling *The Voice,* 1950) and *Now I* (an emphatically trisected vertical which seems to point toward *Here II*). He was like the juggler in Matisse's simile, who has to keep two balls in the air at the same time, one is color, the other, black and white. Newman was also pushing his work, probing its limits, to find a more comprehensive image. It was shortly after finishing *Triad,* with its raw canvas (which to Newman suggested yellow), hot-orange field and black zip (which against the cadmium red lights glints with complementary ultramarine), that Newman began a new series, but this one open-ended and without any given format. He would title it *Who's Afraid of Red, Yellow and Blue.*

He had returned, after some eleven years, to a full, passionate use of color in a large scale.

Among the works that fed this new liberation was a series of color lithographs executed in 1963–1964 under the encouragement of publisher Tatyana Grosman.

Newman titled them "Cantos," surely referring to Dante and to the artist's own experiences of inferno and purgatory. He published a statement with them in which he explains his approach, and it beautifully illustrates how Newman grappled with the issue of a new medium. The challenge of a painting, he once said, is to "destroy the wall"; a sculpture must confront and get up off the floor. As for lithographs, in his preface to the Cantos, he wrote:

I should say that it was the margins made in printing a lithographic stone that magnetized the challenge that lithography had had for me from the very beginning. No matter what one does, no matter how completely one works the stone (and I have always worked the stone the same way I paint and draw—using the area—complete), the stone, as soon as it is printed, makes an imprint that is surrounded by inevitable white margins. I would create a totality only to find it change after it was printed— into another totality. Theoretically a lithograph consists of the separation between the imprint and the paper it is on. Unfortunately it never works that way for me. There is always the inevitable intrusion (in my lithograph at least) of the paper frame. To crop the extruding paper or

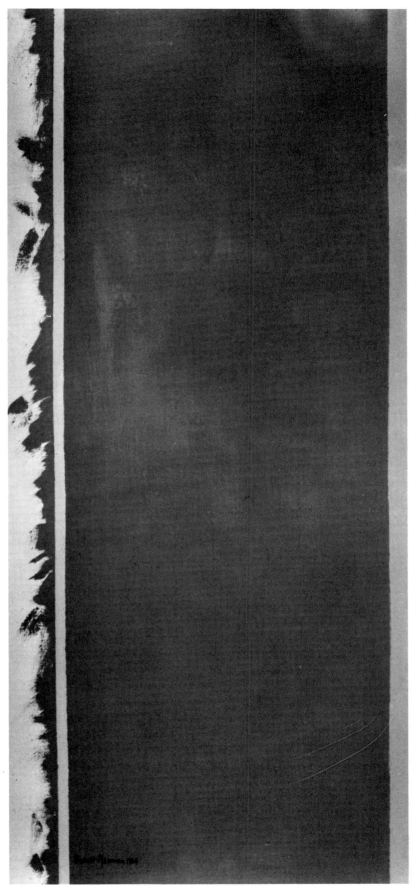

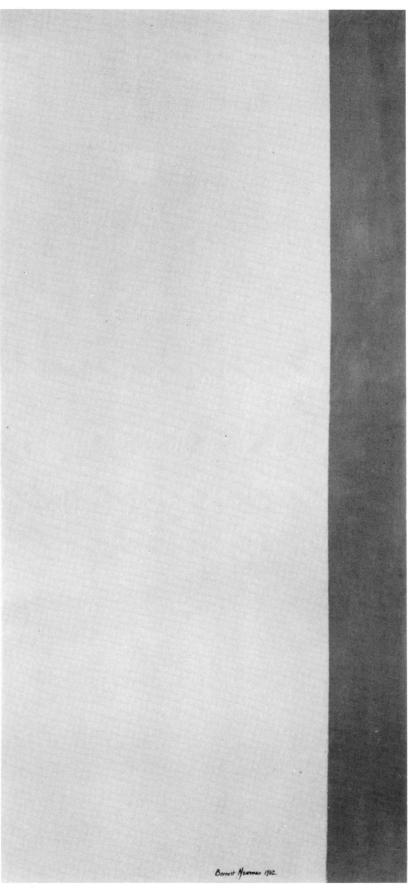

Tertia. 1964.
Oil on canvas, 78 x 35 inches.
Moderna Museet, Stockholm

Not There—Here. 1962.
Oil and casein on canvas, 78 x 35 inches.
Collection Annalee Newman, New York

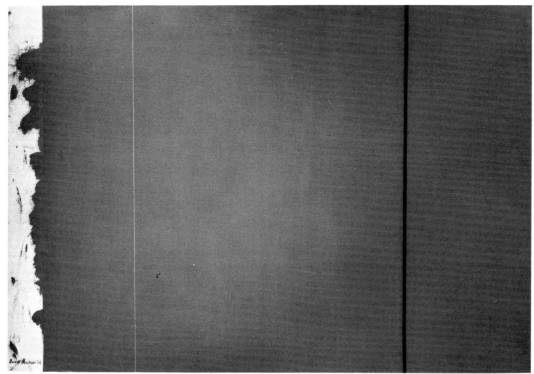

Triad. 1965.
Oil and Magna on canvas, 35 x 50 inches.
Collection Kimiko and John Powers, Aspen, Colorado

to cover it with a mat or to eliminate all margins by "bleeding" (printing on papers smaller than the drawing on the stone) is an evasion of this fact. It is like cropping to make a painting. It is success by mutilation.

The struggle to overcome this intrusion—to give the imprint its necessary scale so that it could have its fullest expression (and I feel that the matter of scale in a lithograph has usually not been considered), so that it would not be crushed by the paper margin and still have a margin—that was the challenge for me. That is why each canto has its own personal margins. In some, they are small, in others large, still in others they are larger on one side and the other side is minimal. However, no formal rules apply. Each print and its paper had to be decided by me and in some cases the same print exists with two different sets of margins because each imprint means something different to me. In painting, I try to transcend the size for the sake of scale. So here I was faced with the problem of having each imprint transcend not only its size but also the white frame to achieve this sense of scale.

These eighteen cantos are then single, individual expressions, each with its unique difference. Yet since they grew one out of the other, they also form an organic whole—so that as they separate and as they join in their interplay, their symphonic mass lends additional clarity to each individual canto, and at the same time, each canto adds its song to the full chorus.

I must explain that I had no plan to make a portfolio of "prints." I am not a print-maker. Nor did I intend to make a "set" by introducing superficial variety. These cantos arose from a compelling necessity—the result of grappling with the instrument.

To me that is what lithography is. It is an instrument. It is not a "medium"; it is not a poor man's substitute for painting or for drawing. Nor do I consider it to be a kind of translation of something from one medium into another. For me, it is an instrument that one plays. It is like a piano or an orchestra, and as with an instrument, it interprets. And as in all the interpretive arts, so in lithography, creation is joined with the "playing"; in this case not of bow and string, but of stone and press. The definition of a lithograph is that it is writing on stone. But unlike Gertrude Stein's rose, the stone is not a stone. The stone is a piece of paper.

I have been captivated by the things that happen in playing this litho instrument; the choices that develop when changing a color or the paper-size. I have "played" hoping to evoke every possible instrumental lick. The prints really started as three, grew to seven, then eleven, then fourteen, and finished as eighteen. Here are the cantos, eighteen of them, each one different in form, mood, color, beat, scale and key. There are no cadenzas. Each is separate. Each can stand by itself. But its fullest meaning, it seems to me, is when it is seen together with the others.

It remains for me to thank Cleve Gray for bringing me to lithography, particularly at the time he did.

Newman's thanks to his friend the painter Cleve Gray refers to an episode in 1961. Gray had been working on some stones at the Pratt Institute's atelier downtown and had telephoned Newman and urged him to join. Newman came and they gave him an old stone with which to practice; he tried to bring out the feeling of the stone itself in a freehand format reminiscent of the Stations of the Cross, but more symmetrical, and emphasizing the stone's texture and rough, chipped edges and nicks. After printing it, he liked the effect and proceeded to make two, more formal, prints. The second lithograph is a heavily textured field, divided into ⅔-⅓ areas by a sharp white zip. The third established a kind of diagram of one of Newman's main preoccupations of the early 1960s. The image is divided vertically, a deep black to the right, a rollered, scraped black reading as gray in a slightly narrower area to the left. In other words, there are two zones to the image. The wider, black one, is ordered, even, calculated, arbitrary, controlled. It could stand for the epic quality—intellectual, masculine (perhaps), conscious, forceful. The gray zone is reserved for the aleatory; the ink is spread in a way that is spontaneous, automatic, instinctive, contingent on change and momentary sensations. It could stand for the lyric quality—sensual, feminine (perhaps), subconscious, seductive. This polarity, as we have seen, goes back to the beginnings of Newman's art—to the contrast between the smeared zip in *Onement I* and the sharply masked one in *Onement II,* and between the rough and smooth edges in *The Promise* and *Here I.* It played an increasingly important role in the works of the late 1950s and early 1960s, from the Stations to *Triad,* 1965. Nowhere is it more clearly affirmed than in the third lithograph the artist made at Pratt in 1961.

Connoisseurs of historical coincidence can add one to their collection with this work; Newman's 1961 black and scumbled gray lithograph exactly predicts the image in a vertical format, of Mark Rothko's last black and gray horizontal painting, even to the white margins. There can be little doubt that Rothko did adapt some of Newman's vertical divisions for his own horizontally stacked fields of color in the early 1950s. It is extremely doubtful, however, that he ever saw Newman's lithograph, and, as Robert Goldwater has pointed out, Rothko evolved his late paintings through an interior logic that is obviously his own. (Another historical coincidence—but, again, nothing more than an oddity—is that Newman's *Broken Obelisk* was "predicted" in 1934 by, of all people, the Non-Objective painter Rudolf Bauer. Bauer's Art Deco versions of German abstract painting were the stars of the Guggenheim Museum of Non-Objective Painting, which New York artists visited in the 1930s and early 1940s to look at Kandinsky. Bauer's doctrinaire geometrics were considered a joke, and he was, without much affec-

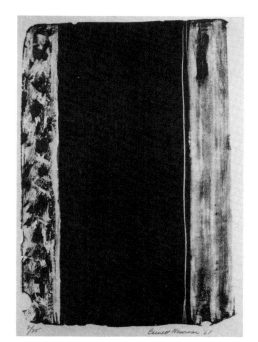

Untitled. 1961. Lithograph,
13¾ x 9⅞ inches (composition size)

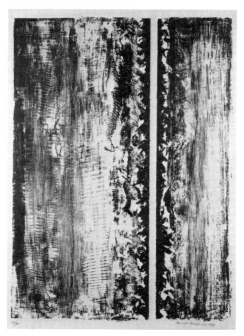

Untitled. 1961. Lithograph,
22⅞ x 16⅚ inches (composition size)

All three lithographs are in the collection of The Museum of Modern Art, New York. Gift of Mr. and Mrs. Barnett Newman, in honor of René d'Harnoncourt, 1969

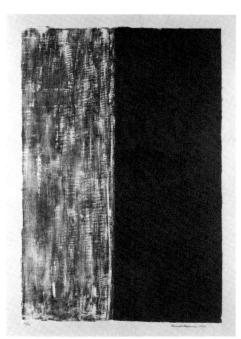

Untitled. 1961. Lithograph,
24¹¹⁄₁₆ x 16⅚ inches (composition size)

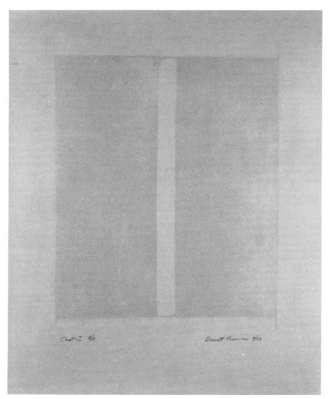

Canto I. 1963. Lithograph,
15¹⁵⁄₁₆ x 12¾₆ inches (composition size).
Longview Foundation, New York

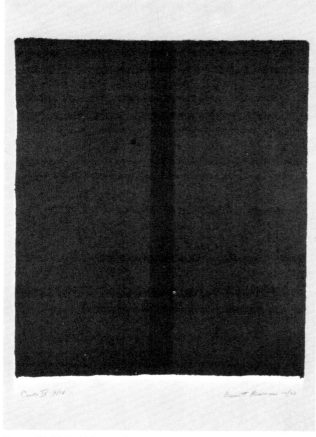

Canto IV. 1963. Lithograph,
14⅝ x 12⅝ inches (composition size).
Longview Foundation, New York

tion, nicknamed "Bubbles," after the spheres that loom through his paintings. There is a sphere in his *Blue Triangle,* 1934, and it floats behind the center of the painting in which an inverted obelisk balances on top of a pyramid.)

All but three of Newman's eighteen Cantos are symmetrical in format. At first he used a zip as the divider, but ten of them are divided either in two equal, facing areas, or by a central half flanked by two quarters. The proportions of the stones are all roughly square pushed slightly to the vertical. Tatyana Grosman remembers that when Newman finished his first print, he wanted to cut down its edges. She agreed, but asked why. He told her that his paintings never have margins. Yes, she said, but this is not a reproduction of a painting; it is a lithograph. The medium is different; it is paper. You wouldn't make the same sculpture in wood, terra cotta and marble. Newman appreciated the point, and characteristically pushed it to a logical extreme. None of his papers would be cut. They would be obtained in certain sizes, printed and then left alone (this meant flying over some fifty sheets from France at one stage of the proceedings). In *Canto II,* for example, the image is given wide, restful, classic margins. In *Canto III*—the same image—the inked stone runs right to the jagged edges, like a rasping cry.

He picked his inks from the wide range Mrs. Grosman had in stock, working with her master printer, Zigmunds Priede, to see how they would combine on the stone. For example, he liked to contrast a green American ink with one made by using French inks, printing yellow over blue. In several works, he used the identical image, varying colors and margins to achieve completely different effects.

Mrs. Grosman remembers that his procedure was to start each of the interior series that make up the eighteen Cantos with an intense color—red at its hottest, reddest; the deepest blue; the densest black. Then he would lighten the color progressively as he developed the series, often planning the maximum contrast of margins between the most closely related prints. It is the same progression that took him from the deep blue of *Cathedra* to the pale cerulean of *Uriel*. I am not sure that Newman's recollection of his interior series is correct: three, seven, eleven, fourteen, eighteen. Fourteen seems logical as a possible stopping point; it was in his mind from the Stations. Eighteen, of course, was always a favorite number. The first three Cantos are obviously a group. *Cantos X, XI, XII* and *XIII* were nicknamed by the Newmans "The Four Seasons," and make one of the most lyrical moments in the series. *Canto VIII* uses the same stones. The last five Cantos all ring changes on the division of the image's width into ¼ -½ -¼ .

The Cantos, then, were not planned as chapters in a preconceived novelistic exercise, but Newman moved in and out of them freely. He could bring back all his colors to this relatively miniature scale, and invent new ones in

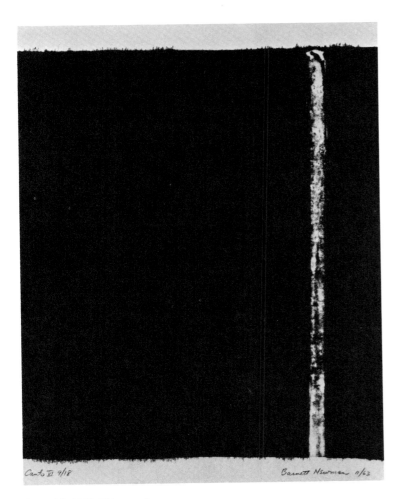

Canto VI. 1963. Lithograph,
14¾ x 12¹¹⁄₁₆ inches (composition size).
Longview Foundation, New York

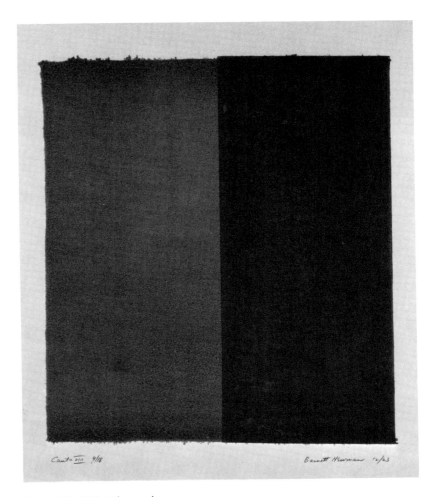

Canto VIII. 1963. Lithograph,
14¹³⁄₁₆ x 13⅛ inches (composition size).
Longview Foundation, New York

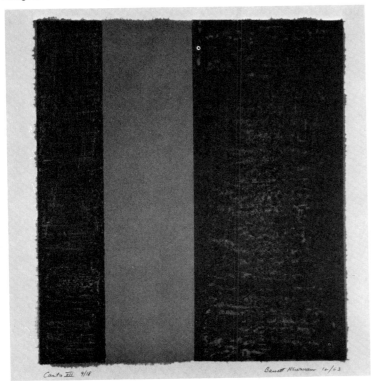

Canto VII. 1963. Lithograph,
14¾ x 13 inches (composition size).
Longview Foundation, New York

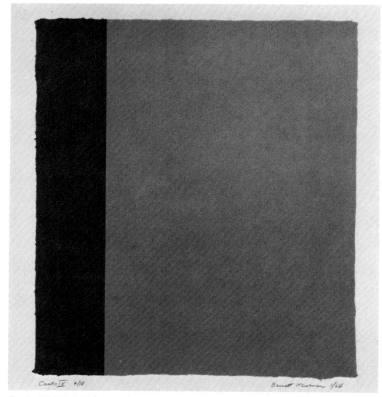

Canto IX. 1964. Lithograph,
14¹¹⁄₁₆ x 13⅛ inches (composition size).
Longview Foundation, New York

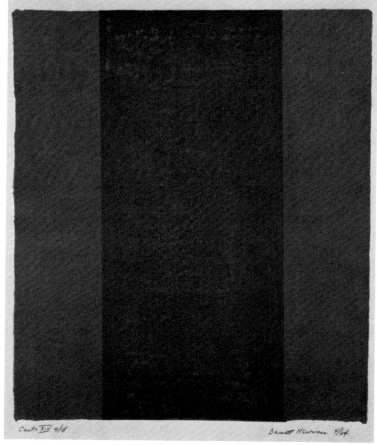

Canto XIV. 1964. Lithograph,
14¹¹⁄₁₆ x 12⁹⁄₁₆ inches (composition size).
Longview Foundation, New York

their contrasts. He could work with craftsmen and people who had a deep respect for materials, and this always pleased and interested him. Among the Cantos, there are moments of deep, solemn color and passages of lacerated, bleeding edge. But the whole impression for me is of an informal, intimate, indeed happy, work.

In the finished "volume," each Canto is presented in an individual folder, and the viewer "reads" the series by turning them over, one at a time, from the right-hand side of the containing leather box, to the left. The layout encourages leisurely looking, underlines contrasts from plate to plate, but discourages wider comparisons of the works beyond recalling the memory of one work to the image of another. Newman wanted them always to be seen flat down and never to be mounted and framed on a wall.

The translation of *Zohar*, according to Scholem, is *The Book of Splendor*—a perfect subtitle for the Cantos. They must have seemed splendid to Newman, for they marked his return to colors.

He dedicated the Cantos to Annalee.

In 1966, Newman stretched a canvas to seventy-five by forty-eight inches, and planned an image which would present a gleaming six-by-four-foot rectangle of red, with a narrow yellow stripe at the right edge and a wider blue one to the left. In 1969 he wrote about the work:

I began this, my first painting in the series "Who's Afraid of Red, Yellow and Blue," as a "first" painting, unpremeditated. I did have the desire that the painting be asymmetrical and that it create a space different from any I had ever done, sort of—off balance. It was only after I had built up the main body of red that the problem of color became crucial, when the only colors that would work were yellow and blue.

It was at this moment that I realized that I was now confronting the dogma that color must be reduced to the primaries, red, yellow and blue. Just as I had confronted other dogmatic positions of the purists, neo-plasticists and other formalists, I was now in confrontation with their dogma, which had reduced red, yellow and blue into an idea-didact, or at best had made them picturesque.

Why give in to these purists and formalists who have put a mortgage on red, yellow and blue, transforming these colors into an idea that destroys them as colors?

I had, therefore, the double incentive of using these colors to express what I wanted to do—of making these colors expressive rather than didactic and of freeing them from the mortgage.

Why should anybody be afraid of red, yellow and blue?[9]

In other words, Newman wanted to use the primaries,

[9] The statement was written by Newman for *Art Now: New York*, vol. 1, no. 3 (March 1969), n.p.

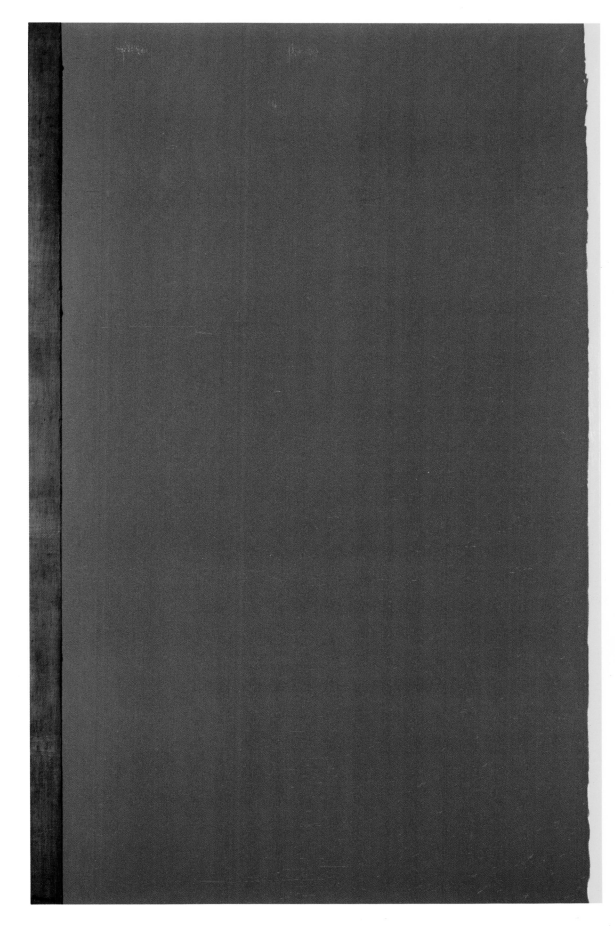

Who's Afraid of Red, Yellow and Blue I. 1966.
Oil on canvas, 75 x 48 inches.
Collection S. I. Newhouse, Jr., New York

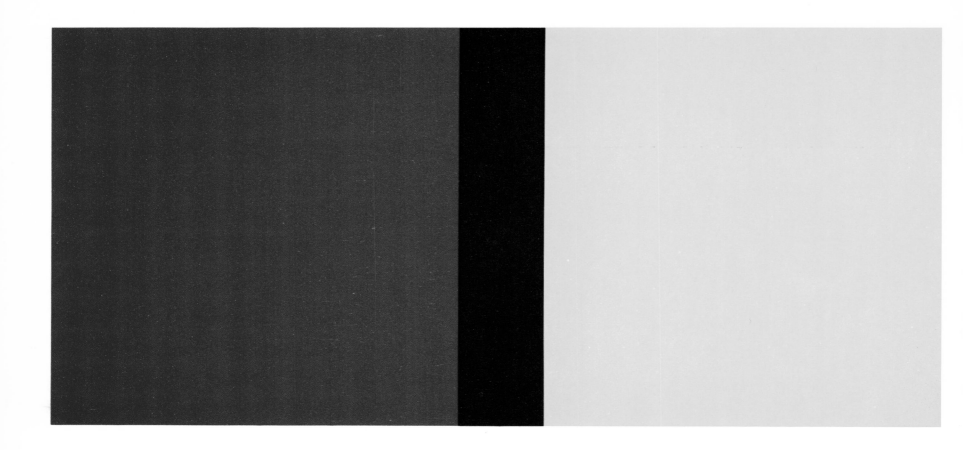

Who's Afraid of Red, Yellow and Blue IV. 1969–1970.
Acrylic on canvas, 108 inches x 19 feet 10 inches.
Estate of the artist

and Mondrian was saying, Good! Wonderful! You *must* use the primaries, so Newman could not use the primaries, but why not use them anyhow, and attack the totem as much as he had attacked the taboo?

The thin yellow band is the aleatory area; its edges are smeared and active (as the orange band had been in *Be II*). The blue, Newman's first use of the color in a painting since *Uriel,* is a translucent ultramarine lovingly smoothed over the white underpainting, making full use of the satiny quality of oil paint. The dominant area is the glowing red. Its flat, blunt surface contrasts with the transparency of the blue, but it is a contrast of similarities, for the red too is emphatically oil paint, layer over layer, brushed to a silk finish. The yellow is the most opaque color of all, and its nervous edge distinguishes it sharply from the cadmium red medium—an orange-red—which chromatically it complements. Thus you have an ardent red six feet high, the height of a man; four feet wide, a natural width to go with the height; and something left over. What is left over—the yellow and blue panels—brings tension and scale to the serene red shape.

It is not a totally new concept for Newman; it relates to the idea behind *Vir Heroicus Sublimis* and *Cathedra* which could be called sixteen-foot paintings with two feet left over, but he has interpreted it in a totally new way.

Who's Afraid of Red, Yellow and Blue II, 1967, is like a tough answer to the dulcet lyricism of number *I*. It is aggressively symmetrical, the knife-edge zips of yellow (at both sides) and blue (dead center) straighten out the quivers in the earlier statement; it is a heroic ten feet high, with a giant's stance, as against the other's "human" six-foot scale. Where *Who's Afraid of Red, Yellow and Blue I* seems painted in caresses of oil, layer on layer, number *II*'s surface is mat, aggressive, all-out acrylic. Newman confronts Neo-Plasticism by using its basic color units in a way that totally contradicts the older style's emphasis on equivalences, nicely wrought balances, pictorial architectonics. The painting is laid open—flat to the surface—as if by three chops of a sword. He also confronts the contemporary painters of the 1960s, pushing even further than they into a composition so evident that it might be called tautological and into colors so intense, pure and physically material that they can carry the conviction of the image. This is the first effect of the painting, but behind it is all the subtlety, emotional nuance and finesse of craft that informs Newman's work and his approach. The primary color contrast, red-orange versus ultramarine, intensifies the center of the canvas—the red flashes redder along the blue zip. The secondary contrast, red-orange and its complementary yellow, brakes and calms the red as it approaches the boundary of the field. Where this action and reaction should make a swelling illusion, it is checked by the mural palpability of the heavy plastic paint and by the "classic" size and pro-

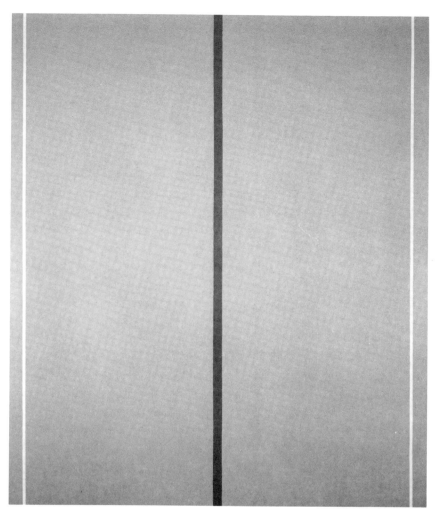

Who's Afraid of Red, Yellow and Blue II. 1967.
Acrylic on canvas, 10 feet x 102 inches.
Estate of the artist

Yellow Painting. 1949.
Oil on canvas, 67 x 52 inches.
Collection Annalee Newman, New York

portions of the canvas.[10] The radical format of this painting alludes to the lyric, intimate *Yellow Painting,* 1949.

Newman's next painting in the series, *Who's Afraid of Red, Yellow and Blue III,* 1966–1967, was begun before number *II.* It is, like *Vir Heroicus Sublimis, Cathedra* and *Uriel,* in his maximum size, approximately eight by eighteen feet. His idea was to see if he could stretch the svelte, oil, cadmium red center of *Who's Afraid of Red, Yellow and Blue I* to the full length of the format (as he had stretched the colors across *Horizon Light,* 1949), leaving a few inches of translucent blue at the left and just an edge of yellow to the right (as in the first picture, only here the yellow is evenly stroked and cleanly masked). The red moves across the friezelike horizontal ground like a burning fuse. It is a rather slow motion; you are drawn in close to the picture; it surrounds you; your kinesthetic reaction is to watch the red act as you turn your head. It is not a painting that can be taken in at a glance, as against *Who's Afraid of Red, Yellow and Blue II,* which stamps itself on the mind in an instant, and only later unfolds a delicate substructure. The slow, almost narrative process informing the red in *Who's Afraid of Red, Yellow and Blue III* is contradicted by the luscious oil-paint surface, which tends to hasten the vision, as if it were sliding across ice, and also by the blue and yellow bands which stretch the red between them. The tension between speed and slowness, between impact and aura, is further heightened by chance variations of texture across the red surface. They are human touches in a larger-than-life image: they add scale; they heighten the quality of intimacy by urging the viewer in even closer to read them. The monumental, full-strength painting also has a strange vulnerability and poignance.

As if to counter this very quality of the lyric, Newman prepared his largest canvas to date, *Anna's Light* (nine by twenty feet), in which he presented an eighteen-foot cadmium red rectangle painted in flat, hard, mat acrylic. Eighteen feet—that is, two nine-foot squares (there were two eight-foot squares in *Cathedra*), side by side with no division marks, and what is left over is apportioned to two white bands, one-quarter to the left, three-quarters (that is, eighteen inches) to the right. The white paint seems to anchor the red onto the surface, instead of letting it seem to spring free, as might be expected. I believe this is because of the basic stability of the nine-by-eighteen-foot rectangle and of the cadmium red acrylic color—the two make an uncanny fit; the form stands in front of you as solidly as a steel construction plate. The white white edge-bands shine with the faintest blue cast,

picked up as an after-image from the adjacent orange-red.

The series ends with *Who's Afraid of Red, Yellow and Blue IV,* which Newman began to paint in 1969 and finished in the spring of 1970. The painting is nine feet high, the same as *Anna's Light,* but now two nine-foot squares are separated—red to the left, yellow to the right—with twenty-two inches of blue in the middle.

He affixed a twenty-one-by-twelve-foot canvas to his painting wall. Then, two coats of acrylic gesso were rollered on, Newman carefully wiping the surface to get the even texture he wanted. Four vertical masking tapes were applied, and Newman studied the painting for hours—indeed, he decided to do another picture sometime in the future, with the same dimensions and with four yellow zips on white where the tapes were placed. His art grew out of his art in this fashion; he was able to keep surprising himself, to interrupt an action, and to find a new image in a moment of revelation, preceded and followed by hours of concentration and contemplation.

The first color, acrylic cadmium yellow light, went on easily and in two coats covered the primed cotton duck, so that the color would count as paint and not as a stain. Two coats also were all that was needed for the acrylic thalo blue. But the cadmium red light was a problem: it dried too fast and left visible ridges. Newman tried to put on the first coat with a roller, but the paint formed bubble marks in the sponge rubber. In several months of work, fifteen coats were peeled off with wooden scrapers, and in time about five final coats were applied to get the effect Newman wanted. Then he went over the surface with his brush, masterfully covering the whole area with even upward strokes.

The two nine-foot squares are not apparent; they are hidden, as they were in *Vir Heroicus Sublimis,* and as soon as you see them they tend to get lost again under the spell of the intense colors. The twenty-two-inch column of blue is like a waist, or an area under extreme pressure—and one is reminded of *Tsimtsum* and what the concept of inward, contracting pressure meant to Newman. Perhaps the three earlier works in the series, as well as *Anna's Light,* represent the expansive moment of "Day One," a return to the drama of Genesis itself. If so, it is a sunnier, more festive vision of that solemn act, and one remembers that, according to the *Zohar,* there is joy in creation. In the chapter "How to Stand before God," we read: "Joy is a secret name of the Community of Israel, and there will come a day when Israel shall go out of the exile by means of joy, as it is written 'For ye shall go out with joy' (Isa. 55:12), and hence it says, 'Serve the Lord with joy.' It says also 'Come before his presence with singing.' Thus the joy is made complete, for the heart holds joy and the mouth holds the song." (This quotation is from a copy of the *Zohar,* edited by Gershom G. Scholem, which Newman had in his library.)

In 1968–1969, Newman was planning his first New

[10]Anyone who searches even casually for the number eighteen in Newman's art will find hundreds of instances. In this painting, for example, the difference between its height, 120 inches, and its width, 102 inches, is eighteen. A favorite game of the Kabbalists is called Gematria; it refers to how they decoded words to numbers and numbers back to words in order to find hidden meanings in the sacred books. But all evidence indicates that Newman never indulged in such exercises, even though he did consider eighteen *his* number.

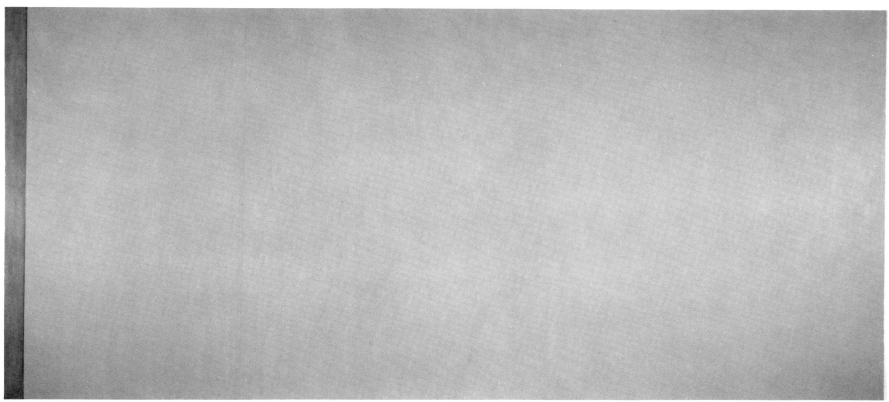

Who's Afraid of Red, Yellow and Blue III. 1966–1967.
Oil on canvas, 96 inches x 17 feet 10 inches.
Stedelijk Museum, Amsterdam

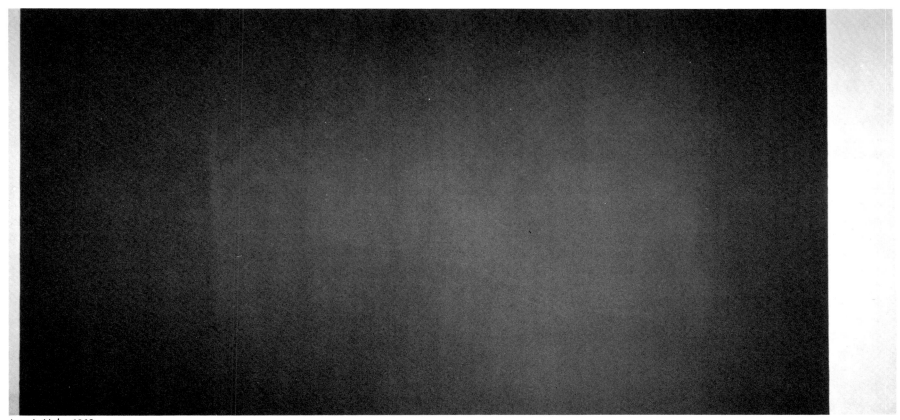

Anna's Light. 1968.
Acrylic on raw canvas, 9 x 20 feet.
Estate of the artist

Jericho. 1968–1969.
Acrylic on canvas, 106 inches x 9 feet 6 inches.
Estate of the artist

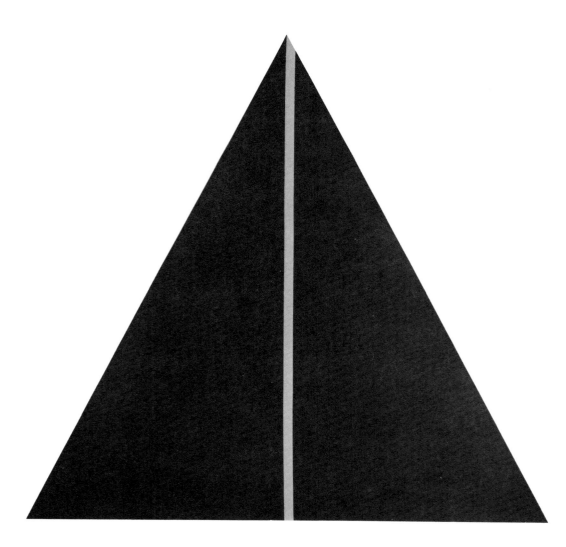

York one-man exhibition in ten years, at Knoedler, and he wanted to get a number of ideas on canvas. There was the yellow on raw canvas image of *The Moment II;* the black-red-black trisection of *The Way II,* which we shall discuss later; and two paintings that came to him while he was working on *Broken Obelisk.* He had a glimpse of two triangular paintings, the size and shape of the pyramid faces as they were being locked into the structure. It will be remembered that the faces of the pyramid in *Broken Obelisk* have a nine-and-one-half-foot base; the height of the triangles is nine and one-half feet; and the angle at apex is fifty-three degrees. Newman ordered his first triangular canvas to be stretched to nine and one-half feet at the base; he slightly narrowed the angle at apex, and he reduced the altitude to eight feet ten inches. In other words, he figured that by lowering the altitude, he would approximate the perspective effect of a plate leaning away from him, into the pyramid.

His aim, as always, was to "break the format"; "to do a painting without getting trapped by its shape or by the perspective," was the challenge of the triangles. "It was only when I realized that the triangle is just a truncated rectangle that I was able to get away from its vanishing points,"[11] Newman wrote.

In other words, he treated the surface as if it were a rectangle, and in the first of the triangles, *Jericho,* he painted a black field and dropped a cadmium red medium zip down the center, bisecting the figure along the zip's left edge. The strategy was not unlike the one he had used for his first secret symmetry, in *Abraham,* also a black painting.

The height was brilliantly chosen; in a reproduction or photograph, *Jericho* does not escape from perspective, but in life, at the over-human size of almost nine feet high, it establishes itself as a field containing a sparkling presence that also splits the dark surface.

The second triangular stretcher was ordered at the same time, and here Newman kept the base at nine and one-half feet, but increased the height to ten feet. He used his red, yellow and blue colors and a straight symmetrical format, dividing the triangle into vertical quarters, the blue zips lapping over the quarter-lines so that the outside reds are a bit wider than the inside yellows. He discovered, in other words, that he could fit his image into the triangle as if the shape were a rectangle with its top corners chopped off; symmetrical changes kept their place within it, stabilized by the centered apex of the isosceles.

His initial approach to the problem, which at first seemed a risky move into the 1960s "shaped-canvas" area, is instructive. As has been mentioned, while setting up the *Broken Obelisk* he had had a glimpse of a painting in the triangular faces; and as the image grew in his mind, he decided to capture it. But where had it come

[11] Barnett Newman, "Chartres and Jericho," *Art News* (New York), vol. 68, no. 2 (April 1969), p. 28.

from? Was it really while the faces were being set in place? Or was it during the work of assembly, when he had seen them tilted forward? He thus ordered his two canvases stretched roughly to the same size as the steel faces, but one of them (*Jericho*), shorter, as if seen in vanishing-point perspective, going away from the viewer, and the other (*Chartres*), taller, as if foreshortened and leaning toward you. You might say that Newman bracketed his glimpse as an artilleryman will bracket a target. In the first triangle, he emphasized the running, receding speed of perspective with the red zip shooting up and down to make a new, "sharper" angle at the bisected apex. In the second, the inside yellows loom upward, reinforcing the allusion to foreshortening (an allusion which only Newman could understand, as only he could refer it to its correlative, the steel triangle in *Broken Obelisk*).

If the base of an isosceles triangle could support an image of a rectangle, Newman's next move would be to get rid of this crutch and attack a more difficult triangle. After considering the problem for about a year, he found what he was looking for in the second of his triangles—and he ordered two stretchers of right triangles, the hypotenuse at the left, like the red shape at the lower left of *Chartres*. They were in his studio, untouched, at the time of his death, like strange white sails.

Newman's answers to the questions posed by his art have seemed simple—overly simple—to many people. It is the old story of "just a stripe in the center." But try to imagine how he would "break the format" of his right triangles. The apex is at the right edge. The center of the base-line is lost, visually, along the expanse of the hypotenuse. Where would he make his divisions? What colors would he use? I, for one, can suggest no satisfactory solution; I can not imagine how he would have done it. Yet, I am sure that, once finished, people would say, "Of course," which would imply, "So what."

Newman finished the two triangles shortly before his exhibition at Knoedler. He titled the first one *Jericho*, referring to his 1950 painting, *Joshua*, with its cadmium red stripe, and to the deep red painting, *Covenant*, 1949 (Joshua's covenant with the Lord and the people's testimony to it). I have suggested that he also might have been punning on Géricault, whose *Raft of the Medusa* had deeply impressed Newman on his first visit to the Louvre; the *Raft* has an emphatically triangular composition, at the apex of which is a black man. The second triangle is titled *Chartres*, after the cathedral which Newman had made a special effort to see on his first trip to France. Newman's invocation of northern light and Gothic feeling in *Chartres* strengthens the possibility that there might be a French interpretation to the other triangle.

Shortly before his show at Knoedler, Newman also undertook to make some etchings. He asked Tatyana Grosman (who enthusiastically backed the project) for

Chartres. 1969.
Acrylic on canvas, 10 feet x 9 feet 6 inches.
Estate of the artist

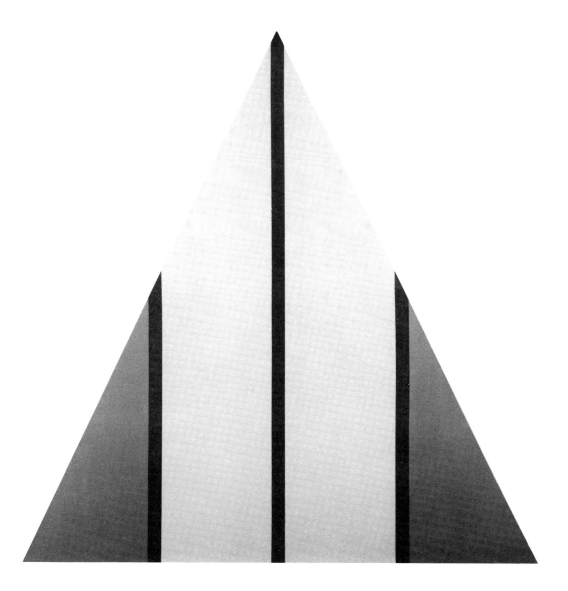

Notes. 1968.
Eight plates from an unpublished portfolio
of eighteen etchings and aquatints.
Collection Annalee Newman, New York

a group of small copper plates, which she delivered in June 1968; he bought an assortment of burins, roulettes, scrapers, and the like with great pleasure, for he loved to shop in hardware and art supplies stores, and he began to teach himself the technique. Eighteen etchings were printed and titled *Notes;* Newman planned to write a brief statement about them and William S. Lieberman of The Museum of Modern Art, an introduction; and the *Notes* were to be published as a little book in a very limited edition, as befits a modest project (which was only to be realized posthumously). No matter how "minor" these works may be, they are compelling; they offer hour by hour evidence of how an artist makes himself familiar with a new medium. In the first *Notes,* Newman simply trisects the plate into sketchy areas and fills each one with the cuts, scrapes and gouges particular to each tool. In the next group, he discovers what these marks can do: he tries various kinds of hatchings and crosshatchings, parallel lines, lines crossing at right angles, diagonals, diagonals superimposed on right angles. Then he tries a few simple images, trisecting the plate with a black band standing against a white area; trying it black on black, wiping the plate to get a black on gray. He constructs a hard-edged band, and a plumed one with scratches spraying from it. He reverses images, prints them upside down.

The *Notes* are like a diary, a series of private memoranda, jottings to oneself. When he finished them, he put aside the proofs, evidently not even studying them carefully, and moved straight into two large etchings. The first is a horizontal, symmetrically trisected (in his duodecimal system), reminiscent of *Shining Forth,* with a hard black zip to the left, a wider one in the center and, to the right, a feathery, gentle one in which a thin white of "reserved" paper reads yellow as it is defined by pulsing black contours. The second is a vertical trisection, white, black, white, in which the concentration is on the depth and velvety quality of the deeply cut and etched center. A third plate remained untouched in his apartment after his death; it was to be a black on black version of the second etching.

Newman's exhibition at Knoedler in 1969 was the first since 1959 in which a large body of his recent work had been brought together, and the first time he had included in a one-man exhibition pictures done since 1953—although the bulk of the works dated from 1965 to 1969. He wanted, he said, "a show of the '60s." It revealed him working in a greater variety of ways and with greater energy than ever before, and most of the New York artists' community was moved and impressed by his accomplishments. As could be expected, however, some of the more rigid formalists decided that his only truly important pictures were those done in the late 1940s and early 1950s, and of course the critics who always fight modern painting continued to attack him. The classic split between the artist and his public was reestablished, but

with the ironic twist with which history likes to embellish such replays. The conservatives still detested him. The modernists who had been influenced by Abstract Expressionism accepted him. And the champions of color-field 1960s abstractions, which Newman had so deeply influenced and inspired, now reversed their earlier ideas and denigrated his contributions. But these attitudes were largely common among critics and curators. The artists were for Newman. And, filled with confidence in his own work, he struck blithely ahead.

Nineteen sixty-nine was a difficult year, however; Newman had to move out of his old Front Street studio (the beautiful 1830s structure was being torn down to make room for a glass and concrete office building), and by the time he got settled in a new place, on White Street, and had his materials and works in progress transported, months had been lost. He had decided to accept an invitation to have a retrospective at The Stedelijk Museum, Amsterdam, and the project grew to include The Grand Palais, Paris, The Tate Gallery, London, and the Museum of Modern Art in New York. He was eager to have a group of new works for the show, to realize a number of projects that he had been contemplating in the studio, and also to open up some new ideas. Thus the last works he completed are an extraordinarily complex and varied body of paintings, prints and sculptures, a number of which have only been adumbrated in these pages.

Five skeins of motif can be unraveled in the late pictures, for the purpose of analysis only, for no simple A to B to C progression exists in Newman's work. The red, yellow and blue pictures have been discussed already. Then there are pictures in black and/or white, blue pictures, red and blue pictures and red pictures. Before examining them, however, a few generalities can be drawn from this 1965 to 1970 group. Almost all are done in acrylic paints. Newman did not enjoy this medium as much as he did working in oils. He used to say it was similar to pulling a ball of rubber cement across the canvas. The material seemed to resist spreading across the large dimensions he preferred, and he had little of the sensuous "feel" for it that he had for oils. He wanted saturated, opaque colors and even surfaces without uncontrolled variations of shine or handwork. This move, as has been noted, might be considered a confrontation with, or a parallel to, the color-field painting which had become famous in the mid 1960s. There is a similar largeness of statement, positiveness of presence, assertion of big color masses in sharply defined shapes. He abandoned the aleatory zone in these pictures. But Newman's work is basically private in subject matter, moral in its choices, subjective and tragic in mode. The works of the younger artists of the 1960s, it seems to me, are in the main public, hedonist, objective, and theatrical—and I do not mean this in a pejorative sense. (Good and bad paintings, obviously, can be made in any mode.) Perhaps the

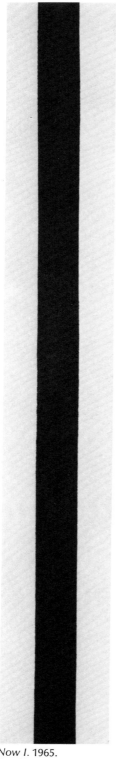

Now I. 1965.
Acrylic on canvas, 78 x 12 inches.
Estate of the artist

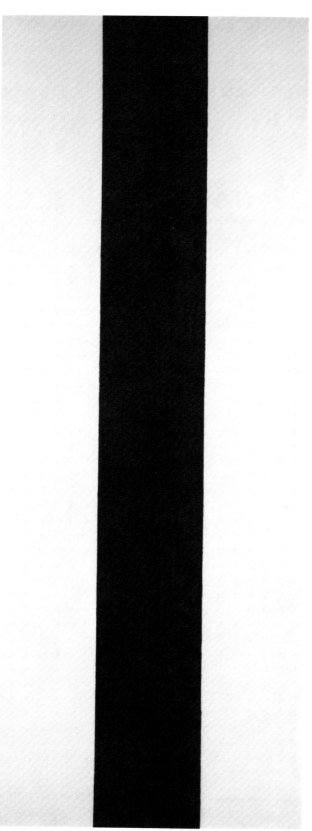

Now II. 1967.
Acrylic on canvas, 11 feet x 50 inches.
Collection Mrs. Christophe Castro-Cid, New York

White Fire IV. 1968.
Acrylic on canvas, 11 feet x 50 inches.
Estate of the artist

best way to state it is that Newman enjoyed intellectual sparring with other art; he believed in the community of artists and that the most important role of such a community is to encourage a mutual testing of ideas and of aims. Artists could answer each other in paintings—even wipe each other out—that was the point in having a community. It made possible an intellectual ferment.

The first of the five skeins in Newman's late work, black and white, is announced in *Now I,* 1965, six and one-half feet high by one foot wide, a format reminiscent of *Outcry* and of the dark red and lighter red untitled painting preparatory to *The Wild,* 1950. Where the 1950 painting had been trisected along Newman's first ideas of secret symmetry—with half the picture in the center band and a quarter of the width on either side— *Now I,* in flat acrylic black and white, is coolly trisected into thirds, the black central band seeming to push against, and simultaneously to slip under the hard white sides. In *Now II,* 1967, Newman increased the height to eleven feet and then enlarged the proportion of the base to fifty inches. He kept the black in the center but by widening the rectangle slightly, braked its velocity. Finally, *White Fire IV,* 1968, is like a negative of *Now II;* its dimensions are the same, but it is white on white.

Voice of Fire, 1967, brings this vertical format up to Newman's favorite eight-by-eighteen-foot dimensions, retains the precise trisection, but uses deep blue in the sides and dark red in the center. (This is the only time that Newman used the eighteen-foot dimension for a vertical painting, and he had practically no hope of exhibiting it as there are few ceilings high enough to accommodate it. By a happy chance, however, he was invited by Alan Solomon to show it in Buckminster Fuller's United States Pavilion at Expo '67, Montreal, and the picture was seen there and later in Boston.) *Voice of Fire,* with its dense, majestic colors, stands in the middle of this series like a crossroads.

Blue, it will be remembered, was absent from Newman's palette from the time of *Uriel,* 1955, until the appearance of the luminous blue edge in *Who's Afraid of Red, Yellow and Blue I,* 1966. In 1967, the color, which seems to have represented the light of the vision of the Throne for the artist, becomes a favorite again. He used it at its deepest and most resonant in *Queen of the Night II,* 1967, and the allusion is no coincidence, for Mozart represented to Newman the highest, purest level of creativity attainable by man. The second version of *Queen of the Night* echoes the first one, but the first is a narrow 1 : 6 vertical; the proportions of the second are 4 : 9, and it is a foot higher. The resemblance is strong enough to suggest that Newman wanted to stand on ground that was sure and familiar for his first blue painting of the 1960s. His next one, *Profile of Light,* 1967, is a trisection, ten feet high, with three bands, blue, white, blue, each twenty-five inches wide. And it is logical to assume that the eighteen-foot-high *Voice of Fire* followed this bright

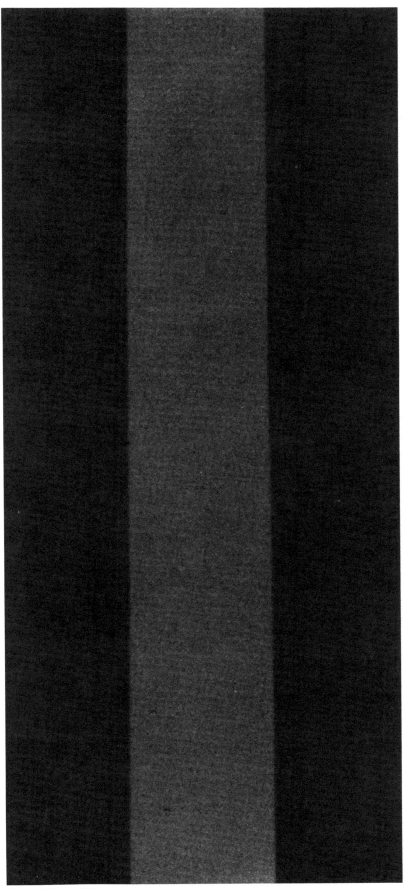

Voice of Fire. 1967.
Acrylic on canvas, 17 feet 10 inches x 96 inches.
Estate of the artist

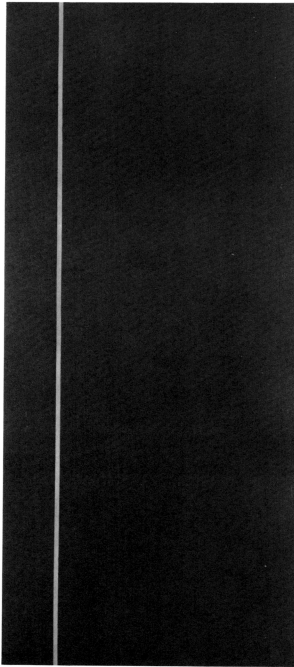

Queen of the Night II. 1967.
Acrylic on canvas, 108 x 48 inches.
Estate of the artist

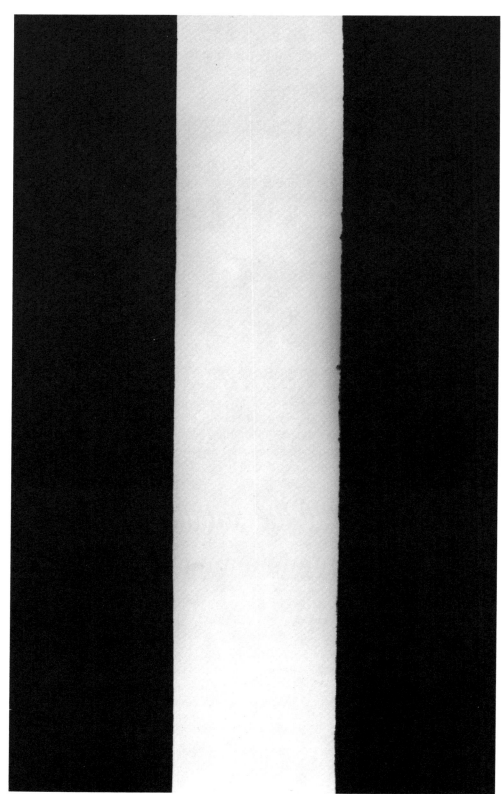

Profile of Light. 1967.
Acrylic on linen, 10 feet x 75 inches.
Estate of the artist

image. *Voice of Fire* is somber; *Profile of Light* has the glints of a winter dawn. This shifting back and forth in emotional content while pursuing a single formal target is characteristic of Newman's invention. In his next blue picture, *Shimmer Bright*, 1968, he goes back to the allegro mood. He also returns to the idea of presenting an invisible square—and to oil paints.[12] The painting is divided from the left by a white band, a blue band, a white band and a blue band; each is exactly three inches wide. The remaining white space is six by six feet. Here the "secret" structure underlying Newman's painting should be at its most evident—like a sonnet in which hard-hitting rhymes emphasize the *a,b,a,b,* pattern, but nothing of the sort happens. Very few observers even recognize the square at all (the perceptive Barbara Reise is one who did[13]), much less the measure established by the blue and white bands, which quarter the left-hand section of the painting. The image looks intuitive, a "felt" positioning that looks right—and so it is—just as a Mozart rondo sounds right. The final vision of the image obscures the machinery within it. We see the skin of art. The force of the image creates a sympathetic echo in the viewer's mind, which informs him of the subject matter, but there is more behind it, just as we have seen that there is more behind *Tsimtsum*.

Newman's next blue painting, *Midnight Blue*,[14] was started in oils in the Front Street studio and moved, unfinished, to White Street. There were considerable difficulties in getting it going again, First Newman mixed a batch of egg-tempera color, but it "just slid off." Then he tried acrylics, a thalo over a cyan blue, and for the zip at the right, thalo blue over zinc white, later repainted in oils. During this process, the picture had to be discarded and begun again from scratch.

Here again, Newman presents an invisible square, this time in the left-center of the image, marked by a white band at the left and the shimmering blue zip to the right. And the two last paintings Newman finished also relate to this blue group. Untitled (number 1), 1970, echoes the format of the red *White and Hot* in smaller dimensions, the cerulean- and thalo-blue central shape glowing with an opposite fire. Untitled (number 2), 1970, sets a deeper, denser blue next to the weighty red-brown of cadmium red dark—one-third blue, two-thirds red.

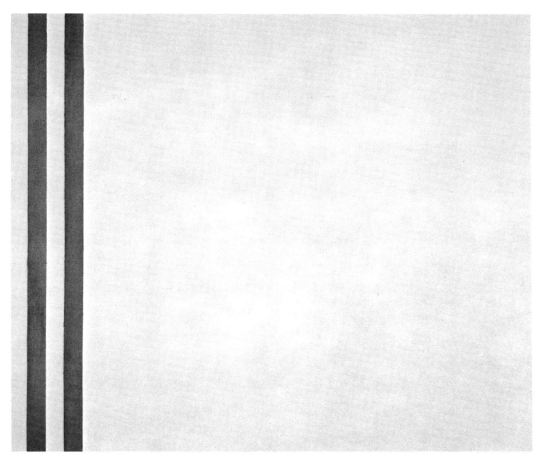

Shimmer Bright. 1968.
Oil on canvas, 72 x 84 inches.
Estate of the artist

[12]*Shimmer Bright* spells out, so to speak, the invisible square within the rectangle of *The Voice*, 1950. The "invisible" side of that square, it will be remembered, was an imaginary bisection between a zip and the right edge of the canvas. In *Shimmer Bright*, the bisection is made real.

[13]Barbara Reise, *op. cit.*, p. 37.

[14]*Midnight Blue* was titled by Annalee Newman after the artist's death. "Midnight" was the name, according to the *Zohar*, by which David addressed the Lord, a fact of which Annalee was *not* aware, thus indicating the dangers of using Kabbalism in a loose way to interpret Newman's work. The linguistic exercises of Jewish mysticism are so vast that they can easily embrace any corpus of work, especially abstract painting, which lends itself easily to interpretations with numbers. In this text, I have restricted myself to following leads into Jewish mysticism which were given overtly by the artist himself.

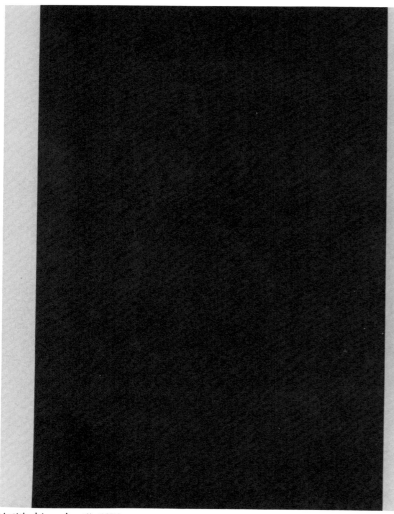

Untitled (number 1). 1970.
Acrylic on canvas, 77½ x 60 inches.
Estate of the artist

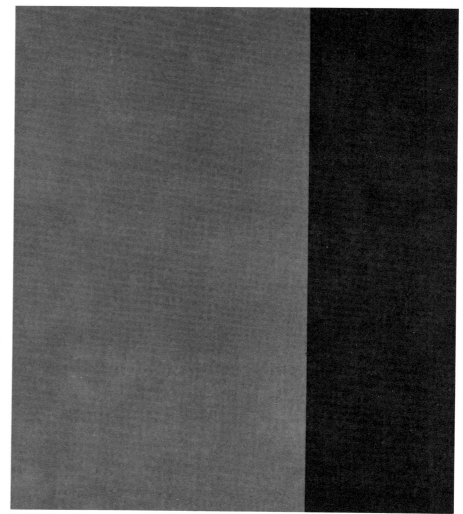

Untitled (number 2). 1970.
Acrylic on canvas, 76 x 84 inches.
Estate of the artist

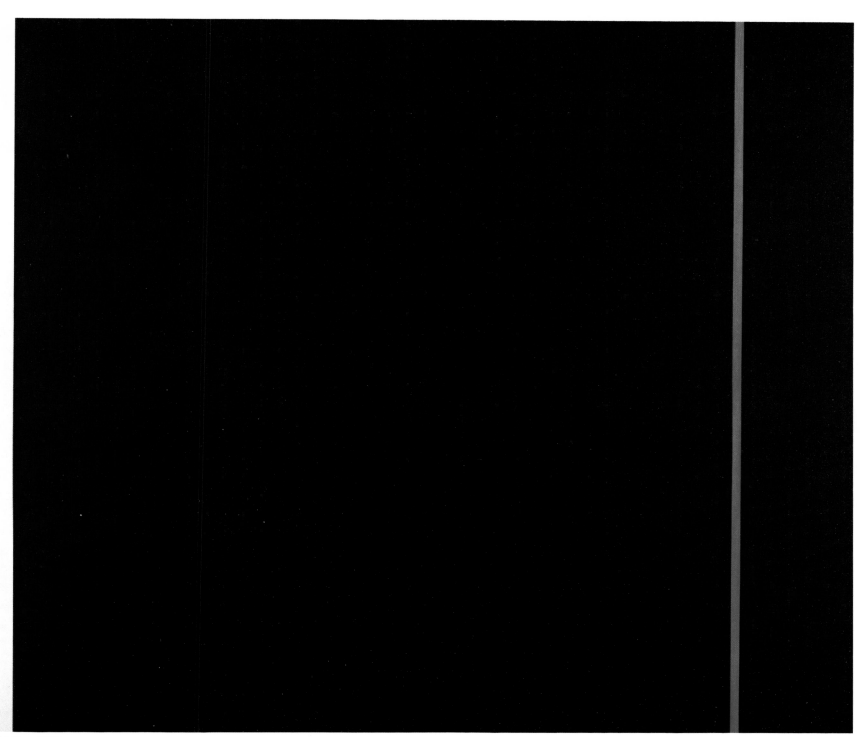

Midnight Blue. 1970.
Oil and acrylic on canvas, 76 x 94 inches.
Estate of the artist

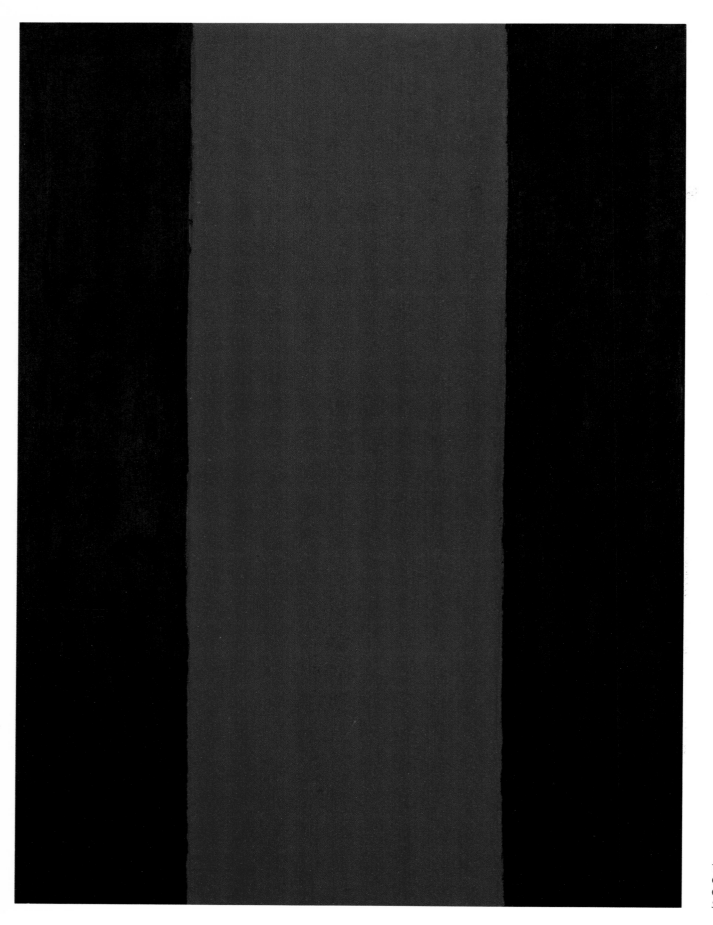

The Way I. 1951.
Oil on canvas, 40 x 30 inches.
Collection Annalee Newman, New York.
See pages 78ff.

Red-brown, Newman's color for *Adam, Onement, Vir Heroicus Sublimis*, meets, in this last finished painting, the deep celestial blue: Newman's vision of the Throne, *Cathedra*, the light of God facing and faced by man—Heaven and Earth.

The last picture contains a new kind of blue, a new tone in Newman's work, and he was excited by its discovery. His blues had been getting paler, as they had in the 1950s and in the Cantos, until he reversed the process, moving to another, more sapphire hue in *Midnight Blue*, and finally to his last and newest rich azure.

The fourth skein of motif in these late works is red, and again is introduced in that crossroads painting, *Voice of Fire*. In 1969, Newman made a larger version of *The Way*, titled it *The Way II*, and again divided the image into three columns, black-red-black. He had also long had in mind painting a new version of *Be I*, which had been damaged in 1959. Again he chose a larger format than the original painting, and in the spring of 1970, covered the nine-and-one-third-by-seven-foot canvas with the most intense cadmium red dark he could find and dropped the razor-thin zip down the center.

This move, I believe, was preparatory for a big red and red painting in his eight-by-eighteen-foot dimensions. He wanted to get the "feel" of a massive red ground, to grasp its scale, so to speak. The large canvas was prepared with a white ground and a square of cadmium red dark placed in the center. The sides, each five feet wide, were to be painted a lighter red. It would have been the first painting of its kind in Newman's work, but it also relates to the central square in *Vir Heroicus Sublimis* and is a fugal inversion of *Who's Afraid of Red, Yellow and Blue IV*, where the two squares are on the outside.

After Newman's death, the painting stood in his studio like a great lighthouse, an unblinking red square flanked by the unfinished white sides, the image surrounded by neatly taped sheets of brown wrapping paper, the floor protected by layers of newspaper. In the studio upstairs, the three last blue pictures hung against white walls. Downstairs, *Who's Afraid of Red, Yellow and Blue IV* stretched with the grace of an athlete, a north light evenly illuminating its monumental presence.

Newman's career was tragically interrupted. There were the sail-shaped right triangles stretched and waiting for him. The large red picture was about half-finished. The black-on-white etching plate was prepared for work, and he was about to return to an eleven-foot-by-fifty-inch black picture which had resisted all his experiments. He had tried a velvety black of Duco enamel, but it turned out to be so velvety that it showed the slightest mark when it was touched. He tried egg tempera and oils and was experimenting with different acrylics. There was the twenty-foot-wide yellow painting he had seen in the taped stage of *Who's Afraid of Red, Yellow and Blue IV*. Also, he had decided to go back to *Broken Obelisk* and make a new version, thirty-six feet

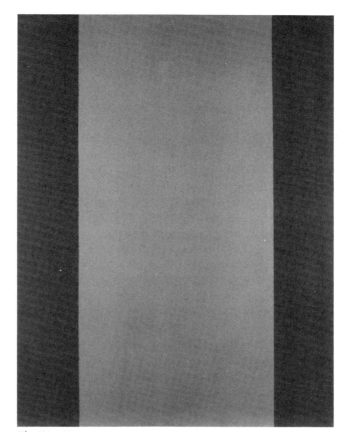

The Way II. 1969.
Acrylic on canvas, 78 x 60 inches.
Collection Annalee Newman, New York

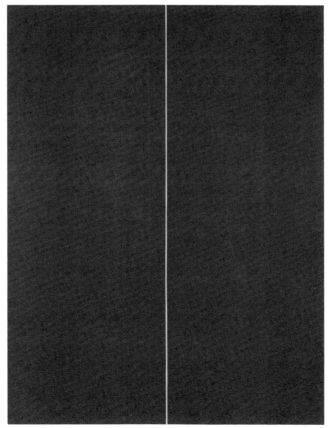

Be I (Second Version). 1970.
Acrylic on canvas, 9 feet 3½ inches x 84 inches.
Estate of the artist

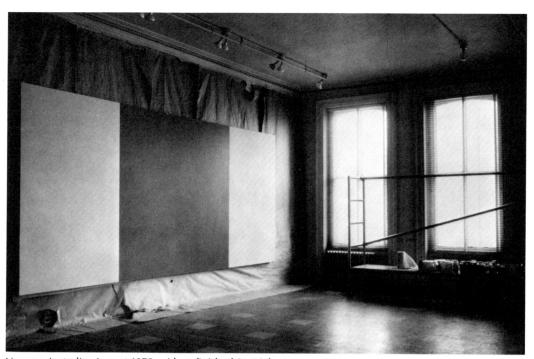

Newman's studio, August 1970, with unfinished 8 x 18 foot canvas.
The center square had been painted red and the sides
prepared with white ground for painting in another, lighter red.
Photograph by Alexander Liberman

high, which would mean shifting all its proportions and making a new cut for the top of the obelisk's shaft. In a drawer, Annalee found a drawing for a sculpture that might have been titled *Here IV*, a steel piece with four evenly spaced vertical elements. These are only the unfinished works about which we know from documentary evidence. Newman did not discuss projects while he was working on the ideas behind them. We can assume that at his death many of the most surprising and daring paintings vanished, for he was in one of his most productive periods and hated each moment he had to spend away from his studio.

It was in the studio that these extraordinarily complicated and interrelated paintings were conceived, changed, abandoned, picked up again, tried out, discarded, attacked anew, finally executed—painted with that deft, steady, knowledgeable, sensitive stroke of which Newman was the master. It was there that the artist decided on the size of his painting, prepared his canvas, analyzed the relationships within his image and then thought about it for hours that could turn into years.

It is to the studio we must return to think about Newman's work—that extraordinary group of paintings which lead us from one to another, which lose us in a labyrinth of possibilities and whose interrelationships seem to present an unassailable complexity. The works, seen together (Newman detested the word "œuvre"), anticipate, overlap and recall each other; they compose a vast metaphor for the weaving and winding of all things, in likeness and in change.

Looking back at them across twenty years, they can, with some difficulty, be fitted into progressions and permutations; each step can be made to seem the inevitable consequence of a previous move. And yet . . . and yet it is impossible for us to predict even an inch of the path he would have taken next, after the skeins we hold have been broken, even though we know more than half of the way to the next step. How would the big red and red painting have looked? Or the black eleven-footer? Or the yellow on white picture which must have stood, for an instant, in front of Newman as he prepared *Who's Afraid of Red, Yellow and Blue IV?* Following his lead, we can see how the last blue pictures evolved out of *Queen of the Night II,* and how the reds were picked up from *Voice of Fire.* It is easy to look backward, but the fact that we cannot see forward, at all, in Newman's work must underline the inevitable oversimplifications in our analyses. It is easy to look backward; it is impossible to see ahead.

There were no skeins or progressions in the studio. There was a painting, then a painting, then a painting. Each one was a new start, just as when you flip a coin a hundred times in a row and it turns up tails, your next toss is still fifty-fifty against heads. There is no predetermined image. Like Joyce or Ingres, Newman kept his past in his head. His work grew into a world where other

works could grow—where *The Way II* answers *The Way I* through the mediation of *Now II*. It is a magic world where orange turns into blue, where widths turn into heights and fractions slide from thirds to quarters to eighteenths to halves.

In the studio, there are rolls of canvas, shelves of paint, buckets to mix it in, rows of paintbrushes hanging hairs-down, attached by rubber bands to the sides of ladders and the pipes of scaffolding. On a table there are piles of rubber gloves, for there is a ritual that demands that brushes be washed in plenty of water for about an hour and a half at the end of every working day. There are visors against the sun, paint scrapers, rollers, solvents, mediums, hand tools and power tools of every description, in an abundance that can be understood only by an artist who has had to pawn his wife's wristwatch in order to keep at work.

This is the New York artist at work, in a loft-space that used to contain light industry, set among streets still lined with the factories where dolls' heads are manufactured, TV parts assembled and books printed.

Here is where the artist makes the paintings and the paintings make the artist. Other artists move in and out of the highly charged field. There are the figures from history—Michelangelo (whose masterpiece also interpreted the moment of Genesis), Géricault, Cézanne, Matisse and Newman's friends Pollock, Gorky and Hofmann. There are his colleagues and his younger friends—all artists. This is enough material for any artist—his own work, plus the works he knows. The studio is filled with it.

The studio is where he is most at ease, most himself, facing his finished pictures, everybody else's pictures, his works-in-progress.

Where, then, is the place of Jewish mysticism, the cosmologies of Ari Luria of Safed, the discussions between Rabbi Isaac, Rabbi Judah and Rabbi Simeon ben Yohai in all their Midrashlike finery that are recounted in the *Zohar*, the visions of White Fire, Black Fire, The Gate, The Way, Covenant, Primordial Light?

Did Newman accept this difficult, traditional approach to the spiritual as part of his identity as a Jew? Did he, like Mallarmé, work on the assumption that God exists because He is the highest creation of man?

Or did he, like Valéry, envision a new *civitas mundi,* which "is not based on the beyond but on the here and now; it draws its strength not from sentiment and opinion but from facts and necessities. Its domain is nothing but the earth; its constituents are men, races and nations; its creative moral force is culture; its creative natural forces are place and climate; its guide is reason; its faith is the intuition of order."

Or was Gershom Scholem nearer the truth when, in Jerusalem, he gave a lecture on "The Possibilities of Jewish Mysticism in Our Day"? Scholem began, according to Herbert Weiner, by declaring that "all of us are anarchists." But, could there be a mysticism of individuals? It might be, said Scholem, that the impulses which in other generations were involved with religion, are today to be sensed in some secular phenomena. He was at a loss for examples, but cited Walt Whitman. "Mystical impulses," he said, "are deeply rooted in the human psyche, only in the future they may be clothed in a naturalistic, rather than a religious consciousness—a consciousness which on the surface will not be related to traditional religion."

Certainly Newman was not involved in any of the orthodoxies or tribal customs of the Jews—no artist is less ethnic. He was the American cosmopolitan, mid-twentieth century.

Could Scholem have found in his paintings—in the veiled symmetries, hidden squares, abstract invocations of the primal forces of contraction and expansion, of systole and diastole—the renewal, from a totally unexpected quarter, of a transcendental experience that has survived for twenty-five hundred years?

Newman studied nature with passion—botany, geology, ornithology—and from such fascinations did he arrive, in Thomas Mann's phrase, at "the mystical or intuitive half-mystical into which human thinking in pursuit of nature is almost of necessity led?"

From this attitude did he turn to the poetry of his heritage for a source of images, colors and insights into the structure of the universe? And, as he moved his art to the sphere of "world thought"—where he felt modern painting must act—did he transcend the poetry of the Kabbalists, just as he transcended the geometric shapes of decorative art? His paintings and sculptures are beyond symbols.

I have no answer to the questions posed in his subject matter; I can only suggest a few, first words.

Barnett Newman died on the first day of the month of *Tammuz,* in the first hours of morning—a new moon—going from deep night to deepest night. It was the Fourth of July, 1970.

Newman on the New York waterfront,
a block from his studio on Front Street, 1965.
Photograph by Ugo Mulas

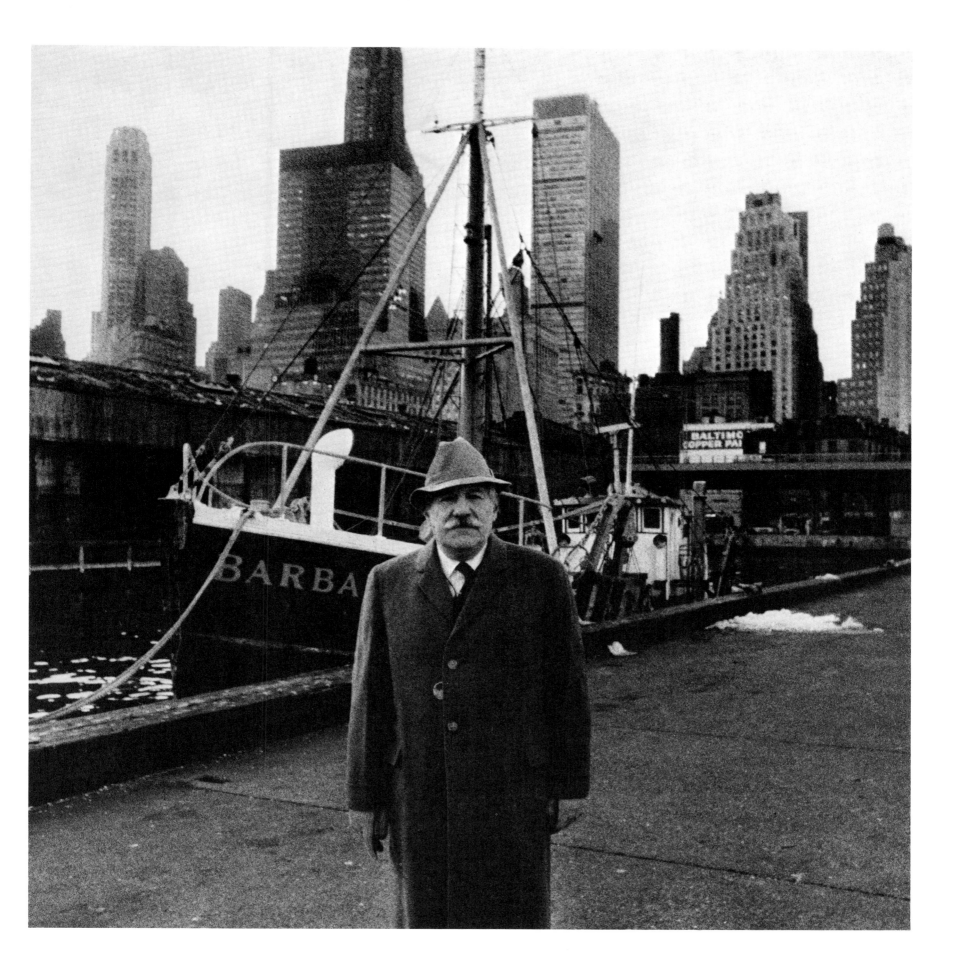

This bibliography was made possible through the generous cooperation of Annalee Newman, who made available her extensive archives on the artist. It is based largely on the one prepared by Helmut Ripperger for the author's earlier monograph, *Barnett Newman* (New York: Walker and Company, 1969). The author and the Museum are grateful to Mr. Ripperger for allowing them to reorganize and update his list for this volume.

STATEMENTS, WRITINGS, AND INTERVIEWS
BY BARNETT NEWMAN
(arranged chronologically)

1 "On the Need for Political Action by Men of Culture." New York, 1933. Unpublished manifesto.

2 "The Answer." Edited and published by Barnett Newman. *America's Civil Service Magazine* 1 (January 1936).

3 "Can We Draw?" ACA Gallery. New York, November 28–December 11, 1938. Catalogue foreword.

4 "American Modern Artists." Riverside Museum. New York, January 17–February 27, 1943. Catalogue foreword.

5 "Globalism Pops into View." *New York Times,* 13 June 1943. Letter to the Editor from Gottlieb and Rothko, written by Gottlieb, Rothko and Newman.

6 "Adolph Gottlieb." Wakefield Gallery. New York, February 7–19, 1944. Catalogue foreword.

7 "Pre-Columbian Stone Sculpture." Betty Parsons Gallery. New York, May 16–June 5, 1944. Catalogue foreword.

8 "Escultura pre-Colombina en piedra." *La Revista Belga* 1 (August 1944): 51–59.

9 "La pintura de Tamayo y Gottlieb." *La Revista Belga* 2 (April 1945): 16–25.

10 "Teresa Zarnower." Art of This Century. New York, April 23–May 11, 1946.

11 "Las formas artísticas del Pacífico." *Ambos Mundos* 1 (June 1946): 51–55. Reprinted in English in "Art of the South Seas." *Studio International* 179 (February 1970): 70–71.

12 "Northwest Coast Indian Painting." Betty Parsons Gallery. New York, September 30–October 19, 1946. Catalogue text. See bibl. 216.

13 "The Ideographic Picture." Betty Parsons Gallery. New York, January 20–February 8, 1947. Catalogue foreword. See bibl. 171, 172, 282.

14 "Stamos." Betty Parsons Gallery. New York, February 10–March 1, 1947. Catalogue foreword.

15 "The First Man Was an Artist." *Tiger's Eye* 1 (October 1947): 57–60.

16 "The Ides of Art—The Attitudes of 10 Artists on Their Art and Contemporaneousness." *Tiger's Eye* 1 (December 1947): 43.

17 "Herbert Ferber." Betty Parsons Gallery. New York, December 15, 1947–January 3, 1948. Catalogue foreword.

18 "The Object and the Image." *Tiger's Eye* 1 (March 1948): 111.

19 "The Sublime Is Now." *Tiger's Eye* 1 (15 December 1948): 51–53.

20 "To Be or Not—6 Opinions on Trigant Burrow's 'The Neurosis of Man.'" *Tiger's Eye* 1 (October 1949): 122–126.

21 Statement on his art. Betty Parsons Gallery. New York, January 1950. Unpublished typescript.

22 Letter to the Editor. *Art Digest* 24 (15 March 1950): 5. Reply to Peyton Boswell.

23 "Studio 35." In Robert Motherwell and Ad Reinhardt, eds. *Modern Artists in America.* New York: Wittenborn Schultz, 1952, pp. 9, 10, 12, 15, 22.

24 Open Letter to William A. M. Burden, President, Museum of Modern Art. New York, July 3, 1953. Second letter dated July 20, 1953. Both unpublished. Concerning Monet acquisition.

25 Letter to the Editor. *Art Digest* 29 (15 February 1954): 3. Disclaimer.

26 Letter to the Editor. "Critic or Commissar?" *New Republic,* 28 October 1957.

27 Letter to the Editor. *Art News* 58 (Summer 1959): 6. Reply to Hubert Crehan. See bibl. 123.

28 Letter to the Editor (First reply to Erwin Panofsky). *Art News* 60 (May 1961): 6. Second reply to Erwin Panofsky. *Art News* 60 (September 1961): 6.

29 "Frontiers of Space." Interview by Dorothy Gees Seckler. *Art in America* 50 (Summer 1962): 82–87.

30 "Embattled Lamb." *Art News* 61 (September 1962): 35, 57–58. Book review.

31 "Amlash Sculpture from Iran." Betty Parsons Gallery. New York, September 23–October 19, 1963. Catalogue foreword.

32 "Recent American Synagogue Architecture." Jewish Museum. New York, October 6–December 8, 1963. Catalogue statement. See bibl. 312.

33 *18 Cantos.* West Islip, New York: Universal Limited Art Editions, 1963–64. Volume of lithographs by Barnett Newman, with preface by the artist.

34 "Barnett Newman, American Painter." Television interview by Frank O'Hara on "Art New York" series, telecast on WNDT-TV (Newark), December 8, 1964. In Television Archive of the Arts, Museum of Modern Art, New York.

35 "The New York School Question." Interview by Neil A. Levine. *Art News* 64 (September 1965): 38–41, 55–56.

36 "United States of America." VIII São Paulo Biennial, São Paulo, Brazil, September 4–November 28, 1965. Catalogue statement. See bibl. 103, 106, 129, 165, 184, 188, 260, 262, 332.

37 Letter to the Editor. *Art News* 64 (November 1965): 6. Reply to Mrs. Clyfford Still.

38 "The Case for 'Exporting' Nation's Avant-Garde Art." Interview by Andrew Hudson. *Washington Post,* 27 March 1966.

39 "The Stations of the Cross." Solomon R. Guggenheim Museum. New York, April–May 1966. Catalogue statement. See bibl. 41, 109, 112, 276.

40 "A Conversation: Barnett Newman and Thomas B. Hess." Solomon R. Guggenheim Museum. New York, May 1, 1966. Unpublished interview. Typescript in library of Museum of Modern Art, New York.

41 "The 14 Stations of the Cross." *Art News* 65 (May 1966): 26–28, 57. See bibl. 39, 109, 112, 276.

42 "Barnett Newman." Part of "U.S.A. Artists" series, National Educational Television, telecast on July 12, 1966. In Television Archive of the Arts, Museum of Modern Art, New York.

43 "The Museum World." *Arts Yearbook* 9. New York: Arts Digest, 1967.

44 "Jackson Pollock: An Artist's Symposium," Part I. *Art News* 66 (April 1967): 29.

45 Letter to the Editor (First reply to Robert Motherwell). *Art International* 11 (September 1967): 51. Second reply to Robert Motherwell. *Art International* 11 (November 1967): 24, 27. Third reply to Robert Motherwell. *Art International* 12 (January 1968): 41.

46 Introduction to *Memoirs of a Revolutionist*, by Peter Kropotkin. New York: Horizon Press, 1968.

47 Letter to the Editor. *Art News* 66 (February 1968): 6.

48 Letter to the Editor. *Artforum* 6 (March 1968): 4.

49 "Pour la critique passionée." *Preuves*, no. 207 (May 1968): 44.

50 "For Impassioned Criticism." *Art News* 67 (Summer 1968): 26.

51 Letter to the Editor: "Dada, Surrealism and Their Heritage" exhibition at The Museum of Modern Art. *Art News* 67 (Summer 1968): 8. See bibl. 203, 349.

52 Statement. *Art Now: New York* 1 (March 1969).

53 "Chartres and Jericho." *Art News* 68 (April 1969): 28–29. Reprinted in *Studio International* 179 (February 1970): 65.

54 "In Front of the Real Thing." *Art News* 68 (January 1970): 60.

55 Film interview with Barnett Newman, April 4, 1970. "Painters Painting, New York." Directed by Emile de Antonio. Distributed by Turin Film Corporation, New York. 35 mm, color, 120 minutes.

MONOGRAPHS

56 Hess, Thomas B. *Barnett Newman*. New York. Walker and Company, 1969.

GENERAL WORKS

57 Alloway, Lawrence. *Systemic Painting*. New York: Solomon R. Guggenheim Museum, September–November 1966, p. 12.

58 Arnason, H. H. *History of Modern Art*. New York: Abrams, 1968, *passim*.

59 Ashton, Dore. *The Unknown Shore*. Boston: Little, Brown & Co., 1962, pp. 34, 210.

60 Cummings, Paul. *A Dictionary of Contemporary American Artists*. New York: St. Martin's Press, 1966, p. 217.

61 *Current Biography*, vol. 30. New York: H. W. Wilson, 1969, pp. 300–303.

62 Dillenberger, Jane. *Secular Art with Sacred Themes*. Nashville: Abingdon Press, 1969, pp. 99–116, 118, 120, 121, 127, 128, 129.

63 Fenton, Terry. *Painting in Saskatchewan 1883–1959*. Regina: Norman Mackenzie Art Gallery, October 16–November 5, 1967.

64 Fried, Michael. *Three American Painters*. Cambridge, Mass.: Fogg Art Museum, April 21–May 30, 1965, pp. 4, 20, 21–23, 40.

65 Geldzahler, Henry. *American Painting in the 20th Century*. New York: Metropolitan Museum of Art, 1965, p. 189.

66 Gilbert, Dorothy B., ed. *Who's Who in American Art*. New York: R. R. Bowker, 1966, p. 346.

67 Haftmann, Werner. *Painting in the Twentieth Century*, vol. 1. New York: Praeger, 1960, pp. 341, 351, 369, 404.

68 Hamilton, George Heard. *19th and 20th Century Art*. New York: Abrams, 1970, pp. 401, 403, 404.

69 *Kindlers Malerei Lexikon*, vol. 4. Zurich: Kindlers Verlag, 1967, p. 579.

70 Kultermann, Udo. *The New Sculpture*. New York: Praeger, 1968, pp. 116–117.

71 Lucie-Smith, Edward. *Late Modern: The Visual Arts since 1945*. New York: Praeger, 1969, pp. 38, 100, 103, 108, 110, 236.

72 McShine, Kynaston. *Primary Structures*. New York: Jewish Museum, April 27–June 12, 1966, p. 5.

73 *Metro International Directory of Contemporary Art*. Milan: Metro, 1964, pp. 260–261.

74 *New Art around the World*. New York: Abrams, 1966, pp. 10, 16, 23, 28, 39, 43, 51, 57, 113.

75 Pellegrini, Aldo. *New Tendencies in Art*. New York: Crown, 1966, pp. 76, 115–116, 127, 131–132, 135, 139, 140, 149, 161, 162, 301.

76 Read, Herbert. *A Concise History of Modern Painting*. New York: Praeger, 1959, p. 274.

77 Rose, Barbara. *American Art since 1900*. New York: Praeger, 1967, pp. 115, 187, 189, 192, 193, 194–197, 205, 207, 209, 224, 226, 233, 257.

78 _____. *American Painting: The Twentieth Century*. New York: Skira, 1970, pp. 61, 80, 86, 87, 90, 96, 102, 103, 112.

79 _____. *A New Aesthetic*. Washington, D.C.: Gallery of Modern Art, May 6–June 25, 1967, pp. 15–16.

80 _____, ed. *Readings in American Art since 1900*. New York: Praeger, 1968, pp. 145, 146, 158–160.

81 Sandler, Irving. *The Triumph of American Painting: A History of Abstract Expressionism*. New York/Washington: Praeger, 1970, pp. 62, 68, 69, 88, 103, 110, 148, 149, 151, 153, 154, 158, 181, 185–191, 200, 209, 211, 212, 213, 220, 229, 230, 247.

82 Solomon, Alan. *New York: The New Art Scene*. New York: Holt, Rinehart and Winston, 1967, pp. 9, 14, 15, 80–97.

83 Vollmer, Hans, ed. *Allgemeines Lexikon der bildenden Künstler des XX Jahrhunderts*, vol. 6. Leipzig: E. A. Seemann, 1962, p. 302.

ARTICLES

84 Ahlander, Leslie Judd. "The Emerging Art of Washington." *Art International* 6 (25 November 1962): 30.

85 Alloway, Lawrence (no title). *Living Arts*, no. 3 (April 1964): 45.

86 _____. "The American Sublime." *Living Arts*, no. 2 (June 1963), p. 11.

87 _____. "Barnett Newman." *Artforum* 3 (June 1965): 20–22.

88 _____. "Melpomene and Graffiti." *Art International* 12 (April 1968): 21.

89 _____. "Notes on Barnett Newman." *Art International* 13 (Summer 1969): 35–39.

89a _____. "One Sculpture." *Arts Magazine* 45 (May 1971): 22–24.

90 "Anti-Daley Art Put in Show in Chicago." *New York Times*, 24 October 1968, p. 40. See bibl. 92, 222, 356.

91 "Art across the U.S.A." *Apollo* 89 (April 1969): 319.

92 "Artists vs. Mayor Daley." *Newsweek*, 4 November 1968, p. 117. See bibl. 90, 222, 356.

93 Ashton, Dore. "Art." *Arts and Architecture* 76 (May 1959): 6, 7.

94 _____. "Art." *Arts and Architecture* 83 (November 1966): 6.

95 _____. "Art: A Change in Style." *New York Times*, 12 March 1959.

96 _____. "Barnett Newman and the Making of Instant Legend." *Arts and Architecture* 83 (June 1966): 4.

97 _____. "The European Art Press on American Art." *Arts and Architecture* 57 (August 1958): 30, 31, 62, 63.

98 _____. "New York Report." *Das Kunstwerk* 16 (November–December 1962): 68, 69.

99 _____. "Report on the New York Gallery Season, Winter 1958–59." *Cimaise* 6 (June, July, August 1959): 38, 39.

100 "Ausstellungen in New York." *Das Kunstwerk* 20 (April–May 1967): 38.

101 Baigell, Matthew. "American Painting: On Space and Time in the Early 1960's." *Art Journal* 28 (Summer 1969): 368–374, 387, 401.

102 Baker, Elizabeth C. "Barnett Newman in a New Light." *Art News* 67 (February 1969): 38–41, 60–62, 64.

103 _____. "Brazilian Bouillabaisse." *Art News* 64 (December 1965): 30. See bibl. 36, 106, 129, 165, 184, 188, 260, 262, 332.

104 Barker, Walter. "The Passion without the Image." *St. Louis Post-Dispatch,* 12 June 1966.

105 "Barnett Newman." *Vogue,* 15 April 1966, p. 110.

106 "Barnett Newman fala de arte e de sua geraçao." *Estado de S. Paulo,* 29 August 1965, p. 18. See bibl. 36, 103, 129, 165, 184, 188, 260, 262, 332.

107 "Barnett Newman, 1905–1970." *New York Times,* 26 July 1970.

108 "Barnett Newman, Painter, 65, Dies." *New York Times,* 5 July 1970.

109 "Barnett Newman Opens at the Guggenheim." *Newsweek,* 9 May 1966, p. 100. See bibl. 39, 41, 112, 276.

110 Baro, Gene. "London Letter." *Art International* 9 (June 1965): 67.

111 Battcock, Gregory. "The Art of the Real." *Arts Magazine* 42 (Summer 1968): 44. See bibl. 351.

112 Berkson, William. Review of "The Stations of the Cross." *Arts Magazine* 40 (June 1966): 44. See bibl. 39, 41, 109, 276.

113 "Betty Parsons—Her Gallery—Her Influence." *Vogue,* 1 October 1951, pp. 140, 141.

114 Bihalji-Merin, Oto. "Crisis and Creation." *Art in America* 48 (Summer 1960): 49–53.

115 "Bladen's X is an X is an X is an X." *Washington Post,* 8 October 1967.

116 Blotkamp, Carel. "Barnett Newman-twee schilderijen." *Museumjournaal* 15 (February 1970): 3–11.

117 Boswell, Peyton. "Too Many Words." *Art Digest* 24 (15 February 1950): 5.

118 Bowness, Alan. "The American Invasion and the British Response." *Studio International* 173 (June 1967): 290.

119 Calas, Nicolas. "Subject Matter and the Work of Barnett Newman." *Arts Magazine* 42 (November 1967): 38–40. Reprinted in Calas. *Art in the Age of Risk.* New York: Dutton, 1968, pp. 208–215.

120 Canaday, John. "Art with Pretty Thorough Execution—Newman and Alloway Provide the Rope." *New York Times,* 23 April 1966.

121 Carlson, Helen. "Diversity of Style and Media." *New York Sun,* 14 October 1949. See bibl. 285.

122 Clair, Jean. "Brève défense de l'art français 1945–1968." *La Nouvelle Revue Française,* 1 October 1968, p. 444.

123 Crehan, Hubert. "Barnett Newman." *Art News* 58 (April 1959): 12. See bibl. 27.

124 Davis, Douglas. "After 10 Years, a One-Man Show by Mr. Newman." *National Observer,* 14 April 1969, p. 20. See bibl. 278.

125 _____. "Death of an Artist." *Newsweek,* 20 July 1970, pp. 47–48.

126 "Day in Day Out." *Time* (Canadian Edition), 20 October 1961, p. 20.

127 "8 New York Painters." *Vogue,* 15 October 1959, p. 90.

128 "Etcetera." *The Art Gallery* 14 (April 1971): 30.

129 "Eua: 46 Obras de 7 artistas; Barnett veio e quer ver Pelé." *Folha de S. Paulo,* 28 August 1965, p. 2. See bibl. 36, 103, 106, 165, 184, 188, 260, 262, 332.

130 Ferretti, Fred. "Houston Getting a Sculpture after All." *New York Times,* 26 August 1969.

131 Fitzsimmon, James. Editorial on exhibition of paintings in St. Gall. *Art International* 3 (1959): 17. See bibl. 292.

132 "Five Sculptors." *Location* 1 (Spring 1963): 81–89.

133 "Flash! Sculpture Still Leads New York." *Art and Artists* (November 1967).

134 Fried, Michael. "Jules Olitski's New Paintings." *Artforum* 4 (November 1965): 36.

135 _____. "Modern Painting and Formal Criticism." *American Scholar* 33 (Autumn 1964): 642–648.

136 _____. "New York Letter." *Art International* 6 (20 December 1962): 54.

137 _____. "Shape as Form: Frank Stella's New Paintings." *Artforum* 5 (November 1966): 18.

138 Fulford, Robert. "American Revolution." *Toronto Daily Star,* 14 October 1961.

139 _____. "Painting." *Toronto Daily Star,* 28 December 1961.

140 Gaul, Winfred. "Amerika, has du es besser?" *Das Kunstwerk* 16 (March 1963): 2.

141 Genauer, Emily. "Art and Artists." *New York Herald Tribune,* 6 May 1951.

142 _____. "Barnett Newman." *New York Herald Tribune,* 23 April 1966.

143 _____. "Barnett Newman Exhibit." *New York Herald Tribune,* 26 January 1950. See bibl. 228, 270.

144 _____. "Christ's Journey on Canvas." *New York Herald Tribune,* 20 April 1966. See bibl. 276.

145 Getlein, Frank. "Kidding the Id in Minneapolis." *New Republic,* 26 August 1957. See bibl. 289.

146 Glueck, Grace. "And an Arty New Year." *New York Times,* 1 January 1967, p. 20D.

147–48 Goossen, E. C. "The Big Canvas." *Art International* 2 (1958): 45–47. Reprinted in Battcock, Gregory, ed. *The New Art.* New York: Dutton, 1966.

149 _____. "The Philosophic Line of Barnett Newman." *Art News* 57 (Summer 1958): 30–31.

150 Gray, Cleve. "The Portfolio Collector." *Art in America* 53 (June 1965): 93.

151 Greenberg, Clement. "After Abstract Expressionism." *Art International* 6 (25 October 1962): 24–32.

152 _____. "American-Type Painting." *Partisan Review* 22 (Spring 1955): 179–196. Revised and reprinted in Greenberg, *Art and Culture.* Boston: Beacon, 1961, pp. 208–229.

153 _____. "Art." *Nation* 165 (6 December 1947): 629, 630.

154 _____. "Art Chronicle." *Partisan Review* 19 (January-February 1952): 100, 101. Revised and reprinted in Greenberg, *Art and Culture.* Boston: Beacon, 1961, pp. 150, 151.

155 _____. "Clement Greenberg's View of Painting and Sculpture in Prairie Canada Today." *Canadian Art* 20 (March 1963): 90–107.

156 Heron, Patrick. "Barnett Newman." *Studio International* 180 (September 1970): 70.

157 Hess, Thomas B. "The Cultural-Gap Blues." *Art News* 57 (January 1959): 24, 25.

158 _____. Editorial. *Art News* 66 (October 1967): 23.

159 _____. Editorial: "Barnett Newman, 1905–1970." *Art News* 69 (September 1970): 29.

160 _____. "Historico-Iconographical Footnote." *Art News* 68 (April 1969): 29.

161 _____. Editorial: "New Man in Town." *Art News* 66 (November 1967): 27.

162 _____. "Newman." *Art News* 49 (March 1950): 48.

163 _____. "Newman." *Art News* 50 (Summer 1951): 47.

164 _____. "Willem de Kooning and Barnett Newman." *Art News* 61 (December 1962): 12. See bibl. 198, 274.

165 Hopps, Walter. "United States Exhibit, São Paulo Bienal." *Art in America* 53 (October–November 1965): 82. See bibl. 36, 103, 106, 129, 184, 188, 260, 262, 332.

166 Hudson, Andrew. "Newman Brings Grandeur to Town." *Washington Post,* 30 January 1966.

167 _____. "On Jules Olitski's Painting—and Some Changes of View." *Art International* 12 (January 1968): 31–36.

168 _____. "Scale as Content." *Artforum* 6 (December 1967): 46.

169 _____. "Shows Are Rich in Comparison." *Washington Post,* 21 May 1967.

170 Hunter, Sam. "Abstract Expressionism—Then and Now." *Canadian Art* 21 (September 1964): 21.

171 "The Ideographic Picture." *New York Herald Tribune,* 2 February 1947. See bibl. 13, 172, 282.

172 "The Ideographic Picture." *New York Times,* 23, 26 January 1947. See bibl. 13, 171, 282.

173 "Interview with de Kooning." *Vrij Nederland,* 5 October 1968, p. 3.

174 "Irascible Group of Advanced Artists Led Fight against Show." *Life,* 15 January 1951.

175 Judd, Donald. "Barnett Newman." *Studio International* 179 (February 1970): 66–69.

176 _____. "In the Galleries—Black and White." *Arts Magazine* 38 (March 1964): 65. See bibl. 319.

177 Kainen, Jacob. "Gene Davis and the Art of Color Interval." *Art International* 10 (20 December 1966): 31.

178 Kaprow, Allan. "Impurity." *Art News* 61 (January 1963): 30–33, 52–55.

179 Kerber, Bernhard. "Der Ausdruck des Sublimen in der amerikanischen Kunst." *Art International* 18 (December 1969): 31–36.

180 Kozloff, Max. "Art." *Nation* 202 (16 May 1966): 598.

181 _____. "Art and the New York Avant-Garde." *Partisan Review* 31 (Fall 1964): 535–554.

182 _____. "The Critical Reception of Abstract Expressionism." *Arts Magazine* 40 (December 1965): 22.

183 _____. Letter to the Editor. *Art International* 7 (25 June 1963): 88–92.

184 _____. "São Paulo in Washington." *Nation* 202 (28 February 1966): 250. See bibl. 36, 103, 106, 129, 165, 188, 260, 262, 332.

185 Kramer, Hilton. "The Latest Thing in Pittsburgh." *Arts Magazine* 36 (January 1962): 24–27.

186 _____. "Month in Review." *Arts Magazine* 33 (April 1959) 45.

187 _____. "The Studio vs. the Street." *New York Times,* 15 October 1967.

188 _____. "U.S. Art from São Paulo on View in Washington." *New York Times,* 29 January 1966, p. 22. See bibl. 36, 103, 106, 129, 165, 184, 260, 262, 332.

189 Krasne, Belle. "The Bar Vertical on Fields Horizontal." *Art Digest* 25 (1 May 1951): 16.

190 Kroll, Jack. "American Painting and the Convertible Spiral." *Art News* 60 (November 1961): 34–37, 66–69.

191 _____. "Bookshelf: Some Greenberg Circles." *Art News* 61 (March 1962): 35.

192 Kuh, Katherine. "Denials, Affirmations and Art." *Saturday Review,* 31 May 1969, pp. 41–42.

193 Lanes, Jerrold. "New York." *Artforum* 7 (May 1969): 59.

194 _____. "Reflections on Post-Cubist Painting." *Arts Magazine* 33 (May 1959): 24–29.

195 Leider, Philip. "The Artist Is Unexplained." *New York Times,* 6 April 1969.

196 _____. "How I Spent My Summer Vacation." *Artforum* 9 (September 1970): 40–49.

197 _____. "The New York School in Los Angeles." *Artforum* 4 (September 1965): 3.

198 Lichtblau, Charlotte. "Willem de Kooning and Barnet Newman." *Arts Magazine* 43 (March 1969): 28–33. See bibl. 164, 274.

199 Lippard, Lucy. "Escalation in Washington." *Art International* 12 (January 1968): 42–46. Reprinted in Lippard. *Changing.* New York: Dutton, 1971.

200 _____. "Larry Poons, The Illusion of Disorder." *Art International* 11 (20 April 1967): 22.

201 _____. "New York Letter." *Art International* 10 (Summer 1966): 108–111.

202 _____. "New York Letter: Off Color." *Art International* 10 (20 April 1966): 74.

203 _____. "Notes on Dada and Surrealism at the Modern." *Art International* 12 (May 1968): 36. See bibl. 51, 349.

204 _____. "The Silent Art." *Art in America* 55 (January–February 1967): 58.

205 Louchheim [Saarinen], Aline. "Extreme Modernists." *New York Times,* 9 January 1950.

206 McKay, Robert. "Emma Lake Artists' Workshop: An Appreciation." *Canadian Art* 21 (September–October 1964): 281.

207 Maxwell, Elsa. "Betty Parsons Christmas Show." *New York Post,* 20 December 1946. See bibl. 281.

208 Meadmore, Clement. "New York—Scene II—Colour as an Idiom." *Art in Australia* (March 1966): 288.

209 M[onte], J[ames]. "Forty-six Works from New York." *Artforum* 2 (January 1964): 7.

210 Morris, Dan. "Why Hush Monet, Artist Asks Modern Museum." *New York Daily Mirror,* 6 July 1953.

211 "Most with the Least." *Time,* 20 July 1970, p. 54.

212 Murray, Robert. "Barnett Newman (1905–1970), an Appreciation." *Arts/Canada,* nos. 146/147 (August 1970), pp. 50–51.

213 Nemerov, Howard. "On Certain Wits Who Amuse Themselves over the Simplicity of Barnett Newman Paintings Shown at Bennington College in May of 1958." *Nation* 6 (September 1958). Reprinted in *Art in America* 53 (October–November 1965): 33. See bibl. 272.

214 "Neue Abstraktion." *Das Kunstwerk* 18 (April–June 1965): 24, 25, 119.

215 Nodelman, Sheldon. "Sixties Art: Some Philosophical Perspectives." *Perspecta 11* (Yale Architectural Journal), 1967: 72–89.

216 "Northwest Coast Indian Painting." *New York Times,* 6 October 1946. See bibl. 12.

217 O'Hara, Frank. "Art Chronicle." *Kulchur* 93 (Spring 1963): 55.

218 Orlandini, Marisa Volpi. "La Forma viviente de Barnett Newman." *Marcatré,* nos. 34/35/36 (December 1967): 34–37.

219 _____. "Vision and Colour in New York." *Arte Contemporanea,* no. 3 (March 1967): 35.

220 "Painting of a Different Stripe." *Time,* 29 April 1966, p. 82.

221 "Picture of a Painter." *Newsweek,* 16 March 1959, p. 58.

222 "Portrait of a Mayor: Art Show in Chicago Takes Aim at Daley." *Wall Street Journal,* 23 October 1968, p. 1. See bibl. 90, 92, 356.

223 "Pre-Columbian Stone Sculpture." *New York Times,* 21 May 1944.

224 Preston, Stuart. "Chiefly Modern." *New York Times,* 4 January 1950.

225 _____. "Current and Forthcoming Exhibitions: New York." *Burlington Magazine* 101 (May 1959): 200.

226 _____. "Diverse New Shows." *New York Times,* 29 April 1951.

227 Ratcliff, Carter. "New York Letter." *Art International* 14 (December 1970): 66.

228 Reed, Judith Kay. "Newman's Flat Areas." *Art Digest* 24 (1 February 1950): 16. See bibl. 143, 270.

229 Reise, Barbara. "Correspondence." *Studio International* 179 (March 1970): 90.

230 _____. "Greenberg and the Group: A Retrospective View," Part 1. *Studio International* 175 (May 1968): 254 *et passim*. Part 2. 175 (June 1968): 314 *et passim*.

231 _____. Letter to the Editor. *Studio International* 176 (October 1968): 127.

232 _____. "The Stance of Barnett Newman." *Studio International* 179 (February 1970): 49–63.

233 Richardson, John. "At the New Whitney." *New York Review of Books*, 3 November 1966. See bibl. 335.

234 Rose, Barbara. "Art—Culture Collision." *Vogue*, 1 October 1970, p. 98.

235 _____. "Blowup—The Problem of Scale in Sculpture." *Art in America* 56 (July–August 1968): 80–91.

236 _____. "New York Letter." *Art International* 7 (5 December 1963): 61.

237 _____. "New York Letter." *Art International* 8 (15 February 1964): 40.

238 _____. "The Primary of Color." *Art International* 8 (May 1964): 22.

239 Rosenberg, Harold. "Barnett Newman: A Man of Controversy and Grandeur." *Vogue*, 1 February 1963, pp. 134, 135, 163–166. Reprinted in Rosenberg, *The Anxious Object*. New York: Horizon Press, 1969, pp. 169–174.

240 _____. "Icon Maker." *New Yorker*, 19 April 1969, pp. 136, 138, 140, 142.

241 Rosenblum, Robert. "The Abstract Sublime." *Art News* 59 (February 1961): 38–41, 56–58.

242 _____. "La Peinture américaine depuis la seconde guerre mondiale." *Aujourd'hui Art et Architecture* 3 (July 1958): 12–18.

243 Rubin, William. "The International Style: Notes on the Pittsburgh Triennal." *Art International* 5 (20 November 1961): 26–33.

244 Russell, John. "Art News from London." *Art News* 64 (Summer 1965): 48.

245 _____. "Search for 'Onement.'" *The London Times*, 19 July 1970.

246 Sawin, Martica. "New York Letter." *Art International* 3 (May–June 1959): 48.

247 Schjeldahl, Peter. "Barnett Newman: 'Aspiration toward the Sublime.'" *New York Times*, 6 September 1970.

248 _____. "New York Letter." *Art International* 13 (Summer 1969): 64.

249 Schneider, Pierre. "Through the Louvre with Barnett Newman." *Art News* 68 (Summer 1969): 34–39, 70–72. Reprinted in Schneider. *Louvre Dialogues*. New York: Atheneum, 1971.

250 Schwartz, Marvin D. "News and Views from New York." *Apollo* 69 (April 1959): 124.

251 "Sculpture." *Time*, 13 October 1967.

252 "Sculpture Festival." *New York Post*, 27 September 1967.

253 "Seattle World's Fair." *Artforum* 1 (September 1962): 36. See bibl. 306.

253a Siegel, Jeanne. "Around Barnett Newman." *Art News* 70 (October 1971): 42–47, 59–62, 65–66.

254 Smith, David. "Ten Americans to Watch in 1959." *Pageant*, February 1959.

255 Solomon, Alan. "The New York Art: Who Makes It?" *Vogue*, 1 August 1967, p. 102.

256 Stahly, F. "Pariser Kunstchronik." *Das Werk* 46 (March 1959): 64.

257 "That's the Whole Point." *New York Daily News*, 28 September 1967.

258 "The Third Stream: Constructed Paintings and Painted Structures." *Art Voices* 4 (Spring 1965): 44.

259 Tillim, Sidney. "Month in Review." *Arts Magazine* 37 (December 1962): 38–40.

260 "2 Artists Share São Paulo Prize." *New York Times*, 2 September 1965. See bibl. 36, 103, 106, 129, 165, 184, 188, 262, 332.

261 "Two Decades of American Painting." *Mizue: A Monthly Review of the Fine Arts*, 15 October–27 November 1966. See bibl. 336.

262 "U.S. Art Exhibit Arrives in Brazil." *New York Times*, 29, 30 August 1965. See bibl. 36, 103, 106, 129, 165, 184, 188, 260, 332.

263 Waldron, Martin. "14 Rothko Works Adorn New Chapel in Houston." *New York Times*, 1 March 1971.

264 Whitford, Frank. "John Plumb: Improvisation and Discipline." *Studio International* 172 (August 1966): 99.

265 Whitford, Frank, and Kudielka, Robert. "Documenta 4: A Critical Review." *Studio International* 176 (September 1968): 74–78. See bibl. 350.

266 Willard, Charlotte. "What's the Big Idea?" *New York Post*, 1 May 1966.

267 Wilson, William. "Barnett Newman, Hypnotist." *Los Angeles Times*, 2 August 1965. See bibl. 275.

268 Young, Mahonri Sharp. "The Metropolitan Museum of Art Centenary Exhibitions 1, The New York School." *Apollo* 90 (November 1969): 426–432. See bibl. 364.

269 Zerner, Henri. "Universal Limited Art Editions." *L'Oeil*, no. 120 (December 1964), p. 36.

EXHIBITIONS
(An asterisk after the title of an exhibition indicates a published catalogue or checklist.)

A. ONE-MAN EXHIBITIONS

270 New York. Betty Parsons Gallery. "Barnett Newman." January 23–February 11, 1950. See bibl. 143, 228.

271 New York. Betty Parsons Gallery. "Barnett Newman." April 23–May 12, 1951.

272 Bennington, Vermont. Bennington College. "Barnett Newman: First Retrospective Exhibition."* May 4–24, 1958. Introduction by Clement Greenberg with a note by E. C. Goossen. See bibl. 213.

273 New York. French & Company. "Barnett Newman: A Selection 1946–1952."* March 11–April 5, 1959. Foreword by Clement Greenberg.

274 New York. Allan Stone Gallery. "Newman–de Kooning."* October 23–November 17, 1962. Two simultaneous one-man shows. See bibl. 164, 198.

275 Los Angeles. Nicholas Wilder Gallery. "XVIII Cantos." July 19–August 14, 1965. See bibl. 267.

276 New York. The Solomon R. Guggenheim Museum. "Barnett Newman: The Stations of the Cross, Lema Sabachthani."* April 2–June 19, 1966. Text by Lawrence Alloway. See bibl. 39, 41, 109, 112.

277 Basel. Kuntsmuseum. "Barnett Newman, 22 Lithographien."* March 15–May 4, 1969. Text by Carlo Huber.

278 New York. M. Knoedler & Co., Inc. "Barnett Newman."* March 25–April 19, 1969. Text by Thomas B. Hess. See bibl. 124.

279 Pasadena, California. Pasadena Art Museum. "Barnett Newman, January 29, 1905–July 4, 1970."* July 31–August 30, 1970.

280 Bern. Kammerkunsthalle. "Barnett Newman: Das graphische Werk."* October 17–November 22, 1970.

B. GROUP EXHIBITIONS

281 New York. Betty Parsons Gallery. "Christmas Show." December 1946. See bibl 207.

282 New York. Betty Parsons Gallery. "The Ideographic Picture."* January 20–February 8, 1947. Foreword by Barnett Newman. See bibl. 13, 171, 172.

283 Chicago. The Art Institute of Chicago. "Abstract and Surrealist American Art."* November 6, 1947–January 11, 1948.

284 New York. Betty Parsons Gallery. "Survey of the Season." June 1–21, 1948.

285 New York. Betty Parsons Gallery. "Group Show." October 10–29, 1949. See bibl. 121.

286 Provincetown, Massachusetts. Hawthorne Memorial Gallery. "Post-Abstract Painting, 1950, France-America."* August 6–September 4, 1950.

287 Minneapolis, Minnesota. Walker Art Center. "American Painting."* October 15–December 10, 1950. Introduction by H. H. Arnason.

288 New York. Betty Parsons Gallery. "Ten Years."* December 9, 1955–January 14, 1956. Introduction by Clement Greenberg.

289 Minneapolis, Minnesota. Minneapolis Institute of Arts. "American Paintings 1945–1957."* June 18–September 1, 1957. Introduction by Stanton L. Catlin. See bibl. 145.

290 New York. The Museum of Modern Art. "The New American Painting: As Shown in Eight European Countries 1958–1959."* Introduction by Alfred H. Barr, Jr. Exhibition organized by the International Council of The Museum of Modern Art. Circulated to Kunsthalle, Basel, April 19–May 26, 1958; Galleria Civica d'Arte Moderna, Milan, June 1–29, 1958; Museo Nacional de Arte Contemporáneo, Madrid, July 16–August 11, 1958; Hochschule für Bildende Künste, Berlin, September 1–October 1, 1958; Stedelijk Museum, Amsterdam, October 17–November 24, 1958; Palais des Beaux-Arts, Brussels, December 6, 1958–January 4, 1959; Musée National d'Art Moderne, Paris, January 16–February 15, 1959; The Tate Gallery, London, February 24–March 23, 1959; The Museum of Modern Art, New York, May 28–September 8, 1959.

291 Pittsburgh, Pennsylvania. Carnegie Institute, Department of Fine Arts. "The 1958 Pittsburgh Bicentennial International Exhibition of Contemporary Painting and Sculpture."* December 5, 1958–February 8, 1959.

292 St. Gallen, Switzerland. Kunstmuseum. "Neue amerikanische Malerei."* March 14–April 26, 1959. See bibl. 131.

293 Tokyo. Gallery Kimura. "Group Show [Motherwell, Newman, Okada, Rothko, Tobey and Youngerman]." April 4–30, 1959.

294 Rome. Rome-New York Art Foundation. "Moments of Vision."* July–November 1959. Organized by Herbert Read.

295 Kassel. Documenta II. "Kunst nach 1945."* July 11–October 11, 1959. Introduction by Werner Haftmann.

296 New York. Whitney Museum of American Art. "Annual Exhibition of Contemporary Painting."* December 9, 1959–January 31, 1960.

297 Columbus, Ohio. Columbus Gallery of Fine Arts. "Contemporary American Painting."* January 14–February 18, 1960.

298 Los Angeles. Ferus Gallery. "New York Painters." February 1960.

299 Paris. Galerie Neufville. "Group Show [Gottlieb, Guston, Kline, Marca-Relli, Newman and Rothko]." February 23–March 22, 1960.

300 Milan. Galleria Dell'Ariete. "Undici Americani." May 1960.

301 Los Angeles. Everett Ellin Gallery. "Drawings by 15 Americans." September 12–October 8, 1960.

302 New York. The Museum of Modern Art. "The Collection of Mr. and Mrs. Ben Heller [circulating exhibition]."* September 22–October 14, 1961.

303 New York. The Solomon R. Guggenheim Museum. "American Abstract Expressionists and Imagists."* October 13–December 31, 1961.

304 New York. Decorative Art Center. "Art in America." December 1961.

305 United States Information Service. "Vanguard American Painting."* Circulated in Yugoslavia, Austria, Poland and England 1961–1962.

306 Seattle. World's Fair. "Art since 1950."* April–October 1962. See bibl. 253.

307 Hartford, Connecticut. Wadsworth Atheneum. "Continuity and Change."* April 11–May 27, 1962.

308 New York. American Federation of Arts Gallery. "The Educational Alliance, Retrospective Art Exhibit."* April 29–May 18, 1963. Preface by John I. H. Baur. Text by Alexander Dobkin and Moses Soyer.

309 Fredericton, New Brunswick. Beaverbrook Art Gallery. "The Dunn International."* September 7–October 6, 1963. Circulated to The Tate Gallery, London, November 14–December 14, 1963.

310 Waltham, Massachusetts. Brandeis University, Poses Institute. "New Directions in American Painting."* October–November 1963. Circulated in 1964 to The Munson-Williams-Proctor Institute, Utica; The Isaac Delgado Museum, New Orleans; The Atlanta Art Association; The J. B. Speed Museum, Louisville; Indiana University, Bloomington; Washington University, St. Louis; and Detroit Institute of Arts.

311 New York. Sidney Janis Gallery. "11 Abstract Expressionist Painters."* October 7–November 2, 1963.

312 New York. The Jewish Museum. "Recent American Synagogue Architecture."* October 6–December 8, 1963. See bibl. 32.

313 San Francisco. Dilexi Gallery. "46 Works from New York." November 12–December 7, 1963.

314 Washington, D.C. National Gallery of Art. "Paintings from The Museum of Modern Art."* December 7, 1963–March 1, 1964. Preface by John Walker. Foreword by René d'Harnoncourt. Introduction by Alfred H. Barr, Jr.

315 New York. Whitney Museum of American Art. "Annual Exhibition of Painting."* December 11, 1963–February 2, 1964.

316 New York. The Jewish Museum. "Black and White."* December 12, 1963–February 5, 1964. Introduction by Ben Heller.

317 Stockholm. Moderna Museet. "The Museum of Our Wishes."* December 26, 1963–February 16, 1964.

318 New York. The Solomon R. Guggenheim Museum. "Guggenheim International Award 1964."* January–March 1964. Introduction by Lawrence Alloway. Circulated to the Honolulu Academy of Fine Arts, Honolulu, May 14–July 6, 1964; Haus am Lützowplatz, Berlin, August 21–September 15, 1964; National Gallery of Canada, Ottawa, October 5–November 9, 1964; John and Mable Ringling Museum of Art, Saratoga, Florida, January 16–March 14, 1965; and the Museo Nacional de Bellas Artes, Buenos Aires, April 20–May 20, 1965.

319 Hartford, Connecticut. Wadsworth Atheneum. "Black, White and Gray." January 9–February 19, 1964. See bibl. 176.

320 Chicago. The Art Institute of Chicago. "Directions in Contemporary Painting." February 28–April 12, 1964.

321 London. The Tate Gallery. "54–64, Painting and Sculpture of a Decade."* April 22–June 28, 1964.

322 Basel. Kunsthalle. "Bilanz International-Malerei seit 1950."* June 20–August 24, 1964.

323 New York. Whitney Museum of American Art. "Between the Fairs, American Art."* June 24–September 23, 1964.

324 New York. The Solomon R. Guggenheim Museum. "American Drawings."* September–October 1964.

325 Amsterdam. Stedelijk Museum. "Amerikaanse grafiek."* September 25–November 2, 1964. Text by William S. Lieberman.

326 New York. Finch College, Museum of Art. "Artists Select."* October 15–December 15, 1964.

327 New York. Sidney Janis Gallery. "3 Generations."* November 24–December 26, 1964.

328 New York. Betty Parsons Gallery. "Drawings from the Collection of Betty Parsons."* Text by Joseph S. Trovato. Circulated by the Western Association of Art Museums, Seattle, Washington, 1965–1968.

329 Philadelphia. University of Pennsylvania. Institute of Contemporary Art. "The Decisive Years 1943–1953."* January 14–March 1, 1965. Introduction by Samuel Adams Green.

330 New York. The Museum of Modern Art. "Modern Sculpture U.S.A."* Introduction by René d'Harnoncourt. Exhibition organized by the International Council of The Museum of Modern Art. Circulated to the Musée Rodin, Paris, June 22–October 10, 1965; Hochschule für Bildende Künste, Berlin, November 20, 1965–January 9, 1966; and the Staatliche Kunsthalle, Baden-Baden, February 25–April 17, 1966.

331 Los Angeles. Los Angeles County Museum of Art. "New York School. The First Generation: Paintings of the 1940s and 1950s."* July 16–August 1, 1965. Text by Maurice Tuchman.

332 São Paulo, Brazil. VIII Bienal. "The United States of America"* (U.S. exhibit organized by Pasadena Art Museum). September 4–November 28, 1965. Circulated to the Smithsonian Institution, Washington, D.C., January 27–March 6, 1966. See bibl. 36, 103, 106, 129, 165, 184, 188, 260, 262.

333 New York. Whitney Museum of American Art. "1965 Annual Exhibition of Contemporary American Painting."* December 8, 1965–January 30, 1966.

334 Stockholm. Moderna Museet. "The Inner and Outer Space."* December 26, 1965–February 13, 1966.

335 New York. Whitney Museum of American Art. "Art of the United States 1670–1966."* September 28–November 27, 1966 See bibl. 233.

336 New York. The Museum of Modern Art. "Two Decades of American Painting."* Circulated in 1966–67 by the International Council of The Museum of Modern Art to the National Museum of Modern Art, Tokyo, October 15–November 27, 1966; National Museum of Modern Art, Kyoto, December 10, 1966–January 22, 1967; Lalit Kala Academy, New Delhi, March 25–April 15, 1967; National Gallery of Victoria, Melbourne, June 6–July 8, 1967; Art Gallery of New South Wales, Sydney, July 17–August 20, 1967. See bibl. 261.

337 New York. Whitney Museum of American Art. "1966 Annual Exhibition of Sculpture."* December 16, 1966–February 5, 1967.

338 New York. Sidney Janis Gallery. "2 Generations: Picasso to Pollock."* January 3–27, 1967.

339 Montreal. Expo '67. "American Painting Now"* (United States Pavilion). April 28–October 27, 1967. Circulated to the Institute of Contemporary Art, Boston, December 1967–January 1968.

340 Washington, D.C. Gallery of Modern Art. "Art for Embassies Selected from the Woodward Foundation Collection."* September 30–November 5, 1967. Introduction by Henry Geldzahler.

341 New York City Parks, Recreation, and Cultural Affairs Administration. "Sculpture in Environment." October 1967. One work (Broken Obelisk) placed in plaza of Seagram Building.

342 Eindhoven, The Netherlands. Stedelijk van Abbemuseum. "Kompas 3."* November 9–December 17, 1967. Preface and introduction by J. Leering. Circulated to the Frankfurt Kunstverein, December 30, 1967–February 11, 1968.

343 Paris. Knoedler Galerie. "Six Peintres Américains."* October 18–November 25, 1967.

344 Dublin. Royal Dublin Society. "Rosc '67. The Poetry of Vision."* November 13–December 30, 1967. Forewords by Jean Leymarie, Willem Sandberg and James Johnson Sweeney.

345 Washington, D.C. Corcoran Gallery. "Scale as Content."* October 1967–January 1968.

346 New York. Whitney Museum of American Art. "1967 Annual Exhibition of Contemporary American Painting."* December 13, 1967–February 4, 1968.

347 Minneapolis, Minnesota. Dayton's Gallery 12. "Contemporary Graphics Published by Universal Limited Art Editions."* February 21–March 6, 1968. Introduction by Harmony Clover.

348 New York. Finch College, Museum of Art. "Betty Parsons' Private Collection."* March 13–April 24, 1968. Text by E. C. Goossen.

349 New York. The Museum of Modern Art. "Dada, Surrealism, and Their Heritage."* March 27–June 9, 1968. Text by William S. Rubin. Circulated to the Los Angeles County Museum of Art, July 15–September 8, 1968; The Art Institute of Chicago, October 19–December 8, 1968. See bibl. 51, 203.

350 Kassel. Documenta 4.* June 22–October 6, 1968. See bibl. 265.

351 New York. The Museum of Modern Art. "The Art of the Real: USA 1948–1968."* July 3–September 8, 1968. Text by E. C. Goossen. Circulated to the Grand Palais, Paris, November 14–December 23, 1968; Kunsthaus, Zurich, January 19–February 23, 1969; The Tate Gallery, London, April 22–June 1, 1969. See bibl. 111.

352 Honolulu. Honolulu Academy of the Arts. "Signals in the Sixties."* October 5–November 10, 1968. Introduction by James Johnson Sweeney.

353 New York. The Museum of Modern Art. "In Honor of Dr. Martin Luther King, Jr."* October 30–November 2, 1968.

354 New York. Whitney Museum of American Art. "Annual Exhibition of Sculpture."* December 17, 1968–February 9, 1969.

355 Philadelphia. Philadelphia Museum of Art. "The Pure and Clear: American Innovations." November 13, 1968–January 21, 1969.

356 Chicago. Richard Feigen Gallery. "Richard J. Daley."* October 23–November 23, 1968. Circulated to The Contemporary Arts Center, Cincinnati, December 19, 1968–January 4, 1969. See bibl. 90, 92, 222.

357 Washington, D.C. Smithsonian Institution. "The Disappearance and Reappearance of the Image: American Painting since 1945."* Text by Ruth Kaufmann and John McCoubrey. Circulated by the International Art Program, National Collection of Fine Arts, to Sala Dalles, Bucharest, January 17–February 2, 1969; Museul Banatului, Timisoara, Rumania, February 14–March 1, 1969; Galerie de Arte, Cluj, Rumania, March 14–April 2, 1969; Slovak National Gallery, Bratislava, Czechoslovakia, April 14–June 15, 1969; the National Gallery's Wallenstein Palace, Prague, July 1–August 15, 1969; and the Palais des Beaux-Arts, Brussels, October 21–November 16, 1969.

358 Vancouver, British Columbia. Vancouver Art Gallery. "New York 13."* January 22–February 16, 1969. Introduction by Doris Shadbolt. Text by Lucy R. Lippard. Circulated to The Norman Mackenzie Art Gallery, Regina; The Art Gallery of Ontario, Toronto; The Musée d'Art Contemporain, Montreal.

359 New York. The Museum of Modern Art. "The New American Painting and Sculpture: The First Generation."* June 18–October 5, 1969.

360 Detroit, Michigan. Michigan State Council for the Arts. "Sculpture Downtown." July 1–August 31, 1969.

361 Hakone, Kanagawa-ken, Japan. Open-Air Museum. "The First International Exhibition of Modern Sculpture."* August 1–October 31, 1969.

362 Worcester, Massachusetts. Worcester Art Museum. "The Direct Image in Contemporary American Painting."* October 16–November 30, 1969. Text by Leon Shulman.

363 New York. American Federation of Arts. "American Painting: the 1960's."* Text by Samuel Adams Green. Circulated to the University of Georgia Art Museum, Athens, September 22–November 3, 1969; Junior League of Amarillo, Texas, November 30–December 28, 1969; Coe College, Cedar Rapids, Iowa, January 18–February 15, 1970; State University at Potsdam,

New York, College Art Gallery, March 8–April 5, 1970; Montreal Museum of Fine Arts, June 14–July 12, 1970; Mobile Art Gallery, Mobile, Alabama, August 2–30, 1970; and the Roberson Museum Center, Binghamton, New York, September 20–October 18, 1970.

364 New York. The Metropolitan Museum of Art. "New York Painting and Sculpture: 1940–1970."* October 18, 1969–February 8, 1970. Text by Henry Geldzahler. See bibl. 268.

365 Pasadena, California. Pasadena Art Museum. "Painting in New York: 1944 to 1969."* November 24, 1969–January 11, 1970.

366 New York. The Metropolitan Museum of Art. "Prints by Four New York Painters: Helen Frankenthaler, Jasper Johns, Robert Motherwell, Barnett Newman."* December 15, 1969–February 1, 1970.

367 Cincinnati, Ohio. Contemporary Arts Center. "Monumental American Art."* September 13–November 1, 1970.

368 Hempstead, New York. Hofstra University, Emily Lowe Gallery. "Graphics in Long Island Collections from the Studio of Universal Limited Art Editions."* September 21–October 22, 1970. Introduction by Diane Kelder and Robert R. Littman.

369 New York. Whitney Museum of American Art. "The Structure of Color."* February 25–April 18, 1971. Text by Marcia Tucker.

370 Antwerp. Middelheim Parc. "XIth International Biennale of Outdoor Sculpture."* 1971.

PHOTOGRAPH CREDITS

Oliver Baker, New York: top 62, top 63.

Geoffrey Clements, New York: left 142.

Jonathan Holstein, New York: 116.

Balthazar Korab, Troy, Mich.: 121.

Paulus Leeser, New York: 123, all 129, page facing 132, top 133, bottom 135, 136, 137, right 140.

Leonardo LeGrand: 120.

Robert E. Mates and Paul Katz, New York: 68, 94, 95, all 98-102.

Ugo Mulas, Milan Italy: 6, 10, 14, 18, 32, 54, 86, 108, 112, 118, bottom 126, 149, 150.

Hans Namuth, New York: 16, 74.

Rolf Petersen, New York: 72.

Eric Pollitzer, New York: top left 44, top right and bottom 46, bottom right 47, top left and bottom right 49, top 51, top 52, top 56, 58, bottom 63, 64, top 66, page facing 72, 82, 83, 84, page facing 85, top left and bottom 105, 106, both 127, 128, right 142, 143.

Walter J. Russell, New York: right 77, 78.

Aaron Siskind, New York: top 26, 28, 30.

Ezra Stoller, Mamaroneck, New York: both 113, 115.

Frank J. Thomas, Los Angeles: 76.

Malcolm Varon, New York: bottom 44, both 45, top left 46, top and bottom left 47, 48, page facing 48, page facing 49, 50, bottom 51, bottom 52, page facing 61, bottom 62, 69, 70, 71, page facing 73, 75, 80, 93, all 96, all 97, page facing 133, all 138-139, left 140, both 144, page facing 144, bottom 145.

Solomon R. Guggenheim Museum, New York: 103.

M. Knoedler & Co., New York: top right 105, top 126, both 130, all 131, all 132, center 140, top 145.

Metropolitan Museum of Art, New York: 20, bottom left 49, page facing 60.